WITHDRAWN

St. Louis Community College

Forest Park Florissant Valley Meramec

Instructional Resources St. Louis, Missouri

Edited by Richard Kendall
Translations by Bridget Strevens Romer

Paintings, drawings, pastels, letters

MONET by himself

A Bulfinch Press Book · Little, Brown and Company Boston · Toronto · London Copyright © 1989 by Macdonald & Co (Publishers) Ltd All rights reserved. No part of this book may be reproduced in any form or by any electronic or mechanical means, including information storage and retrieval systems, without permission in writing from the publisher, except by a reviewer who may quote brief passages in a review.

First United States Edition 1990 Second printing 1990

First published in Great Britain in 1989 by Macdonald & Co (Publishers) Ltd London & Sydney

International Standard Book Number 0-8212-1766-6

Library of Congress Catalog Card Number 89-84988

Bulfinch Press is an imprint and trademark of Little, Brown and Company (Inc.)

Filmset by Jolly & Barber Ltd, Rugby Colour separation by La Cromolito, Milan Printed in Italy by Arti Grafiche Vincenzo Bona S.r.l. This book would not have been possible without the generous support and co-operation of Daniel Wildenstein, the author of Claude Monet: Biographie et catalogue raisonné. My thanks are also due to the many owners of the copyrights in the Monet letters, principal among them Caroline Durand-Ruel Godfroy and the heirs of the Monet family, who have graciously allowed the publication of the artist's correspondence. Strenuous efforts have been made to contact all the owners of the original letters and in no case has permission for publication been refused. One or two owners have proved elusive and to these our apologies are offered.

Monet By Himself owes much to the model established for the series by Derek Birdsall and Bruce Bernard, as well as to the editorial support of Sarah Snape, Lewis Esson and others at Macdonald Orbis. The final appearance of the book is largely due to the discernment and sympathetic eye of its designer, Andrew Gossett; and I am again much indebted to Sharon Hutton, picture co-ordinator, factorum and occasional plenipotentiary.

My gratitude must also be extended to a number of individuals and institutions who have helped in the preparation of this volume: Juliet Bareau, Graham Beal, Peter and Angela Brookes, Philip Conisbee, Anne Dumas, Christian Geelhaar, John House, Ariane Lawson, Anne Roquebert, Bridget Strevens Romer, and Gretchen Wold; the curators and staff of the Art Institute of Chicago; Durand-Ruel et cie; the Fondation Wildenstein; the Galerie Beyeler, Basle; the Manchester Polytechnic art library; the Metropolitan Museum, New York; the Musée d'Orsay; the Musée Marmottan; the Museum of Fine Arts, Boston; the Museum of Modern Art, New York; the Palace of the Legion of Honour, San Francisco; the San Francisco Museum of Modern Art; and a number of private collectors who prefer to remain anonymous.

Contents

Preface Monet's France Introduction 1840–1881: Paris and the Seine 1882–1890: The Sea 98 1890–1908: The Series Paintings 170 1909–1926: The Water-lilies 240 List of Plates 316 Guide to the Principal Personalities 323 Mentioned in the Text Index 326 Text Acknowledgements 328 328 Further Reading

Claude Monet's paintings are among the most well known and widely enjoyed works of art in the world. His pictures of the French landscape in radiant sunshine have captured the imagination of our age, and have often been taken to exemplify the twentieth century's favourite art movement, Impressionism. It has also been frequently assumed that such sun-filled canvases were produced by an equally sunny and uncomplicated artist, and Monet himself has not been subjected to the same scrutiny as some of his more troubled contemporaries. During much of his lifetime Monet encouraged this tendency, insisting on his right to privacy and refusing to indulge in theoretical speculations about his art.

In recent years the publication by Daniel Wildenstein of Monet's complete surviving correspondence has made available a wide range of new information and new insights into the artist and his work. It is now clear that Monet was a compulsive writer, leaving behind him more than two thousand letters which between them contain almost half a million words. Such superabundance has its problems: while the four-volume Wildenstein Catalogue Raisonné, which contains the collected letters, is an essential feature of any good art library, Monet By Himself is the first selection of the artist's correspondence intended for the less specialized reader. The distillation of such a vast amount of material into a manageable and representative compilation has been an arduous and sometimes agonizing process. Letters from Monet's early years are relatively scarce, but the need to preserve a balanced coverage of his later career has led inevitably to a concentration on the correspondence referring directly to his painting or to his relationships with family and fellow artists.

The translation of Monet's letters for this volume has also been far from straightforward. Monet's formal education was limited, and his written French can be highly idiosyncratic. Apart from his use of obscure or colloquial phrases, Monet's resistance to punctuation and his preference for successive subclauses are not easily rendered into standard English. It is as well to remember, however, that Monet read quite widely and that his correspondents included many of the major literary figures of his age. His letters can be matter-of-fact or impassioned, evocative or rhetorical, lucid or warmly affectionate, and together they make an infinitely more various and rewarding study than the conventional picture of the artist might allow.

Richard Kendall

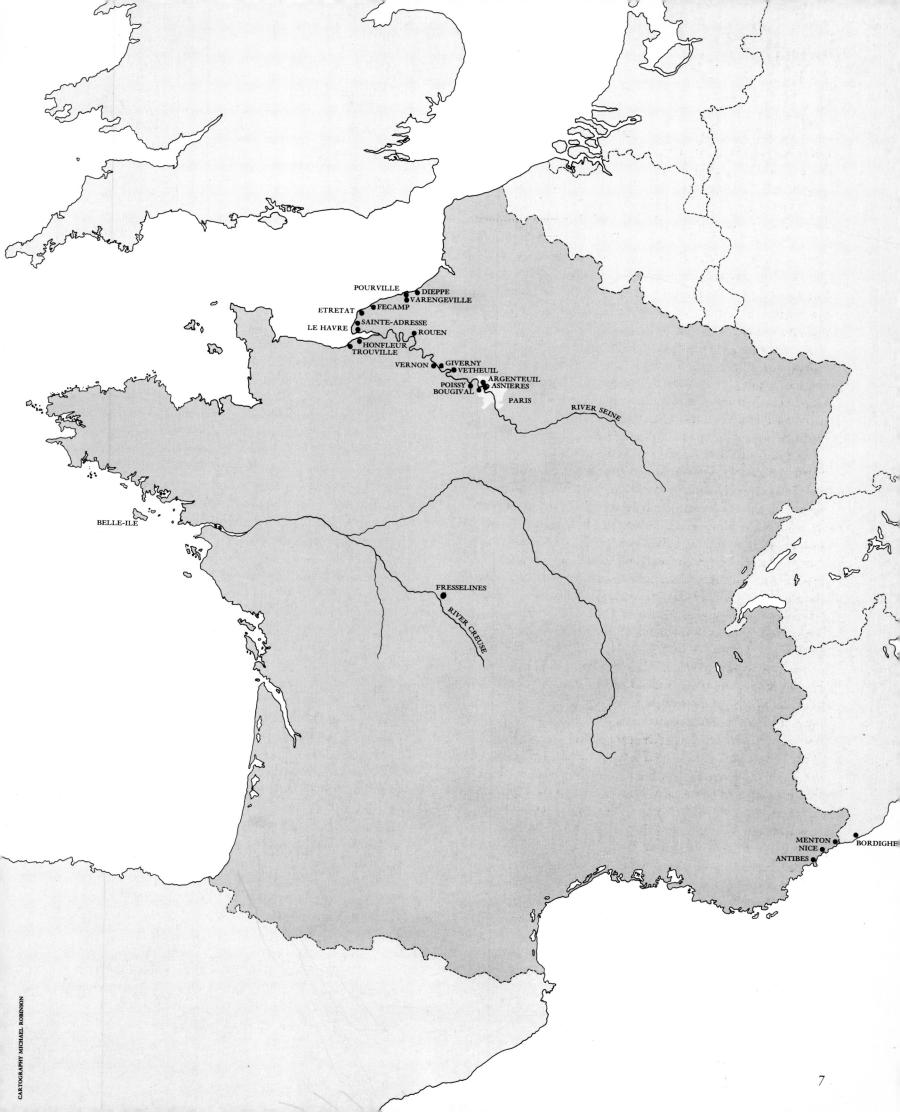

Introduction

1840–1881: Paris and the Seine

The River Seine, which flows through the centre of Paris and then runs westwards to the sea at Le Havre, forms a central axis in the long career of Claude Oscar Monet. He was born in Paris in 1840, but as a child moved with his parents to Le Havre, where he produced his first paintings around the Seine estuary. In his formative years, Monet travelled regularly between the coast and the city of Paris in order to study, paint and exhibit with the artists who were later to become known as the Impressionists. Many of his most brilliant early pictures show the Seine itself, with its suburban pleasure-seekers on the outskirts of Paris or the busy shipping around the estuary at Le Havre. Monet painted the river at a dozen different sites and lived on its banks at Argenteuil, Vétheuil and elsewhere. In the 1890s he worked at Rouen (situated on the Seine halfway between Paris and the sea) on his celebrated paintings of the façade of the city's cathedral. Most famously, in the second half of his career the artist and his family settled at Giverny, within walking distance of the Seine and beside their own small tributary of the river. Here Monet was to create his famous waterlily garden, a miniature world of light, colour and sensation, where his stated ambition to paint 'directly from nature with the aim of conveying my impressions in front of the most fugitive effects' was most spectacularly realized.

Monet's early years in Le Havre were largely uneventful, though his resistance to schooling and his boredom in the classroom are said to have encouraged a talent for drawing caricatures of his classmates. By about 1857 his reputation as a caricaturist was sufficient for his drawings to be exhibited by a Le Havre picture-dealer, and according to Monet himself this led to the beginnings of his career as a painter. In a letter of 1920 the elderly artist recalled how his precocious talents had been noticed by Eugène Boudin, a local landscape painter whose fresh, directly observed oil studies of the coast were later much admired by the Impressionists. Monet remembered how 'One day Boudin said to me . . . "Learn to draw well and appreciate the sea, the light, the blue sky." I took his advice and together we went on long outings during which I painted constantly from nature. This was how I came to understand nature and learnt to love it passionately.' Little survives from these outdoor excursions, but it seems that they were responsible for establishing the great preoccupations of Monet's later career; Boudins' delight in the landscape and his insistence on studying nature at first hand were to stay with Monet for the rest of his life.

The story of Monet's struggle to launch himself as a painter is a long and tortuous one. As a gifted provincial teenager he naturally turned his attention towards Paris, where a conventional training in the studio of an established artist might be expected to lead to success in the annual public exhibition, or Salon! As early as 1859 Monet's letters show him writing home

from Paris to his friend Boudin, describing the paintings he had seen and his search for a suitable studio in which to enrol. Not long afterwards, his progress was interrupted by an unlucky draw in the lottery for the National Service, and the would-be painter found himself stationed for more than a year in North Africa. By 1862, at the age of twenty-two, Monet was back in Paris, studying in the studio of the academic painter Gleyre, where his fellow students included Renoir, Bazille and Sisley. The tuition of Gleyre counted less than Monet's discovery that many of his interests and aims were shared by these young artists, and within a short time they were painting together in the countryside and even sharing studios. As a consequence, Monet's formal education as an artist was remarkably brief, but his determination to begin his career, and perhaps to take the lead among his friends, was as strong as ever.

In the 1860s the principal route to fame and fortune was still the Salon, where a painting by an aspiring young artist might catch the eye of the critics or the public. For several years Monet went through the annual ritual of submitting a canvas to the Salon, experiencing initial success and later rejection at the hands of the jury. In both 1865 and 1866 two of his pictures were accepted and shown, encouraging him to embark on larger and more ambitious canvases (such as *Women in the Garden* and *Déjeuner sur l'herbe*) which were either rejected or left unfinished. As his letters show, Monet's Salon successes brought him to the attention of a number of picture collectors and led to important commissions and a number of modest purchases by dealers. Anxious though he was to establish his reputation, Monet was also in desperate need of money, and these early sales were essential to his survival.

The question of money was to haunt Money throughout the 1860s and 1870s, and it was not until his middle years that the artist was able to rely on a regular and substantial income from his paintings. His father's business as a wholesale grocer was prospering in Le Havre, but there was neither the inclination nor the necessary surplus to subsidize the hazardous career of a young painter. From an early age Monet was obliged to be financially self-supporting, benefiting from the generosity of relatives (such as his Aunt Lecadre) and his more affluent friends (such as Bazille) while moving from one cheap lodging to another, often one step ahead of his creditors. While Monet tended to exaggerate his plight when writing to friends for assistance, it is also clear that he worked remorselessly at his art and fought hard to cultivate patrons. In his maturity Monet acquired a reputation as a shrewd and intransigent dealer in his own pictures, his later prosperity perhaps offering some compensation for the indignities of his youth.

As with any ambitious young artist, part of Monet's search for success depended on the identification of his particular talents and the cultivation of an individual subject matter and technique. Monet's earliest canvases were remarkably diverse, encompassing portraiture, figure composition, still life and

flower painting as well as the landscapes, seascapes and townscapes associated with his later career. The scale and treatment of his pictures were equally experimental, ranging from the almost life-size figures and high degree of finish of the Women in the Garden to the brash flourishes of pigment in a small canvas like The Wave. Some of these experiments were inevitably influenced by other artists, and Monet's letters make frequent references to the objects of his current enthusiasm. Among artists of Boudin's generation, both Jongkind and Courbet clearly made their mark, while his admiration for the landscape painters based in the Barbizon area, such as Millet, led him to paint at nearby Chailly-en-Bière. Edouard Manet, whose name was initially confused with Monet's, served as a model of the combative public artist for Monet and his friends, while Monet's contemporaries such as Renoir had much to teach him about colour, drawing and technique. What most of these artists had in common was a fierce dedication to everyday subject matter and a conviction that new ways of painting were needed to breathe life into the outmoded conventions of French art. Many of their experiments in open-air painting, in hightoned colour and in spontaneous brushwork lie behind Monet's own search for style.

As Monet approached the age of thirty, a number of events occurred which were to determine both his private and professional future. In 1867 his mistress, Camille Doncieux, gave birth to their son, and the three of them established a modest household together. Both Camille and their child, Jean, served as models for some of Monet's most impressive portraits and figure compositions, though it was not until 1870 that Camille and Monet were married. Within months of the marriage, the declaration of war between France and Prussia persuaded Monet to leave the country with his family and spend some time in London, where he met both Pissarro and the picture-dealer Paul Durand-Ruel. Even more significantly, it was during this period that Monet's painting arrived at a sudden and remarkable maturity. Working side by side with Renoir at La Grenouillère, a boating and bathing establishment on the Seine in the outskirts of Paris, Monet produced what have been called the first Impressionist paintings, their sparkling colours and gestural brushmarks conveying something of the rapidity with which they were executed. This freshness and directness of approach, coupled with a confident use of colour and a greater command of technique, is also evident in Monet's subsequent paintings from London and Holland, and points to the emergence of a mature and authoritative vision. As if to mark this new departure in his career, Monet moved with his family in 1871 to a house at Argenteuil, where they were to remain for the next seven years. Here Monet embarked on a period of intense creativity, refining his distinctive approach to the landscape and increasingly finding customers for the steady stream of canvases that emerged from his studio. The reasons for his choice of Argenteuil are not known, but its

A location on the banks of the River Seine and its accessibility from Paris may have provided the initial attraction. Argenteuil was then a small town on the outskirts of the city, much favoured by weekend boating parties and well established as a centre for local industry. It had been occupied by the Prussians during the recent war and severely damaged, but the continuing expansion of the city of Paris soon led to its reconstruction. Monet painted its streets and buildings, his own family in their rented house and garden, and above all the spectacular light and reflected colours of the river. Along the banks of the Seine the curious juxtapositions of modern suburban life were much in evidence, ornate weekend villas contrasting with vast steel bridges and delicate pleasure craft with distant factory chimneys. Monet's art flourished among these contradictions, at times celebrating the stark modernity of The Railway Bridge at Argenteuil and at others recording the simple play of light in Poplars, near Argenteuil. While Monet chose to turn his back on much of the industrial landscape at Argenteuil, his studies of the 1870s show a marked preference for sites where 'nature' had been modified by the intervention of human society.

It was perhaps during these years at Argenteuil that Claude Monet's exceptional powers of observation and visual analysis first came into their own. Painting by now almost exclusively from the landscape, Monet worked at his canvases in the open air, scrutinizing the chosen subject in bright natural light and meticulously analysing its tones, colours and textures. When Paul Cézanne said of him that he was 'Only an eye, but my God what an eye!', he surely had in mind Monet's extraordinary ability to see his surroundings in a vivid and apparently untutored way, and to translate that vision into startlingly original compositions. Monet's technique of building up the picture surface in a series of small strokes of paint helped to keep his colours pure and to suggest the sparkle of natural light, as well as conveying something of the artist's exhilaration in the presence of nature. At Argenteuil he converted a boat into a floating studio, enabling him to study the reflections, textures and tones of the river at closer quarters than ever before. Monet's reputation among his peers, many of whom shared his delight in the shifting moods of the river, was such that painters like Renoir and Manet came to Argenteuil to paint by his side. Though he was not the only strong personality in this circle, Monet's pictures helped to define some of the group's aspirations, and it was a happy coincidence that turned one of his own canvases, characteristically based on the play of light on water, into the unofficial symbol of their first group exhibition.

In April 1874 an exhibition opened in Paris of the works of Cézanne, Degas, Monet, Morisot, Pissarro, Renoir, Sisley and their friends, soon to be labelled the 'Impressionists' after the satirical reception given to Monet's canvas *Impression, Sunrise*. In marked contrast to the worldwide renown and record sale prices of Impressionist art today, the first exhibition stimulated little favourable interest and few sales. The lively brush-

work of Monet and some of his colleagues was criticized for its lack of finish, their bright colours were blamed on collective eye disease and their subject matter was mocked for its banality. A few courageous critics admired the modernity and the startling brilliance of the work and some of them, like Edmond Duranty and Jules Castagnary, helped to formulate some of the ideas about Impressionism still current today. Despite public ridicule, many of the artists exhibited together in subsequent years, slowly attracting the attention of dealers and collectors. In 1876 an exhibition was held in the galleries of Paul Durand-Ruel, the dealer Monet had met during his exile in London, who had already been selling his canvases for some time. While a few of the artists, notably Cézanne and Pissarro, continued to meet with indifference or even outright hostility, Monet and his colleagues Degas and Renoir began to experience their first taste of critical and financial success.

The first Impressionist exhibition had taken place in the studio of the photographer Nadar, and it was from the windows of this building that Monet painted two of his greatest views of Paris. By including one of these canvases, of the Boulevard des Capucines, in the exhibition itself, Monet drew attention to the paradoxical relationship between art and observed reality, while at the same time making new claims for the immediacy and topicality of his art. Later in the decade Monet embarked on another series of paintings of the city, this time even more aggressive in their modernity. For his subject he chose the Gare Saint-Lazare, the railway station he used each time he travelled between Paris and Argenteuil or Le Havre, and in 1877 he rented a studio in the vicinity and obtained permission to work in the station itself. Unusually for Monet, a group of sketchbook drawings has survived for some of his painted compositions, suggesting that the congestion of the station prevented him working directly from the subject and that the paintings were executed or perhaps finished in his Paris studio. Whatever their origin, these canvases represent some of the most vivid responses of a nineteenth-century artist to the new forms and structures of the Industrial Age. The blunt angularity of that station's glass-and-iron construction appears to be celebrated unashamedly, while the featureless human figures beneath are dwarfed by its superhuman scale. Only the rich touches of oil paint and the delicately brushed clouds of steam remind us of the humanizing presence of the landscape painter.

Monet's regular journeys from Argenteuil to Paris and his periodic use of studios in the city continue the pattern of his early career, but they also hint at difficult times in his relationship with Camille. When his pictures had been selling well, Monet was able to rent a substantial house at Argenteuil and employ domestic servants, recording his pride in the family's prosperity in a number of gloriously coloured canvases of their garden and home. His dependence on the whims of collectors, and through them on the fluctuations in the nation's economy,

also led to lean periods during which the artist was obliged to write begging letters to friends and patrons. In 1876 one of these collectors, the wealthy department-store owner Ernest Hoschedé, commissioned a series of decorative paintings for his country residence and this soon led to an unusual domestic intimacy between the two families. Hoschedé himself was increasingly absent from the family circle, and Monet established a close relationship with his wife Alice. In 1878 the situation was further complicated by the birth of Camille's second child, Michel, and by a serious decline in both her health and the painter's finances. Finally deciding to leave Argenteuil, Monet and his family moved in with the Hoschedé household further along the Seine at Vétheuil, where they were to stay for more than three years. A letter of 1879 from Monet to Ernest Hoschedé records one of the artist's periodic phases of discouragement and an attempt by him to resolve the problems of their new living arrangements. Soon afterwards a letter to another of Monet's patrons, Georges de Bellio, announced a further tragic development in the story. In September 1879, after a long period of suffering, Camille had died, leaving Monet with their two young children and the responsibilities of his new and extended family.

1882–1890: The Sea

In 1880, when Monet passed his fortieth birthday, his personal life was in disarray and his professional career once again in a state of uncertainty. Over the next decade several factors were to determine the changing pattern of his life, among them his new family, his precarious financial circumstances and the insistent demands of his art. Monet had become, in effect, the head of a combined household which included Alice Hoschedé, her six children and his own two sons. The need for the artist to earn money was now greater than ever, and his correspondence in the 1880s shows how vigorously he pursued this aspect of his profession. At the same time, Monet's relationships with the other Impressionist artists were changing, and much of his activity was directed towards exhibitions of his own work and the promotion of his own independence. This was his most restless decade, and his travels took him to northern Italy, Holland, the Côte d'Azur, Normandy and Brittany in search of new subject matter and new artistic challenges. His paintings are full of exotic colour, brilliant brushwork and startling new kinds of composition, pursuing many of the practices of the early Impressionist years into unexplored areas of expressiveness and significance.

One of the consequences of Monet's travels was the large number of letters he wrote to his friends and family, many of which have been preserved. He wrote to Alice almost every day, leaving us with an unusual insight into his activities as a painter and into his feelings for his new companion. Little is

known of Monet's relationship with his first wife, Camille, but it seems that the artist became estranged from her and may have compromised her in his liaison with Alice. He could also be demanding in his dealings with Alice, staying away from her for several months at a time while on painting expeditions and relying on her to act as mother to his children. Their joint household had moved from the Hoschedé residence at Vétheuil in 1881 and settled briefly in Poissy, before moving further westwards along the Seine to a rented house at Giverny in 1883. From modest beginnings, the new family was able to establish a secure home for the growing children and a stable base for the wandering artist. There were times of hardship, worries about the children's health and even talk of a separation, but the letters continue to show the great affection that existed between Monet and the woman who finally became his second wife in 1892.

Monet's letters also show that the need to support his enlarged family and to finance his travels involved him in a continuous search for new markets for his pictures. To the surprise and concern of many of his colleagues, he had declined to exhibit at the Fifth Impressionist Exhibition in 1880 and had reversed the habit of a decade by submitting two canvases to the official Paris Salon. For some time Monet had been distancing himself from the city-based circles of Impressionism and what he saw as their undiscriminating approach to group exhibitions, and he became increasingly involved in direct negotiations with a number of picture-dealers. In spite of the uncertain state of the national economy and the unstable demand for Impressionist paintings, Paul Durand-Ruel had regularly found customers for Monet's paintings and had at times provided him with a significant income. In 1883 Durand-Ruel's gallery showed the first substantial exhibition of Monet's pictures, although a contemporary letter from the artist to the dealer records both a lack of public interest and Monet's own dissatisfaction with the exhibition arrangements. It appears that Monet and Durand-Ruel had established an informal working relationship, the painter arranging for crates of recently completed paintings to be sent by train to Paris and the dealer acting as his agent and banker. For several decades a steady stream of letters passed between the two men and documented their fluctuating fortunes and their increasing prosperity. There were disagreements, notably over Durand-Ruel's decision to sell Monet's pictures in America and Monet's overzealous cultivation of rival picture-dealers, but their friendship grew and lasted into their old age.

The sense of restlessness and urgency that pervaded Monet's career in the 1880s is vividly expressed in much of his finest painting of the decade. The long residence at Argenteuil had been a time of consolidation, giving Monet the chance to define his identity as a landscape painter and develop a use of oil paint appropriate to his experience and his chosen terrain. After many years of painting in the Seine valley, Monet's extra-

ordinary mastery of colour and atmosphere gave him the confidence to tackle even more demanding subject matter, as well as the ambition to push his painting beyond its existing confines. The objects of his attention in the 1880s all seem chosen for their difficulty, whether they were the rainbow-coloured vegetation of the Mediterranean or the inhospitable rocks of the Brittany coast. His letters show that he often chose the winter months for these long expeditions, when he could set up his easel without fear of interruption, but they also record the bitter weather and violent storms he had to contend with. Between 1881 and 1885 Monet made annual winter visits to the Channel coast, painting near the haunts of his childhood at Fécamp, Pourville and Etretat. He seemed to delight in extremes of weather and in vertiginous clifftop perspectives, tackling the full fury of an Atlantic storm or the unexpected tranquillity of a spring evening. Writing home to Alice, Monet would describe the progress of these expeditions, expressing his delight in a newly discovered site and then the inevitable frustration as his paintings failed to match his intentions. Monet's painting method still depended on first-hand contact with the subject, often involving long hours in the open air and continual exposure to the elements. His hardiness became legendary, as did his eruptions of anger when the weather changed while he was finishing a group of paintings. After several months of virtual solitude, he would often arrive home exhausted, highly critical of his own canvases and in great need of the reassurance of his family.

In January 1884 Monet wrote to Durand-Ruel that he was about 'to spend a month' in Bordighera, just over the French border in northern Italy and within sight of the Mediterranean. In the event, Monet was so captivated by the landscape that he stayed until April, covering dozens of canvases while assuring Alice that it was only a matter of days before he would return. Bordighera was a revelation for Monet, with its exotic palm trees and unfamiliar citrus groves, its dazzling light and its almost unchanging weather. Within days of his arrival, he recorded with alarm the brilliance of his surroundings: 'As for the blue of the sky and the sea, it's beyond me', he wrote to Alice, and 'I'm appalled at the colours I'm having to use . . . yet I really am understating it'. This challenge to Monet's understanding of colour was part of a wider challenge to his art. At Bordighera he encountered nature at its most spectacular and radiant, and his great sense of exhilaration demanded to be transformed into the materials of painting. Heightening the tone of his pictures, building up thick encrustations of oil paint and pushing his colour range further than ever before, Monet found himself liberated from most of the remaining constraints on his technique. In contrast with the sombre canvases of the Channel coast, Monet discovered the power of colour to express the higher registers of human experience. Increasingly, he was to discuss his paintings in terms of his feelings and responses to nature, rather than the visual impression made

upon him by the scene. Subsequent painting expeditions in the 1880s, such as the trips to Belle-Île, Antibes and the Creuse valley, were to confirm this departure in his art. At Belle-Île, a rocky island off the coast of Brittany, he wrote of his attempt to express the 'sinister and tragic quality of the place' and at Fresselines, beside the River Creuse, he announced 'I have finally entered into the spirit of this countryside'.

By the end of the decade, Monet's fortunes were changing for the better. The dramatic developments in his art were finding favour with collectors, and Monet found himself able to dictate terms to a number of competing picture-dealers. His letters record negotiations with Durand-Ruel, Boussod et Valadon, Theo Van Gogh (Vincent's brother) and Georges Petit, the latter having arranged an exhibition of Monet's paintings at his gallery in 1889. The Petit exhibition was shared with Rodin, the sculptor who had been associated with the Impressionist painters and for whose work Monet professed the highest regard. After their final group exhibition in 1886, the Impressionist artists had followed their own independent careers, some of them benefiting from the rising prices and shifts in public taste that Monet had experienced. Monet's own increased income had enabled him to buy the house at Giverny in which his family had been living for some time and to free himself from the financial worries that had pursued him throughout his career. A number of paintings of the children and of the artist's boats at Giverny reflect this more leisurely way of life, hinting at the end of Monet's trips away from home and the many years he was to continue to enjoy beside the River Seine; and as he began to make studies of the countryside around Giverny, Monet put down on canvas for the first time many of the themes, such as haystacks, flowers and poplar trees, that were to occupy him for the rest of his life.

1890–1908: The Series Paintings

In the autumn of 1890, Monet wrote to his friend Gustave Geffroy: 'I'm hard at it, working stubbornly on a series of different effects (grain stacks), but at this time of the year the sun sets so fast that it's impossible to keep up with it'. These paintings, formerly referred to as the Haystacks, were to form an important departure for Monet and set the pattern for much of his later career. We know from eye-witness accounts that he would set out from his studio at Giverny, preferring the early morning or the hours before sunset, to paint the changing effects of light and colour on the grain stacks in the fields near his house. He would take with him his paints, several easels and an assortment of partially completed canvases, usually requiring the help of one of his family or the assistance of a wheelbarrow. As the minutes went by, Monet would work on the canvas that most closely resembled the scene in front of him, then move on to another as soon as the light changed. In

this way he might paint briefly on a dozen or more pictures in a single session, each picture corresponding to a new nuance of tone, a shift in the angle of sunlight or a change in the perceived mood of the scene. For this series Monet also painted the subject throughout the seasons, recording the glow of an autumnal sunset behind a single stack, the cold shadows on a snow-covered field and the crisp greens and pinks of early springtime. As the months passed and the paintings accumulated, Monet was able to gather around him in his studio a rich catalogue of nature's moods, as well as a detailed record of his own perceptual history. As he noted in the same letter to Geffroy, 'I am increasingly obsessed by the need to render what I experience...'.

The experiment with the Grain Stacks series opened up dramatic new possibilities for Monet's art, as well as deepening and revitalizing his ambition at this central point in his career. In 1891 an exhibition of some of the paintings at Durand-Ruel's gallery was enthusiastically received, and for the rest of the decade Monet's principal energies were directed towards groups of pictures rather than single canvases. In 1892 and 1893 he spent several months at Rouen, in an improvised studio opposite the Cathedral, producing more than forty paintings of the passage of sunlight across the façade and the modulations in the intervening atmosphere. Nearer home, Monet modified one of his boats to take a rack of unfinished canvases, in order to work on several new motifs from a vantage point in the middle of the river. A series of Poplars was exhibited in 1892, the regimented lines of the tree trunks contrasting severely with the horizontal thrust of the river bank and the richness of the surrounding foliage. Four years later Monet showed the Mornings on the Seine, one of his most sustained attempts to register fine nuances of tone and hue at the point where light dissolves into landscape. In all the Series paintings, Monet stripped down his subject matter to a few boldly stated shapes and planes of colour, at times almost losing the identity of the chosen subject. In some of the pictures he also limited the depth of the scene, filling the rectangle with a cathedral façade or thrusting the spectator up against a parallel line of trees. Though there were precedents for some of these features in works of art that Monet admired, such as the paintings of Whistler or Japanese wood-cuts, Monet's Series pictures were among the most radical and challenging images of his day.

The significance of the Series paintings, and in particular the importance of their subject matter, has been much debated in recent years. It has been suggested that these simple, repetitive motifs are of little interest in themselves, serving essentially as pretexts for colour and texture in the manner of certain kinds of abstract painting. Conversely, it has been proposed that some of the subjects had a precise meaning for Monet and his contemporaries, the Cathedral being inseparable from its religious significance and the rural motifs having explicit connotations in a newly industrialized age. Monet himself was, characteris-

Ι2

tically, almost silent on the matter, although his letters offer some insights into his methods and attitudes. From his earliest years as an artist, Monet had made occasional variants of the scenes he portrayed, delighting in the acutely perceived shift of light and tone from one set of circumstances to another. In this sense, his paintings of the Impressionist era form a natural extension of his early work and lead directly into the Series pictures. Another letter he wrote at the time of the Grain Stacks series insists that he was trying 'to convey the weather, the atmosphere and the general mood', and subsequent correspondence from Rouen reminds us how much Monet still relied on highly specific weather conditions while he was working. From the artist's letters of this period also comes the clearest acknowledgement of the extent to which he continued to work on the canvases after they had been taken back to his studio. In the case of the Rouen pictures, it took more than two years of retouching and revision before he considered the paintings ready for exhibition. Although Monet's practice was still firmly rooted in his responses to the landscape, his finished paintings were now the product of a complex dialogue between his perceptual experience and the nature of his craft as an artist.

During the 1890s a number of exhibitions of Monet's Series paintings drew attention to his continuing inventiveness and his increased authority as an artist. On several occasions Monet was approached by dealers and collectors wishing to acquire individual pictures from the Series, but he preferred to keep the paintings together so that he could complete them and exhibit them as a continuous ensemble. These displays of fifteen or twenty brilliantly coloured variants of a single image offered a new kind of experience to the viewer, an extended encounter with a sequence of successive perceptions that seemed to go beyond the limits of conventional painting. Never before had the spectator had such access to the nuances of an artist's sensibility, nor had the possibility that the passage of time might itself become the object of painting been so dramatically made evident. The originality and complexity of the Series pictures did much to promote Monet's reputation in Europe and overseas, establishing him as a major figure in French cultural life. Analogies were drawn between his ideas and those of contemporary literature, and Monet's letters show that he enjoyed the acquaintance of a number of distinguished poets, novelists and critics. Articles on his work began to appear in the Press, the prices of his pictures rose to heights undreamed of a few years earlier, and Monet settled down to the life of a prosperous and respected, if not entirely untroubled, celebrity.

The achievements of the second half of Monet's career must be seen against his changed personal and financial circumstances. The death of Ernest Hoschedé in 1891 had opened the way for Monet's marriage to Alice in the following year, an event which was followed by almost two decades of domestic and emotional stability for the family. The purchase of the

house at Giverny, which was to be the artist's home until his death in 1926, was followed by the acquisition of an adjoining area of land, the reorganization of the gardens and the construction of new studios. As early as 1893, a letter from the artist to the local authorities described his intention to develop a waterlily garden 'to delight the eye and also to provide motifs to paint', a project that was increasingly to dominate his life as the years went by. Monet's marriage to Alice also effectively brought to an end the years of solitary wandering and distant travel, the subject matter of the artist's later pictures being largely derived from the rivers and fields in the countryside around Giverny. There were glorious exceptions to this rule, notably the journeys to London between 1899 and 1901 and the visit to Venice with Alice in 1908. The London and Venice pictures can be seen as a late flowering of Monet's Series painting, a further exploration of the colours, light effects and expressive possibilities that had so intensified his art in the early 1890s. Monet's letters from London remind us that every picture still emerged only after intense effort and endless frustration, while the canvases themselves, with their starkly geometric constructions and blazing, iridescent colours, often look as radical as anything produced elsewhere in the early twentieth century.

1909–1926: The Water-lilies

In the last twenty years of his life Claude Monet produced some of the most expansive, ambitious and luminous canvases of his long career. By this time he was so popular that collectors from all over Europe, as well as from Japan and the United States, competed for his pictures, ensuring him considerable wealth in his old age. In France he approached the status of a national institution, enjoying the friendship of many of the country's notable figures and becoming uniquely celebrated in the Décorations of the Orangerie in Paris. Monet's letters from these decades reflect his new status, and record visits from would-be biographers and admiring young artists, as well as the dubious attentions of a professional forger. The letters also tell a more sombre story, as Monet advanced into old age and suffered the loss of friends and family, and as his declining health curtailed his painting activities. These were also the years of the Great War, when the younger members of Monet's family saw active service and the artist himself felt threatened at Giverny by the armies marching on Paris.

Five years before the outbreak of war, in May 1909, Monet exhibited at Durand-Ruel's gallery a group of forty-eight canvases which he entitled *Nymphéas*, *paysages d'eau*, or *Water-lilies*, *Water Landscapes*. This was the first public showing of a subject which had already occupied him for almost a decade and which continued to dominate his art until his death. Ever since his arrival at Giverny in 1883, Monet had worked to improve the

large gardens in front of his house and had gradually started to develop them as a source of motifs for his painting. With the exception of his London and Venice pictures (which are also concerned with effects of light and water) almost all Monet's late work was based on the features of his own garden, and in particular the large water-lily pond that had been built and enlarged from his own designs. The gardens at Giverny occupy a rectangular plot of land more than twice as long as it is wide, with Monet's house and studios at one end and the lily pond at the other, while a formal arrangement of flower-beds, trellises and pathways runs along the centre. The pond itself is surprisingly modest in scale, being roughly oval in shape and some twenty metres across at its widest point, but Monet surrounded it with paths, bridges, flowers and shrubbery to create for himself a repertoire of subject matter that remained unexhausted even after a quarter of a century.

At one end of the water-lily pond Monet built a curving wooden bridge in the Japanese style, a starkly geometric form to contrast with the richness of the surrounding greenery. Between 1899 and 1900 he used this bridge as the subject of his first great series of water-lily paintings, placing it symmetrically across the middle of the canvas and parallel to the picture plane. Below the bridge he painted the sun-speckled lilies and the mysteriously coloured depths of the pond, above and beyond it the willows and other surrounding foliage. It is an image at once radical in its simplicity and satisfying in its profusion, contrasting cool blues and greens with eruptions of pink and orange, the dramatic thrust of the bridge and pond against the more gentle verticals of trees and reflections. In many ways the Japanese bridge pictures represent a precocious summary of the challenges and contradictions of the entire water-lily project. On the one hand, they are the work of an artist spellbound by nature, who delights in the play of light on a flower or the luminosity of a cast shadow; in this sense, these $\mathcal V$ pictures belong with Monet's earlier work, where objects exist in an illusionistic space and retain their identities within the natural order. On the other, they brazenly declare themselves as works of art, parading the artifice of their construction and their factual existence as rectangles of pigment; their colour, their brushwork and their aggressive geometry never allow us to forget that we are looking at a flat canvas surface covered with patches of oil paint.

By the time of the Durand-Ruel exhibition, Monet had advanced even further in the audacity of his water-lily pictures. Putting the Japanese bridge behind him, both literally and metaphorically, the artist had taken up a vantage point above the surface of the water, painting little but the flowers and leaves and their watery environment. In some of the paintings a narrow strip of bank appears at the top of the picture, but progressively the artist sets us adrift in the indeterminate spaces of the pond, surrounded only by lily-pads and reflections of the sky. As we confront these pictures, we also find

ourselves cut off from the conventional experiences of art, from the certainties of perspective and the comforts of familiar subject matter. Monet's high viewpoint presented him with an almost flat plane of water, and he increasingly treated the surface of the canvas as if it were the mirror-like face of the pond itself. At this stage, however, the illusion of pictorial depth continues to be maintained by the diminishing forms of the lilies and their foliage, as they recede towards an invisible horizon. This interplay between flatness and depth, between art and illusion, gives these pictures much of their dynamism, allowing the artist to develop their decorative possibilities without ever losing sight of their origins in nature.

In December 1909 Monet wrote to a friend: 'What with the upheaval of my exhibition of Water-lilies, the bad weather all summer and worst of all, my own health problems, it's a sad state of affairs as you can see, not to mention all the little miseries and problems that accumulate with age...' As the years went by, Monet's experience of physical decline in himself and those around him was to cast a sombre shadow over his life and his correspondence. In 1910 he recorded the deterioration of Alice's health and in May of the following year he wrote briefly to Paul Durand-Ruel: 'My beloved wife is dying. It's only a matter of hours now.' Monet's distress and sense of isolation after the death of his second wife were exacerbated by the declining health of his own eldest son, Jean, whose untimely death followed Alice's only three years later. During the First World War the artist endured the absence of his youngest son, Michel, who fought at Verdun and elsewhere, and between 1917 and 1919 he lost three of the companions of his youth with the deaths of Degas, Rodin and Renoir. Throughout this period of loss, Monet derived reassurance from his remaining friends and colleagues, receiving regular visits from them at Giverny and communicating as energetically as ever through his letter-writing. His correspondence with the two families of picture-dealers, Durand-Ruel and Bernheim-Jeune, shows that their relationships could be both businesslike and affectionate, and his letters to Gustave Geffroy, the writer and critic who was gathering material for a biography of the artist, reveal Monet at his most lucid and informative.

The most distinguished friend of Monet's old age, as well as the most decisive influence on the direction of his late work, was Georges Clemenceau. In his earlier days Clemenceau had known and been painted by Manet, and at the time of his greatest celebrity, as Minister of War and negotiator of the Treaty of Versailles, he developed a remarkable intimacy with Monet, his near-neighbour at Giverny. It was Clemenceau who encouraged Monet to produce a large cycle of water-lily pictures to be presented to the French nation, initially as a tribute to the victorious outcome of the war but ultimately as a monument to the painter's own achievement. As early as 1914 Monet began work on the *Décorations*, as he called them, a series

of large canvases that required the construction of a special studio at Giverny. In spite of setbacks and ill-health, Monet persevered with the project for almost a decade as it grew in scale and ambition, urged on by Clemenceau but alarmed by the quantities of paint the pictures were consuming. After long negotiations and the repeated intervention of his powerful friend, Monet agreed that his canvases should be installed in the remodelled building of the Orangerie, not far from the Louvre, where two large rooms with curving walls would eventually form an almost uninterrupted panorama of shadow, colour and sunlight.

During and after the war years, Monet worked intermittently at a number of other subjects besides his Décorations, delighting now in the increased maturity of his Giverny garden. There are studies of irises, flowering aquatic plants and swathes of wisteria, as well as the willow trees that provided a welcome contrast to the horizontal spread of the water-lily pond. Monet's involvement in his garden was as passionate as ever, although his advancing years, to say nothing of the expanding scale of his canvases, meant longer spells in the nearby studios and a greater reliance on memory. A letter written in February 1916 regrets that he is unable to paint outside after a fall of snow, but contemporary photographs show the artist working in the sunshine during more favourable weather, continuing the dialogue with nature that had sustained him throughout his career. There is even a short sequence of black-and-white film by the director Sacha Guitry, which records Monet painting under a vast umbrella and ceaselessly transferring his gaze from canvas surface to lily pond and back again. At this stage in his career Monet's mastery of his methods was such that his direct perceptions of nature, or the great store of perceptions that had been accumulated over a long career, were indistinguishable from his ambition to paint large, arresting works of art. While in daily contact with his garden, Monet produced paintings of astonishing technical originality, pursuing a single dominant colour, such as indigo or emerald green, across the surface of a canvas two or three metres high, or dramatically interposing a mighty willow trunk between the lily pond and the spectator.

Monet's long career as an artist had depended, perhaps as much as any painter before or since, on the acute responses of his eyes to the world around him, and the decline of his eyesight in old age added further to his considerable tribulations. Cataracts were diagnosed in 1912 and it appears that the artist suffered some distortion of his colour vision, though the effect was gradual and intermittent. After the war friends urged Monet to undergo an operation, but he initially resisted, preferring to 'give up painting if I have to, but at least be able to see something of the things I love, the sky, the water and trees, not to mention my nearest and dearest'. Again it was Clemenceau who was instrumental in changing Monet's mind, and after an operation in 1923 and some initial disappointment, the

artist was able to announce that 'I have truly recovered my sight'. Throughout this period Monet was working hard at his Décorations, determined to complete them before his powers gave out. Painting on the largest canvases he had ever used, Monet literally extended his vision of the water-lily garden until it occupied his entire field of view, arranging the pictures in a continuous sequence around him in his Giverny studio. While it is impossible to evaluate the significance of his changing colour vision, it can be said that these late canvases are triumphs of tonal organization and optical refinement, registering the richest hues and the subtlest shimmerings of light on a scale unthinkable a decade earlier. Monet produced many more canvases than were used in the final scheme, as well as destroying a number that dissatisfied him, but he lived just long enough to pronounce that the sequence had reached a point where it could be transferred to the walls of the Orangerie.

In the final years of his life, Monet turned again to his favourite motifs in the garden at Giverny to produce the last, and in some ways the most dramatic, paintings of his career. The Japanese bridge, now engulfed under two decades of wisteria, was painted in the blaze of a fiery sunset and in conditions not far from darkness. The golden tones of these pictures have been related to Monet's eye condition, but their spectacular brushwork and expressive use of paint are equally part of his lifelong exploration of nature in all its moods. Looking back from the garden towards the house that he had known for more than forty years, Monet even discovered a new motif for some of these late canvases, showing the distant building above conflagrations of foliage in orange and scarlet or green and purple. Many of these late paintings have a poignant urgency, even a desperation, about them, as if the elderly artist were seizing his last chance, as he wrote in a letter in June 1926, of 'conveying my impressions in front of the most fugitive effects'. Struggling against illness and often bedridden, Monet finished his life as he had begun it, subordinating all his concerns to the imperative demands of painting. In his last surviving letter, written at the age of eighty-six in September 1926, Monet talked of his plans for the improvement of his studios and gardens, adding that 'I was thinking of preparing my palette and brushes to resume work'. Within two months he was dead, attended in his last hours by the friend of his old age, Georges Clemenceau.

The early decades of Monet's career are the least well documented of all: many of his letters to family and friends have disappeared, and the correspondence that remains tells a story that might have come from the pages of a popular novel; we read of the teenager's determination to become a painter against his parents' wishes, the years of poverty and lack of recognition, the clandestine love affair and the hasty removals from cheap lodgings, and eventually the first taste of success. All is not as it seems, however. From his earliest days Monet had shown great independence of mind, preferring the company of painters like Boudin and Courbet who worked at the periphery of, or even in opposition to, the established art institutions of the day. In his twenties, Monet did go through some of the preliminaries of a conventional career, showing himself willing and able to please potential patrons by tackling a range of subjects, including portraits, still lifes and flower studies. But much of the direction of Monet's early development was self-willed, as he knowingly associated with the most radical artists of the day and resisted the traditional pattern of training and advancement. It has also been shown that he was capable of exaggerating his own plight and that some of his poverty may have been more imagined than real.

Monet's earliest surviving letters show both his youthful self-confidence and his determination to succeed as an artist. As a teenager living in Le Havre, his talent had been noticed by the local landscape painter Eugène Boudin, who may also have arranged the necessary introductions for Monet when he visited Paris. At the age of nineteen Monet wrote to Boudin from the capital, describing the studios he had visited and the advice he had been given. On this occasion and several others, it is instructive to note that Monet was urged to work at his drawing, in recognition perhaps of the fact that his skills with colour and paint were already well advanced. There is also little evidence that Monet followed such advice, either at this period or later in his career, and he became one of the exceptions to the rule that great art is founded on great draughtsmanship. In other respects too, Monet resisted the well-intentioned guidance of his mentors: their recommendation that he study in the studio of an established artist was soon forgotten, and Monet learnt to prefer the company of his new friends Bazille, Renoir and Sisley. Writing to Frédéric Bazille, the wealthy and talented young artist whose career was cut short by his death in 1871, Monet also recorded his growing enthusiasm for the life of a landscape painter. Landscape was still officially regarded as a minor category of painting, and Monet's early adoption of it as his principal subject can be seen as further evidence of his developing single-mindedness.

The paintings that emerged from these apprentice years show Monet's considerable natural talent and also his first encounters with subjects that were to preoccupy him in his maturity. The two studies of the rue de la Bavolle appear to be a precocious demonstration of the artist's delight in shifting light effects, while the pictures of Paris painted in 1867 anticipate the later series of Rouen, London and Venice. Most conspicuously, the numerous paintings of sky and water, showing light effects on the River Seine or the moods of the sea around the Channel ports, announce one of the major themes of Monet's art. Working outdoors and in all weathers, Monet discovered the fascination of atmosphere and extremes of weather, gradually developing a vocabulary of colour and brushwork that would do justice to his perceptions of nature. Along with a number of his fellow artists, Monet learnt to abandon the sombre colours and dull tones of orthodox landscape painting and see his subject afresh, 'as if he had been born blind and had suddenly been granted his sight', as he later phrased it. The technique that these painters evolved, based on small touches of bright colour and a rapid, spontaneous execution, was to become one of the hallmarks of what we know today as Impressionism.

In December 1871 Monet wrote to another of the stalwarts of the emergent Impressionist group, Camille Pissarro, announcing that he and his family had just moved to Argenteuil, a small town on the banks of the Seine near Paris. They were to live there for seven years, through a long and productive phase in the artist's career during which his style, technique and subject matter were defined and consolidated. Subsequent letters from Argenteuil show that Monet maintained contact with a number of his former colleagues, among them Manet, Cézanne and Renoir, and that some of them came to work with him beside the Seine. There is even a painting by Edouard Manet which shows Monet at work on the river, sitting in his studio boat with his wife Camille beside him, a small canvas perched on a portable easel. In such circumstances Monet excelled at the rapid notation of fleeting light effects, and during his years at Argenteuil he refined even further his responsiveness to atmosphere, weather and the passage of the seasons. The subject matter of the busy town and its river traffic also stimulated his art, offering challenging juxtapositions of the rural and the contemporary. Monet's paintings of the recently constructed road and railway bridges emphasize the stark modernity of these structures, a theme he was to take up three years later in his pictures of the Gare Saint-Lazare in Paris.

It is one of the misfortunes of Monet's history that almost all the letters he must have written at the time of the first Impressionist exhibitions, when his career became both public and controversial, have been lost. Equally unfortunate is the absence of any letters between the artist and his first wife Camille, whom we know mainly through Monet's paintings. Camille is referred to briefly in 1867, when their first son was born, but thereafter appears rarely in the surviving correspondence until her untimely death in 1879. Monet recorded his distress at her death in a number of brief notes to his friends and also in a haunting picture of his wife as she lay on her deathbed. Their two sons, Jean and Michel, also feature in his paintings and letters, as do the children of the family he virtually adopted, the Hoschedés. Ernest Hoschedé was one of several picture collectors whose commissions and purchases had provided Monet with a sporadic income (Georges de Bellio, a doctor who bought from a number of the Impressionists, was another), but Monet's letter to Hoschedé of May 1879 shows the complexity of the developing relationship between their two families. Driven by a lack of funds to share the Hoschedés' house at Vétheuil, Monet had succumbed to a characteristic bout of depression, disheartened by the weather, the progress of his painting and his inability to support his family by his work. A number of sombre pictures of the frozen River Seine and still-life groups of fruit and dead game birds probably reflect this painful phase in the artist's life.

[Paris], 19 May 1859

To Eugène Boudin

Having a moment to spare I thought I'd write and tell you of all the fine things I'm seeing in Paris.

So far I've made only one visit to the Exhibition, which has just closed for a week: however, in the little time I had, I was able to see that most of the landscape painters were represented. As for quality, the Troyons are superb and the Daubignys are, to my eyes at least, really beautiful. In particular there is one of Honfleur which is sublime.

There are some nice Corots and, strange to say, some awful Diaz. Monsieur Gautier's picture is very pretty: it's subdued and in a range of greys expressing deep sadness. He has been overwhelmed by critical acclaim. Monsieur Lhuillier's picture is way off the mark.

I've paid visits to several painters. I began with Monsieur Gautier who sends you his best wishes and looks forward to seeing you in Paris in the near future. Everyone is of the same mind. Don't stay put in that backwater until you've lost all hope. As for myself, he made me very welcome. He has a lot of small pictures under way. He's due to start work on a big lithograph any day now. You asked me to make a few enquiries as to the state of the art market. Things are cooling off a bit at the moment because of the war.

Afterwards I visited M. Lhuillier. He is lodging with M. Becq (of Fouquières) who is lending him his studio. He's very happy. His picture sold for six hundred francs. He's doing another one and has a lot of small portraits to do at a hundred francs a time.

There are some pretty things to be seen at the moment in the galleries.

How's this for a good bit of news? Before I left Le Havre I was given a letter to see Troyon. I duly went. I could not begin to describe all the lovely things I saw there; wonderful cattle and dogs. He talked of you a lot and is surprised not to see you in town.

He told me to tell you to send him ten or so of your most finished pictures, grey seascapes, still lifes and landscapes. He will undertake to find homes for them as long as they are more finished than the ones you've given him in the past. He strongly advises you to come here. He seems a really good man and he doesn't mince words.

This is the advice he gave me: I showed him two of my still lifes; his comment was 'Well, my dear chap, your colour will be all right; the effect is correct. However, you must get down to some serious study, for this is all very fine but it comes very easily to you: that's something you'll never lose. If you want my advice and want to go in for art seriously, begin by joining a studio which specializes in figure painting, *académies*: learn to draw: that's where most of you are falling down today. Take heed and you'll see I'm not wrong, but draw with all your might; you can never learn too much. However, don't neglect painting: go to the country from time to time and make studies and above all develop them. Do some copying at the Louvre. Come and see me often: show me what you're doing and with enough courage you'll make it.'

As a consequence my parents have decided to give me a month or two to follow Troyon's advice, who says I must stay here and draw hard. 'In this way', he told me, 'you'll have more means at your disposal: you'll go to Le Havre and you'll be able to do some good studies in the country, and when winter comes you'll come back and settle here permanently.'

This has been approved by my parents.

Then I had to ask Troyon where he wished me to go and his reply was, 'If you want my advice I'd go to Couture if I had my time round again: I can recommend you personally. There's always Picot or Cognier: but I've always hated their way of doing things.'

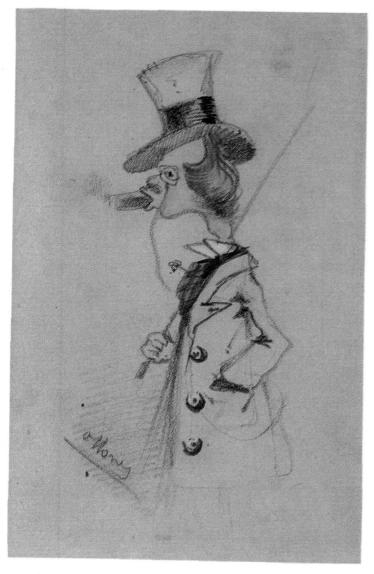

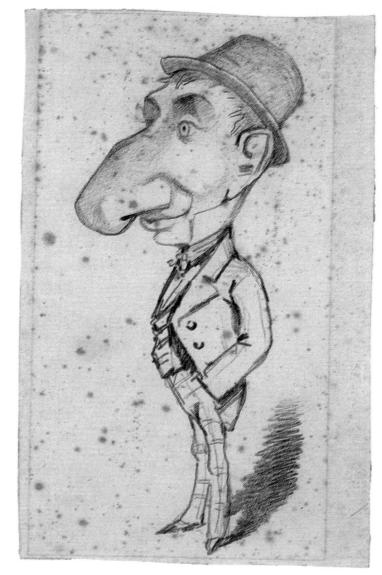

YOUNG DANDY WITH MONOCLE

CARICATURE OF A MAN WITH A LARGE NOSE

Write soon and tell me what you think about all this. Here's my address: Place Du Havre, Hôtel du Nouveau-Monde.

Write back soon, because in two days I'll be moving. I'll give you my new address in my next letter.

Yours, C. Monet

. .

Chailly near Fontainbleau, 23 May 1863

TO AMAND GAUTIER

Please forgive me for leaving as I did without paying you a visit, but my intention when I arrived was to stay for only a week or so, but it's so beautiful in spring, everything turned green, the fine weather came and I couldn't resist the temptation of staying on longer . . .

I've just received a letter from Madame Lecadre of Le Havre, the doctor's wife, who has seen Toulmouche who asked her to tell me that on no account should I stay any longer in the country, and above all that it was a grave mistake to have left the studio so soon: but I hope you will understand: I have certainly not abandoned the studio but I found a thousand things to charm me here which I just could not resist. I've worked a great deal and you will see, I think, that I have looked harder than usual, and now I'm going to get down to drawing once again. I'm not giving it up in any way.

Honfleur, 15 July [1864]

To Frédéric Bazille

I wonder what you could be doing in Paris in such beautiful weather, for I imagine it must be as lovely down there. It's simply adorable here, my friend, and each day I find something even more beautiful than the day before. It's enough to drive one crazy, I so want to do it all my head is bursting. Damn it man, come on the 16th, get packing and come here for a fortnight, you'd be far better off; it can't be that easy to work in Paris.

Today I have exactly a month left in Honfleur; and what is more, my studies are almost done, I've even got some others back on the go. On the whole, I'm quite content with my stay here, although my studies are very far from being as I should like. It really is appallingly difficult to do something which is complete in every respect, and I think most people are content with mere approximations. Well, my dear friend, I intend to battle on, scrape off and start again, since one can do something if one can see and understand it, and when I look at nature I feel as if I'll be able to paint it all, note it all down, and then you might as well forget it once you're working...

All this proves that you must think of nothing else. It's on the strength of observation and reflection that one finds a way. So we must dig and delve unceasingly. Are you making any progress? I'm sure you are, but I'm also sure you don't work enough and in the right way. You can't hope to work with playboys like your friend Villa and the others. One's better off alone, and yet there are so many things that are impossible to fathom on one's own. In fact it's a terrible business and the task is a hard one.

Have you done your lifesize figure? I've some wonderful things lined up for myself. It's quite awesome what I've got in mind for this coming winter in Sainte-Adresse and Paris.

I must tell you that I received a charming letter from little Eugénie: it pleased me enormously and if I'd had the money I would have jumped for joy all the way to Paris. It is so sweet of her to remember me.

My flower painting is at last framed and varnished and on show and looks a darned sight better for it. It's undoubtedly the best thing I have done to date. It appears that it was remarked upon in Le Havre...

I'd be very happy to hear from you. Tell me what you're doing and what's going on in Paris. Do you go to the country sometimes? And above all, come and see us, if you don't come now, then I'll be expecting you on I August at the very least. By that time almost all my paintings will be finished.

In the meantime warm greetings from your good friend, CLAUDE MONET

*

Honfleur, 26 August 1864

To Frédéric Bazille

I received your kind letter. I had just spent a day at Sainte-Adresse when your letter arrived. It gave me a great deal of pleasure, please write nice long ones like that more often. I hope you're working hard, it is important that you devote yourself to it wholeheartedly and seriously now that your family is giving up on your medicine. I'm still at Saint-Siméon, it's such a pleasant place and I'm working hard. I'm quite content: although what I'm doing is far from being as I should like, I am complimented often enough all the same . . . We are now quite a crowd here in Honfleur, several painters I did not know, and very

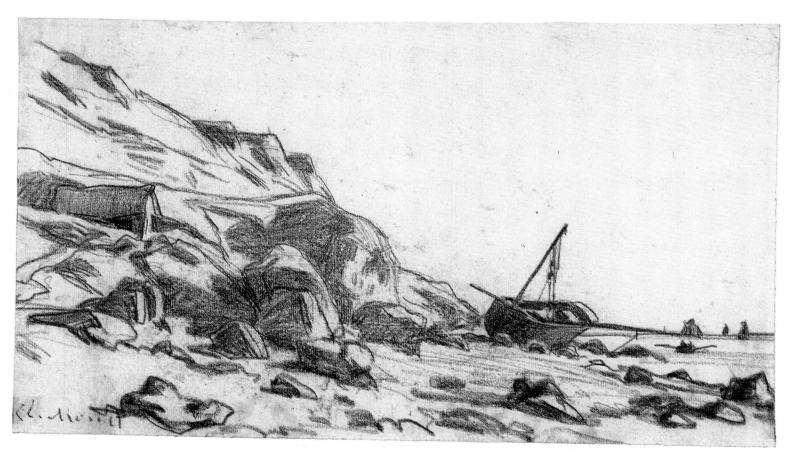

THE COAST OF NORMANDY VIEWED FROM SAINTE-ADRESSE

bad ones at that. Rozias and Charpentier are a bunch of jokers, but we form a very pleasant little group of our own. Jongkind and Boudin are here and we get on extremely well and stick together. Ribot is probably coming too; he's due to be painting a fishing boat with figures *en plein air*. I'd be interested to see him do it. I'm very sorry that you're not here, since there's a good deal to learn from such company and the landscape is growing more beautiful. It's turning yellow and becoming more varied, really lovely in fact, and I think I'm going to be in Honfleur for some while yet. I wouldn't have the heart to leave. Sometimes we go to Trouville which is superb and I really hope to go back there next year, as well as to Etretat.

I must tell you that I'm sending my flower picture to the Rouen exhibition: there are some really beautiful flowers about at this time; sadly I've got so much to do on my outdoor studies that I dare not start on any, though I'd love to paint those gorgeous daisies. Why don't you do some yourself, since they are, I think, an excellent thing to paint. Let me know what you're doing and when you think you'll be coming. Come and join me now with the country at its best. It's windy, and there are some beautiful clouds and storms; it's the best time to see the country, in fact, there are many more effects, and believe me I'm putting my time to good use...

Well, my dear friend, I must end here, lunch is served and I'm ravenous. Madame and Madamoiselle Toutain send best wishes and so does Monsieur Vivien.

Your good friend, CLAUDE MONET

Write to me at Saint-Siméon.

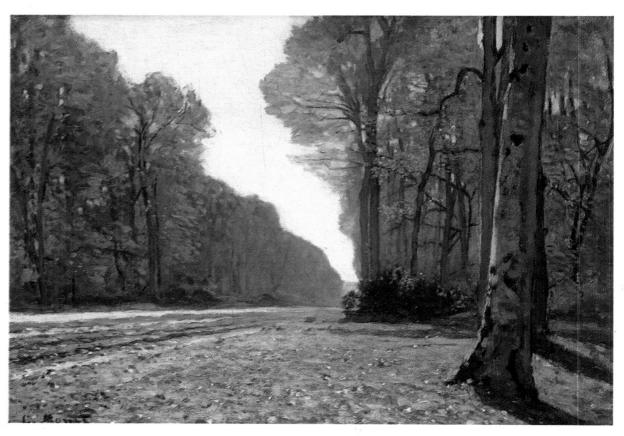

LE PAVÉ DE CHAILLY

Sainte-Adresse, 14 October 1864

To Frédéric Bazille

I received your fine letter which gave me a great deal of pleasure; I never doubted that you would be ready to do anything to help me out and I'm very grateful to you.

Next Monday I'm going to put a box on the express train containing three pictures with frames which I've just had made, since you know well enough how a picture gains a hundred per cent in a fine frame. One of these is a simple study which you didn't see at the outset, it's done entirely from nature. You might find it bears a certain relationship to Corot, but if this is so, it is not because of any attempt to imitate him on my part. It is due entirely to the motif and above all to the calm and misty effect. I did it as conscientiously as possible and did not think of any painting whatsoever. Besides, you know that's not the way I do things. The two other canvases are the shipyard for small boats below Saint-Siméon and the road in front of the farm. These are two of my best studies, though it's not the studies I'm sending you but the two paintings I'm finishing here based on my studies . . . I'm going to get down to a still life on a size 50 canvas of rayfish and dogfish with old fishermens' baskets. Then I'm going to turn out a few pictures to send wherever possible, given that now, first and foremost (unfortunately), I have to earn some money.

Yours affectionately, CLAUDE MONET

*

[Chailly, July or early August 1865]

TO FRÉDÉRIC BAZILLE

I'm writing to you again, as you didn't let me know whether my pictures were ready in time to be sent. I'd also like to know if my tickets have been paid for. I'm angry with you in fact, for not having written; you appear to have forgotten me completely. You promised to help me with my picture, you were supposed to come and pose for some figures and my picture depends on it: so I hope you will keep your promise, but time is passing all the same and no sign of you. Please, my dear fellow, don't hold me up like this. All my studies are progressing admirably, it's only the men that are missing now. So come right away, there can't be anything serious keeping you in Paris. Here it's as agreeable as ever, we are quite a pleasant little group of artists. So come, but above all write and tell me at once; I'm very worried, I know how fickle you are, my dear fellow, I think only of my painting, and if I were to drop it, I think I'd go crazy. Everyone knows what I'm doing and I'm getting a lot of encouragement, so it must be done, and well, I'm counting on the kindness that you've shown in the past to come quickly and help me out.

Yours affectionately, MONET

*

Place Pigalle [early April 1866]

TO AMAND GAUTIER

I've just had bad news from Le Havre. My aunt has finally decided to put an end to the allowance she sends me this very month. I'm utterly shaken. It does seem as though a certain person wishes to destroy my reputation in her eyes. As you have seen yourself how I live and how I work, I beg of you to help me placate my aunt for a little while longer . . . I don't know quite how I could manage otherwise . . .

Sèvres, Tuesday 22 May 1866

TO AMAND GAUTIER

I am writing to thank you for all the interest and kindness you have shown towards me: a few days ago I received a letter from my aunt informing me that she received news from you addressed from Lille, and that you compliment her on my Salon success; I thank you from the bottom of my heart.

My aunt appears to be delighted. She is congratulated at every turn; no less than three people sent her the *Evénement* which you also sent. My aunt tells me that you must be in Paris by now: the first day I come to Paris, my first errand will be to come and see you, and that will probably be Thursday.

I am increasingly happy; having decided to get away to the country, I'm working hard with more determination than ever. My success at the Salon led to my selling several paintings and since your absence I have made 800 francs; I hope, when I have contracts with more dealers, it will be better still.

In haste, with warm greetings.

See you soon, CLAUDE MONET

[Paris, 20 May 1867]

To Frédéric Bazille

I was very happy to receive your letter; I'm very touched by your compliments, and all the more relieved because I dreaded the contrary, and it's the hardest thing to be alone in being satisfied with what one's done. Do try and show it to M. Bruyas, to see if it appeals to him; don't forget me will you?

... Manet's opening is in two days and he is in a frightful state. Courbet opens a week today, next Monday that is. That's quite another story. Can you imagine, he's inviting every artist in Paris to the opening: he's sending three thousand invitations, and on top of that, every artist also gets a copy of his catalogue. Rest assured he's doing well; his intention is to hold on to the building where he's already had a studio built on the first floor: and next year he'll rent the room out whenever anyone wants to hold an exhibition there. So let's work hard, and end up there with some pictures that are beyond criticism. Nothing else for now. Renoir and I are still working on our views of Paris. I saw Camille yesterday: I don't know what to do; she is ill, bedridden and penniless, or almost, and as I count on leaving on the 2nd or 3rd at the latest, I have to remind you of your promise to send me fifty francs at least, for the first of the month . . .

*

Sainte-Adresse, 25 June [1867]

To Frédéric Bazille

I've been staying with my family for two weeks now and am as happy and as well as could be. Everyone is good to me and every brushstroke I do is admired.

I've set myself a lot of work, I've twenty or so canvases well under way, stunning seascapes, figures and gardens, something of everything in fact. Among my seascapes I'm painting the regattas at Le Havre with lots of people on the beach and the ship lane covered with small sails. For the Salon I'm doing an enormous steamboat. It's very curious. Did you know that before I left Paris I sold a small seascape to Cadart, and one of my Paris views to Latouche? It was a great relief and a joy to me as I was able to be of some help to poor Camille. But my dear friend, what a painful situation it is, all the same; she is so kind, a really good lass and she has seen sense and in so doing has made me even sadder. In this context, I'm writing to ask you to send whatever you can, the more the better, send it to me by the 1st, since although I'm getting along well with my parents, they warned me that I could stay here as long as I liked but if I needed money I had to earn it. So don't let me down, will you? But I have a favour to ask of you. On 25 July Camille's baby is due. I'm going to Paris where I'll be for ten or fifteen days and I'll need money for a lot of things. Do try and send me a little more then, if only 100 or 150 francs. Please bear it in mind; without it I'll be in a very awkward position.

... You didn't know about the Courbet and Manet exhibitions. That's very odd. God, what horrors Courbet came up with. He did himself a lot of harm, since he had enough good pictures not to have to show everything. When I left, Manet's takings were becoming more substantial, which must have done him a lot of good, and there are some good things which I didn't know about. The *Femme Rose* is bad, he's done better in the past. God knows it's terrible to be swayed by praise the way he is, because he really ought to be doing some very fine things...

Best wishes, CLAUDE MONET

THE ARTIST'S SON ASLEEP

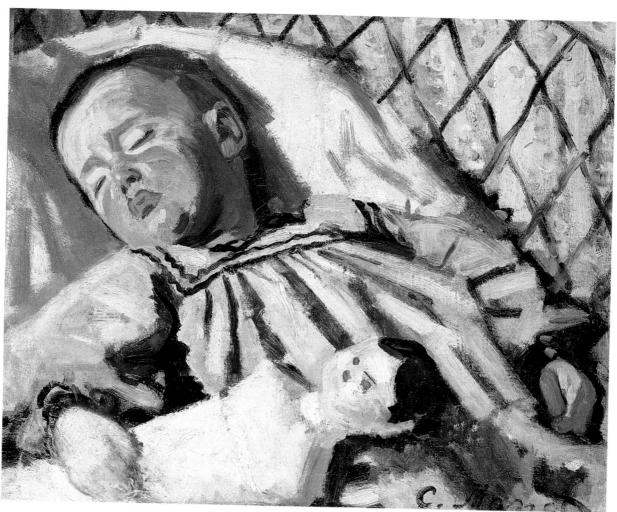

Sainte-Adresse, 12 August [1867]

TO FRÉDÉRIC BAZILLE

I really don't know what to say to you, you've shown such pig-headedness in not replying, I've written letter after letter, a telegram and nothing has got through to you; yet you know me better than anyone, and my situation too. Once again I had to borrow and received snubs from people I don't know, and I'm really angry with you; I didn't think you would abandon me like this, it really is too bad. It's now almost a month since I asked you first: since then, in Paris as here, I've waited for the postman and every day it's the same. For the *last* time I am asking you for this *favour*, I'm going through the most terrible torments, I had to come back here not to upset the family and also because I didn't have enough money to stay in Paris while Camille was in labour. She has given birth to a big and beautiful boy and despite everything I feel that I love him, and it pains me to think of his mother having nothing to eat. I was able to borrow the strict minimum for the birth and my return here, but neither she nor I have a penny of our own.

It's all your fault, so hurry up and make amends and send me the money right away to Sainte-Adresse: as soon as you get my letter, send a word by telegraph as I am terribly worried.

Really, Bazille, there are things that cannot be put off until tomorrow. This is one of them and I'm waiting.

In hope, and with warm greetings, CLAUDE MONET

Paris, 29 June [1868]

To Frédéric Bazille

A hasty note to ask you to come speedily to my rescue if you can. I must have been born under an unlucky star. I've just been turned out, without a shirt to my back, from the inn where I was staying. I have found somewhere safe in the country for Camille and my poor little Jean to stay for a few days. As for myself, I arrived here this morning and I leave this evening, very shortly, for Le Havre, to try and see if my patron can help me.

Don't fail to write as soon as you receive this if you can do something for me; in any case, I expect a word from you.

Write to me at Le Havre, poste restante, as my family refuses to do anything more for me, so I don't even know yet where I'll be sleeping tomorrow.

Your loyal and tormented friend, C. M.

I was so upset yesterday that I was stupid enough to hurl myself into the water. Fortunately no harm was done.

[Etretat, December 1868]

To Frédéric Bazille

As I told you in my little scribble, I'm very happy, very delighted. I'm setting to like a fighting cockerel, for I'm surrounded here by all that I love. I spend my time out-of-doors on the shingle when the weather's stormy or when the boats go out fishing; otherwise I go into the country which is so lovely here that I perhaps find it even more agreeable in winter than in summer; and naturally I'm working all the time, and I think this year I'm going to do some serious things. And then in the evening, dear fellow, I come home to my little cottage to find a good fire and a dear little family. If only you could see how sweet your godson is now.

Dear friend, it's a delight to watch this person grow, and I'm glad to have him to be sure. I'm going to paint him for the Salon with other people around of course. This year I'm going to do two figure paintings, an interior with a baby and two women and some sailors in the open, and I want to do them in a striking way. Thanks to the gentleman from Le Havre who is coming to my aid, I'm enjoying the most perfect tranquillity, free from all worries, and in consequence would like to stay this way forever, in a peaceful corner of the countryside like this. I assure you that I don't envy you being in Paris, and scarcely miss the gatherings, even though I'd be glad to see some of the *habitués*, but frankly I don't think one can do anything good in such surroundings: don't you think that face to face with nature and alone, one can do better? I'm sure of it, myself. Moreover I've always thought so, and what I've completed in such conditions has always been better.

One is too taken up with all that one sees and hears in Paris, however strong one is, and what I do here will at least have the merit of being unlike anyone else, at least I believe so, because it will simply be the expression of what I, and only I, have felt.

The further I get, the more I regret how little I know, that's what hinders me the most. The further I get the more I notice that one never dares give frank expression to what one feels. It's strange. That's why I'm doubly happy to be here and I don't think I will spend much time in Paris now, a month at the very most, each year...

With warm greetings and best wishes, CLAUDE MONET

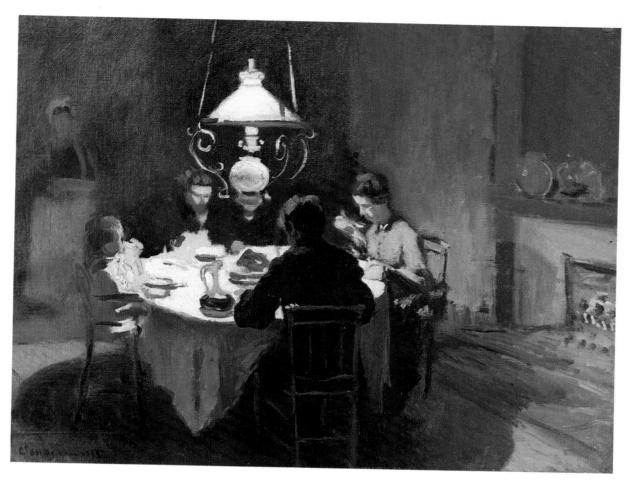

THE DINNER

Paris, 2 June 1869

TO ARSÈNE HOUSSAYE

When I had the honour of visiting you to request support for a permit to work in the Salon, you advised me to settle in Paris where it would evidently be easier to turn my small talent to best account. My rejection at the Salon brought an end to my hesitation since after this failure I can no longer claim to cope. In Le Havre, Gaudibert was once again kind enough to provide me with means to move here and bring my small family back with me. We are now settled, working conditions are very good and I have a lot of courage for the task but alas, that fatal rejection has virtually taken the bread out of my mouth, and despite my extremely modest prices, dealers and art lovers are turning their backs on me. It is, above all, very depressing to see the lack of interest shown in an art object which has no market value.

I thought, and I hope you will excuse me for this, that since you have already found a painting of mine to your taste, you might perhaps like to see the few canvases I was able to save from the bailiffs and the rest, since I thought you might be so good as to help me a little, as I am in quite a desperate state, and the worst is that I can no longer even work.

It goes without saying that I will do anything at any price to pull myself out of a situation like this so that I can start work immediately on my next Salon picture and ensure that such a thing should not happen again.

I hope you will forgive my boldness in writing to you and that you will be so kind as to give my request due consideration.

In this hope, I remain, Sir, your most obedient servant. CLAUDE MONET

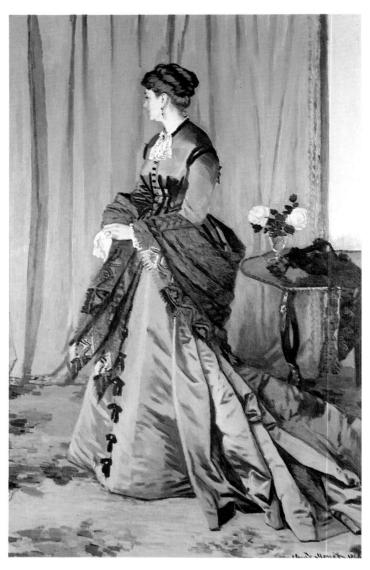

MADAME GAUDIBERT

Argenteuil, 7 May 1873

To Paul Alexis

A group of painters assembled in my home read with pleasure the article you published in the *Avenir National*. We are all happy to see you defend ideas which are ours also, and we hope that, as you say, the *Avenir National* will kindly lend us its support when the Society we are in the process of setting up is fully established.

My colleagues join me in sending you kind regards, CLAUDE MONET

*

[Argenteuil], Monday morning, 28 June [1875]

TO EDOUARD MANET

It's getting more and more difficult. Not a penny left since the day before yesterday and no more credit at the butcher's or the baker's. Even though I believe in the future, you can see that the present is very hard indeed.

So could you send something then, on whatever terms, to a broker? Only be careful as to whom you choose to deal with, in case some harm comes of it.

You couldn't possibly send me a twenty franc note by return of post, could you? It would help me out for the time being.

Best wishes, CLAUDE MONET

1840–1881: Paris and the Seine

Argenteuil, 4 February 1876

To Victor Chocquet

I made Cézanne promise he would come with you tomorrow, Saturday, and expect lunch.

If you are not put off by the prospect of a very frugal meal, it would give me great pleasure, since I would be delighted to make your aquaintance. I will expect you both tomorrow morning,

Yours most sincerely, CLAUDE MONET

² Boulevard St Denis, opposite the station, pink house with green shutters.

*

[Argenteuil], 25 July 1876

To Georges De Bellio

I am writing to you with a heavy heart to ask you, if you have the time, to come and choose the two sketches that you were kind enought to buy and pay for in advance. I can find no way out of it, the creditors are proving impossible to deal with and short of a sudden appearance on the scene of wealthy art patrons, we are going to be turned out of this dear little house where I led a simple life and was able to work so well. I do not know what will become of us... and yet I had so much fire in me and so many plans...

*

[Late March 1877]

TO EMILE ZOLA

Although Renoir has seen you, I'm writing to tell you that we all hope you will be at our meeting on Thursday. Cézanne should be with us and will be delighted to see you. So we'll count on you for Thursday then, meeting at 7 in the Café Riche. Aside from that, we'll see each other on Wednesday, I hope, at our private opening.

Best wishes, CLAUDE MONET

*

10 March 1879

To Georges De Bellio

...I am absolutely sickened with and demoralized by this life I've been leading for so long. When you reach my age, there is nothing more to look forward to. Unhappy we are, unhappy we will continue to be.

Each day brings its tribulations and each day difficulties arise from which we can never free ourselves. So I am giving up the struggle once and for all, abandoning all hope of success, and I no longer have the strength to work in such conditions. I hear that my friends are preparing another exhibition this year but I must discount the possibility of participating in it since I have nothing worth showing.

*

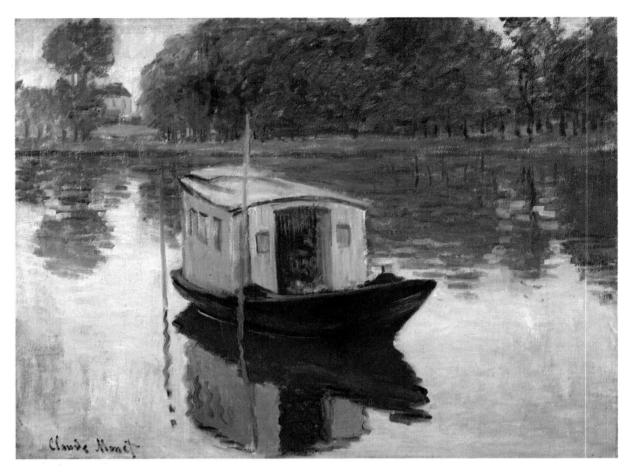

THE STUDIO BOAT

Vétheuil, 14 May 1879

To Ernest Hoschedé

I don't know if the weather in Paris is the same as here, though it's quite likely it is, so you can imagine how dispirited I am. My heart is heavy and I have to share the burden of my disappointments with you. For almost two months now I've been struggling away with no result. You may have some reason to doubt this, perhaps, but it's a fact. I didn't waste an hour and would have reproached myself for taking even one day off to go and see our exhibition, for fear of nothing more than the loss of one good working session, an hour's sunshine. No one but myself knows the anxiety I go through and the trouble I give myself to finish paintings which do not satisfy me and seem to please so very few others. I am utterly discouraged and can no longer see or hope for a way ahead. I have just been jolted into this realization; I have to come to terms with the fact that I cannot hope to earn enough with my paintings to live in Vétheuil. That is the sad fact of the matter. Moreover, I can't imagine that we are very good company for Madame Hoschedé and yourself, with me becoming

1840–1881: Paris and the Seine

increasingly bitter and my wife ill most of the time. We must be and we are, I'm sure, a hindrance to all your plans, and I regret now that we once again started living in arrears. I am only too aware of the wall that has grown up around me and of the impossibility of coping with our share of expenses if we continue to live together; if we left it any later, we would be unable to extricate ourselves. It is far better that we should face up to things as they are. Personally speaking, we will not be any better off as a result, but at least we'll be living the life laid out for us.

I am heartbroken to have to talk to you in this way, please believe me. I am utterly without hope, and see everything at its blackest and worst, and I don't think I'm wrong in saying that our departure will be a relief to everyone in the house. I actually believe it would be doing you a service in a place where, in the eyes of tradesmen and servants, we look like your dependants. That is what bothers me, and as it will become a reality I would rather ask you to settle our accounts, it's wiser I think, much as I might have believed in an idyll of work and happiness.

You must believe how much it pains me to upset you like this.

Yours, CLAUDE MONET

To Georges De Bellio

Vétheuil, 17 August 1879

For a long time I have been hoping for better days ahead, but alas, I believe the time has come for me to abandon all hope. My poor wife is in increasing pain and I cannot imagine that she could be any weaker than she is now. Not only does she not have the strength to stand up or walk one step, but she cannot hold down the slightest bit of nourishment, although she has an appetite. One has to be at her bedside continually attending to her smallest wish, in the hope of relieving her suffering, and the saddest thing is that we cannot always satisfy these immediate needs for lack of money. For a month now I have not been able to paint because I lack the colours; but that is not important. Right now it is the sight of my wife's life in jeopardy that terrifies me, and it is unbearable to see her suffering so much and not be able to provide relief... But I would ask another favour of you, dear M. de Bellio, which is to help us out from your own pocket. We have no resources whatsoever. I have a few canvases in the rue Vintimille; take them for whatever price you like: but please respond to my call for help and send us what you can. Two or three hundred francs now would save us from hardship and anxiety: with a hundred francs more I could procure the canvas and paints I need to work. Do what you can, in short; I told our landlady to let you in: so look at my paintings and buy them for whatever you like.

Awaiting your reply, I send you my best wishes.

Yours, CLAUDE MONET

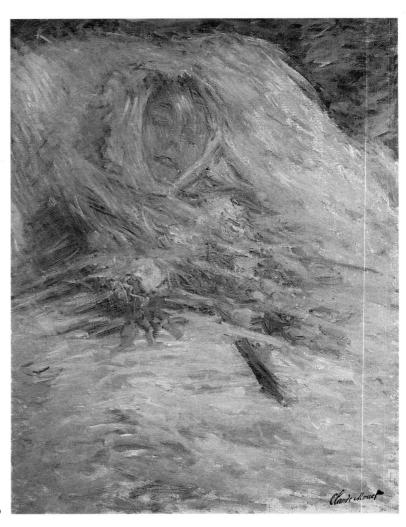

CAMILLE ON HER DEATHBED

Vétheuil, 5 September 1879

To Georges De Bellio

My poor wife gave up the struggle this morning at half past ten after the most ghastly suffering. I am in a state of distress, finding myself alone with my poor children.

I am writing to ask another favour of you; could you retrieve from the *Mont de Piété* the locket for which I am sending you the ticket. It is the only keepsake my wife had managed to hold on to and I would like to be able to place it around her neck before she goes.

Could you do me this favour and send it tomorrow, on receipt of my letter, to the main office in the rue des Blancs-Manteaux before 2 o'clock? You could send it by post; in this way I would get it before she is placed in her bier.

I hope to have word from you tomorrow in response to my previous letter.

Your very unhappy and very pitiable friend, CLAUDE MONET

Vétheuil, 26 September 1879

TO CAMILLE PISSARRO

Thank you for your letter and its expression of sympathy; you, more than anyone, must know something of my affliction.

I am devastated, and have no idea where to turn or how to organize my life with two children. I am much to be pitied, for I am very pitiable.

Thank you again, dear friend, and your wife, for all your kindness, and trust in my sincere friendship.

Yours, CLAUDE MONET

1840-1881: Paris and the Seine

Fécamp, 23 March 1881

TO PAUL DURAND-RUEL

As I informed you, I came here for a brief spell by the sea and I am in such good form that I am very keen to stay for a little while longer. I have worked hard and put my time to good use, but I would like to take some of the studies I have begun somewhat further. To do this I fear I might be somewhat short of money, particularly since I have a lot to pay out elsewhere before the end of the month.

I am thus writing to ask whether you could kindly make a note for 6 or 700 francs available to me. It would be a great help and would enable me to stay here a little while longer. Please be so kind as to forward your answer as soon as possible.

With my best wishes,

Yours sincerely, CLAUDE MONET

*

Fécamp, 26 March 1881

TO PAUL DURAND-RUEL

I received your letter. Thank you for your generosity.

I have to settle various expenses here and there before the end of the month: it would therefore be extremely kind of you if you could send me the sum in question before Wednesday. Send it to me at the home of M. Lemarrois in Fécamp.

I'm working hard. I'm putting a lot of effort into it and I hope to bring you back some good things.

I thank you in advance and send my best regards,

CLAUDE MONET

Vétheuil, 13 September 1881

TO PAUL DURAND-RUEL

Here I am, back in Vétheuil. The continuing bad weather having prevented me from doing any kind of work, I have been forced to come back and I return empty-handed. I am as a result very discouraged, for your sake, having wanted to provide you with some fine things, and for my own, having counted so much on a period by the sea to get over my discouragement.

It is all the more heartbreaking because I have to leave Vétheuil within the month. I have to look for somewhere else and this is going to be a great upheaval for me. I'll need quite a lot of money when the time comes to move house and I won't dare to ask you for any if I can't give you the masterpieces you expect of me.

I will, however, come and see you in Paris when I've found somewhere. I'll bring along all that I have which is presentable. Please don't be too angry with me for my temporary disability and accept my very best wishes.

Yours sincerely, CLAUDE MONET

PS If only the weather would improve, there'd be hope of some work, but every day brings rain.

1861-1870

CORNER OF THE STUDIO

SPRING FLOWERS

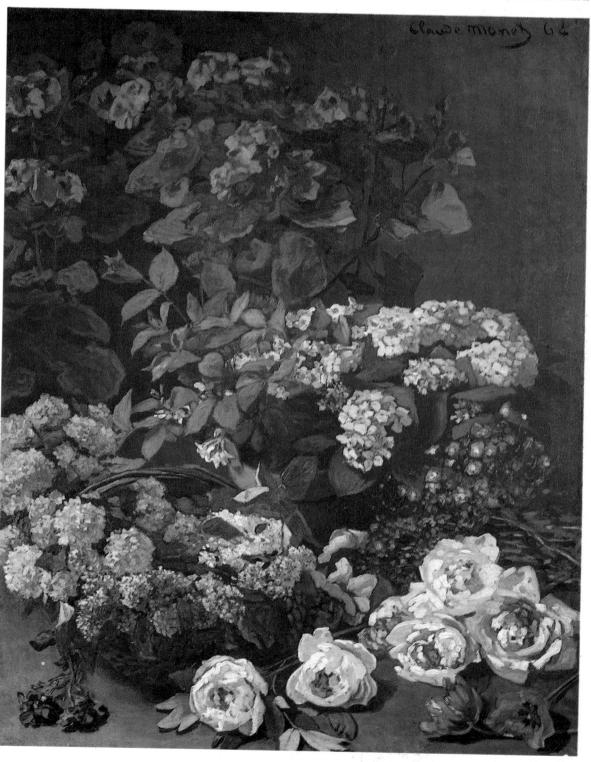

RUE DE LA BAVOLLE, HONFLEUR

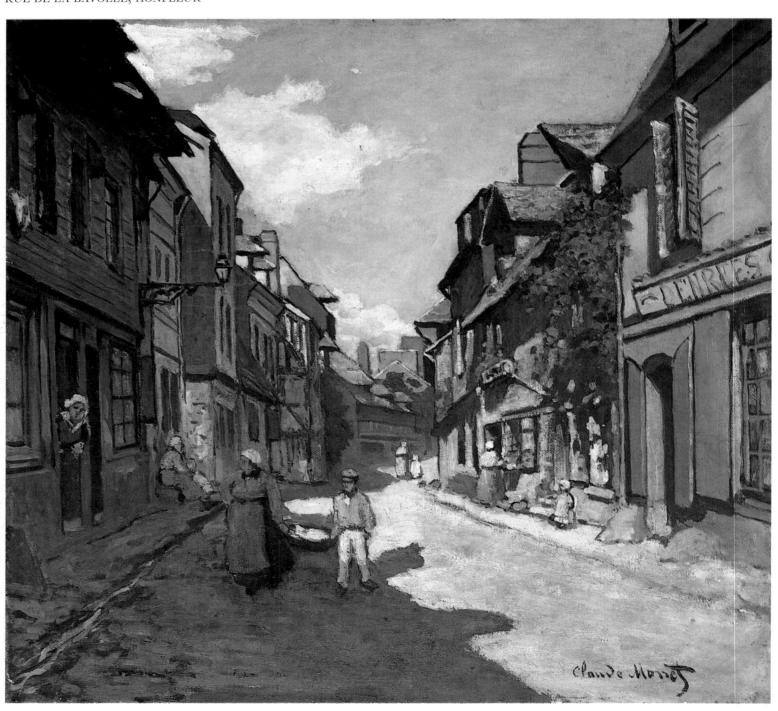

RUE DE LA BAVOLLE, HONFLEUR

CLIFFS AND SEA

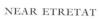

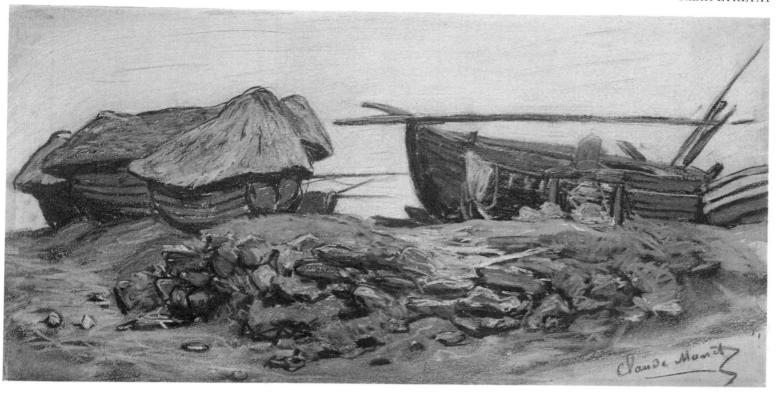

THE GREEN WAVE

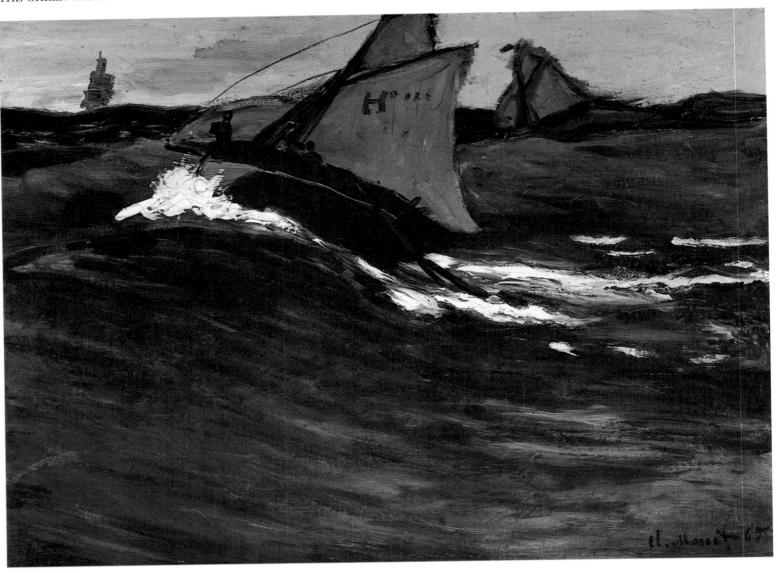

SEASCAPE, STORM

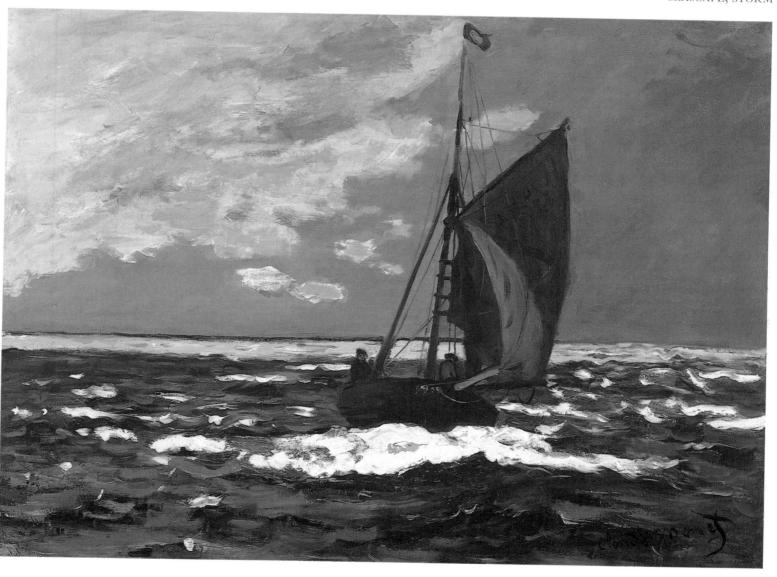

THE REGATTA AT SAINTE-ADRESSE

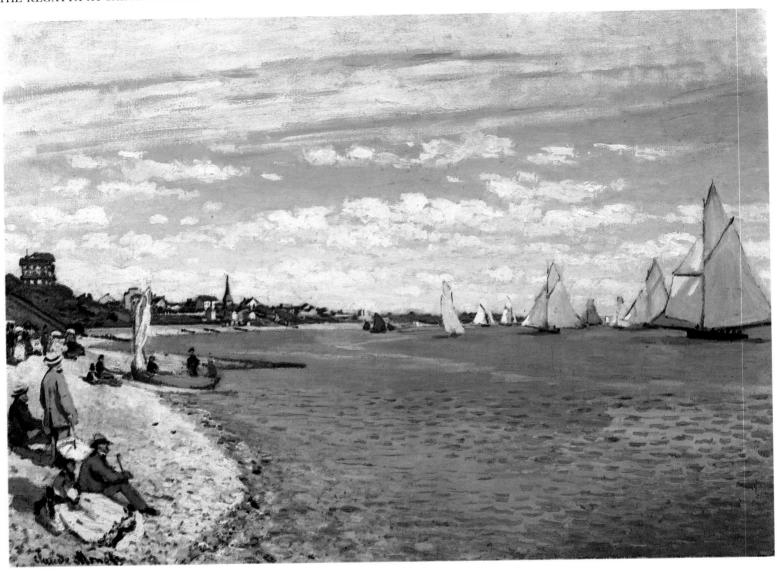

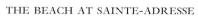

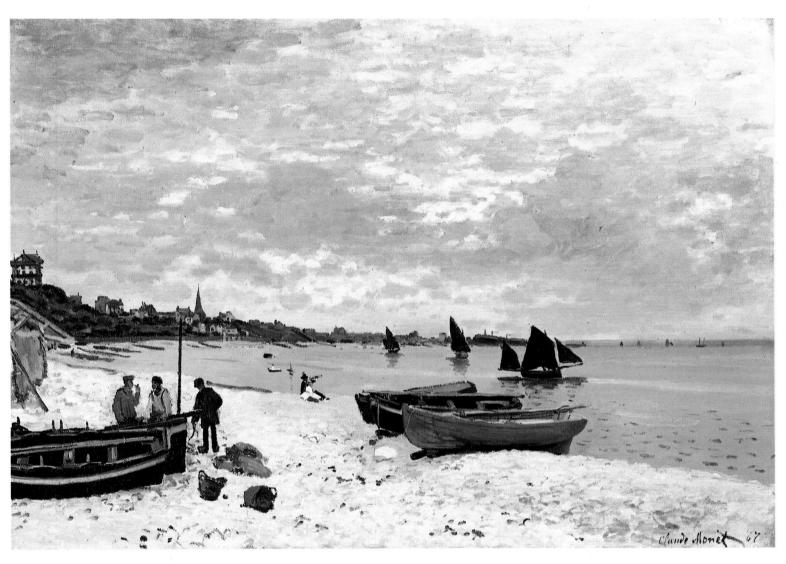

WOMEN IN THE GARDEN

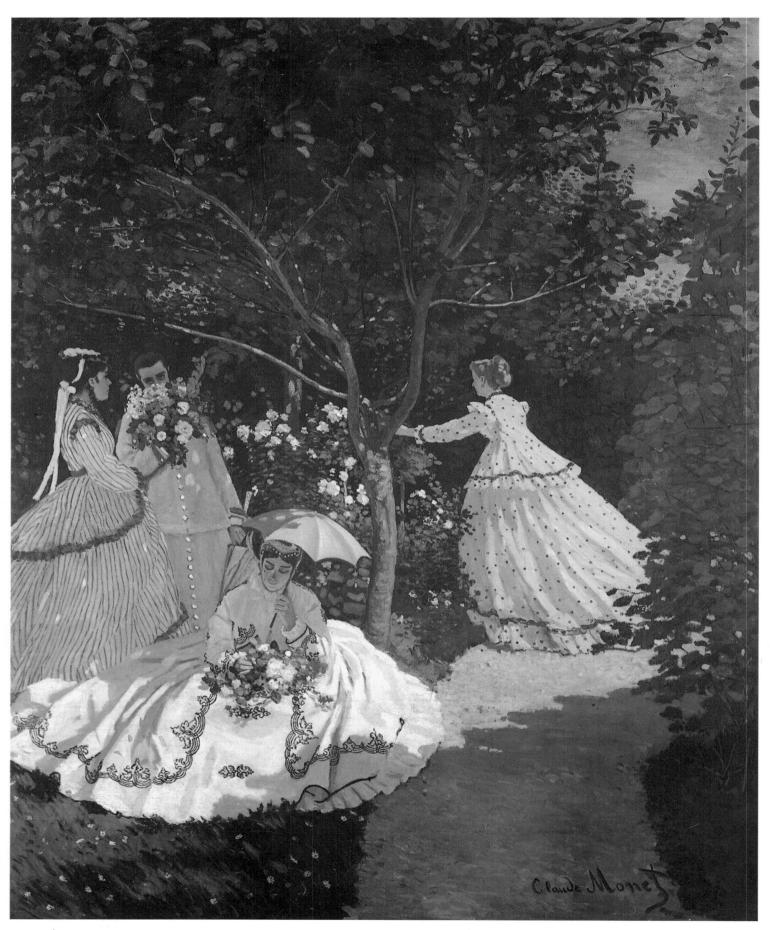

GARDEN IN FLOWER

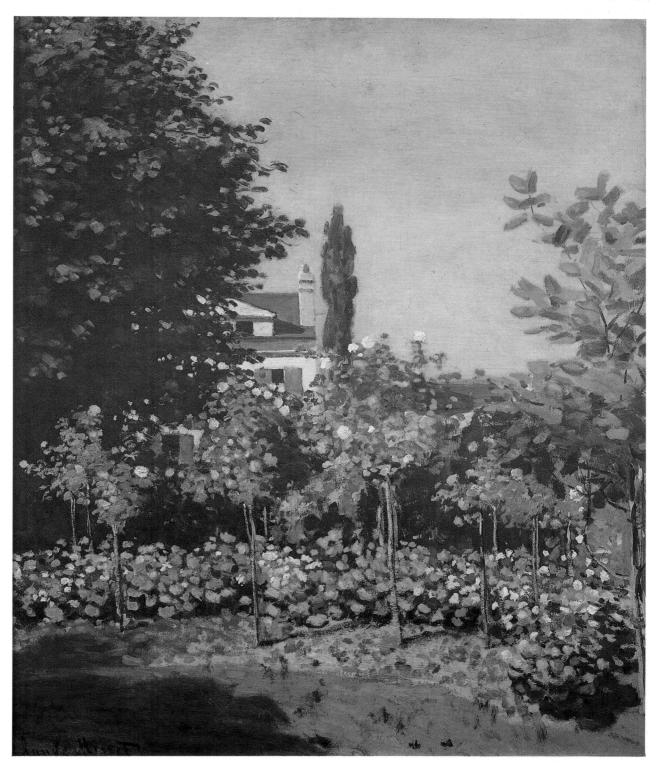

THE QUAI DU LOUVRE

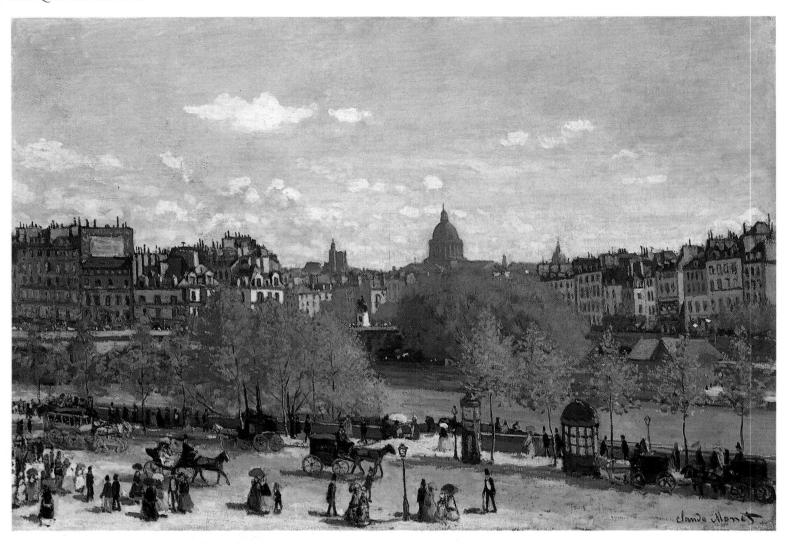

THE GARDEN OF THE PRINCESS, THE LOUVRE, 1867

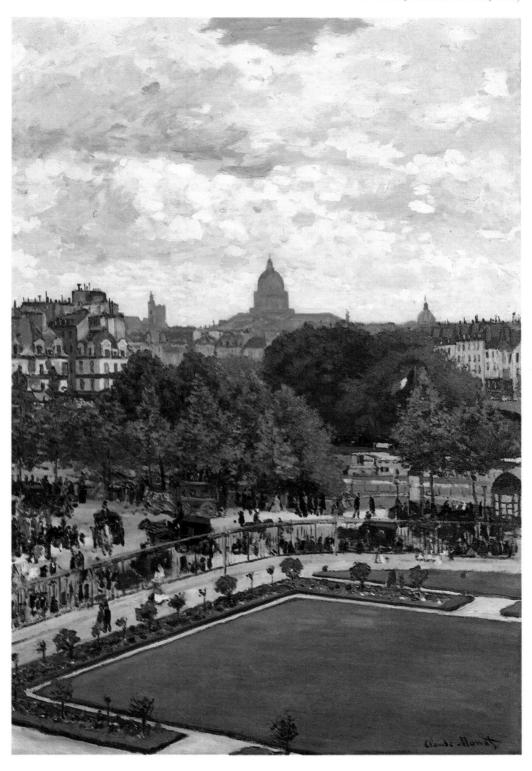

ICE ON THE SEINE AT BOUGIVAL

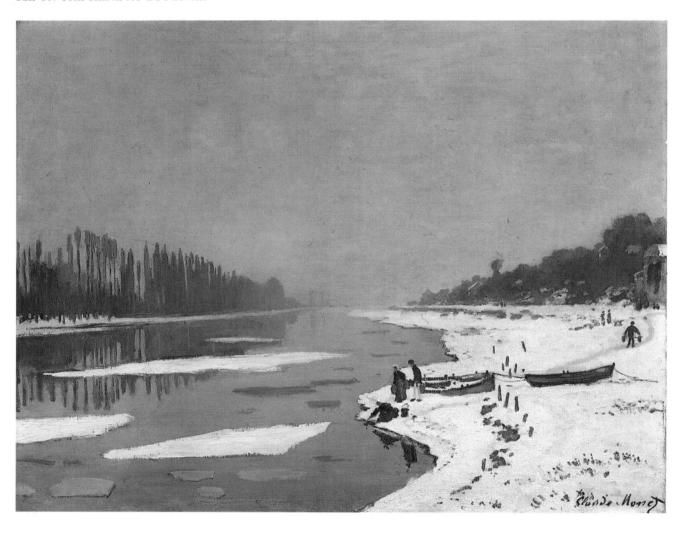

THE MAGPIE

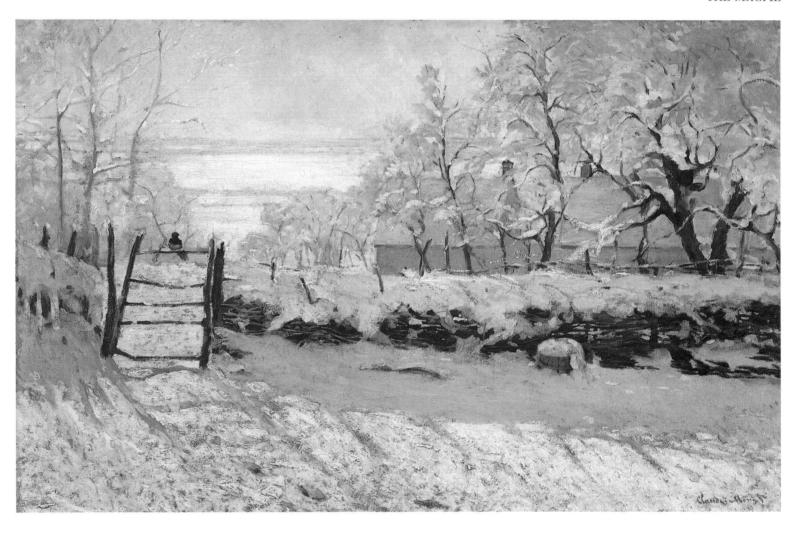

BATHERS AT LA GRENOUILLÈRE

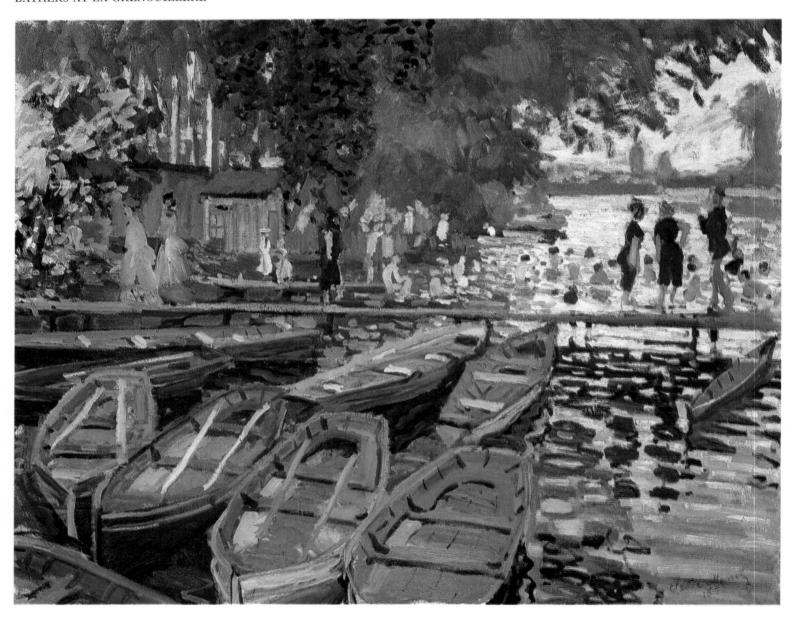

LA GRENOUILLÈRE

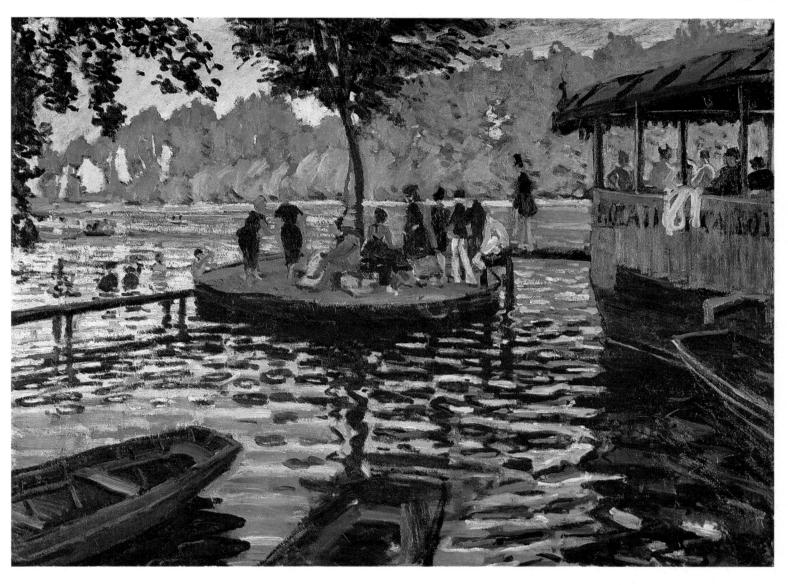

THE POOL OF LONDON

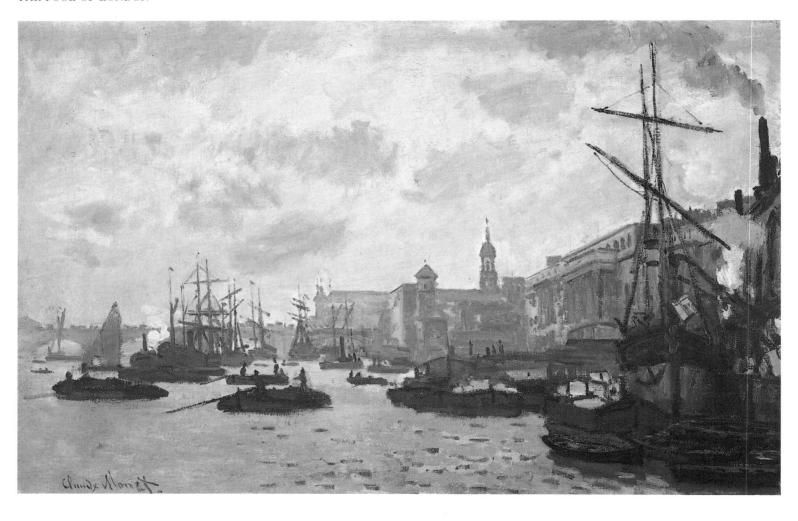

THE JETTY AT LE HAVRE

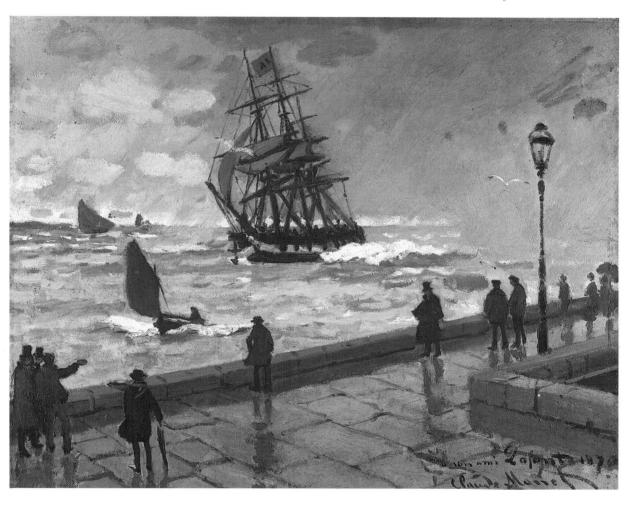

THE BEACH AT TROUVILLE

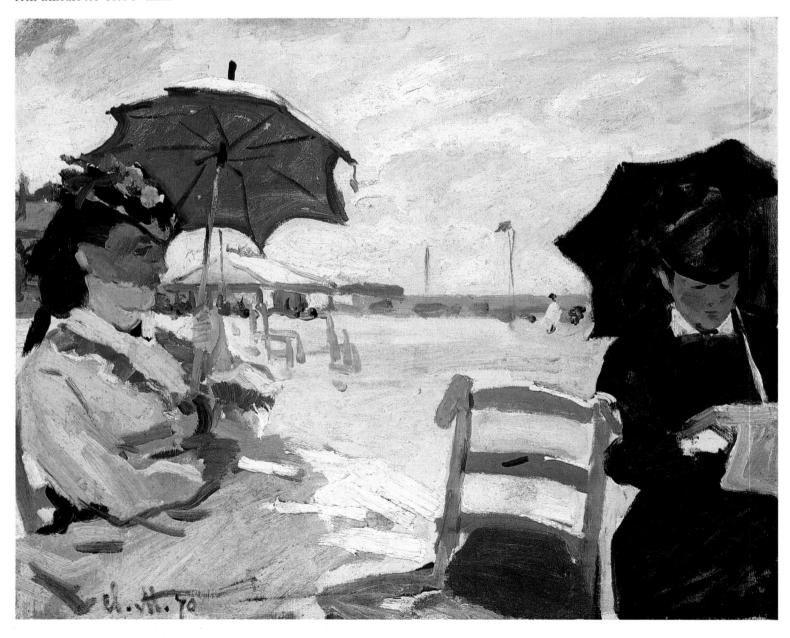

CAMILLE ON THE BEACH

THE THAMES BELOW WESTMINSTER

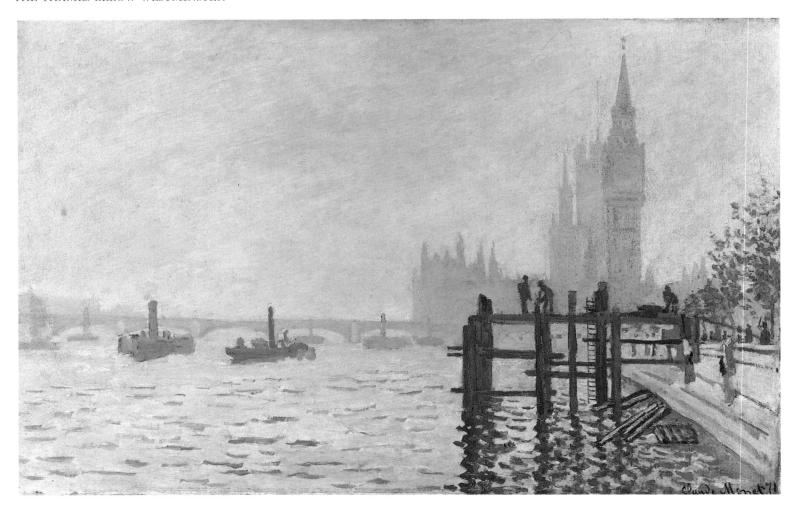

ZAANDAM, (HOLLAND)

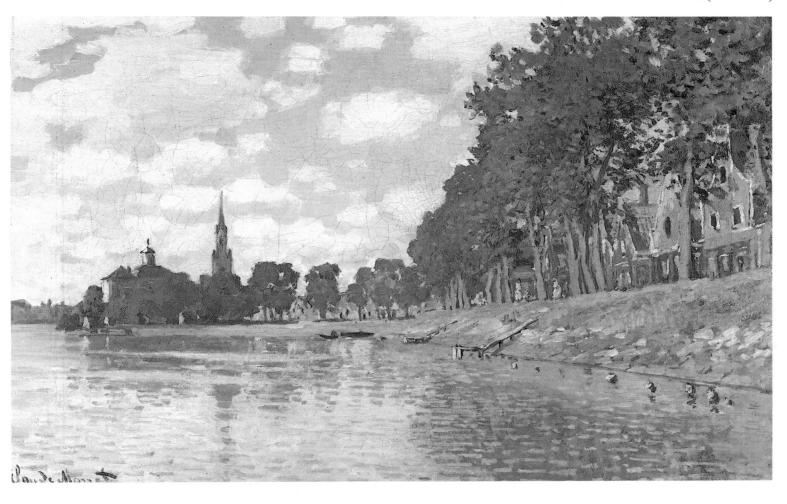

THE ZAAN AT ZAANDAM

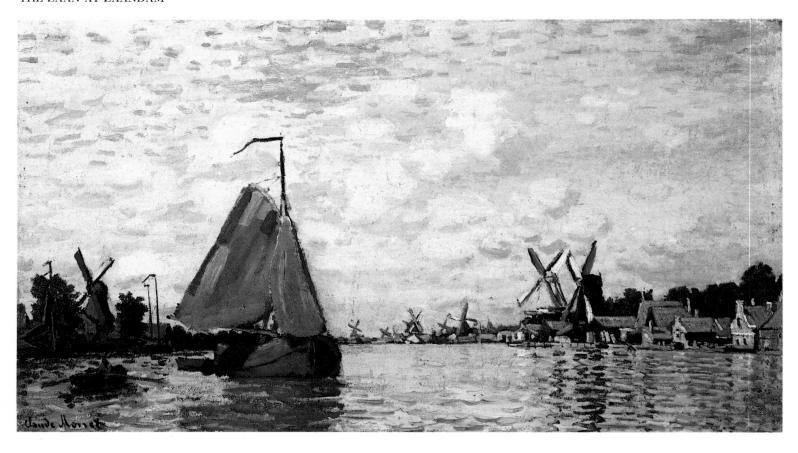

A MILL NEAR ZAANDAM

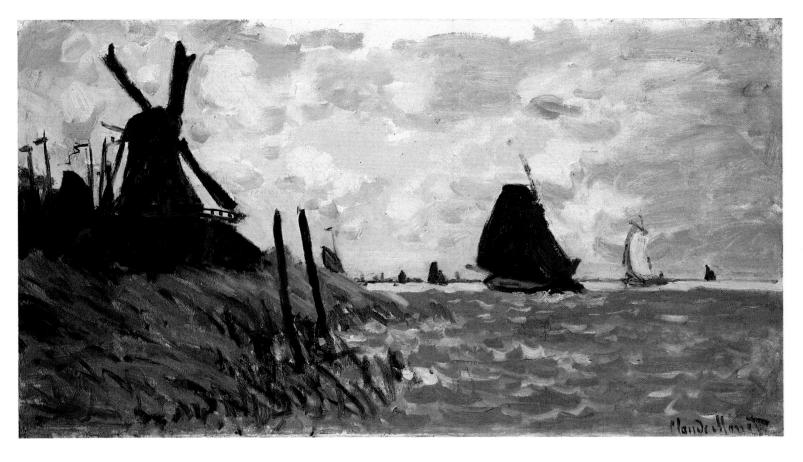

ARGENTEUIL, LATE AFTERNOON

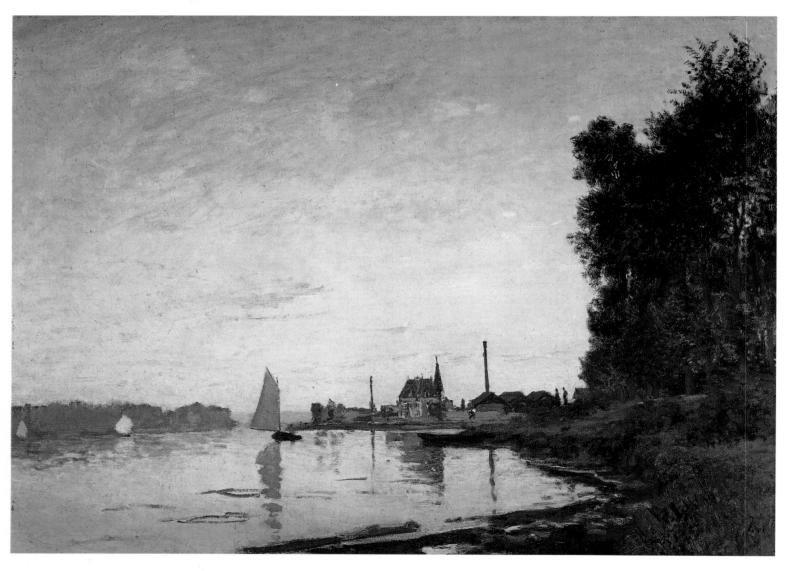

ARGENTEUIL

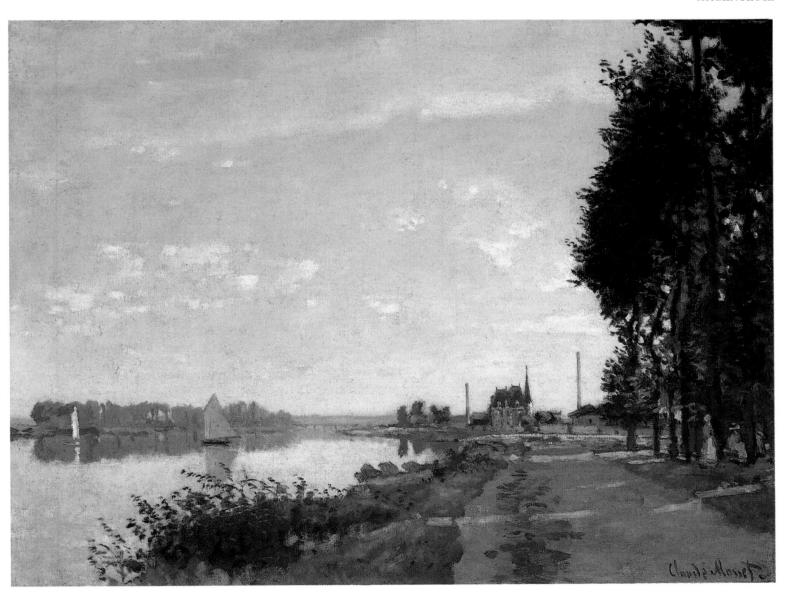

LE BASSIN D'ARGENTEUIL

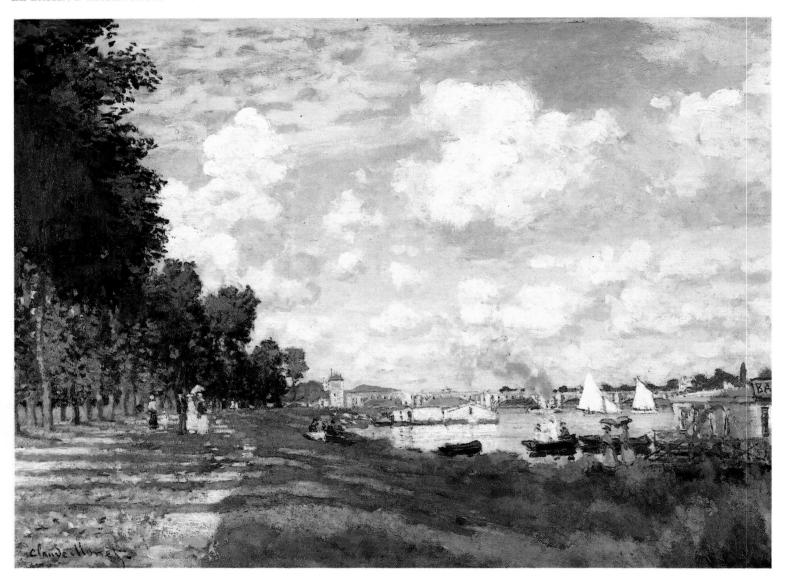

THE PLAINE DES COLOMBES, HOAR FROST

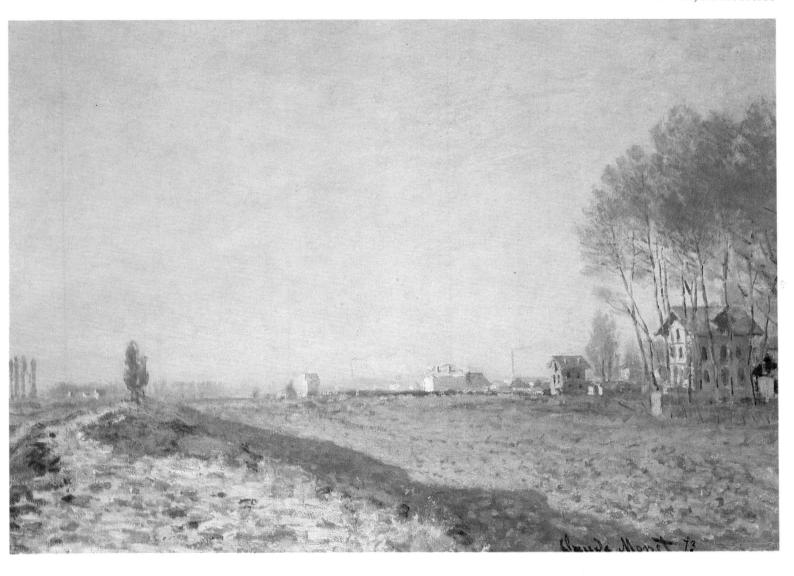

SHIPS IN A HARBOUR

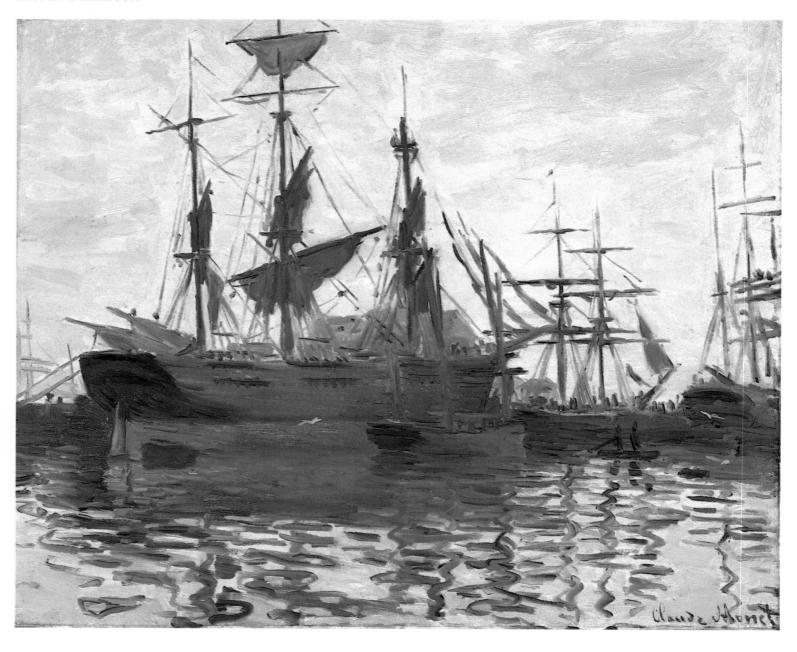

IMPRESSION, SUNRISE

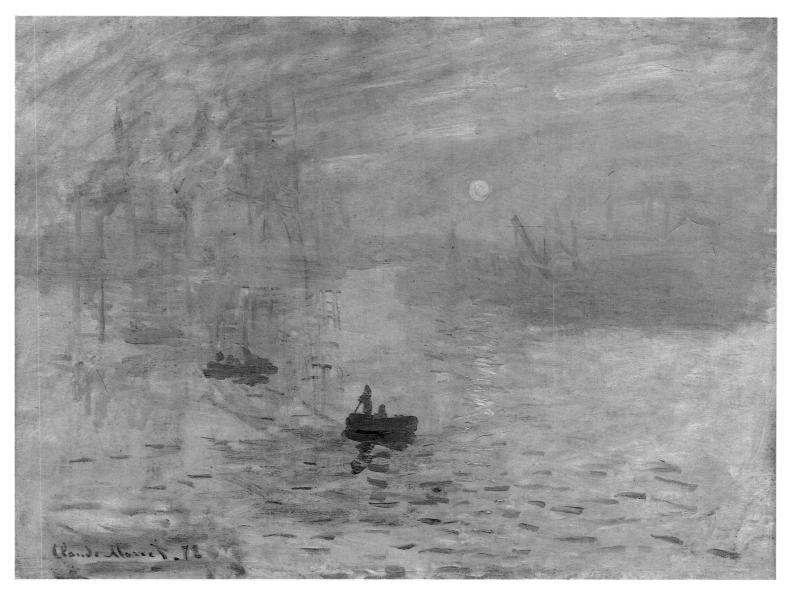

THE READER

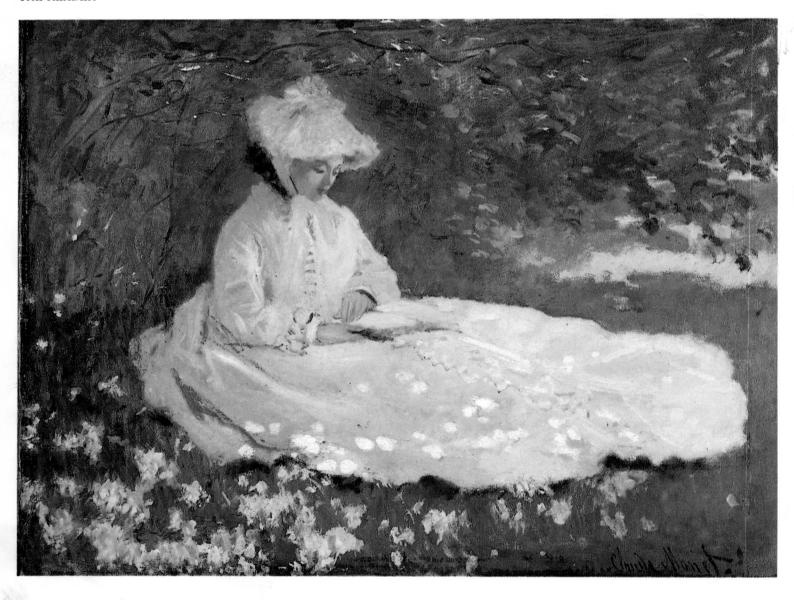

BENEATH THE LILACS

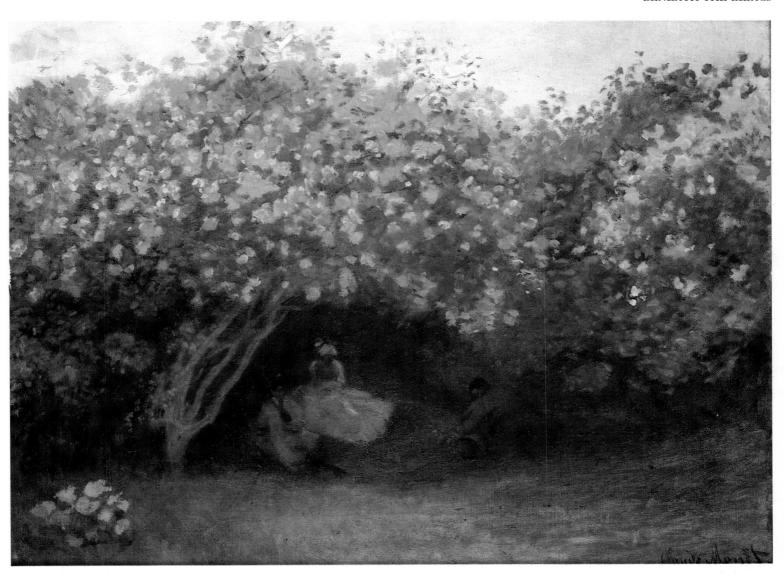

MONET'S HOUSE AT ARGENTEUIL

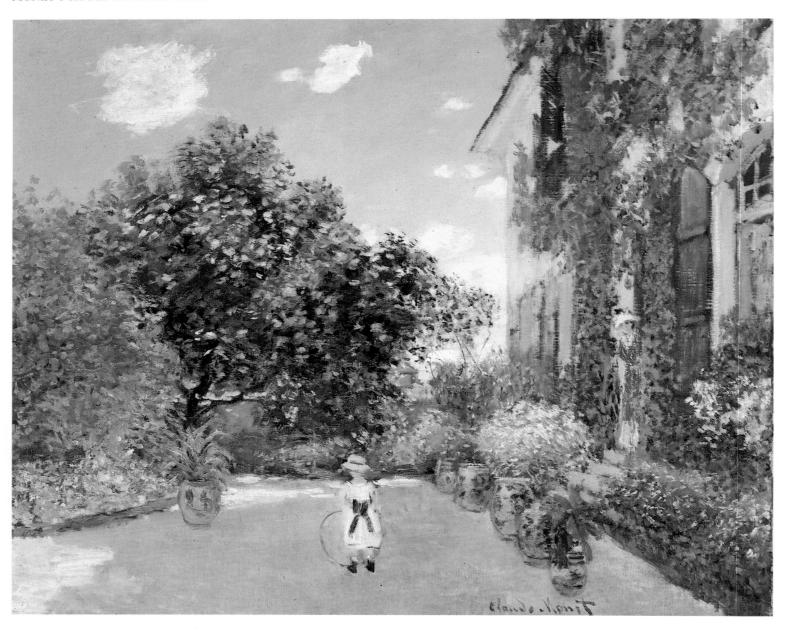

CAMILLE AT HER WINDOW, ARGENTEUIL

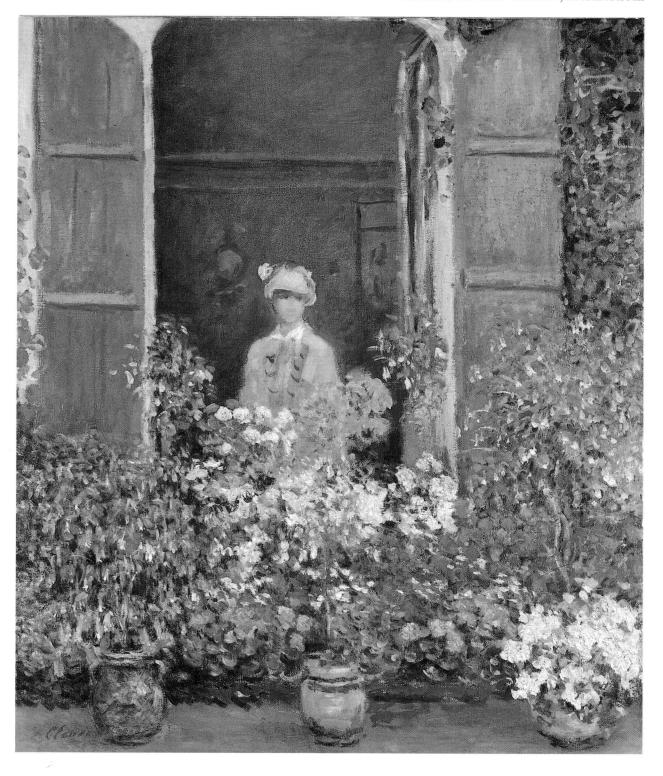

APPLE TREES IN BLOOM

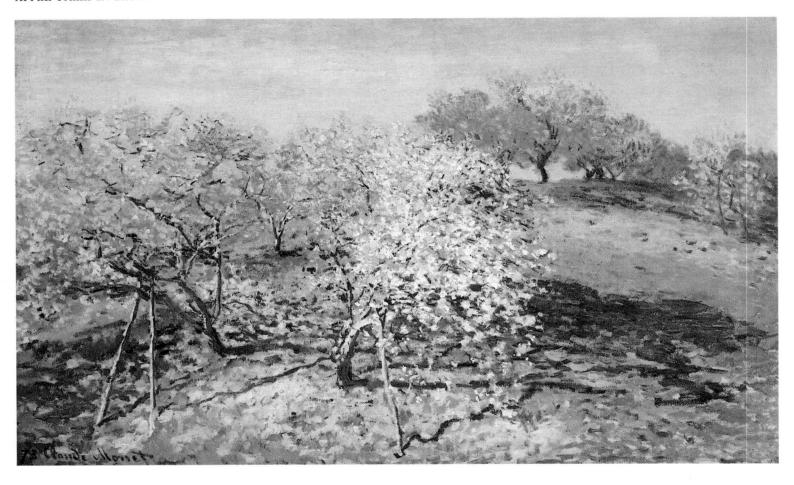

THE PARC MONCEAU, PARIS

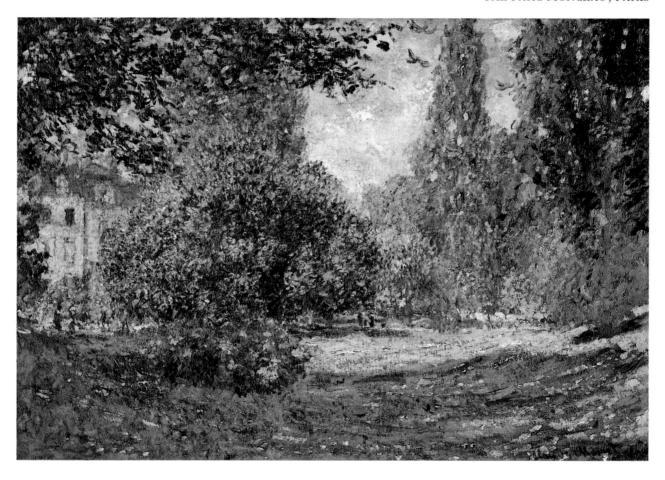

MEADOW WITH POPLARS

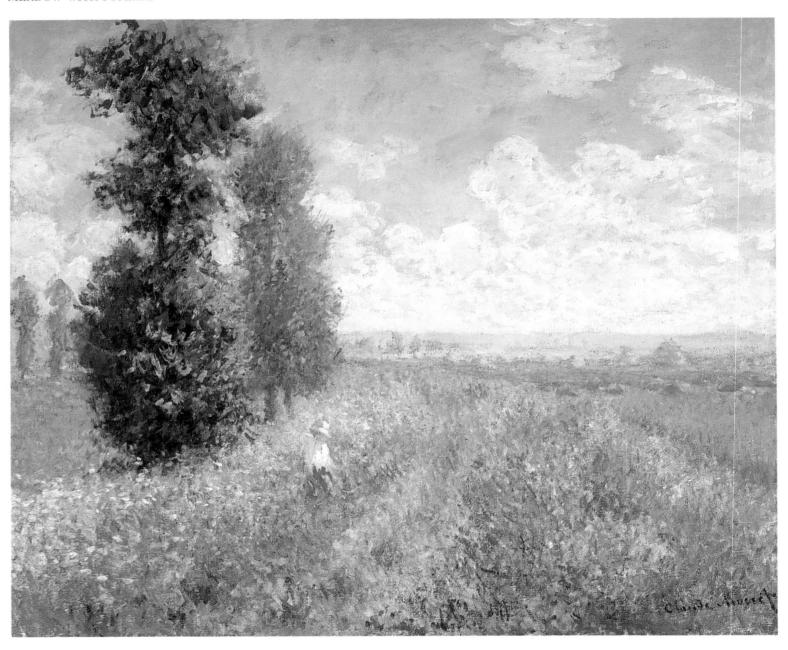

THE SHELTERED PATH

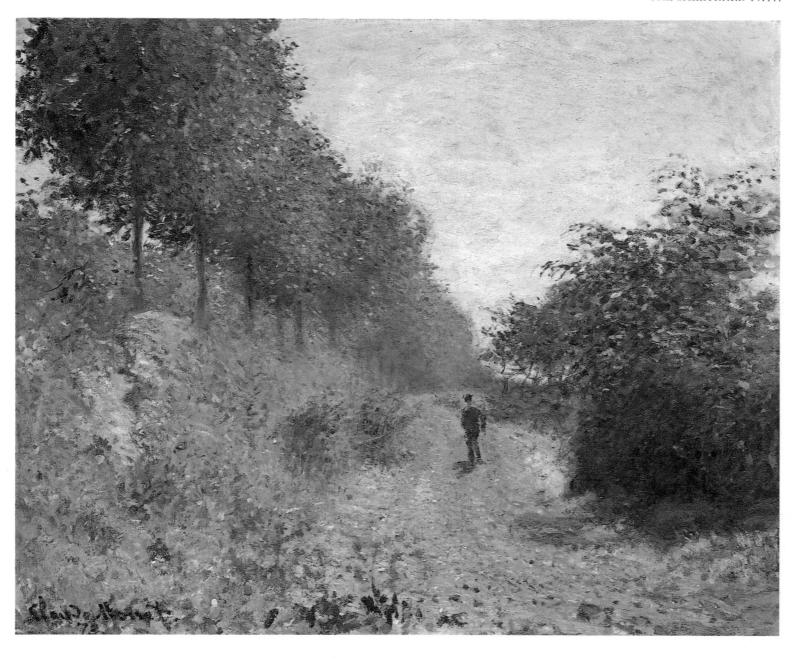

THE SEINE AT ARGENTEUIL, AUTUMN

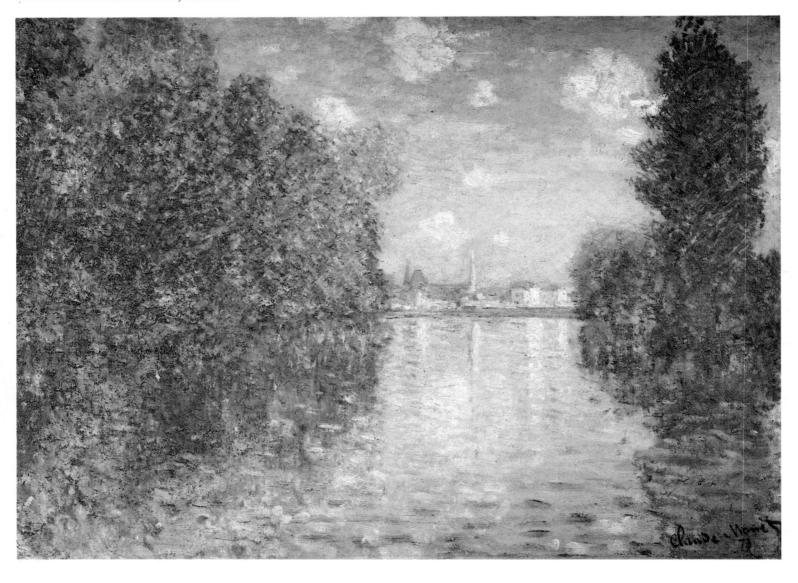

THE BRIDGE AT ARGENTEUIL

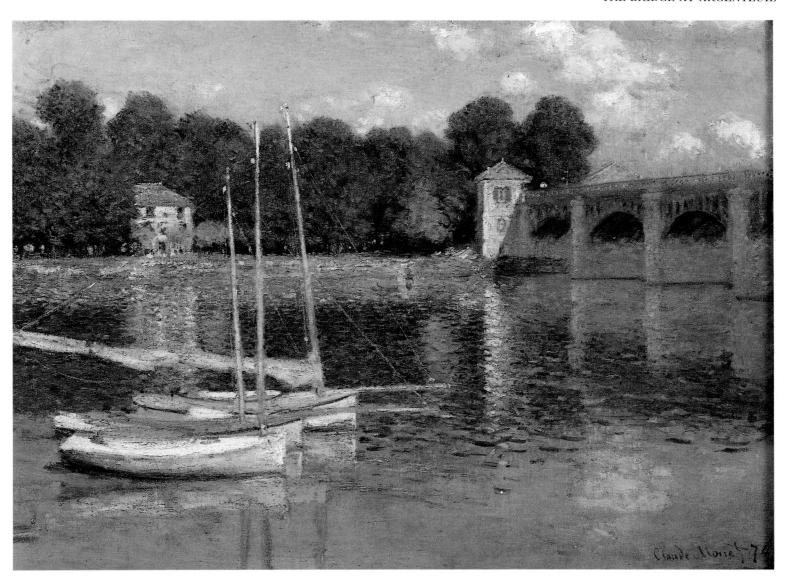

THE BOULEVARD DES CAPUCINES

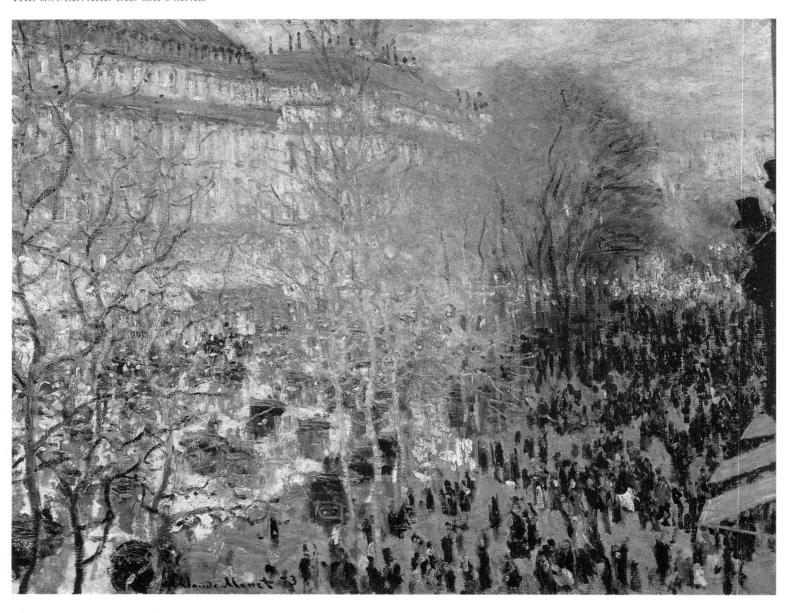

THE RUE MONTORGEUIL

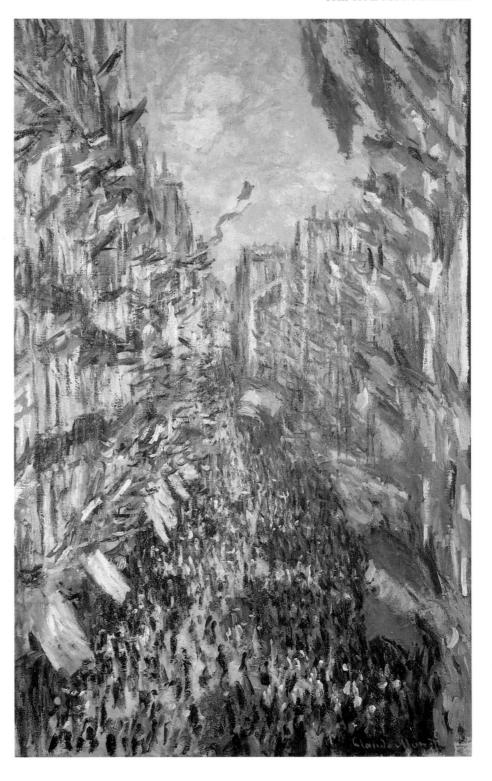

SNOW AT ARGENTEUIL

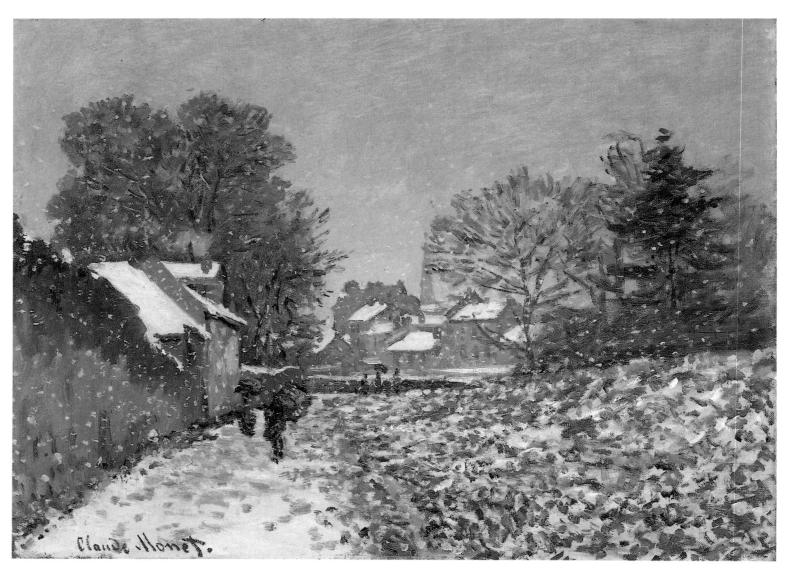

BOULEVARD ST-DENIS, ARGENTEUIL, IN WINTER

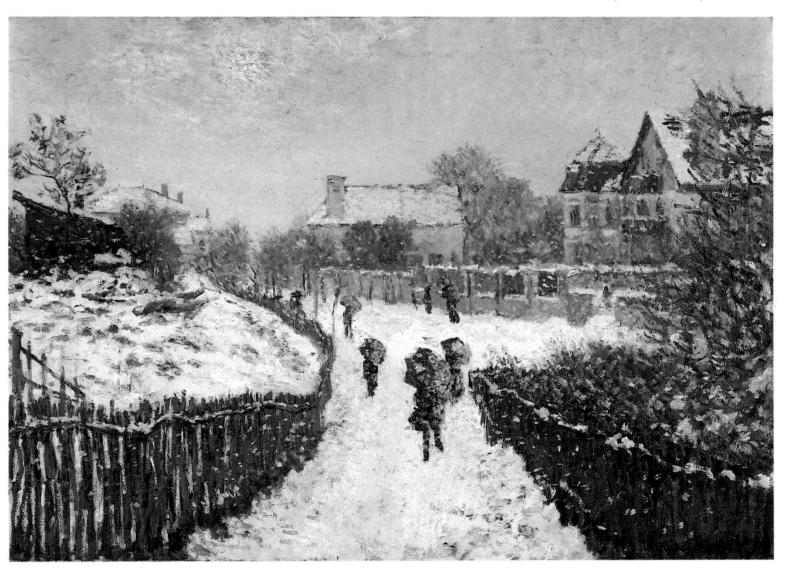

THE RAILWAY BRIDGE, ARGENTEUIL

THE RAILWAY BRIDGE, ARGENTEUIL

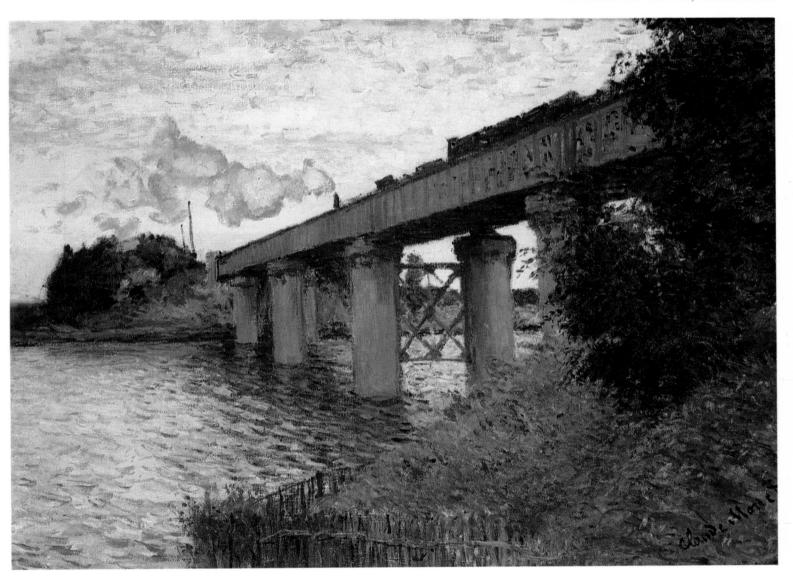

THE PONT DE L'EUROPE, GARE ST-LAZARE

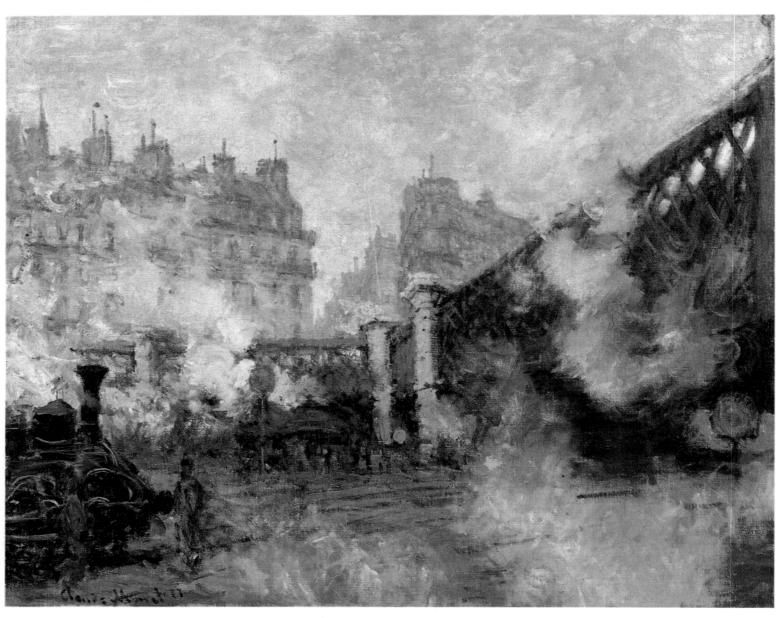

THE GARE ST-LAZARE

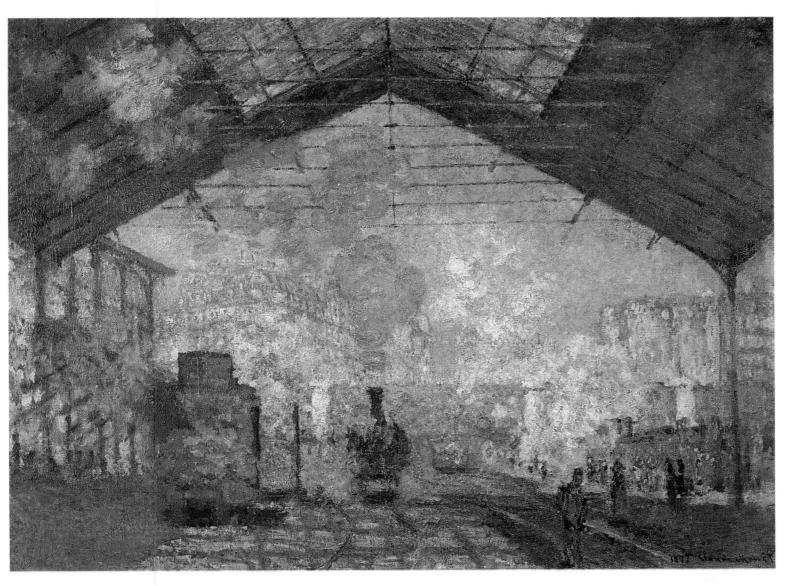

THE GARE ST-LAZARE, EXTERIOR (THE SIGNAL)

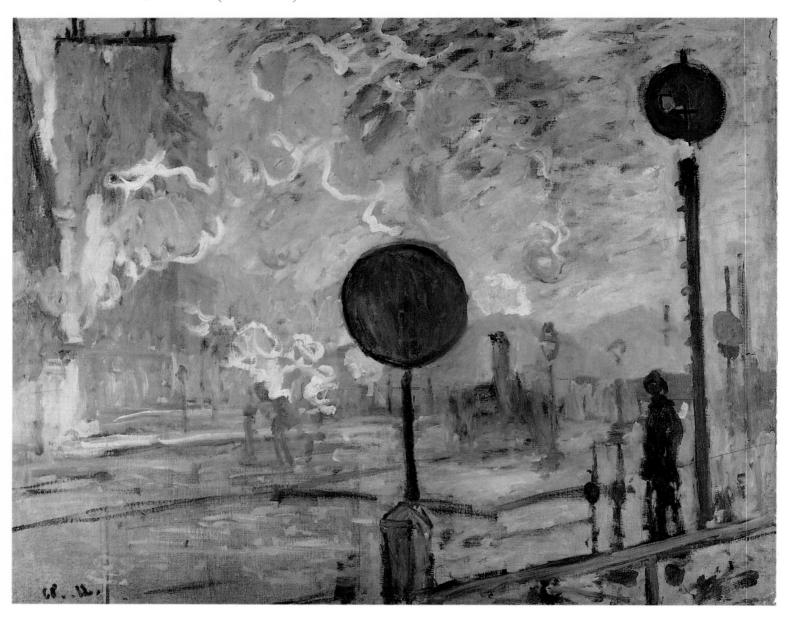

THE GARE ST-LAZARE

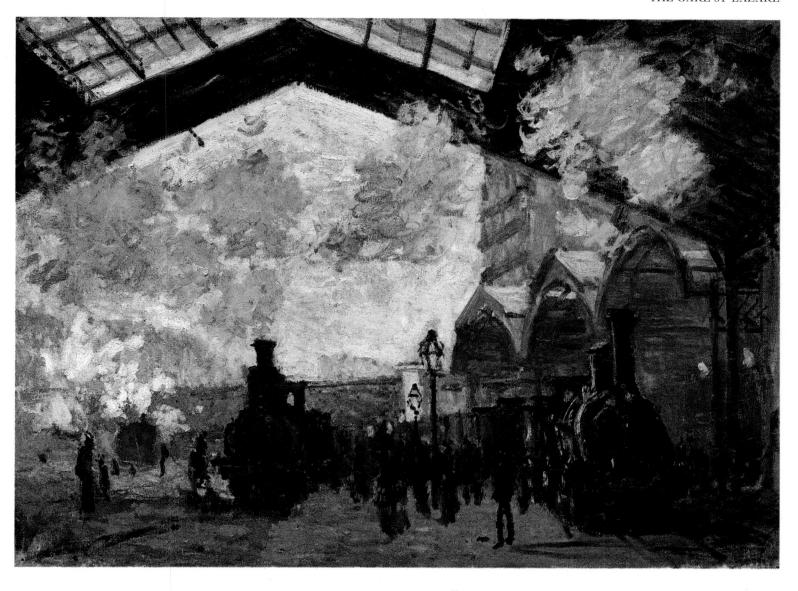

THE CHURCH AT VÉTHEUIL, SNOW

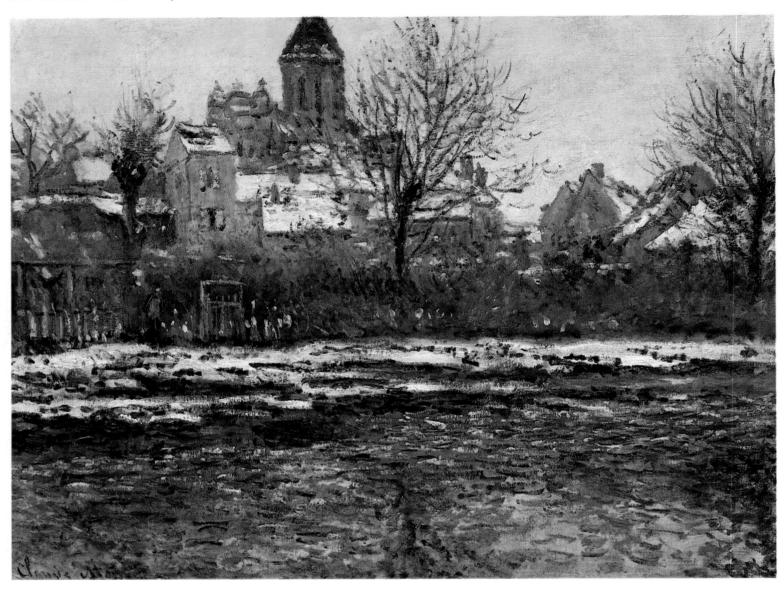

ENTRANCE TO THE VILLAGE OF VÉTHEUIL IN WINTER

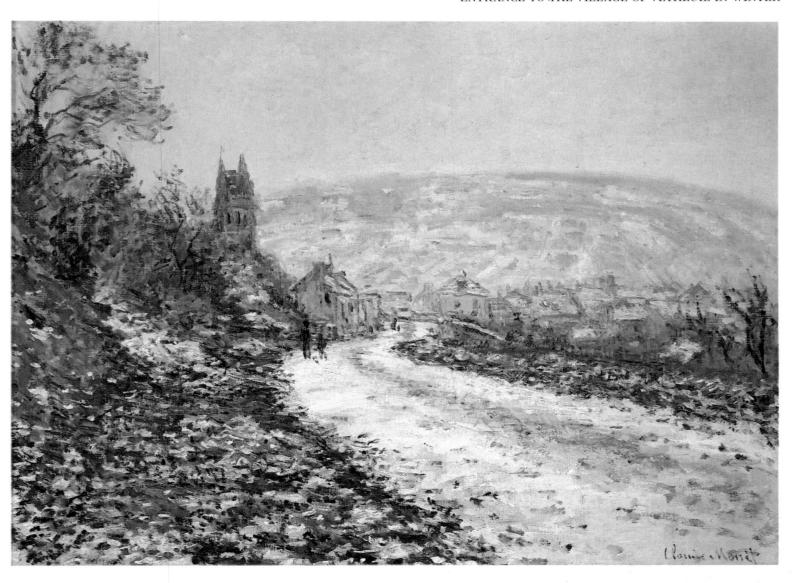

THE FLOATING ICE

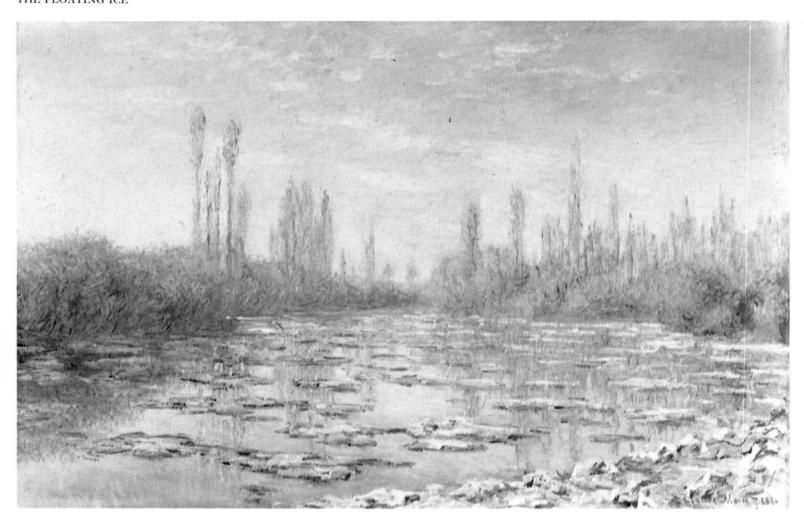

THE ICE-FLOES

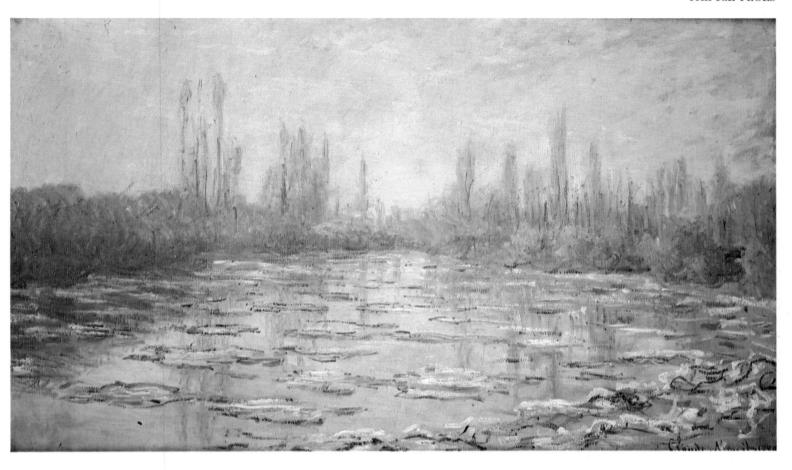

VÉTHEUIL IN WINTER

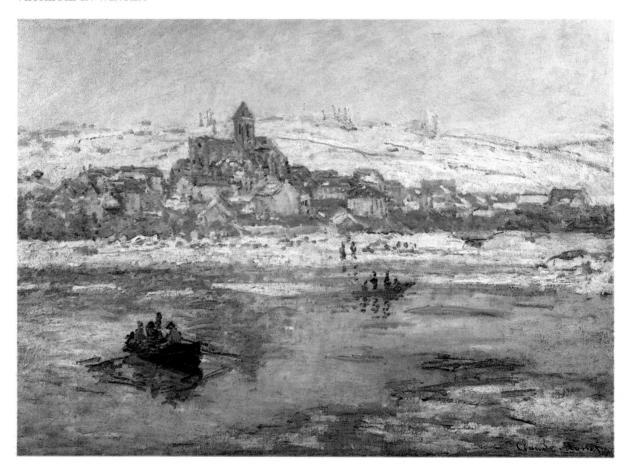

VÉTHEUIL IN SUMMER

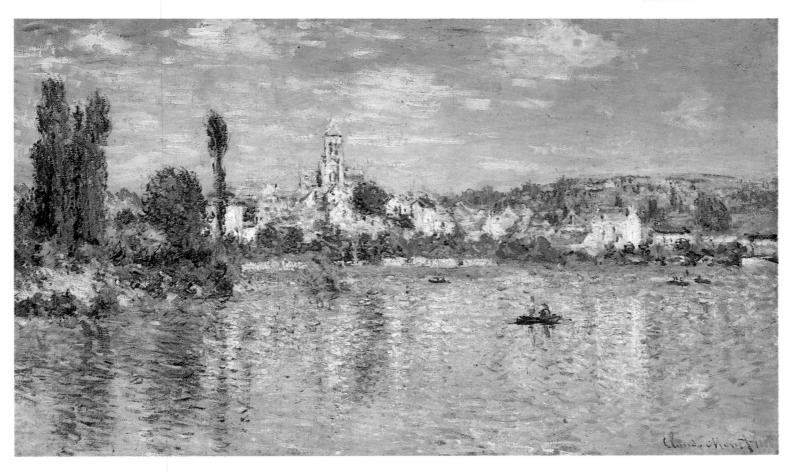

VÉTHEUIL

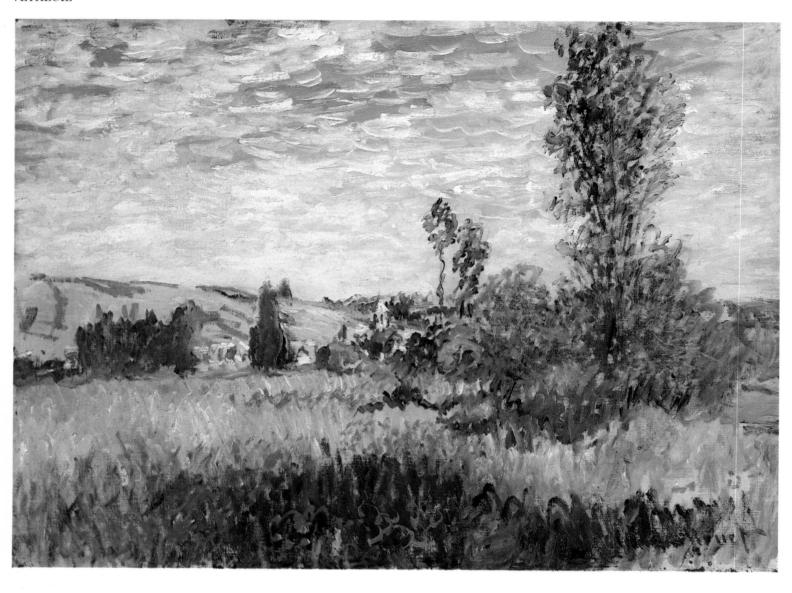

PATH IN THE ÎLE ST-MARTIN, VÉTHEUIL

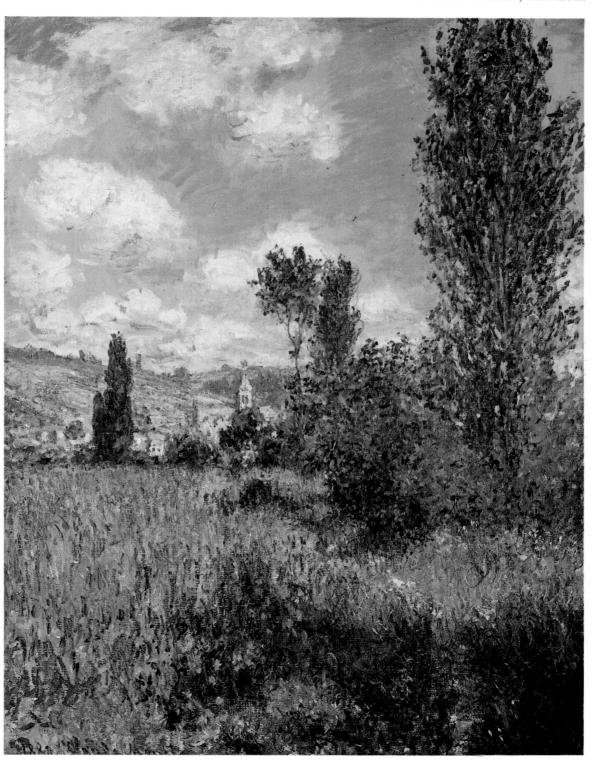

THE ARTIST'S GARDEN AT VÉTHEUIL

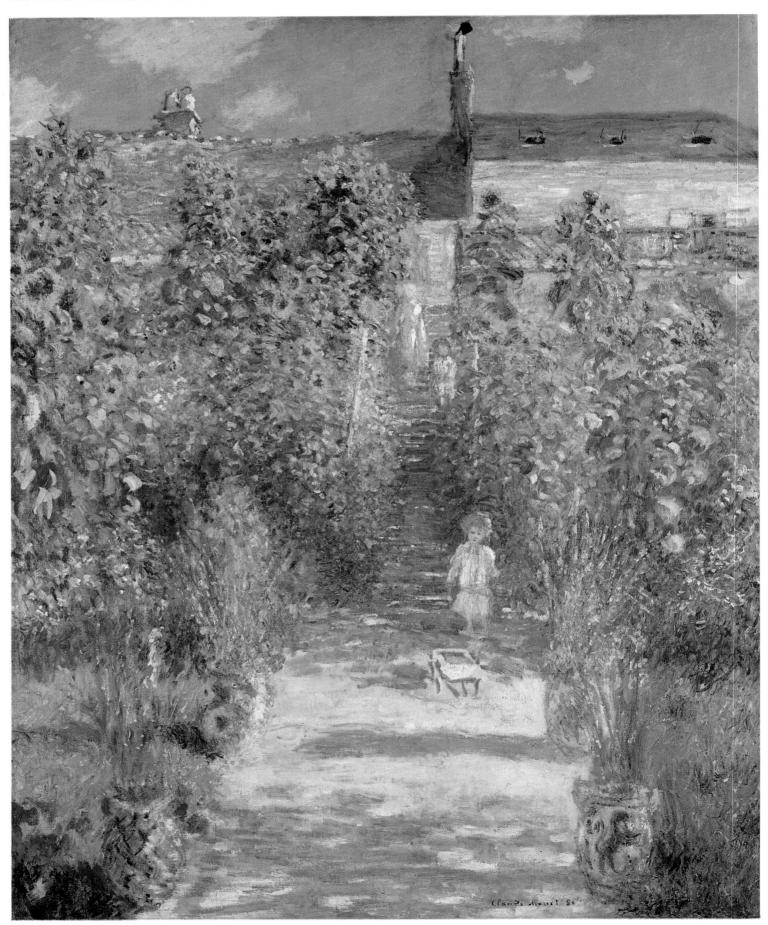

THE STEPS AT VÉTHEUIL

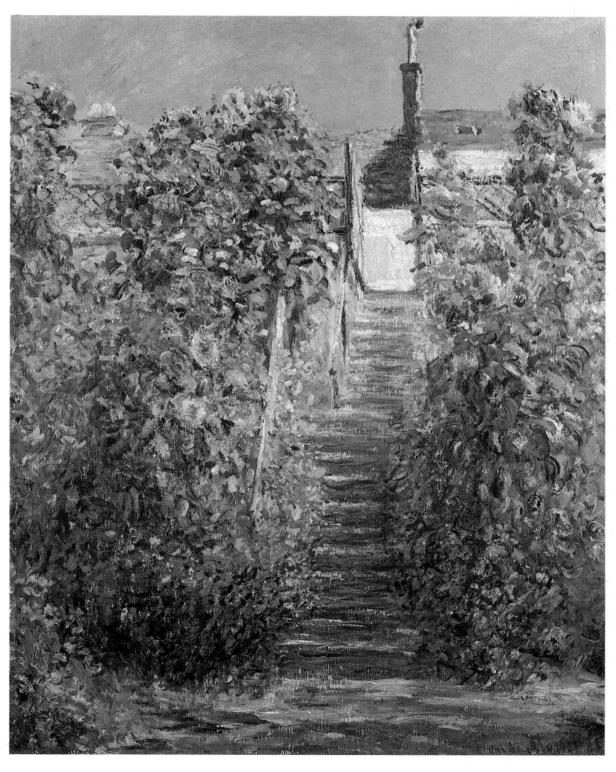

SUNFLOWERS

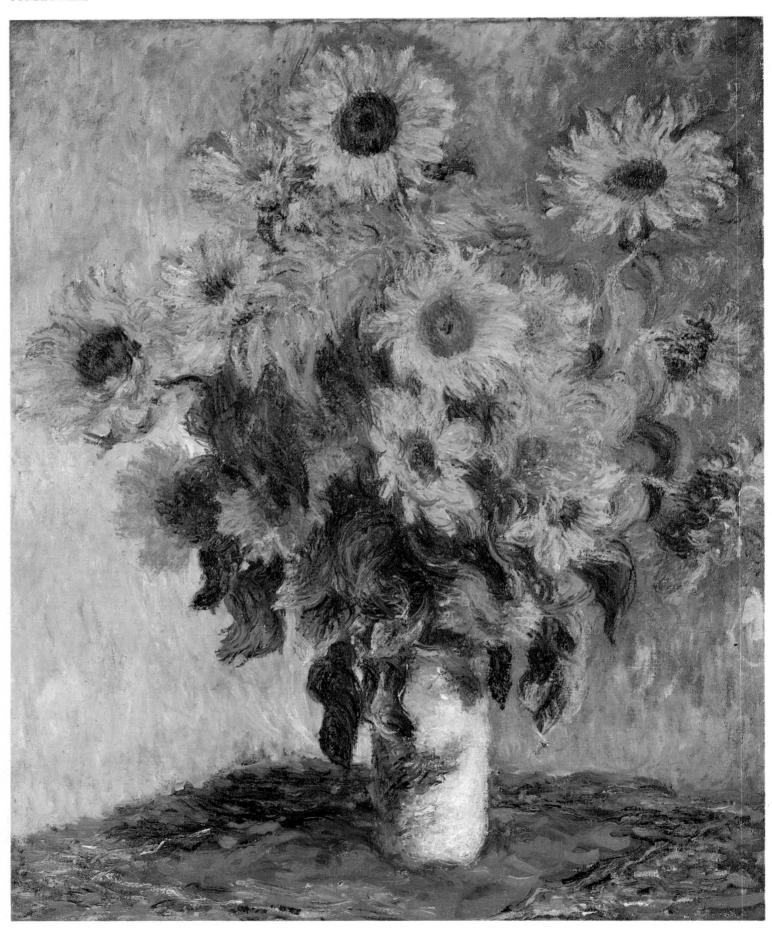

VASE OF FLOWERS

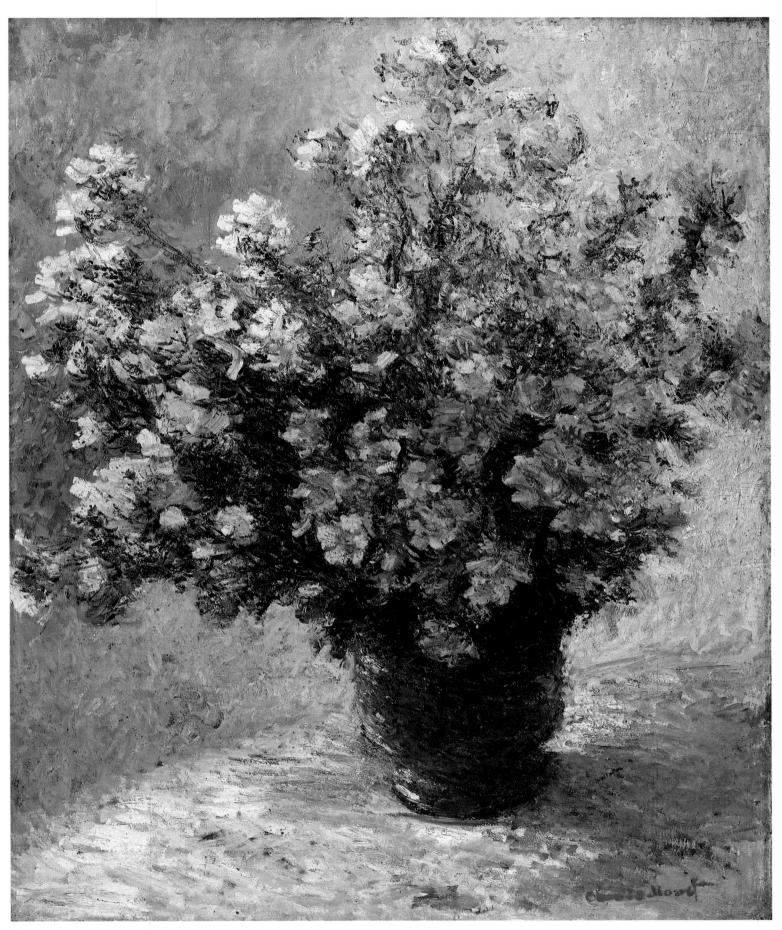

The character of Monet's correspondence in the 1880s differs markedly from that of his earlier career, reflecting a number of profound changes in his domestic and professional circumstances. Many of his letters took on a businesslike manner, as he negotiated with picture-dealers over the price of his paintings or with exhibition organizers over the availability of new work. Throughout this decade, Monet became even more active in the promotion of his own interests, developing exceptionally close links with dealers like Paul Durand-Ruel and attempting to open up new markets for his work. After his early involvement with the Impressionist group, Monet chose to participate in only one of their last four exhibitions, preferring to exhibit by himself or in the company of carefully selected colleagues. In 1880 he had a small show of his pictures on the premises of the periodical La Vie Moderne, and three years later Durand-Ruel arranged the first retrospective of Monet's work in his Paris gallery. It is clear from his letters that Monet actively pursued a number of picture-dealers at the same time, and was probably able to benefit from the rivalry that existed between them. At the end of the decade, at the gallery of Georges Petit, the artist shared an exhibition with the most distinguished and controversial sculptor of the day, Auguste Rodin. The success of this exhibition and Monet's increased ability to dictate terms to dealers and collectors both point to a new era of financial independence after almost thirty years of struggle.

Among the reasons for Monet's energetic intervention in the picture market was the need to finance his long painting expeditions and to support his newly extended household. In 1883 Monet and his two sons moved with Alice Hoschedé and her six children into a rented house at Giverny, a village on the banks of the Seine. Here their combined families were to live for many years. Ernest Hoschedé, Alice's husband, had effectively abandoned his family, but it was not until after his death in 1891 that Monet was able to regularize the situation by marrying Alice. The new domestic relationship brought a measure of stability into the artist's life, but Alice seems never to have reconciled herself to Monet's regular painting trips. Fortunately for posterity, Alice preserved all the letters the artist wrote while he was away, providing an unusually rich source of information about their relationship and his own travels. Monet's great affection for his new companion comes through in most of this correspondence, as does their mutual need for reassurance and the artist's occasional bursts of irascibility. Above all, it is Monet's preoccupation with the activity of painting that dominates the letters, as he describes an exhilarating encounter with a new stretch of landscape or the discovery of a new subject for a picture. Often this initial optimism became tempered and then bitterly regretted when the weather conditions changed or a particular quality of light failed to reappear, reminding us that Monet's most tranquil pictures frequently arose out of failure and frustration.

Almost every year between 1880 and 1890 Monet spent several months away from home, usually resident in a single location and typically painting a series of variants on a few local motifs or subjects. His travel took him to Normandy and Brittany, to the Mediterranean coast and to the River Creuse in central France, a wide variety of terrain that has in common only one element, that of water. After two decades of painting the tones and textures of the River Seine, Monet was now drawn obsessively to the sea, delighting in the variety of its colouring and the intensity of its moods. At the beginning of the decade he favoured the haunts of his childhood, visiting Fécamp, Pourville, Varengeville and Etretat on the Channel coast. Writing home to Alice almost daily, Monet described the problems of painting on a windswept beach or an exposed clifftop, reflecting his new fascination with the wilder aspects of nature. As the years went by, he travelled to less familiar territory, luxuriating in the brilliant colours of the French Riviera and braving the jagged rocks of Belle-

Île, an island off the coast of Brittany. Each site offered new challenges, both practical and artistic. At Belle-Île he complained that his lodgings were over a pigsty and that he lived on nothing but fish and lobster, and one letter to Alice recounts his 'efforts to work in a dark register and express the sinister and tragic quality of the place'. Other letters show how ambitious and demanding Monet's landscape painting had now become, as he insisted on familiarizing himself with the subject, painting it in all weathers and conveying something of his own feelings in the presence of nature.

Monet's painting expeditions allowed him to work intensively and uninterruptedly on a limited number of motifs, concentrating his attention on the qualities of the subject and the challenges it created for his art. His correspondence shows him increasingly obsessed by subtle shifts in daylight and weather, learning to carry with him more than a dozen canvases so that he could work on them in rapid succession as the light changed. The paintings themselves show the effects of this demanding process, often having densely worked surfaces and jewel-like encrustations of colour. Even their compositions suggest a visual confrontation, as the viewer is made to peer down from a clifftop or into the depths of a river or rock-pool. The intensity of Monet's visual experience becomes an insistent theme in the paintings of the 1880s, placing new demands on his technique and on his working procedures. The first-hand perception of nature was still his starting point, but there are signs that the unrefined canvases he brought back from his journeys were 'tidied up' or 'finished' (as the artist described it in his letters) in his Giverny studio.

In a short letter written to Durand-Ruel in June 1883, soon after his family had moved to Giverny, Monet unwittingly summarized a number of the preoccupations of his middle years. The letter opens and closes with a plea for money, reminding the dealer that 'peace of mind is a prerequisite for good work'; almost prophetically, Monet announces that he has been spending time on his new garden, 'as I want to have some flowers to paint when the weather's bad'; and in explaining his failure to send Durand-Ruel any recent paintings, Monet notes that he has been making arrangements for his boats on the banks of the Seine. During the rest of the decade Monet continued to develop his garden, and he earned enough money from Durand-Ruel and others to buy the house he had been renting. In his walks and boat trips around Giverny, the artist accustomed himself to the landscape that was to occupy him for so many years, producing the first of the sun-filled canvases of local pastures and meadows. Nearer home, Monet applied himself to one of his less well-known ambitions, that of producing a series of large, outdoor figure compositions, using the numerous children of the household as his models and, in some cases, his own boats on the Seine as the setting.

1882–1890: The Sea

Dieppe, 6 February 1882

To Alice Hoschedé

... Much to my joy I've arrived to superb sunshine and you may rest assured that I'll sleep soundly after the walk I've just had. There are some fine things to do. The sea is superb, but the cliffs don't match up to those at Fécamp. Here I'll be certain to do more boats.

I'm staying at the Hotel Victoria. Hug all the children for me, best wishes to Marthe, and my best and most loving thoughts to you. Don't fail whatever happens to keep me in touch with all the news, good and bad.

Your CLAUDE MONET

*

[Dieppe], Tuesday 7 February 1882

To Alice Hoschedé

... I've had a very tiring day, I've been all over the countryside, along all the paths below and above the cliffs. I've seen some lovely things and I was helped by superb sunshine, but even so I'm afraid that I might not be able to work as well as I did at Fécamp. It has a lot to do with my set up, and it's too close to the centre of town. Anyway, tomorrow I'll do some more exploring and the day after I'll set to work and depending on how I do, I'll see whether I should stay here, or go back to Fécamp or Yport. The truth is, I don't feel at ease and I am bored. Don't fail to send me your news regularly and make sure you tell Jean to write. You didn't tell me whether the children, big and small, are better. Hug them all warmly for me, best wishes to Marthe. For you my warmest thoughts,

Your devoted CLAUDE MONET

Pourville, 15 February 1882

To Alice Hoschedé

If you only knew how much it pains me to see you suffer like this. Your letter this morning upset me so much. It arrived just as I was about to leave Dieppe and for a moment, with all my cases packed, I wondered whether I shouldn't come back to you, but I feel that above all I must bring back a lot of paintings, so I came and settled in here but had an appalling day. I wanted to go and work regardless and I've just come back soaked to the skin, and had to change out of all my clothes. I am with some good people who are delighted to have a lodger and can't do enough for me. The countryside is very beautiful and I am very sorry I did not come here earlier instead of wasting my time in Dieppe. One could not be any closer to the sea than I am, on the shingle itself, and the waves beat at the foot of the house. There is cause for concern on Sunday, since as you might know from the newspapers, the highest tide of the year is due then...

Hug everyone for me. Best wishes to Marthe.

My warmest thoughts for you; take courage,

Your CLAUDE MONET

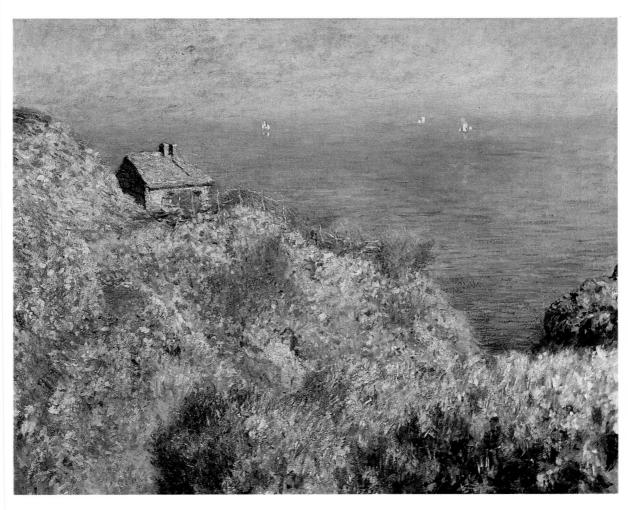

THE FISHERMAN'S HOUSE, VARENGEVILLE

[Pourville], 23 February 1882

TO PAUL DURAND-RUEL

I found your letter on my return from work, too late for me to send a telegram (there is no post office here). In any case I could not be more at a loss to know how to reply. I want above all to be agreeable to you, especially after all you have done for us, the least we can do is to help you sell our paintings. Like you, I am convinced that a well-planned exhibition at this moment would do us a lot of good, but the list of exhibitors is the most difficult matter. I have nothing personal against the three painters whom I see as having only a detrimental effect on the exhibition; but you must admit that if I accept their participation and exclude Caillebotte's, who while he may have caused an outcry, has also done a lot for the success of our exhibitions, I would deserve his severest reprimand particularly since I recently reassured him that on no account would I take part in an exhibition which would include outsiders. You must admit my position is not an easy one. One possibility, I think, if Caillebotte were to be dropped, would be to leave out one or two of the three painters you mention. If I am obliged to break with Caillebotte who is a friend of mine, then Pissarro should break with one of his. Under these conditions I would accept. Only if Renoir takes part, however, and even so, I'd want your help to sort things out with Caillebotte, and ask him on my behalf to lend a painting he has of mine which is very fine (red chrysanthemums)...

In friendship, CLAUDE MONET

1882–1890: The Sea

[Pourville], 25 March 1882

TO PAUL DURAND-RUEL

... As for myself, if you could spare me a thousand francs for the 29th I would be very grateful, having the usual obligations at the end of the month in addition to spending a lot here. I will be in Paris for Easter; between now and then I will, I hope, have finished all my paintings. I have finished a few already, but if you don't mind I would prefer to show you the whole series of studies at once, keen as I am to see them all together at home...

I'm relying on you for the 29th and send you my kindest regards.

Yours sincerely, CLAUDE MONET

*

[Pourville], Tuesday morning [4 April 1882]

To Alice Hoschedé

It was too late when I got back last night to write to you; I am writing these few lines in some haste, hoping that you will have them this evening. If I have several more days in a row like yesterday, I'll be ready by Sunday. But as it turns out the sun is hidden this morning; I am on tenterhooks as I've a lot to do. I've spent so long on some paintings that I no longer know what to think of them, and I am definitely getting harder to please; nothing satisfies me and in addition to that nature is changing so much at the moment. How lovely the countryside is becoming, and what a joy it would be for me to show you the delightful places there are to see here! In any case, we will be able to go for some good walks together along the Seine and your dear baby must accept all the good care proffered. I can see that Mimi is going from strength to strength, and I hope he will be fully fit to look around our exhibition, but I think you are being unfair when you say you find talent only in my own work, unless it's because you are blinded by the feelings you have towards me.

I received another letter from Durand-Ruel informing me that M. Gonse from the *Gazette des Beaux-Arts* wants a painting from me, but he finds those at Durand's too highly priced and he's going to write and try and twist my arm to get one for nothing.

Durand is advising me not to sell anything to him.

See you soon and be sure to hug all the children for me and tell them that the real Monet is coming back at last and everyone must be on their best form.

All my best to Marthe, my warmest thoughts for you.

Your CLAUDE MONET

*

[Pourville], 18 September 1882

TO PAUL DURAND-RUEL

You will think I am wanting in courage, but I can't hold out any longer and am in a state of utter despair. After a few days of good weather, it's raining again and once again I have had to put the studies I started to one side. It's driving me to distraction and the unfortunate thing is that I take it out on my poor paintings. I destroyed a large picture of flowers which I'd just done along with three or four paintings which I not only scraped down but slashed. This is absurd, I know, but I feel the hour of my departure drawing

near and I am witnessing a complete transformation taking place in Nature, and my courage is failing as a result, in the awareness that I have spent money in advance and have nothing to show for it. I have, in short, decided to drop everything and go back now. Please be kind enough to have some more money forwarded to me so that we can set off straight away; I'd like to be able to leave today so I wouldn't have to set eyes again on all the places I was unable to paint...

Your sincere but unhappy CLAUDE MONET

*

[Poissy], 10 November 1882

TO PAUL DURAND-RUEL

... Following the conversation we had at your place the other day with Sisley, he sent me a letter which I found on my return, informing me of what he must also have told you, and asking me to think it over and give him my answer.

I have just written to tell him what I think, and I am not entirely of his opinion. My belief is that with the collective exhibitions we have always held and too often repeated, we will finish up with public curiosity satiated and the Press still against us. I do, however, agree with him about one-man shows: if each of us were to do our own show in turn it would go on for ever; we will have to come to a decision, and it is above all up to you to decide what you think best for your own interests which are also our own. I will, for my part, do whatever you suggest, even though I really dread exhibitions when not sufficiently prepared for them, as is my case. In short, what I've suggested to Sisley is this: to hold two exhibitions this winter, one of landscapes and the other of Renoir or Degas. Should he not want to be the first in line, I am willing to begin if that's your wish, or if on the other hand he would prefer to be first, so be it. The main thing is that we all agree first and foremost as to the nature of the exhibition, weighing up the pros and cons of each system; and without wishing to impose my own view of the matter, I believe that a one-man show would be far more beneficial for everyone concerned than a joint exhibition, particularly in the venue available which is small and intimate and where some rooms would have to be set aside . . .

A word in reply, and believe me

Yours sincerely, CLAUDE MONET

*

[Poissy] 7 December 1882

TO PAUL DURAND-RUEL

I promised to bring you a few paintings this week, but I had not reckoned with the Seine flooding. For the moment I'm no painter but a life saver, rower, removal man etc. We are literally in the water, surrounded by water on all sides, and the house can only be reached by boat; we had to take refuge on the first floor but the water is still rising and where will all this end? It's quite frightening. And if we were forced to move I don't know how we would manage. Painting is out of the question, yet there would be some very curious things to do, but my presence is a continual help in the house, our terrified servants having left us in the lurch. I must admit our situation is a curious one; you'd have to see it to understand.

Regards,

Yours sincerely, CLAUDE MONET

1882–1890: The Sea

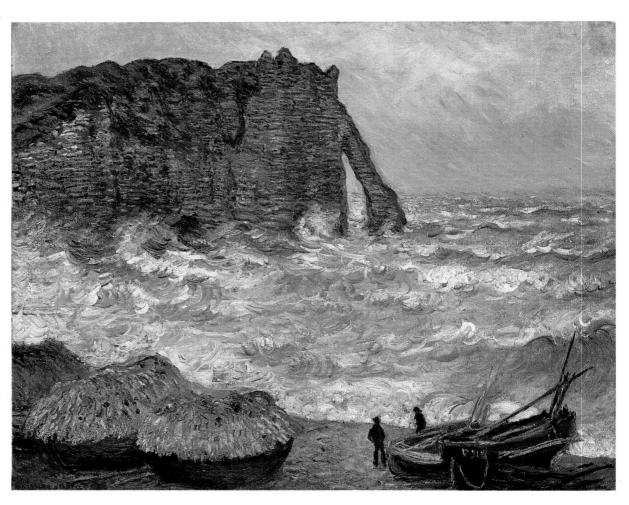

ETRETAT, ROUGH SEA

Etretat, 1 February [1883]

To Alice Hoschedé

... I've done an excellent day's work today, I'm very happy and what's more the weather is superb even though a little cold. I intend to do a large painting of the cliff at Etretat, although it is terribly bold of me to do so after Courbet has painted it so admirably, but I will try to do it in a different way...

Your CLAUDE MONET

*

Etretat, 2 February 1883

To Alice Hoschedé

... It makes me miserable to know that you are unhappy and while I understand your anxiety I'd like to see you less downcast. It is absolutely essential that you see Hoschedé whatever you do, the longer it drags on the harder it will be for you to confront it, unless you prefer to leave it to chance, since there is no doubt that April will come round and he'll probably be at Vétheuil, perhaps without having visited you yet, but I'm sure that there must be a way of drawing him out of there to have a serious and reasonable discussion.

As for myself, you need have no fears, I think of you constantly, you can be sure of my love, be brave, I won't be long, I am working as hard as I can, as I told you yesterday, I am very happy to be here and I hope to come up with something good, in any case I will bring lots of studies back with me so I can work on some big things at home. Today it looks like the weather's going to be very bad, a gale possibly, but luckily I have a shelter to go to . . .

Your CLAUDE MONET

1882–1890: The Sea

Etretat, 19 February [1883]

To Alice Hoschedé

Forgive me for having tormented you with my telegram, but for several days now I've been in such a state that I'm quite overwhelmed by it and feel I'm going mad. I feel very strongly that I love you more than you imagine, more than I thought possible. You have no idea what I've been through since Sunday morning, the degree of anxiety I was in to have some news; so you can imagine how I felt when I received your four lines this morning which no doubt tell me more than four detailed pages would have done. I have read and reread each line twenty times over; my eyes are swimming with tears; can it really be so? Must I get used to the idea of living without you? I know well enough that I can do nothing and must say nothing to come in the way of the decision you made yesterday, I'll have to resign myself to it, having no right whatsoever to do otherwise, but I am so very, very sad. Nothing means anything to me anymore. I couldn't care less if my paintings are good or bad. The exhibition is the least of my concerns, those four lines were a terrible blow to me and I am struck down. In your telegram you tell me to come right away; do you mean you want to leave me right away? What in heaven's name have people been saying to you, for you to be so resolved?...

Your CLAUDE MONET

*

[Poissy], 7 March 1883

TO PAUL DURAND-RUEL

If you can manage it I'd be very grateful if you could send me a little money *straight away* as I am in a very embarrassing financial position and cannot wait. I am not particularly keen to go to Paris for the moment as I would only be confronted by my failure and hear it being talked about, either with delight or with concern. I prefer to stay put and keep my worries to myself, and it's no use your trying to raise my spirits, I don't see things the way you do, and I have no doubt that this fatal exhibition was a step in the wrong direction. You must realize that if we have to rely only on people of taste, it would take an eternity, and one might as well give up; you only have to see what little progress we have made since we first took a stand. I don't doubt that subsequent exhibitions will be more profitable for you; my friends will have the advantage of having learnt from the experiment made at my expense, anyway I hope so, for your sake and for theirs. As for myself, this new and unfamiliar indifference has affected me deeply. When we were attacked and even vilified in the newspapers we could always comfort ourselves with the thought that it was all a measure of our worth since no one would have bothered about us if that weren't the case. So how should this silence be interpreted?

You musn't imagine that I want to see my name in the newspapers. I really am above all that and I couldn't care in the least about what the Press and so-called art critics think, since they rival each other in their stupidity. Indeed, it doesn't affect the artistic side of things at all, I know my worth, and am harder on myself than anyone else could be. But things have to be looked at from the commercial angle. And we'd be blind not to see the truth staring us in the face, not to recognize that the exhibition was ill-prepared and poorly advertised . . .

Yours sincerely, CLAUDE MONET

Villa Saint-Louis, Poissy, 21 March [1883]

To A Journalist

It is only now that I have read the kind article you wrote on my exhibition, published in the *Journal de Paris*.

Allow me to express my rather belated thanks. I am doubly grateful since very few of the critics have the courage to defend me, or at least to write what they think. But as you say so rightly, people must first of all learn to look at nature, and only then may they see and understand what we are trying to do.

Very many thanks and my compliments to you.

Yours sincerely, CLAUDE MONET

*

[Poissy], Sunday morning, 29 April [1883]

TO PAUL DURAND-RUEL

We are still in the throes of moving house. In the past week I've experienced every kind of difficulty imaginable. Anyway, I'm setting off for Giverny this morning with some of my children. We are so short of money, however, that Madame Hoschedé must remain here though she has to leave the house by ten o'clock tomorrow at the latest. So I am writing to ask if you could provide the carrier with one or two hundred francs, whatever you can manage, and if you could send the same amount directly to me at *Giverny*, near Vernon, Eure, as we won't have a sou when we get there. I am counting on you...

My thanks in advance,

Yours, CLAUDE MONET

*

Giverny, 1 May [1883]

TO PAUL DURAND-RUEL

I have just learnt the terrible news that our poor Manet is dead. His brother is counting on me to be a pall-bearer. I must be in Paris by tomorrow evening and be fitted for a suit of mourning. If my letter does not cross with one from you containing some money, I depend on your being so kind as to send me a postal order to Giverny, payable at Vernon. I am counting on you.

Yours sincerely, CLAUDE MONET

*

[Giverny], 5 June 1883

TO PAUL DURAND-RUEL

I am writing to acknowledge receipt of your remittance for 200 francs. Please, I beg of you, send me a bigger sum tomorrow without fail. I do not know where to begin with sums as small as this.

I had to have a shed made on the bank of the Seine to shelter my boats and store my easels and canvases. The work is done and I must settle up so I am counting on your promise . . . As soon as I have something worthy I'll send it to you. Now at last I'll be able to

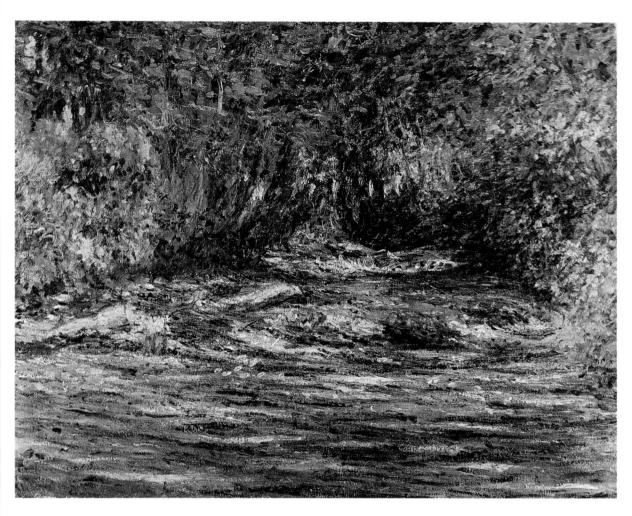

THE RIVER EPTE, AT GIVERNY

concentrate on my painting, as I was very put out with organizing my boats: as the Seine is not very close to the house they had to be made secure, then the garden took up some of my time as I want to have some flowers to paint when the weather's bad.

Now all this is done, I won't lay aside my brushes any more and I'll provide you with some things to please you.

Meanwhile, I must ask you not to forget me, for peace of mind is a prerequisite for good work.

Yours sincerely, CLAUDE MONET

Giverny, 27 July 1883

TO PAUL DURAND-RUEL

I am sending a crate to Vernon this evening for delivery to you tomorrow containing seven pictures, details of which I enclose. You have had to wait a little, but all I can say is that while adding the finishing touches to a painting might appear insignificant it is much harder to do than one might suppose, and I had a lot of problems. Anyway I hope you'll be satisfied with what I send. I took your advice and managed to make some quite good things out of paintings I considered irredeemable. I'd have liked to have sent you something from here but the weather hasn't been fine enough. In a week or ten days' time I'll send you some more paintings. I'm instructing my art supplier to deliver some fresh canvases; would you be so kind as to put them into my crate and return it to me as soon as possible, addressing it to me via the station at Vernon . . . I am counting on having some money from you by Saturday, tomorrow, that is.

Regards from yours sincerely, CLAUDE MONET

Giverny [12 January 1884]

TO PAUL DURAND-RUEL

which I will pick up when in Paris, since I've decided to leave for Italy straight away. I want to spend a month in Bordighera, one of the most beautiful places we saw on our trip. From there I have great hopes of bringing you a whole new series of things.

But I would ask you not to mention this trip to *anyone*, not because I want to make a secret of it, but because I insist upon *doing it alone*. Much as I enjoyed making the trip there with Renoir as a tourist, I'd find it hard to work there together. I have always worked better alone and from my own impressions. So keep the secret until otherwise instructed. If he knew I was about to go, Renoir would doubtless want to join me and that would be equally disastrous for both of us. You will agree with me I'm sure. So till Wednesday or Thursday morning then, at the latest, and in the meantime, send me 300 [francs]. Thank you in advance.

Yours sincerely, CLAUDE MONET

*

Bordighera, 24 January 1884

To Alice Hoschedé

At lunchtime today I received your letter dated Tuesday the 22nd, from the day before yesterday that is. It is some consolation to know that by now you must have received several letters from me, and since I never let a day go by without writing to you, you will thus have one every day.

I'm hard at work with four paintings under way; it's now a matter of finishing them and doing four more and so on. The weather is still magnificent, although today there were a few clouds about and tonight the sea is raging despite a clear, star-studded sky.

The locals would be glad of some rain; it hasn't rained at all since September; let's hope that their prayers won't be answered until I leave.

I'm not at all surprised at what you say about your tiredness, since it's easy to get used to not going for walks, but you must get back to it all the same and make a habit of what really is the best thing about living in the country. Mine is a dog's life and I never stop walking; I walk here, there and everywhere. As a break between studies, I go on explorations down every path I find, always on the look-out for something new; so by dusk I've had it. I dine well (and am actually thankful I came to an English *pension*), I have my little chat with you as usual, I climb into bed and, crossing my hands, I ruminate on Giverny, and my eyes dwell on the paintings on the wall, then after a little reading I'm off, sound asleep for the night.

Your CLAUDE MONET

*

Bordighera, 26 January 1884

To Alice Hoschedé

... Today I worked even harder: five canvases and tomorrow I intend to begin on a sixth. So things are progressing quite well, although it's hardgoing: those palm trees make me curse and swear; and the motifs are terribly hard to get hold of and put down on canvas; everywhere is so luxuriant; it's gorgeous to behold. You could walk on for ever under palms, orange and lemon trees and also under the splendid olive trees, but things are not so easy when you're looking for motifs. I'd like to paint some orange and lemon trees standing out against the blue sea, but can't manage to find any the way I want them.

As for the blue of the sea and the sky, it's beyond me. I am hoping for good news tomorrow, a nice letter with no reproaches.

Till tomorrow then; I send my most loving thoughts to you and kisses to share out among everyone; to Marthe, best wishes.

Your, I say 'your' because it's the truth, CLAUDE MONET

*

Bordighera, 29 January [1884]

To Alice Hoschedé

... We're having marvellous weather and I wish I could send you a little of the sunshine. I am slaving away on six paintings a day. I'm giving myself a hard time over it as I haven't yet managed to capture the colour of this landscape; there are moments when I'm appalled at the colours I'm having to use, I'm afraid what I'm doing is just dreadful and yet I really am understating it; the light is simply terrifying. I have already spent six sessions on some studies, but it's all so new to me that I can't quite bring them off; however the joy of it here is that each day I can return to the same effect, so it's possible to track down and do battle with an effect. That's why I'm working so feverishly and I always look forward to the morrow to see if I can't do better next time.

Bordighera, 3 February 1884

To Alice Hoschedé

... I'm still slaving away, very absorbed in what I'm doing and very content with myself; I've made some progress and my early paintings look pretty poor alongside my latest efforts. Now I really feel the landscape, I can be bold and include every tone of pink and blue: it's enchanting, it's delicious, and I hope it will please you. Today was incomparably calm and hot. I do hope you have some good weather at Giverny so you can go for walks and have a bit of fun with the children. How I yearn to see and hug them! And how I long for you! What a joy it would be after a good day's work like today, to have the chance to talk properly and not have to rely on the post which takes four or five days to bring you the replies you long for! Still we must be patient, we'll make up for it eventually.

Lots of kisses to everyone, best wishes to Marthe and my very best to you.

Your CLAUDE MONET

Bordighera, 3 March 1884

To Alice Hoschedé

Your letter does a little to restore my hope: I wish you'd love me as I love you, while being a little more reasonable about it. Yesterday I was quite overcome as you will have seen from my letter which I now regret having sent, but I really did not know what to think; I'll be reduced to weighing up every word I say. Your letter today is reassuring, despite your unhappiness; all the same you can be unhappy and not look on the black side of things; the idea that we should no longer see each other, no longer love each other, doesn't bear thinking about, but you musn't hide such notions from me either; I want to know everything, but I do wish you could be a little more reasonable.

The weather is marvellous and I'm working well. You know I'm increasingly hard on myself, but I don't think I'll be too discontented when I look at all these paintings at home. I've put a lot of effort into them and this must bear fruit. If I said I was wrong to come here it was because things didn't come easily to start with, and if there's one thing that I find hard to come to terms with, it's that all but two or three of my paintings have no sea in them and the sea is very much my element. That is why I want to do two or three motifs in Menton along the seashore. Here, it wouldn't fit in with the landscape which has other charms: but all my studies are making good progress and I might not be as long as you suppose...

Now my dearest, we must say goodbye until tomorrow; loving kisses to you and the children, best wishes to Marthe; till tomorrow.

Your CLAUDE MONET

*

Bordighera, 5 March 1884

To Alice Hoschedé

That's better, I am glad to see that you're being a little braver now, it gives me heart; and the weather has been so marvellous these past few days that my work is beginning to show it: I'm having more success in capturing that wonderful pink light, as I see it every day morning and evening; it's glorious, just perfect and more beautiful by the day. My studies are going well, they are all progressing and looking better these last few days. I'm glad to know that you were able to get out a little, but it's upsetting to think of you being so cold, while here it is so hot that the flowers are charmed out of the ground. You saw the anemones I sent you on your birthday, the roses and red carnations; they are everywhere to be found, growing wild; my little Italian boy who carries my baggage makes enormous bunches of them and masses of other flowers while I work. How happy we'd be here and what a pretty garden we would have . . .

A most extraordinary pink tone predominates here, which is impossible to convey, the mornings are peerless. I'm painting now with the Italian paints I had to order from Turin. Apart from that I've run out of canvases, shoes, socks, and even decent clothes and I'll look in a sorry state when I get home; my clothes have faded in the sun, so the only gallant thing will be yours truly, though there are times when I'm exhausted by the work, the never-ending battle. What a delight it will be to rest by your side.

Your CLAUDE MONET

>

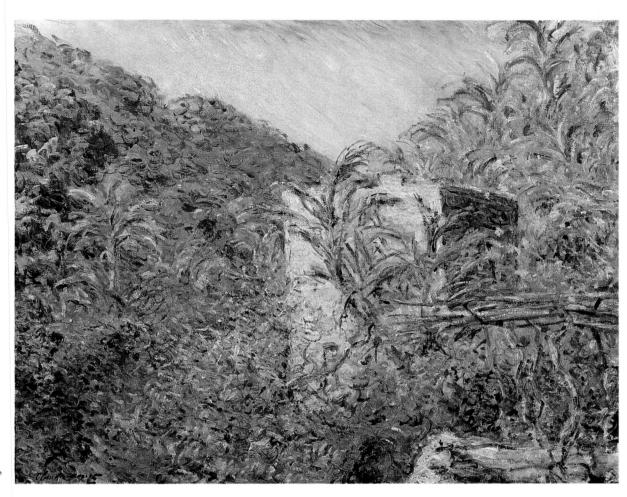

VALLÉE DE SASSO, SUNSHINE

Bordighera, Monday evening [10 March 1884]

To Alice Hoschedé

I've been working non-stop today right up to 6 o'clock this evening, and took only an hour off for lunch, but I worked well and am very satisfied with what I've done today; what a lot of daubs I did in the beginning, but now I've caught this magical landscape and it's the enchantment of it that I'm so keen to render. Of course lots of people will protest that it's quite unreal and that I'm out of my mind, but that's just too bad, anyway that's what they say when I paint our part of the world...

Your CLAUDE MONET

*

[Bordighera], 21 March 1884

To Alice Hoschedé

... You have no idea how keen I am to leave. I am exhausted and you know how hard I work once I've got going. A task like this is possible for a month but for more than two it's murderous, and I can't go on like this, but all the same things are moving. It was very fine today and I finished another painting; I must finish one each day as things stand, besides I'm longing to be with you. You can't imagine how much I am looking forward to coming back; to share things with you again, talk and see you all, this will be reward enough for my labours, and with our troubles behind us, my paintings will seem very much better away from the pitiless light here and there's no question that there are some good ones among the group . . .

Your CLAUDE MONET

Giverny, Sunday [27 April 1884]

TO PAUL DURAND-RUEL

I will come as you wish tomorrow morning but with a very few paintings and only because I don't want to offend you, since every single one of my paintings is in need of some kind of revision and the finishing touches must be done with care, and this will mean much more than a day's work. I need to look over it all in peace and quiet, in the right conditions. For three months I've been at work and have spared no efforts and as I'm never satisfied when working from nature, it's only since I've been here these last few days that I've seen what can be done with a certain number of the paintings I did. You have to understand that out of the large number of studies I executed, not all are ready for sale, a few, I think, could be very good, and others, even if a little vague, may turn out well if the finishing touches are done with care, but I must emphasize that this cannot be done overnight and it would not be in your interest or in mine to go ahead and exhibit them regardless; my aim is to give you only the things with which I am completely satisfied, even if it means asking you a little more for them. I hope you'll understand that, for if I were to do otherwise I'd turn into a mere painting machine and you would be landed with a pile of incomplete work which would put off the most enthusiastic of art collectors . . .

So until tomorrow then,

Yours sincerely, CLAUDE MONET

[Paris], Wednesday morning [7 May 1884]

TO PAUL DURAND-RUEL

I must confess that this situation is making me desperate, and I'm writing to ask you to give me a frank reply, since I cannot hold out any longer in this state of uncertainty.

I have done everything I possibly could do to obtain money in order not to have to call upon you at such a time, all to no avail, despite my need being pressing. I can't go back home without money. This morning I had some very bad news from Giverny, so I'm expected there urgently, but I don't want to go back with empty pockets. So here I remain, without a sou, wasting valuable time, and obliged to avoid people's awkward questions which are scarcely reassuring . . .

You mustn't think that I have no faith in you. On the contrary, I know what courage and energy you have, but I don't trust anyone else an inch. So tell me plainly what the situation is, are you certain to be able to provide me with money today? If you absolutely can't manage it I will go back to my old job of chasing up collectors, if they now want my paintings that is, and I have my doubts about that...

Yours, CLAUDE MONET

Etretat, 15 [October 1885]

To Alice Hoschedé

...I'm still working in spite of the persistent bad weather. This morning, for the first time since you left, the sun appeared in all its radiance and the sea was calm; it was magnificent and everyone thought the weather would take a turn for the better, but the wind changed without warning and it started raining again, but I carry on working regardless, making use of my various windows. Yesterday I spent the evening with Maupassant, a very likeable and interesting man: he's going to be doing the next Salon in the République française . . .

Your CLAUDE MONET

*

[*Etretat*], 20 October, 6 pm [1885]

To Alice Hoschedé

... Etretat is becoming more and more amazing; it's at its best now, the beach with all these fine boats, it's superb and I rage at my inability to express it all better. You'd need to use both hands and cover hundreds of canvases...

*

Etretat, 27 October 1885

To Camille Pissarro

For some while now I've been meaning to write to ask for your news and give you mine, but you know what it's like when you're working outside all the time, by nightfall you're tired and feel too indolent to write.

I had no idea I'd stay here for such a length of time, but I've been so poorly favoured with the weather and it's damned hard to bring anything off.

It was not much use getting something down on canvas for every kind of weather, I can't get to the end of it all now. Added to this, there are the changes in the tides and the boats which never stay put, in short I can see I'll be here for some while yet if I want this visit to be worthwhile; so I won't be able to join you all at the next dinner. Would you kindly apologize for my absence to all our friends and send my best wishes? What are you up to yourself, and what about Renoir, Cézanne, Sisley, Durand, business and so on? It would be kind of you to let me know a little of what's going on . . .

Kindest regards to your wife and to Lucien.

Best wishes from your old friend, CLAUDE MONET

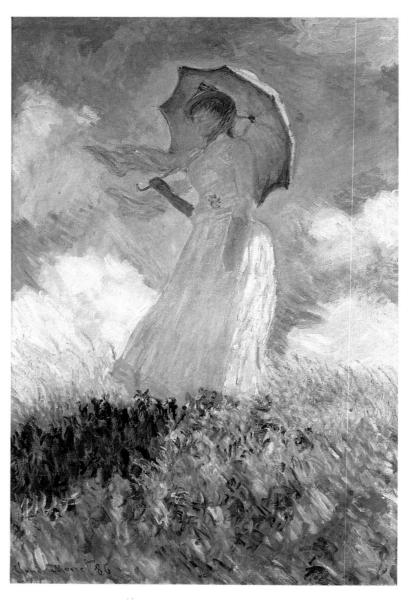

WOMAN WITH A PARASOL

Etretat, 5 November 1885

TO PAUL DURAND-RUEL

Your silence is worrying, and it's causing me a good deal of hardship as I have no money to speak of, especially since neither Madame Hoschedé nor I received the 200 francs due to each of us last Saturday.

I'm quite sure that your silence is not a good sign, for although I scarcely look at the papers here, I did learn that you were mixed up in some business of fakes and that people were using that as an added excuse to come down on you. All this is a great torment to me, and I fret all the more as I am so cut off. On top of that my work is not advancing at all well; the weather is appalling and others might have given up long ago, but I am reluctant to lose what I've started. A few days of fine weather would, I know, enable me to turn at least one group of paintings to account. I'm staying on in that hope . . .

Yours sincerely, CLAUDE MONET

[Etretat], Monday evening [9 November 1885]

To Alice Hoschedé

How odd it is that while I think of you with such affection and try and show it to you as well as I am able, your thoughts are always at their blackest. I expect you any day and then you tell me that I'd rather come home than have a visit from you; it's too bad. I'd like both, and that's the truth. As things stand you can trust in no one but me; well, stop worrying your head about the rest then! It's a hard lesson, but that's how it is and you know it.

You say that making savings is all you think about, but you can't seem to manage to. You have to manage though, and you musn't count on having anything other than what we've got already, nothing more for the time being. Now take it from me that if your children are brought up simply with not too many frills, they'll be the better for it, and more appreciated and that goes for you too, and it's quite possible to be happy in such circumstances...

Now take courage and cheer up or I'll get upset; many kisses to the children and all my love.

Your CLAUDE MONET

*

[Etretat], Friday evening [27 November 1885]

To Alice Hoschedé

After another rainy morning I was glad to find the weather slightly improved: despite a high wind blowing and a rough sea, or rather, because of it, I hoped for a fruitful session at the Manneporte; however an accident befell me. Don't alarm yourself now, I am safe and sound since I'm writing to you, although you nearly had no news and I would never have seen you again. I was hard at work beneath the cliff, well sheltered from the wind, in the spot which you visited with me; convinced that the tide was drawing out I took no notice of the waves which came and fell a few feet away from me. In short, absorbed as I was, I didn't see a huge wave coming; it threw me against the cliff and I was tossed about in its wake along with all my materials! My immediate thought was that I was done for, as the water dragged me down, but in the end I managed to clamber out on all fours, but Lord, what a state I was in! My boots, my thick stockings and my coat were soaked through; the palette which I had kept a grip on had been knocked over my face and my beard was covered in blue, vellow etc. But anyway, now the excitement is passed and no harm's done, the worst of it was that I lost my painting which was very soon broken up, along with my easel, bag etc. Impossible to fish anything out. Besides, everything was torn to shreds by the sea, that 'old hag' as your sister calls her. Anyway, I was lucky to escape, but how I raged when I found once I'd changed that I couldn't work, and when it dawned on me that the painting which I had been counting on was done for, I was furious. Immediately I set about telegraphing Troisgros to send me what's missing and an easel will be ready for tomorrow . . .

I send you all my love and hug all the children for me, remember me to Marthe. To think I might never have seen you again.

Your CLAUDE MONET

Giverny, 22 January 1886

TO PAUL DURAND-RUEL

L ... I have looked at all my paintings and it's no use, there aren't any, as far as I can see, which could be said to be finished and good as they are: no doubt there are some interesting ones but they're too unfinished for the average collector. But do you really need quite so many paintings for America? Surely you already have a fair number? You do, it's true, keep them cleverly hidden, since they're never on display, which in my opinion is a mistake: what's the point of us painting pictures if the public never gets to see them?

It's not that I don't want to give you any — there would be some I could give you, and I wouldn't be angry if you actually displayed them. You think only of America, while here we are forgotten, since every new painting you get you hide away. Look at my paintings of Italy which have a special place among all I've done; who has seen them and what has become of them? If you take them away to America it will be I who lose out over here.

Anyway, you doubtless have your reasons, but I deplore the disappearance of all my paintings like this.

Yours sincerely, CLAUDE MONET

*

[Etretat], Monday evening [22 February 1886]

To Alice Hoschedé

You ask me to think things over and come to a decision: but that is, alas, just why I am in the state I am in. It's no use me weighing things up for and against since, unlike you, I find it impossible to get used to the idea of a separation: I think of the children whom you love and who love you, but I can also see everything that is coming between us and this will increasingly divide our life together, which I thought was to be so enjoyable. Anyway, enough of that, I'm very unhappy, really miserable and I haven't the heart to do anything; the painter in me is dead, a sick mind is all that remains of me and if you think that once I've made up my mind to go it alone I'll feel better, you are very much mistaken! I had a terrible night, thinking of you constantly and seeing you so clearly, and I hadn't the courage to get out of bed until 10 o'clock...

Your unfortunate MONET

*

Giverny, 5 April 1886

TO EMILE ZOLA

How kind of you to send me *L'Oeuvre*. Thank you very much. I always find it a great pleasure to read your books and this interested me all the more since it raises questions to do with art for which we have struggled for so many years. I have just finished reading it and I have to confess that it left me perplexed and somewhat anxious.

You took great care to avoid any resemblance between us and your characters; all the same I am very much afraid that enemies in the Press and among the general public will bandy about the name of Manet, or at least our names, and equate them with failure, which I'm sure was not

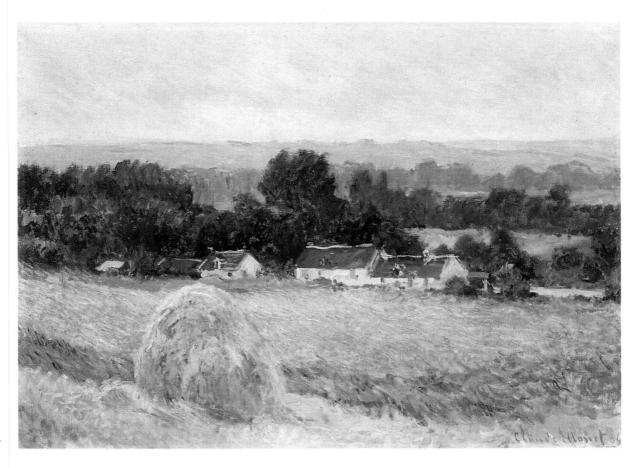

HAYSTACK AT GIVERN

your intention. Forgive me for mentioning it. I don't intend it as a criticism; I read *L'Oeuvre* with a great deal of pleasure, and every page recalled some fond memory. You must know, moreover, what a fan I am of yours and how much I admire you. It is not that. My battle has been a long one, and my worry is that, just as we reach our goal, this book will be used by our enemies to deal us a final blow. Forgive me for rambling on, remember me to Madame Zola and thank you again,

Yours sincerely, CLAUDE MONET

*

Giverny, 26 April 1886

TO PAUL DURAND-RUEL

It has now been a month since you left and I've had no word from you, or any money from your son. I have no idea how you imagine I survive, and your indifference continues to amaze me and is more than worrying, for assuming that you are successful over there, what would happen if, back in Paris, I were forced to revert to the practice of selling my work for next to nothing? What a waste of all the time and effort! I don't know what to think, but you are very well aware how keen I am to know how business is doing. To cap it all, it has come to my knowledge (and it was reported to me with much relish) that before you left, you sold some pictures of mine at the lowest possible prices, notably to a M. Blanche.

Anyway all this is very upsetting and, given the situation, don't be surprised if I accept any offers that come my way, since I can't live on nothing and go further into debt...

Yours sincerely, but very unhappily, CLAUDE MONET

Giverny [Late July-early August 1886]

TO BERTHE MORISOT

It was so kind of you to think of me and I hope you'll forgive me for not having written sooner, but I've had to make several trips to Paris which has been a great nuisance. You are right, I am pleased with the exhibition, and I was very sorry you weren't able to come as I'd have liked to have had your opinion of it.

I'm not sure if I should call it a success, but it has all the appearances of one if sales are anything to go by; everything on display was sold for a good price to decent people. It has been a long time since I believed that you could educate public taste and it would be asking too much to want to sell only to connoisseurs — that way starvation lies.

... I've done no work here as yet because of all the bother of the exhibition and I'm not sure for the moment whether I'll go off on a trip somewhere or not, although I'm very keen to go to Brittany.

Madame Hoschedé asks me to send you her best wishes, her daughter's health is not much improved.

Thank you again for your kind words, my best wishes to M. Manet.

Yours sincerely, CLAUDE MONET

[Le Palais], Tuesday evening [14 September 1886]

To Alice Hoschedé

I was so pleased to find your two excellent and kind letters waiting for me after a day spent travelling, but I am upset at the thought that you might not yet have mine: anyway you're all in good health and the children have been enjoying themselves, and I'm glad about that; it's also a relief to hear that the little ones are going to work a little more seriously now.

As for myself, I'm happier than I was, I've seen some wonderful sights and I'm going to stay on the island; I leave town tomorrow morning and will be moving into a little hamlet of eight or ten houses, near the area known as *la Mer Terrible* which is aptly named: there isn't a tree within miles, and the rocks and caves are fantastic; it's as sinister as hell, but quite superb and since I don't believe I could ever find anything like this anywhere else, I want to try and do a few paintings here; so tomorrow I set to work. I'm not quite sure how I'm going to fare, I've found a clean and sufficiently large room belonging to a fisherman who owns a small inn and he has agreed to cook for me, and all this for a charge of 4 francs a day; I imagine I'll be living on nothing much but fish, particularly lobster, since the butcher and even the baker only come once a week, anyway I can't expect the cooking to match up to that of the Café Riche . . .

Don't fail to write and tell me as much as you can, just remember how cut off I am, and tell Jean to write; hug them all warmly for me, best wishes to Marthe, my warmest thoughts and all my love to you.

[Kervilahouen, Belle Île, Morbihan], Saturday 18 September [1886]

To Alice Hoschedé

... Fortunately I'm spending very little here, so I've taken the plunge and I'm working; it's quite superb, but so different from the Channel coast that I'm having to familiarize myself with the scenery here; the sea is very beautiful, as for the rocks, they are an extraordinary combination of grottoes, outcrops and needles but as I've said, it will take time to find out how to capture all this; anyway I am having a go and putting a lot of effort into it; added to this I'm having to carry my own things, which is tiring me out. The weather is superb, but increasingly hot . . .

I was sure I'd be alone in such a remote corner of the world, but an American painter and his wife are living in a neighbouring hamlet; yesterday he came and wandered around me while I was working and ended up by asking me whether I wasn't Claude Monet ('the Prince of the Impressionists'); it was a great joy to him. He's a kind man, and in the evening we went for a walk together and tonight I'm dining at his house; so I look forward to a proper meal, since he's really quite well set up here and they have their own cook with them. It will help to make my isolation a little more bearable anyway. Evenings are deadly and despite my exhaustion I have a devil of a time getting to sleep because of the rats above my bed and a pig who lives beneath my room; you can see it and smell it from here . . .

Your CLAUDE

*

[Kervilahouen], Tuesday 21 September [1886]

To Alice Hoschedé

...I am right in the thick of work here and I want to finish three or four paintings at least; I've seven under way, but the early ones were very bad and I've abandoned them. Unfortunately the weather has now changed; there was a terrific storm last night and it's very squally, and as I still haven't got a porter, I can't carry all the canvases I need with me which means I can't work as much as I'd like...

Till tomorrow then, lots of hugs and kisses to all the children, I send you all my love.

Your CLAUDE

*

Kervilahouen, 27 September [1886]

To Alice Hoschedé

... The weather is still fine, but there's a devil of a wind which is hampering me in my task; I'm having to tie everything down, canvases and parasol. I didn't have such a good day today, I messed up a study and only realized it once I'd got back and I'm furious since the painting's ruined. Added to which, the strongest tides of the year are due now, and the sea draws out a lot and this is hindering progress on many of the studies. I will actually have to do something else for two or three days; anyway I can't complain, I've got good weather and I'm hard at it...

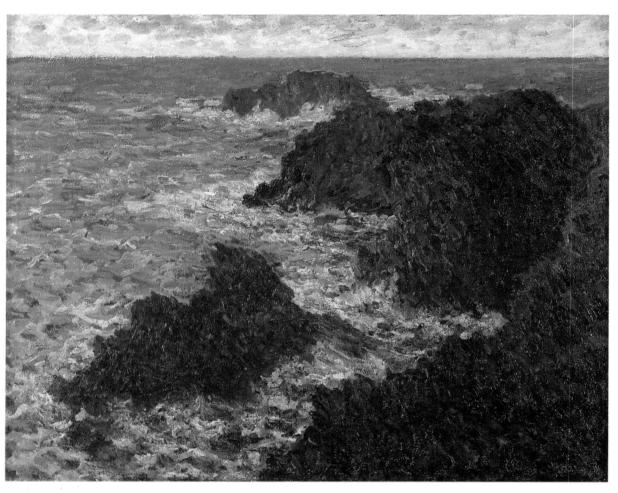

ROCKS AT BELLE ÎLE

[Kervilahouen], Friday 1 October [1886]

To Alice Hoschedé

... I have just looked over all my paintings, they're all spread out before me here (and I wish you were with me, to have your reaction); well I think I can say that I am content and if this damned weather doesn't take a turn for the worse, I'll have some good things to bring back home with me. There, I hope this will cheer you up as your letter yesterday was very depressing. I hope that my earlier letters will by now have reassured you a little . . .

*

Kervilahouen, Monday 4 October [1886]

To Alice Hoschedé

... Monsieur Geffroy, the critic, arrived here today with a friend of his, an engraver and his wife, and I had to show them my studies which met with considerable approval, but admirers like these are not as hard to please as I am: anyway I was glad, even though I haven't yet got as far as I would like: the sea is giving me a terrible time of it, it's so unlike the sea I'm used to painting, but I have hopes of achieving what I want...

Kervilahouen, Saturday 23 October [1886]

To Alice Hoschedé

You tell me in the kind and excellent letter you sent yesterday, to keep up my morale; that is indeed what I am doing, only I'll need a goodly dose of it with the weather being so changeable and each day ending in rain. This morning I was content; though there was no rain the sky was dark and threatening the way it can be sometimes, just right for several of my studies and I worked well. Two of my paintings need only one more session on them. In the afternoon the rain didn't let up, but, after waiting around for an hour I braved the elements and carried on working in the rain; wet rocks look that much darker, but perhaps it adds to the beauty of it.

I have to make tremendous efforts to work in a darker register and express the sinister and tragic quality of the place, given my natural tendency to work in light and pale tones; this is why I am very curious to know what you'll think of it. No doubt you've seen darkly painted pictures of Brittany; but the reality is quite different, it's all that is most beautiful in tone, and the sea here today set against a leaden sky was so green that I was quite unable to express its intensity . . .

Just imagine, I've covered thirty-eight canvases; seven or eight are simple sketches, it has to be said, and about the same number are pretty poor, but there are a good twenty-five to finish all together. So you see I'm not wasting my time and must persevere...

My love and kisses to you and the children, best wishes to Marthe.

Your old CLAUDE

*

[Kervilahouen], 26 October [1886]

To Alice Hoschedé

I've now got your two letters of yesterday and the day before and am glad to know you are all on such good form, but it is upsetting to hear your endless laments over household or money worries, or over *loving me too much*; come now, if we forget our temporary separation for the moment, you really have no cause for complaint. The new servants are fine, you haven't wanted for money since I left, which is quite something, and when all's said and done you're all in good form despite the children's occasional upsets.

I'm always happy when I know you're safe from money worries, and what's more I do all I can to guarantee it, but this is the best I can do for the moment; even so it upsets me to know that the little ones are in need of new clothes since they might catch something; I'm very glad to know they're being civil to each other, and I can't wait to see them; it feels like a lifetime since I left.

As to my worries over Mimi, you know very well that I have every confidence in you, but when you're far away you can't help worrying more than ever; you mustn't ever hide anything from me, though. The big lads are a devil of a problem for us; it's terribly important to keep things moving and not give them any chance of acquiring lazy habits...

... What I would like is be to be near you, that is my real wish, but we must be patient for a little while longer. It is of utmost importance that I bring off all these paintings with which I am generally very pleased, and in this I don't believe I'm deluding myself; for this very reason I mustn't lose hope. I must struggle on despite the showers. Once I've left Belle-Île, I won't be long away from you since I've already given up plans of touring Brittany...

Kervilahouen, Saturday 30 October [1886]

To Alice Hoschedé

... I'm sure that Giverny will look quite lovely with its yellow trees, once my eyes have tired of the sight of these rocks; but you know how passionate I am for the sea, and here it's particularly beautiful. With my experience and my unceasing observation I have no doubt that if I carried on for another few months I could do some excellent work here. Each day I feel I know the 'old hag' a little better, and there's no doubt it's a perfect name for the sea here, terrifying as it is; just one look at those bluey-green depths and its terrifying ways (I'm repeating myself) and you're hooked. I'm absolutely mad about it in other words: but I do know that to paint the sea really well, you need to look at it every hour of every day in the same place so that you can understand its ways in that particular spot; and this is why I am working on the same motifs over and over again, four or six times even; but I'll be able to explain all this to you much better when I see you with my paintings laid out in front of you...

Kervilahouen, Belle-Île, Morbihan, 9 November [1886]

TO PAUL DURAND-RUEL

... You ask me to send you what I have finished; nothing is finished and you know very well that I can't really judge what I've done until I look over it again at home and I always need a short break before I can put in the final touches to my paintings. I'm still working a lot, unfortunately with the constant bad weather I'm having some difficulty in finding the effects again in many of my motifs, so I'll have a lot to do once I get back to Giverny.

Yours sincerely, CLAUDE MONET

*

[Kervilahouen], Wednesday 10 November [1886]

To Alice Hoschedé

It's getting harder and harder as I want to get things finished, and to do that you need to find exactly the right effect again, which is often impossible, since each day the sun shortens its course and things aren't lit up in the same way; added to this the weather is so variable that I'd need a cart to carry all my paintings along with me; I often have to choose which ones I think I'll be working on judging from the weather, and very often, like today, for example, the weather changes on my way to the location; you can imagine my mood after that, but since I know there has to be an end to it, I am well-nigh forced to change certain paintings completely . . .

Until tomorrow then, I send you my most tender thoughts, and kisses to you and the children, best wishes to Marthe.

Your old Monet who loves you and looks forward to seeing you.

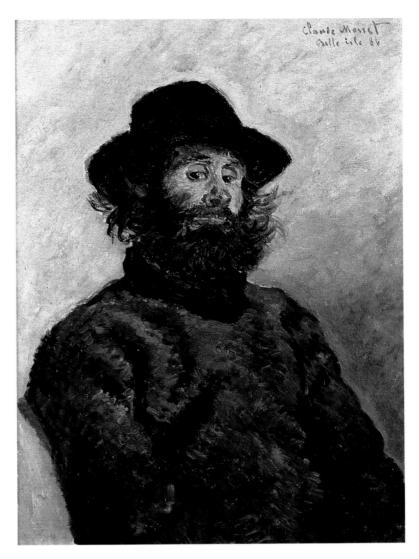

PORTRAIT OF POLY

Kervilahouen, Sunday evening, 14 November [1886]

To Alice Hoschedé

... The weather's still as bad, it's really disheartening; what's more I'm in a foul mood as I'm making stupid mistakes, I'm working desperately on my paintings, knowing full well that they are incomplete, despite my energy for the task. What weather! What can I do? I can't achieve anything. This morning I lost beyond repair a painting with which I had been happy, having done about twenty sessions on it; it had to be thoroughly scraped away; what a rage I was in! And I'm still working in the rain . . .

[Kervilahouen], Wednesday 17 November [1886]

To Alice Hoschedé

... Today was one of the worst days so far and I resolved not to go and work outside; it's the second time this has happened since I've been here. But to prevent myself falling into a bad mood I got *le père* Poly to pose for me and I did a sketch of him which is an extremely good likeness; the whole village had to come and see it, and the funny thing is everyone's congratulating him on his good fortune as they're under the impression that I did it for him, and I don't quite know how to get out of it...

Giverny, 23 April 1887

To Georges Petit

You will be aware that business with Boussod is going very well and I only regret that you never managed to get to Giverny. We might have worked out what you could have had from my exhibition, but as it is, several have already gone elsewhere.

Yesterday Monsieur van Gogh came to tell me that he's already sold one of the *Mer de Belle-Île* pictures, and asked me for something more, so he has six now, four of which are for the exhibition.

Anyway you musn't worry, there are still some left for you and good ones at that. Moreover I'm working non-stop and all will be well if I succeed as I'd like in finishing several things that are under way.

In any case, I'll aim to come on the 30th and draw up the catalogue, but I can't be sure as to its contents until the very last minute.

I count on you to remind the picture framer to be ready on time.

My kindest regards,

Yours, CLAUDE MONET

Giverny, 13 May 1887

TO PAUL DURAND-RUEL

I too am a little late with my reply but these past few days I've been caught up with my work, and the opening of the exhibition at Petit's has also taken up a lot of my time. Thank you for your letter, though what you tell me is upsetting and while I've never been particularly in favour of the American venture, I had hoped that after all you succeeded in doing last year you might at least have reaped the benefits of all the effort and money you put into it this time.

I'm convinced that you would have done better to stay here where you deserve to be successful. As it happens there's a growing movement in our favour and it's more pronounced this year. Almost all of us are represented in the International Exhibition and there's no doubt we're getting a better reception from the people who buy pictures. But you'll have a better idea of what's going on if I tell you that Boussod now have some Degas and some Monets and soon they'll have some Sisleys and Renoirs too. I'm quite in favour of it, since the first pictures they bought from me were sold immediately. In other words, business is going pretty well, and this is precisely why I deplore your absence, particularly if you're not succeeding in doing what you'd hoped in America.

I have to say that I was surprised and somewhat hurt by your silence and if Boussod hadn't come forward and if it hadn't been for the Petit exhibition, there's no doubt I would have been in real trouble; anyway you don't have to worry about me now. Try your best to come back to us soon with everything as you'd wish it. Above all let me know what happens, I'd be so glad to hear of your success.

Regards to your son,

Yours sincerely, CLAUDE MONET

Renoir has done a superb picture of his bathers, not understood by all, but by many. Sisley's having a lot of success with old pictures; for my part I've sold almost all of my paintings. Whistler has joined us with some very beautiful work.

ON THE BOAT

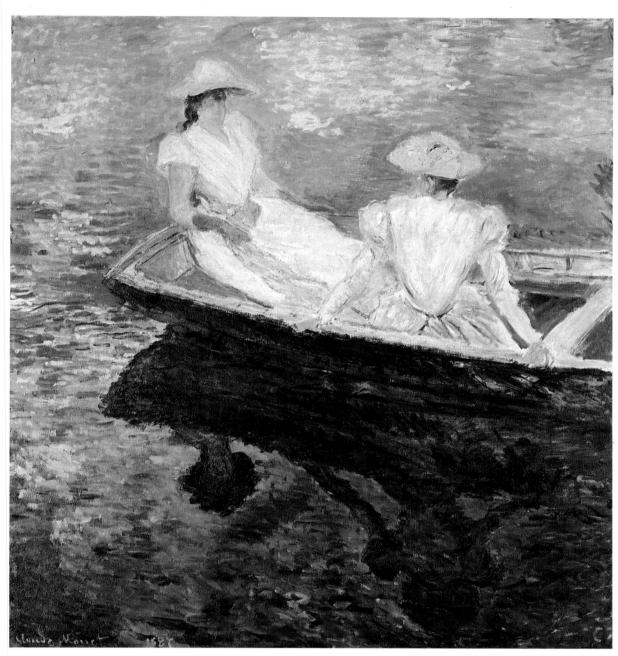

[Cap d'Antibes], Monday evening [23 January 1888]

To Alice Hoschedé

I received both your letters this morning, yours and Jean's, and I'm glad to see that life at Giverny isn't too dull; I have to admit that I wasn't too worried on that score; with me away, all those little parties can go on uninterrupted. So make the best of the good weather, but watch the little ones: things happen so fast. I must say I was surprised at your news and I'd love to be able to watch the skating for a while (without being seen); it's not hard to imagine how delighted the children must be.

As I wrote this morning, the weather's marvellous and I'm working hard if slowly, not wanting to embark on too many paintings for fear of being detained here too long...

Enclosed are five hundred-franc notes; that's all I can manage for the moment.

Still haven't written to Petit, but I'll try again tomorrow, though I don't hold out much hope; if I succeed all well and good and I'll forward it to you at once. In any case be very economical and careful, won't you; let's hope the results of my labours won't be squandered on my return. Please excuse this little sermon but it's for your own good. I love you and am faithful.

[Cap d'Antibes], Wednesday evening [1 February 1888]

To Alice Hoschedé

I am weary, having worked without a break all day; how beautiful it is here, to be sure, but how difficult to paint! I can see what I want to do quite clearly but I'm not there yet. It's so clear and pure in its pinks and blues that the slightest misjudged stroke looks like a smear of dirt. Anyhow, I'm hard at it and when I'm working away like this I'm bound to come up with something. I've fourteen canvases under way, so you see how carried away I've become, but I won't be able to see them all through to the end; I'm too preoccupied with my dreams of Agay and also of Cassis on the way back . . .

[Cap d'Antibes], Friday evening [24 February 1888]

To Alice Hoschedé

The weather's absolutely superb again but, alas, my motifs have changed utterly and I'm having a lot of trouble resuming work on them; in some the lighting's changed, in others there is so much snow on the mountains that it's something else entirely; so I've had to start some all over again. Everything's against me, it's unbearable and I'm so feverish and bad-tempered I feel quite ill; though I've slept so soundly all the time I've been here, I couldn't get a wink of sleep last night.

So I hope that you'll understand the comments and fears I expressed in yesterday's letter in the light of my present condition. I assure you that it's a miracle that I can work at all with all these worries, but I'm beginning to earn a reputation here as a ferocious and terrible person.

It would be so nice if I could give you some good news. But what do you want? Everything seems to be turning against me. So it's better to write less than to bother you with a lot of complaints.

You have the children with you and their gaiety must comfort you in some small way. Hug them all for me, send my best to Marthe and accept my loving thoughts, my sad heart,

Your CLAUDE

Château de la Pinède near Antibes [10 March 1888]

TO PAUL HELLEU

I've been wanting to write to you for a long time, but you know I work to my limit and by the time evening's upon me I haven't the strength to pick up a pen. What's more, I didn't think I'd be here for such a long time, I'm never finished with my paintings; the further I get, the more I seek the impossible and the more powerless I feel. I've no idea whether what I'm bringing back with me is good or bad, struggling as I am with the wonderful sunshine, I don't know where I am any more. What about you, have you been working hard? I hope you have and that this time you'll have some good things for our exhibition . . .

CLAUDE MONET

Château de la Pinède near Antibes [just before 11 April 1888]

TO PAUL DURAND-RUEL

I've just received your letter and am writing to you in some haste so that you have my news before you leave . . .

You ask me to set aside some of my new work for you; rest assured that I will always be glad to do further business with you, even though it's upsetting to see everything go off to America, but in any case I'm at your service and I'll let your son know when I get back, though we didn't decide on anything when he expressed his desire, before I left, to come and buy a few paintings from me in Giverny.

That apart, I have to say that I've already promised to show some other people my work. So I'll let everyone know at once and the choice will fall to the first comer. I can't do better than that and I would be glad if it were to be Monsieur Charles...

I'm working hard and would be home already were it not for the weather, which has been something of a problem, besides which the further I get the harder I am to please. Nevertheless, I think I'll have some good work at the end of it. I'll be back in Giverny some time between the 15th and the 20th and hope to stay put all summer. I've been away for three months now and I can't wait to see my nearest and dearest, my family and home again. The news from everyone is good . . .

Thank you for your letter and I wish you every success in Paris and over there.

Yours sincerely, CLAUDE MONET

*

[Cap d'Antibes], Thursday [19 April 1888]

To Alice Hoschedé

I'm continuing the good work, but I felt so uncomfortable this morning that I had to lay down my brushes; I had a headache, and was so dazed I couldn't see straight. I had to stop work at 10 a.m., and I'm limiting myself now to working mornings and evenings only; the heat is very great and I've been overdoing it, although I'm well under way.

As it turns out, I needn't have worried unduly about this enforced rest, since the sky has suddenly clouded over and it's starting to rain. But if it lasts I'll be desperate: I've so many paintings that need very little work for them to turn out well! It would be an annoyance, if it does, a real blow, and in any case I feel very strongly that I can't leave you like this any longer. Finally, let's pray that after this day of rest I'll wake up to fine sunshine tomorrow!

I plan to be with you a week from today, next Thursday; I'll leave on Wednesday at I o'clock from here and get into Paris the following day at 9 a.m.; from there I'll go straight off to see Petit, van Gogh and Durand and will catch the I o'clock train to Vernon. If between now and then I'm blessed with good weather, I'll be overjoyed, otherwise I'll be very miserable (only on account of my poor pictures, that is).

Until then, my darling, all my love and affection; kisses to all, big and small, best wishes to Marthe.

Giverny, 15 May 1888

To Auguste Rodin

Has Geffroy told you that I've abandoned plans for an exhibition at Durand-Ruel's? I presume he has by now.

You may also know that since getting back I've had nothing but trouble. After working myself so hard, it really is beyond a joke. I don't know where to turn and don't want to do anything this spring. I'll see if I can arrange for a more complete show at the beginning of winter. I telegraphed you because I know my name is being used to hold an exhibition at Durand's but I'm not actually exhibiting and I'm within my rights to stop pictures of mine being shown if the exhibition is a paying one. If it's free, then there's not much I can do, dealers can do what they like on their own ground, but it's always a failure in such circumstances.

I thought it best to warn you, imagining you'd prefer to exhibit with me a little later on, rather than go ahead without me. However, if that was in fact your intention, I wouldn't want to do anything to prevent you.

Best wishes and hoping to see you soon,

Your friend, CLAUDE MONET

GRAINSTACK AT GIVERNY

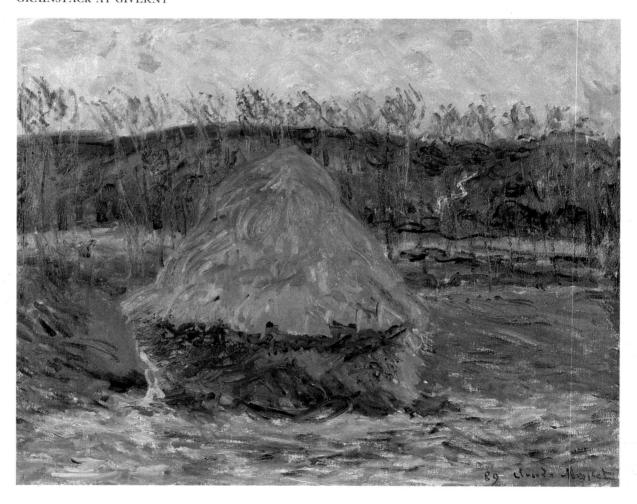

[Giverny], 19 June 1888

To Stéphane Mallarmé

Thank you for your very kind letter.

I'm very glad you like my pictures, praise from an artist like yourself is always a pleasure to receive.

Yes indeed, poor Manet was a very good friend to me, and we return his affection and I'm appalled at the silence and injustice surrounding his name and great talent.

My very best wishes to you, my dear Mallarmé.

Yours, CLAUDE MONET

Have you heard from Whistler and is he coming back soon?

[Giverny], 15 February 1889

To Stéphane Mallarmé

I must tell you with what pleasure and delight I read

your book.

I was quite unaware of Poe's poetry; it's wonderful, true poetry, the stuff of dreams, and how well you seem to have captured its soul!

I'm only an uneducated ignoramus, but I'm no less moved by it. All I knew of Poe was his prose, which I had read and admired in my youth before I had heard him talked about, but your poems complete the picture and reveal the character of the man.

Many, many thanks for the pleasure you've given me and it will be a delight to read it again often.

My very best wishes to you, CLAUDE MONET

I haven't forgotten your drawing, but haven't yet had the time to do it.

[Fresselines, Creuse], Saturday [9 March 1889]

To Alice Hoschedé

...I'm back from work, a bad session, and I wiped out everything I did this morning; it wasn't well realized or understood. It's always like this to start with. I worked better yesterday. On top of this the weather's very changeable today, grey skies and sunshine.

I'm very comfortably installed and not at all disturbed by Rollinat who leaves me to myself to do what I like; I only see them at mealtimes, but I'm finding it hard to get to bed early; they dine late at half-past seven or eight and I can hardly leave straight after the meal.

Forgive me for not writing to you at greater length today. It will soon be midday and I must see about sending your letter off. Till tomorrow, kisses to the children, best wishes to Marthe, all my love and tenderness to you.

Fresselines, Creuse [22 March 1889]

To Alice Hoschedé

I'm utterly desolate, snow came this morning accompanied by a wind and glacial cold, what a curse.

I was a little more content with myself last night, having managed to get two studies just right despite the rain, or perhaps because of it, since both paintings had a gloomy look about them which I couldn't quite get as I wanted.

Anyway, they were coming along well and I held out the highest hopes for today, but what am I to do with this snow, which is settling sufficiently to be a nuisance but not enough to paint it. Still, if it persists after lunch I'll have a go at something.

But troubles never cease, the struggle is endless.

Fresselines, 31 March [1889]

To Alice Hoschedé

... As I said last night, work's been going much better these last few days and I'm beginning to think that I might have some good and interesting work to bring back with me. By looking hard I've finally entered into the spirit of this countryside, I understand it now and have a clearer idea of what to do with it.

The most recent work I had to start on when the weather changed is much better than the early paintings and less hesitant, in the end it's the result of a great deal of effort...

Your old Claude who loves you tenderly.

Fresselines, 4 April 1889

To Alice Hoschedé

... So with this damnable weather, which is too sinister for words, progress is slow and the sight of my paintings terrifies me, they're so dark: what's more, several are skyless. It will be a gloomy series. A few have some sunlight in them but they were started so long ago that I'm very much afraid that when the sun finally re-emerges I shall find my effects considerably altered. Apart from this, the Creuse is bound to rise with all the rain we're having now and it will change colour, so I live in a state of continual suspense, and I'll have to consider myself fortunate if I can manage to bring off a quarter of the canvases I've begun, having given up all hope of Crozant, much to my regret; it will have to wait for another time . . .

I send you my loving thoughts. Best wishes to Marthe, kisses to the children.

CREUSE VALLEY, EVENING

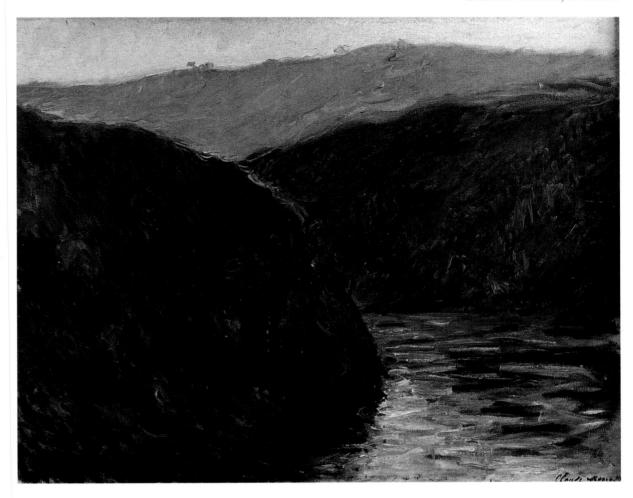

Fresselines, 17 April 1889

To Alice Hoschedé

What a lot of trouble you've had, but at least you're back and it's all over; I, however, am in a state of utter despair and feel like throwing everything into the river; I'm so miserable I didn't feel like writing, but now my mind's made up, you'll cheer me up and it's consoling to talk about one's hardships.

Briefly, yesterday was a very bad day and this morning was worse still; a painting which might have been very good is utterly spoilt and I fear for the others. What's more, the weather's wearing me down, a terrible cold wind which wouldn't have bothered me in the slightest if I'd captured my effect, but the endless succession of clouds and sunny intervals couldn't be worse, especially when I'm getting to the end; but the thing that is upsetting me the most is that with the drought the Creuse is shrinking visibly and its colour is altering so radically that everything around it is transformed. In places where the water once fell in green torrents all you see now is a brown bed. I'm desperate and don't know what to do, as this arid weather is here to stay. None of my paintings are right as they are, and I was counting on these last few days to rescue a good number of them; to give up now would mean that all my efforts have been wasted, but the struggle terrifies me, and I am worn out and longing to come home...

Advise me, comfort me.

All my loving thoughts, kisses to all.

Fresselines, Wednesday 8 May [1889]

To Alice Hoschedé

... I'm going to offer fifty francs to my landlord to see if I can have the oak tree's leaves removed, if I can't I'm done for since it appears in five paintings and plays a leading part in three, but I fear it won't do any good as he's an unfriendly old moneybags who's already tried to prevent access to one of his fields, and it was only because the priest intervened that I was able to carry on going there. Anyway, therein lies the only hope of salvation for these pictures.

[Fresselines], Thursday 9 May [1889]

To Alice Hoschedé

I'm overjoyed, having unexpectedly been granted permission to remove the leaves from my fine oak tree! It was quite a business bringing sufficiently long ladders into the ravine. Anyway it's done now, two men having worked on it since yesterday. Isn't it the final straw to be finishing a winter landscape at this time of year . . .

Giverny, 12 October 1889

TO STÉPHANE MALLARMÉ

I really am ashamed at my conduct and I deserve to be reprimanded by you. It's not, however, due to any lack of desire on my part, as you might think; perhaps I am too proud, but the truth is that all the attempts I've made with the pencil look quite absurd and uninteresting, and consequently unworthy of a position alongside your exquisite poems (I was enchanted by *La Gloire* and fear I don't have the necessary talent to do something worthy of you). Please don't think of it as a vulgar defeat; unfortunately it's the plain and simple truth. So please forgive me, most of all for having taken so long to make this confession.

You must be aware of my sympathy and admiration for you — allow me then to express it by offering you a small painting (a sketch) as a token of our friendship, which I'll bring when I next come to Paris; I'd be very pleased if you were to accept it in the spirit in which it was offered, as a simple gesture.

This said, my dear Mallarmé, let us talk of our friend Manet. Perhaps you know that I am organizing a subscription from friends and admirers of the great artist to acquire his *Olympia* for the Louvre. It is one way to pay our respects and do justice to the memory of our friend and it's also a discreet way of coming to the aid of Madame Edouard Manet. I am sending you the list of subscribers I've obtained. I know you'd like to support it in whatever way you can and I thought you might give me names of other people who would be glad to participate in our venture. I've already obtained over fifteen thousand francs, and the figure of 20,000 must be reached.

If you could suggest some more subscribers to me I would be very grateful.

Yours, CLAUDE MONET

>

Paris, 7 February 1890

TO THE MINISTER OF PUBLIC INSTRUCTION, ARMAND FALLIÈRES In the name of a group of subscribers, I have the honour of offering the *Olympia* by Edouard Manet to the State.

We are quite certain that in doing this we are acting on behalf of, and representing the wishes of, a great number of artists, writers and art lovers who have long since recognized the important role in this century's history of a painter whose early death was an untimely loss to his art and country.

The controversy which Manet's paintings provoked, the attacks to which they were subjected, have now subsided. Had the war against such individuality continued we would have been no less convinced of the importance of Manet's *oeuvre* and of his ultimate triumph. One need only recall what happened to artists such as Delacroix, Corot, Courbet and Millet, to cite only a few famous names that were once decried, their isolated beginnings preceding certain glory after their death. However, according to the great majority of those interested in French painting, the part that Edouard Manet played was beneficial and decisive. Not only did he play a great individual role, but he also stood for a great and fruitful evolution.

It seems to us, therefore, unacceptable that such a work should not have its place in our national collections, that a master should not be represented where his disciples are already admitted. We were also concerned by the ceaseless activity of the art market, the competition created by America, the all-too predictable departure to another continent of countless works of art that are the joy and glory of France. We wanted to hold on to one of Edouard Manet's most characteristic paintings, one in which he is seen at the height of his glorious struggle, master of his vision and of his craft.

We are placing the *Olympia* in your care, Minister. Our wish is for it to take its proper place in the Louvre, among contemporary works of the French school. Should the regulations make immediate entry impossible, if, despite the precedent set by Courbet, it is objected that a period of ten years has not yet elapsed since Manet's death, we consider that the Musée du Luxembourg is the appropriate place to keep *Olympia* until the date in question. We hope you will kindly give your support to the work to which we have linked ourselves, in the satisfaction of accomplishing what is quite simply an act of justice.

I am, Sir, yours most respectfully, CLAUDE MONET

WAVES BREAKING

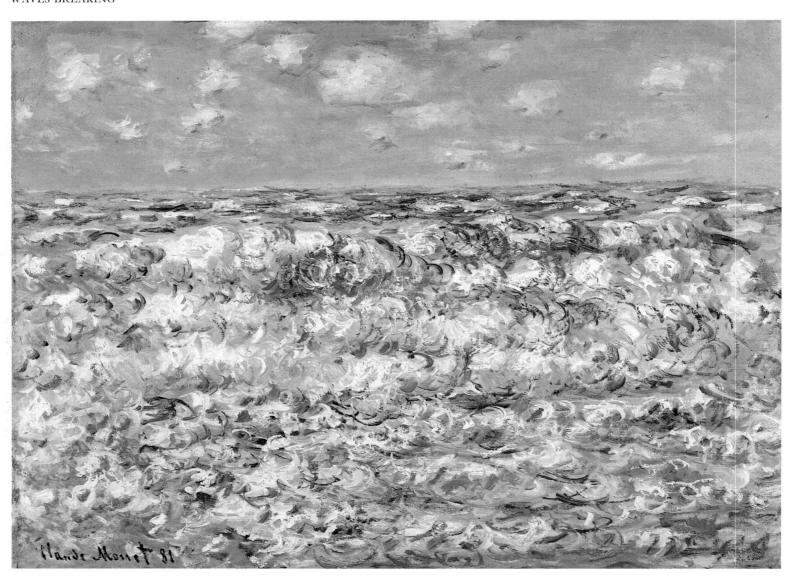

THE ROCKS AT POURVILLE, LOW TIDE

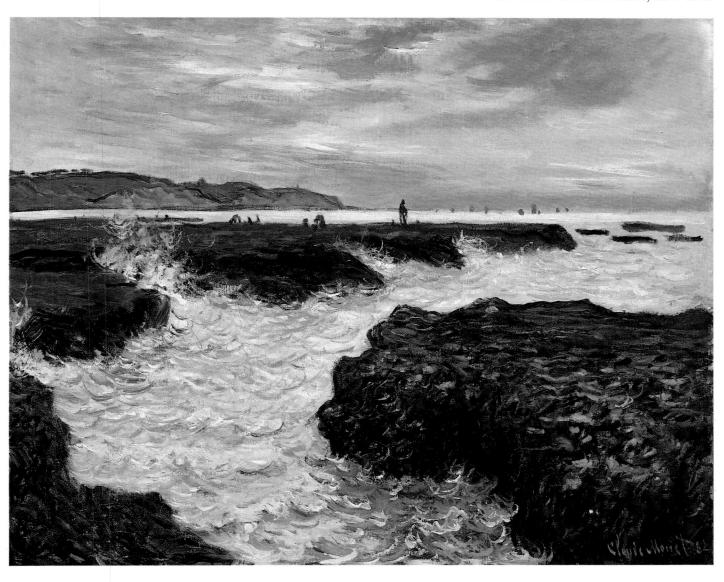

SEA COAST AT TROUVILLE

ROAD AT LA CAVÉE, POURVILLE

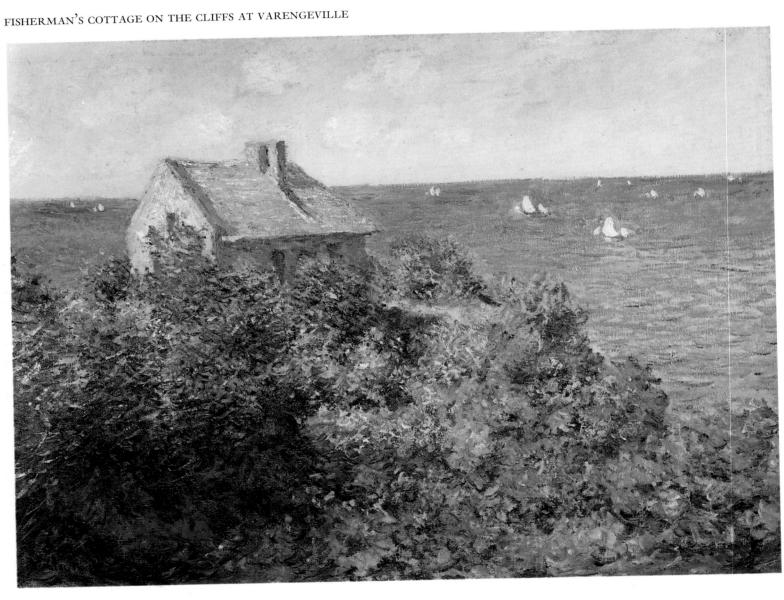

CLIFF AT DIEPPE

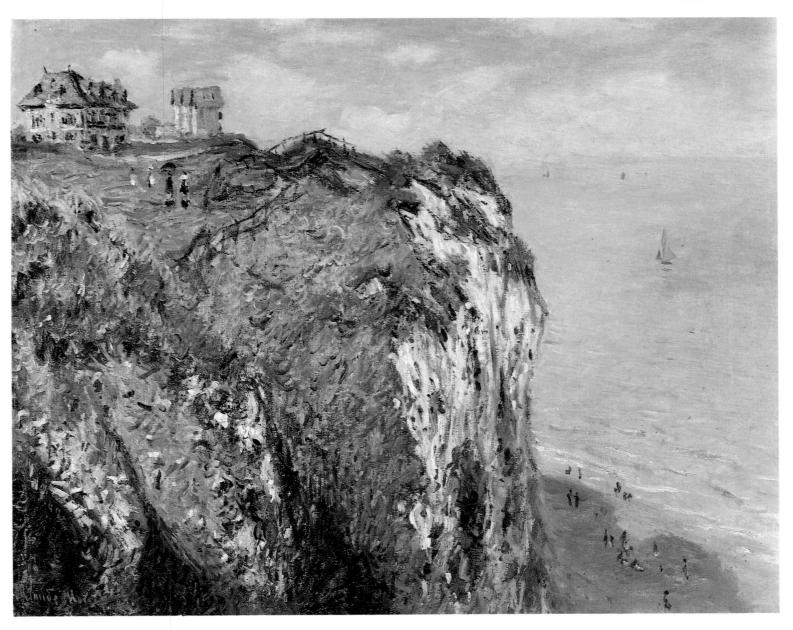

THE MANNEPORTE, ETRETAT

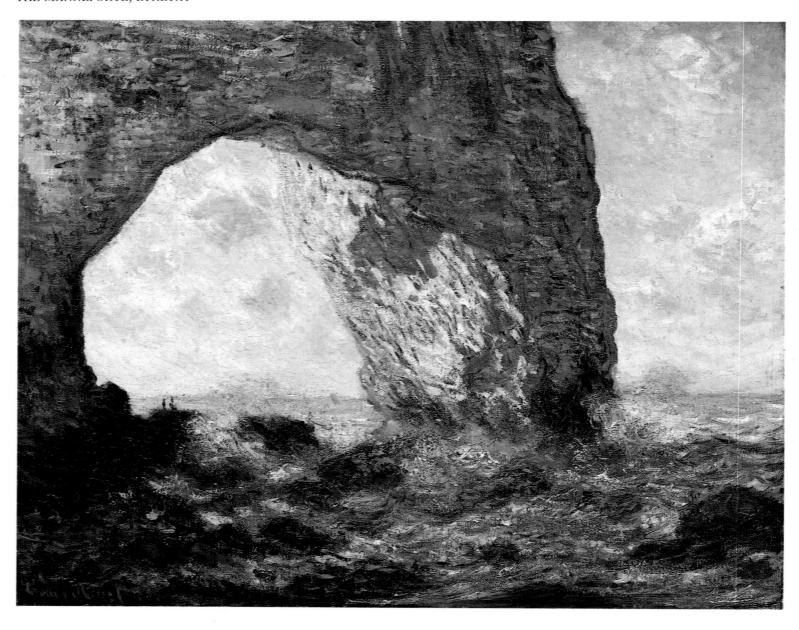

THE MANNEPORTE, ETRETAT

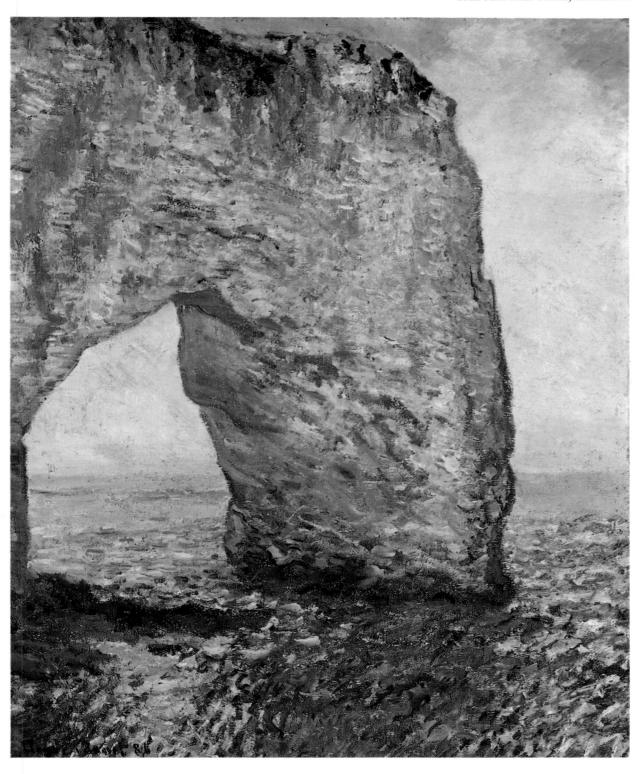

THE CLIFFS AT ETRETAT

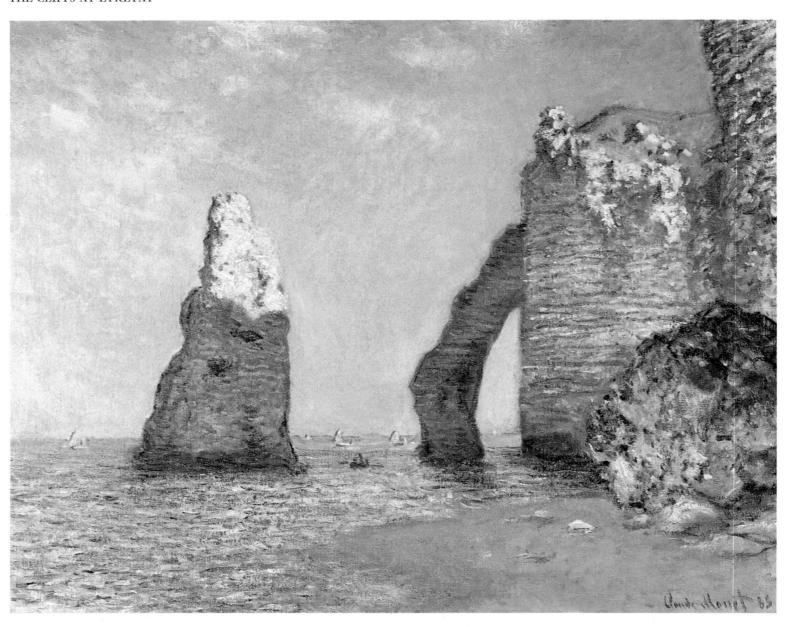

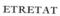

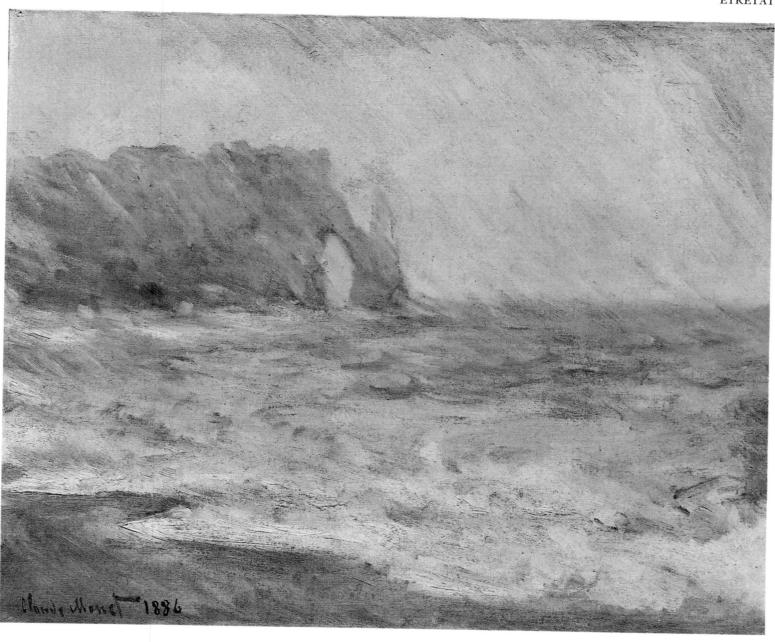

THE DEPARTURE OF THE BOATS, ETRETAT

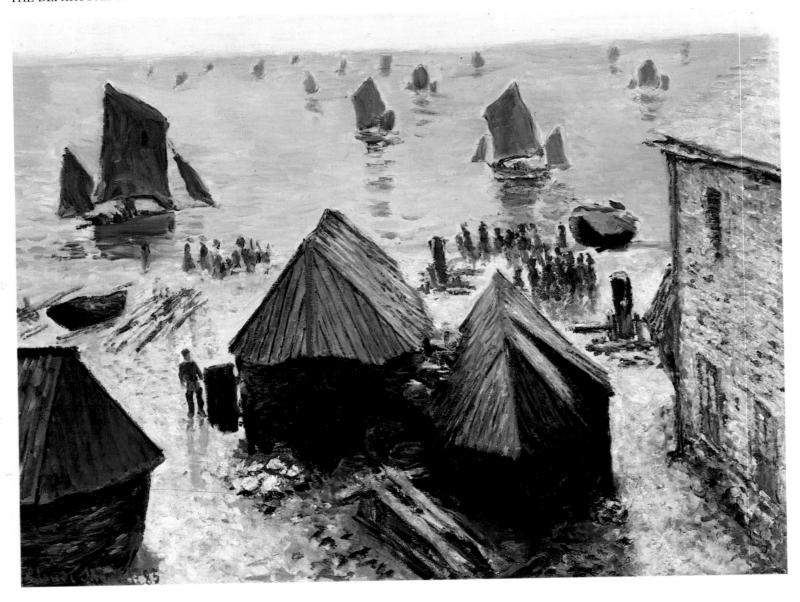

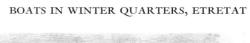

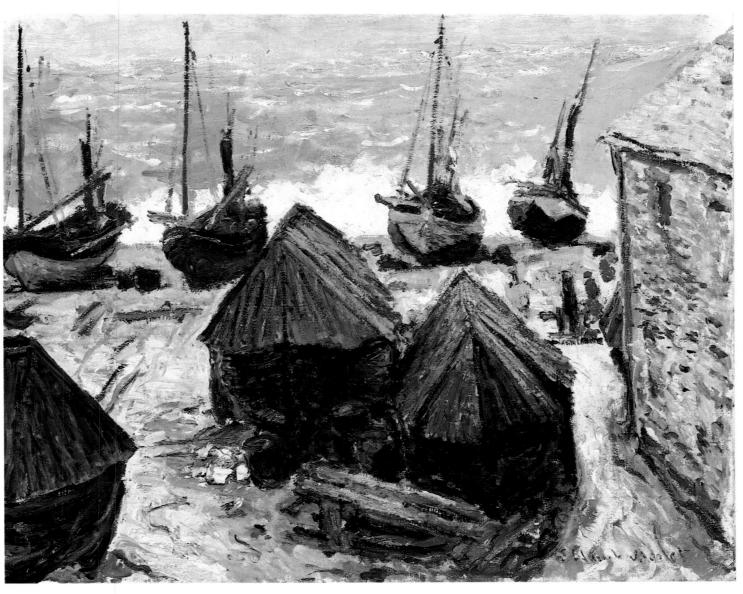

BORDIGHERA

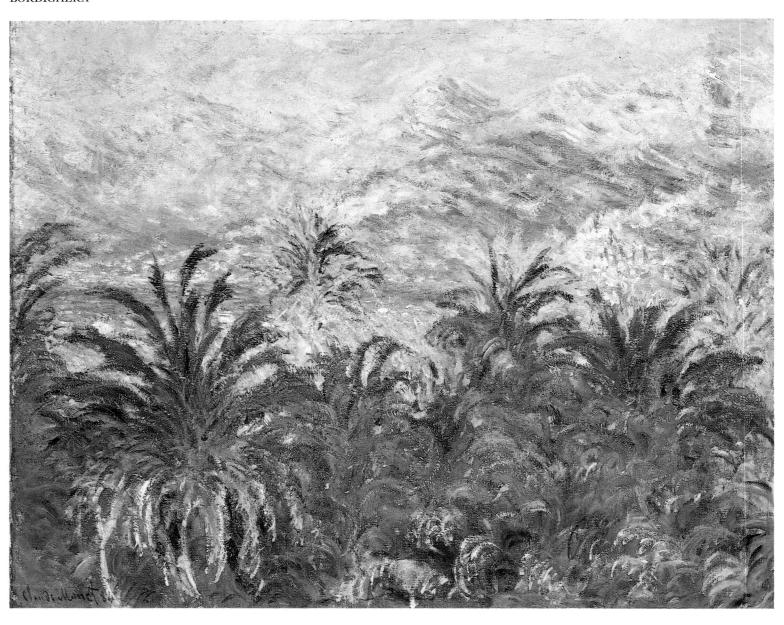

BORDIGHERA

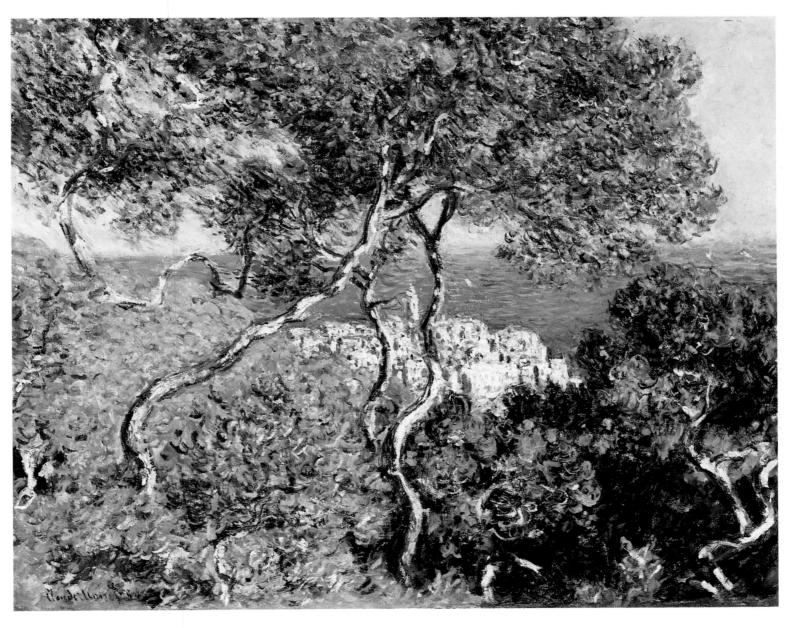

CAP MARTIN, NEAR MENTON

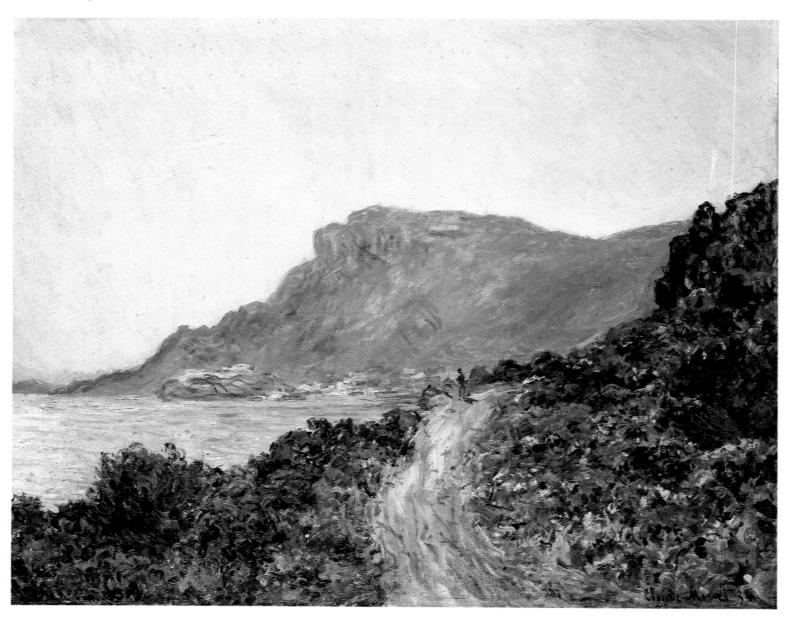

LA CORNICHE DE MONACO

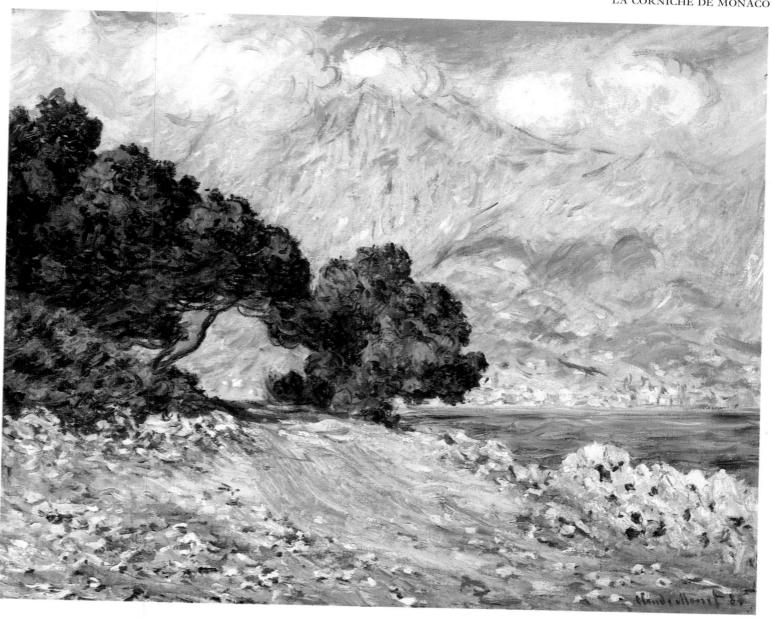

POPPY FIELD IN A HOLLOW NEAR GIVERNY

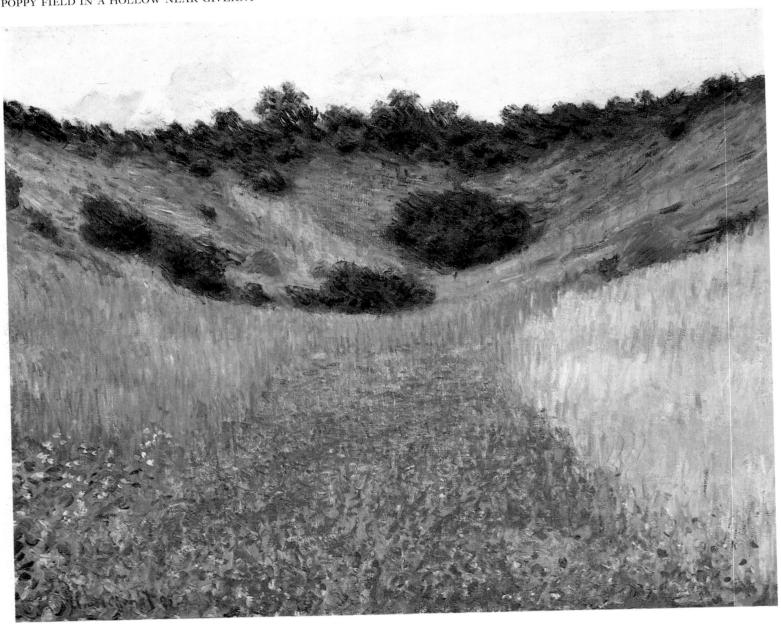

FIELD OF POPPIES, GIVERNY

SPRING

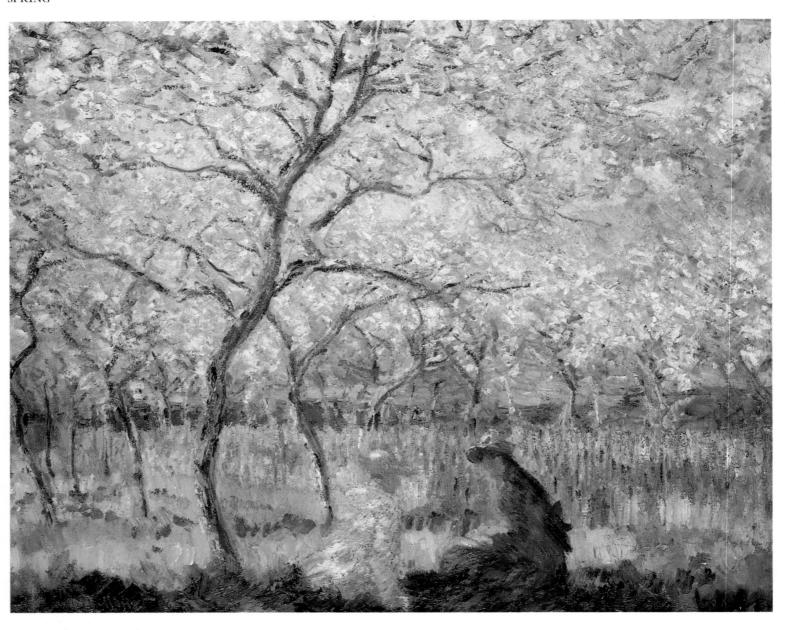

IN THE WOODS AT GIVERNY—BLANCHE HOSCHEDÉ MONET AT HER EASEL WITH SUZANNE HOSCHEDÉ READING

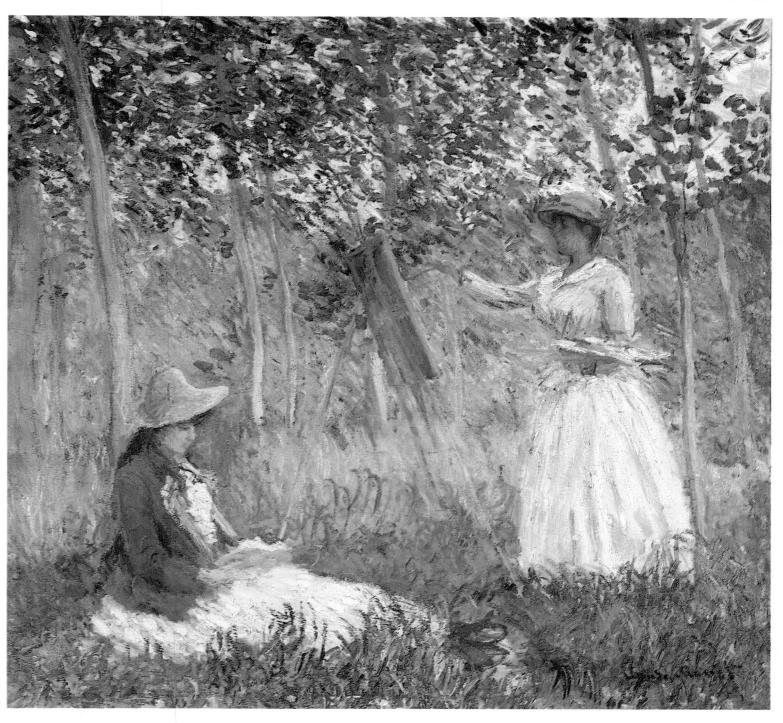

THE BOAT

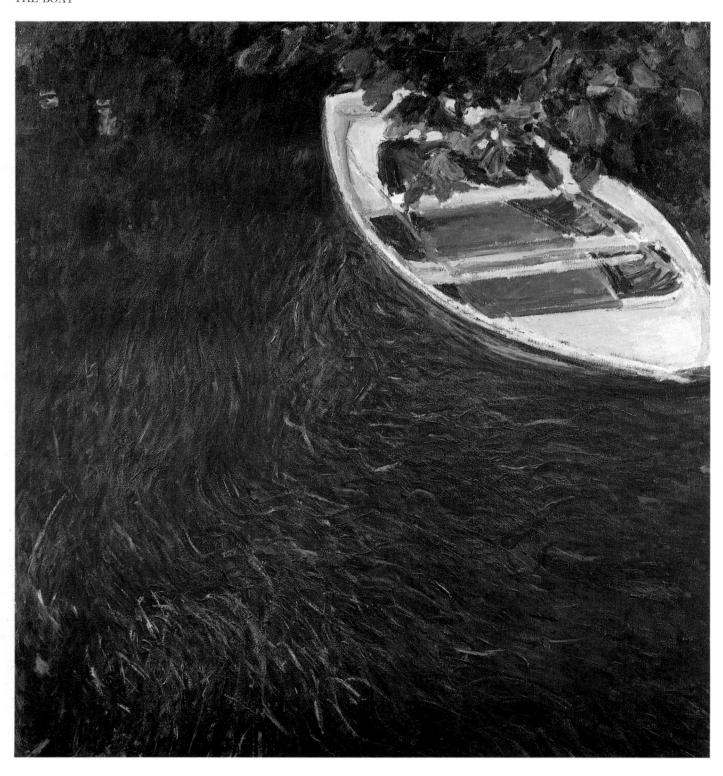

BOATING ON THE EPTE

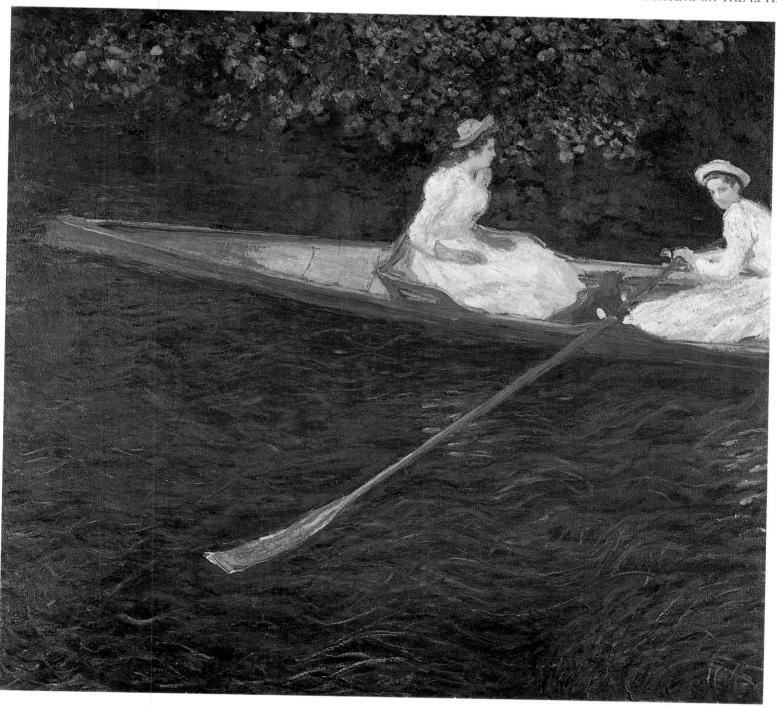

THE 'PYRAMIDES' AT PORT-COTON, BELLE-ÎLE-EN-MER

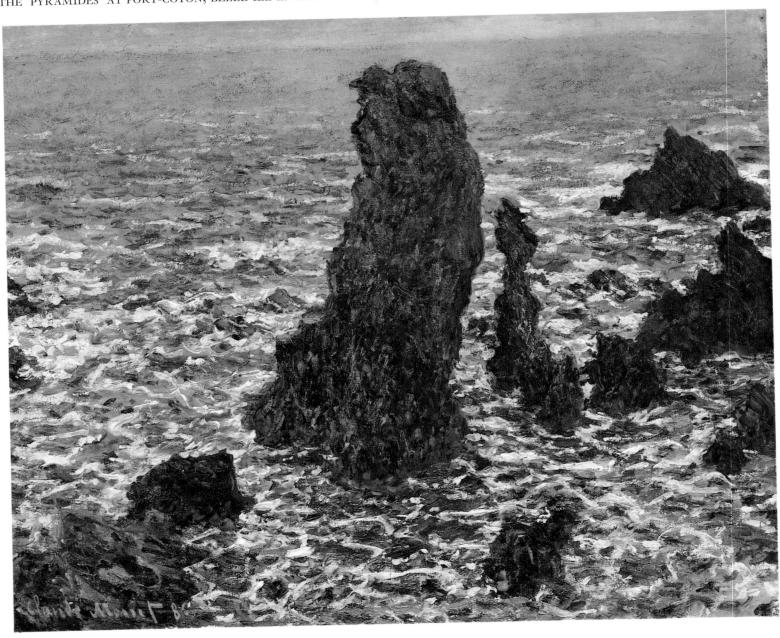

BELLE-ÎLE, RAIN EFFECT

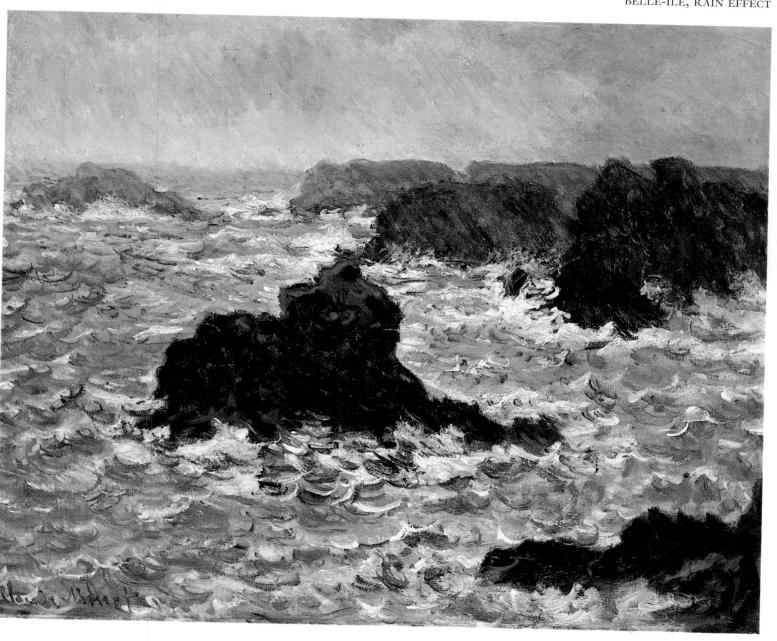

ROCKS AT BELLE-ÎLE

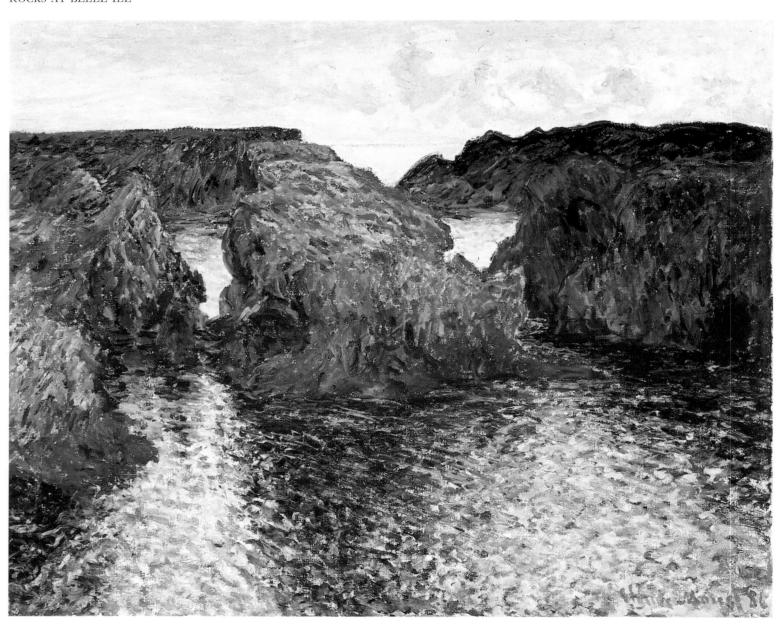

PORT DONNANT, BELLE-ÎLE

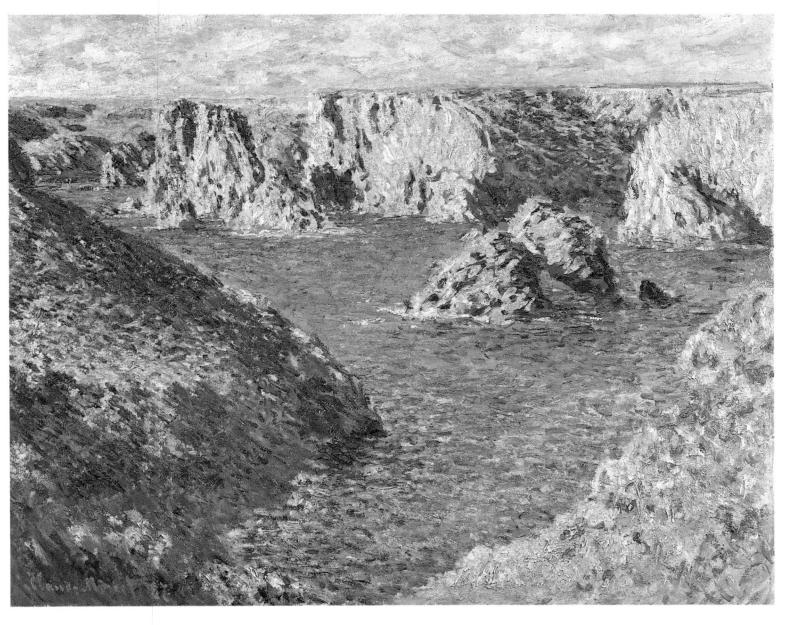

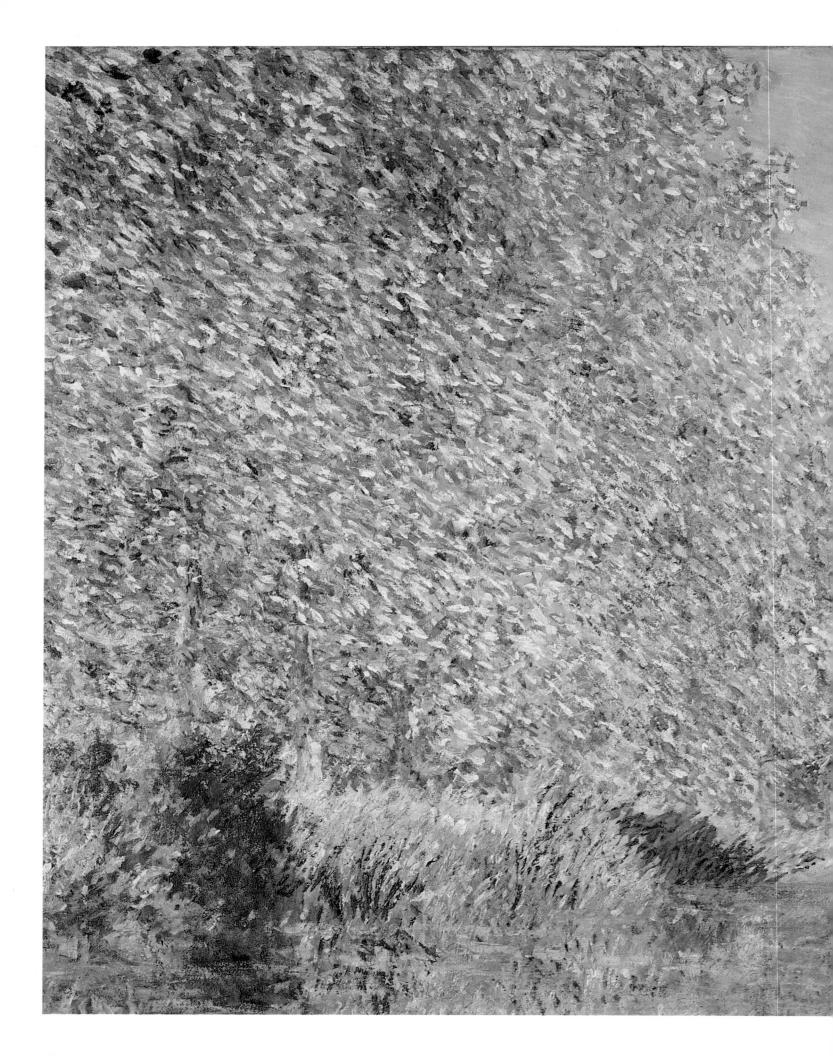

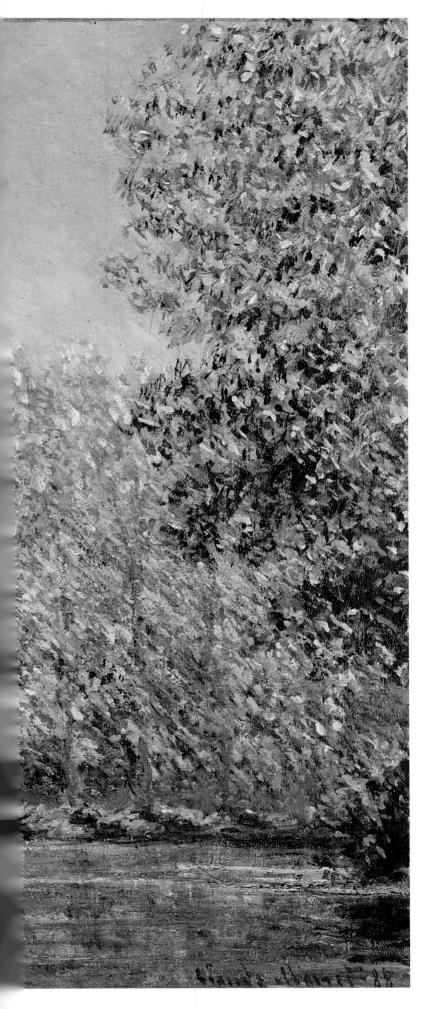

A BEND IN THE RIVER EPTE, NEAR GIVERNY

ANTIBES

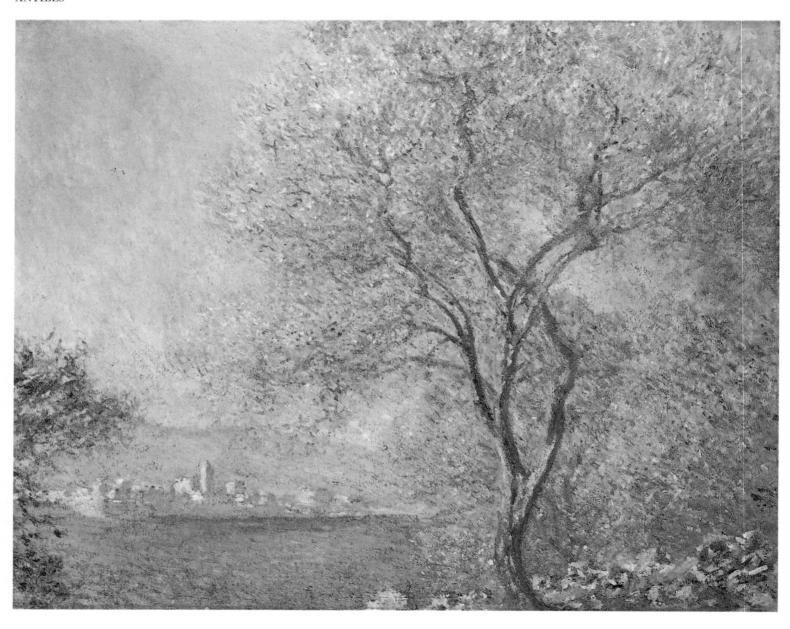

ANTIBES, VIEW FROM THE SALIS

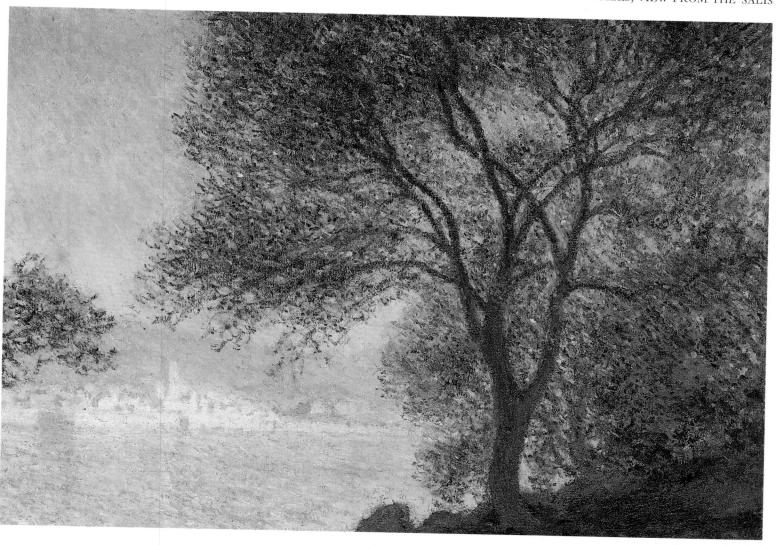

ANTIBES SEEN FROM PLATEAU NOTRE DAME

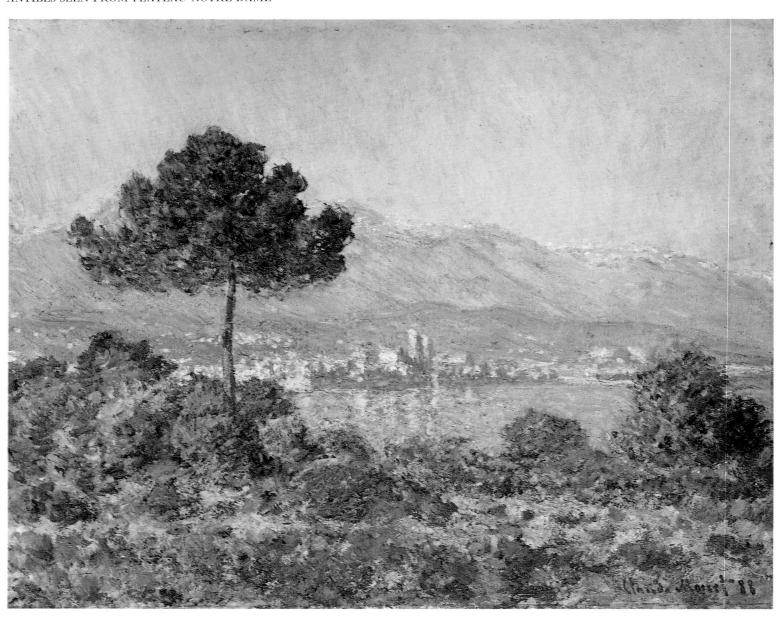

CAP D'ANTIBES: MISTRAL

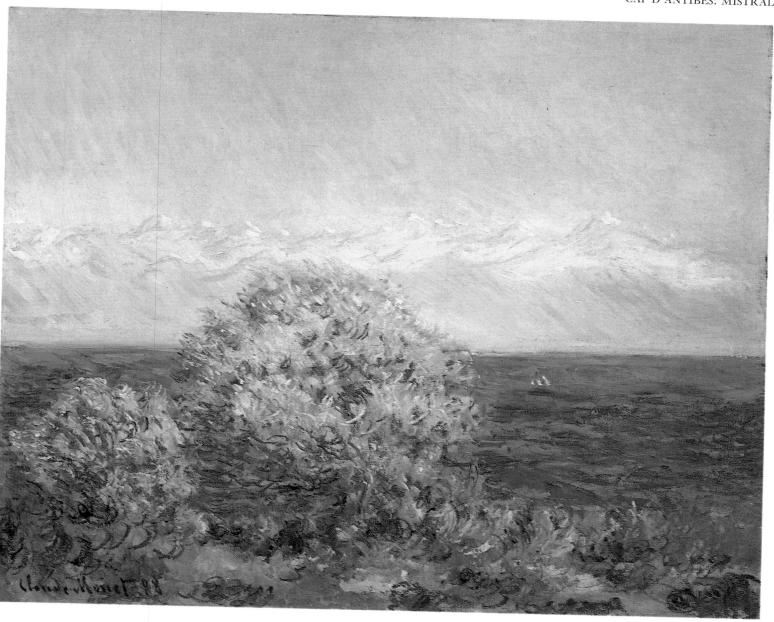

RAVINE OF THE CREUSE IN SUNLIGHT

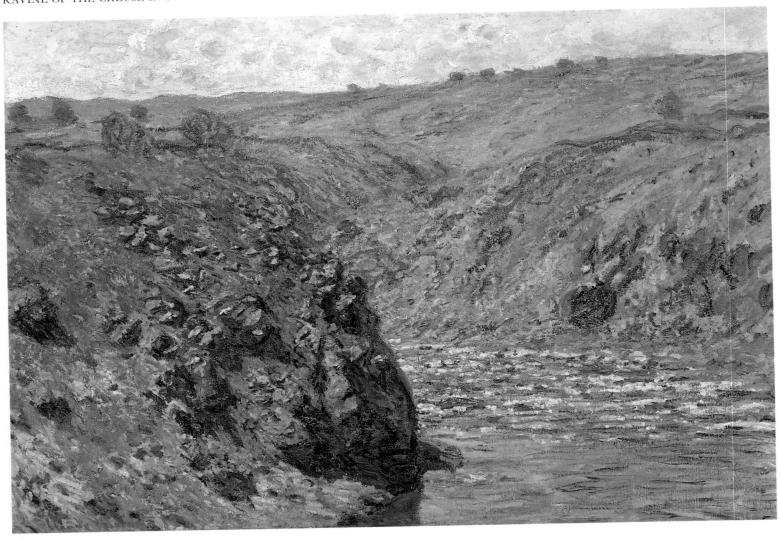

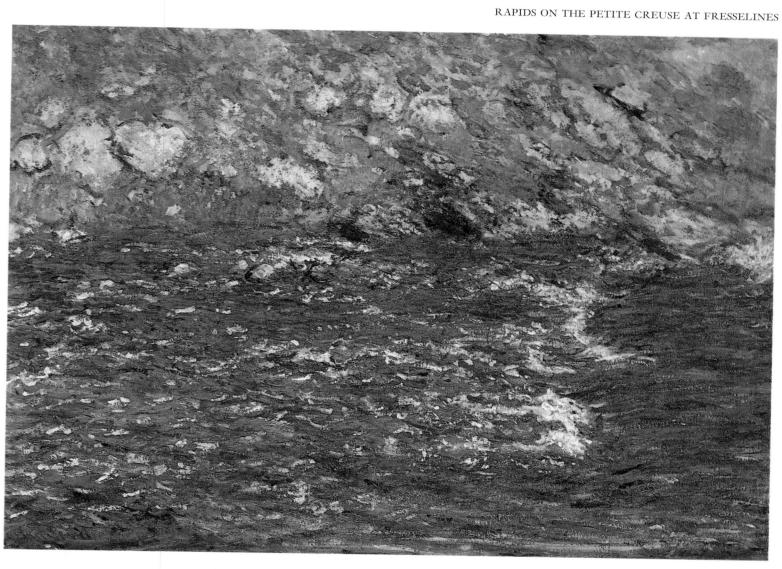

RAVINE OF THE PETITE CREUSE

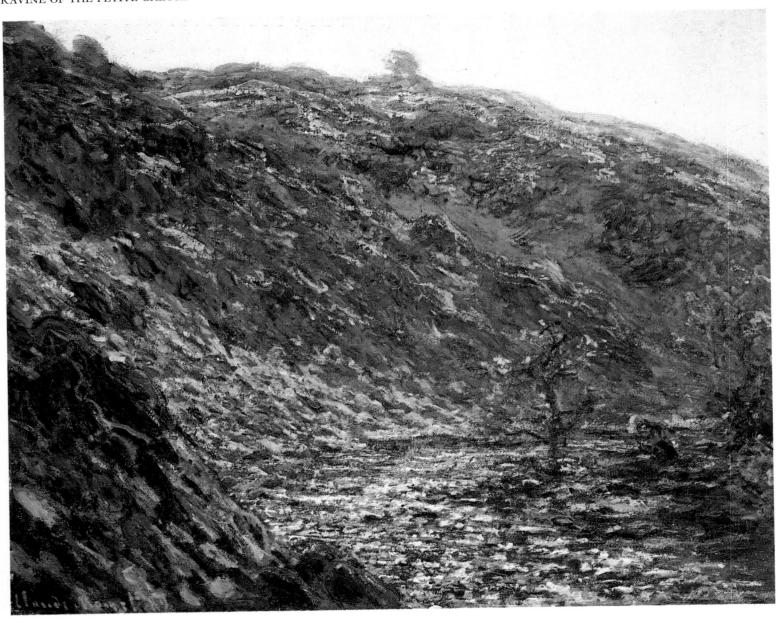

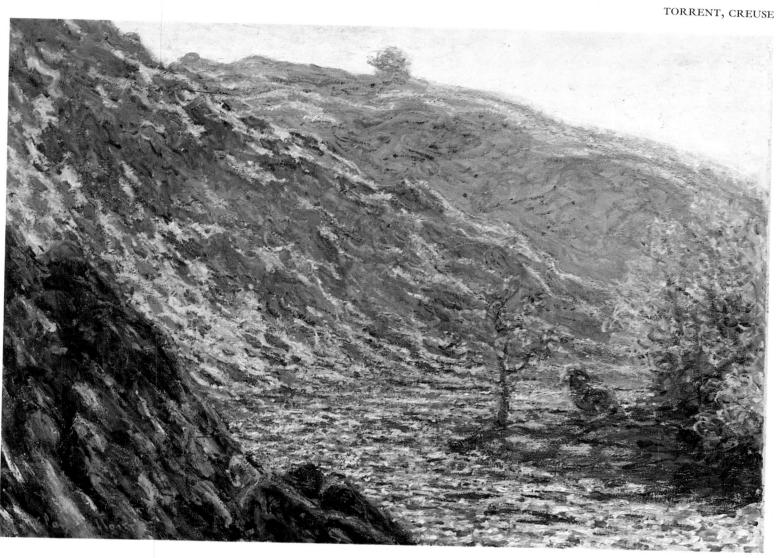

1890–1908: The Series Paintings

Among the most persistent themes in Monet's letters are his complaints about the contrariness of the weather and the unpredictability of the light. From long experience working in the open air, in all weathers and throughout the seasons, Monet had developed an exceptional sensitivity to atmosphere and to the moods of the landscape. In his maturity, this responsiveness to the most sublte 'effects', as he called them, drove Monet to modify his working procedures and even to rethink the basis of his art. During the painting expeditions of the 1880s, Monet had come to accept that a single canvas could never do justice to his chosen motif and that every shift in the sunlight or the quality of the atmosphere presented him, in effect, with a new subject. In order to be true to his subject, therefore, it had to be painted only while the light conditions remained stable, which might be a matter of an hour or just a few minutes. When he set out for a day's work, Monet was obliged to take with him a selection of canvases which corresponded to the conditions he would encounter, making it necessary to hire a porter to help carry all the necessary equipment. Any dramatic change in the weather could be disastrous, denying him the possibility of finishing his paintings in the right circumstances and leaving him with a series of half-completed canvases.

In both 1892 and 1893 Monet spent several months in the city of Rouen painting its famous cathedral, and almost every one of the letters he sent to his wife Alice contains some reference to the vagaries of the weather. His subject was the cathedral façade, which he painted from a shop overlooking the church, hardly changing his vantage point or composition from picture to picture. According to the artist himself, he would sometimes work on ten or a dozen canvases in a single day, moving from one to another as light conditions altered. Monet's letters show how obsessive he became in such circumstances, alternately exhilarated by a burst of sunshine or suddenly demoralized by the progress of his pictures. At the beginning of the decade, Monet had produced two earlier sequences of paintings, one based on stacks of grain and the other on rows of poplar trees beside the Seine at Giverny. Monet had learnt to minimize the inconvenience of working on a number of canvases at the same time, while allowing himself to pursue even further his studies of light and colour, by painting subjects near his house or within sight of a studio. In the Rouen paintings this encounter between artist and subject takes on a new and particular intensity, as both composition and viewpoint remain virtually unchanged and each canvas becomes, in effect, a subtle variant of the artist's own experience. This extension of Monet's art towards his perceptions and personal responses is also indicated in his letters, where he describes 'how difficult it is to paint what I feel'.

The increased complexity and subtlety of Monet's art in the 1890s was widely admired by his friends and by the growing circle of enthusiasts who competed for his paintings. Successful exhibitions of the Series pictures in 1891, 1892 and 1895 confirmed Monet's position at the centre of contemporary artistic life and carried his fame to collectors and institutions in other countries. His continuing correspondence with Paul Durand-Ruel emphasizes the shift in initiative from dealer to artist, as Monet declined to exhibit new work, almost casually asked for the dispatch of '3000 or 4000 francs', and distanced himself from Durand-Ruels's picture-dealing activities in America. Other letters record Monet's illustrious circle of acquaintances: we read of the mutual admiration of Monet and the American painter James McNeill Whistler, of the artist's support for Emile Zola in his stand against anti-Semitism at the time of the Dreyfus affair, and of Monet's intimacy with the writers Stéphane Mallarmé and Octave Mirbeau. The Impressionist artists had long since gone their own ways, but Monet maintained sporadic contact with some of his former colleagues, among them Boudin, Renoir and Sisley. A brief note to Gustave Geffroy in 1894 announced the arrival at Giverny of Paul Cézanne, and

we know from other sources that the visitor, who revered Monet above all other living artists, was deeply moved by his host's attentions to him on this occasion. Geffroy himself had become a much-valued friend, inspiring some of Monet's most informative and revealing letters. Monet had met the young critic by chance while at Belle-Île, and a relationship of affection and mutual respect had grown up between them. Writing to Whistler in 1891, Monet was able to help in advancing Geffroy's career, and in later years he cooperated with Geffroy in the production of his book Claude Monet, Sa Vie, Son Oeuvre.

Much of Monet's activity in his later life was centred on the house and gardens at Giverny. Here he was able to work on the canvases brought back from his painting excursions and to turn his attention to motifs in the garden itself. Monet's interest in gardening, like so many of his preoccupations, became obsessive, and his letters describe the acquisition of plants from the Botanical Garden at Rouen, detailed instructions for one of the gardeners employed at Giverny, and his efforts to establish and enlarge his water-lily pond. At Giverny, the children of his own and Alice's previous marriages were able to grow up and enjoy their rural surroundings, posing occasionally for the artist's brush. Monet's tenderness towards his extended family is evident in his letters, as he offers sympathy for the children's ailments and maintains an interest in their games and parties. His expedition to Norway in 1895 was partly prompted by the fact that Alice's son Jacques lived there, and the two families moved even closer in 1897 with the marriage of Jean, the painter's eldest son, to Alice's daughter, Blanche Hoschedé. Alice herself, whom Monet had finally been able to marry in 1892, continued to occupy the centre of his affections, and the decreasing frequency in his journeys away from home has been seen as evidence of her influence over him.

The last important painting expeditions of Monet's career were to London and Venice in the early years of the twentieth century. In both cities Monet became fascinated by the unfamiliar and even exotic effects of their light and atmosphere; his paintings of Venice are among the most brilliantly coloured canvases of his career, while the dense fogs that were so typical of industrialized London offered a new challenge to his eye and to his technique. During his stays in London, Monet installed himself beside the Thames at the Savoy Hotel, painting from the balcony of his room or from the nearby Charing Cross Hospital. Writing home to Alice, he described the extraordinary coloured mists and sudden transformations of the weather that alternately delighted and infuriated him, reminding us how vital this first-hand contact with the motif still was to his art. Monet's letters from his three visits to London are the most detailed account of his working methods to have survived, recording the roomful of canvases he needed in order to respond to changes in the light, his long hours of working in freezing conditions and the exhilaration and despair of the painting process. The pictures he produced were some of the most radical images of his career, dramatic rectangles of luminous colour with bold, geometric compositions of the utmost simplicity. At this time few artists had approached, or could even have comprehended, Monet's audacity with colours and pictorial organization, and it is surprising to note the approving responses of some of Monet's London visitors. During his stays at the Savoy, Monet was feted by prominent London artists and writers, among them John Singer Sargent and George Moore, and invited into high society in the company of the visiting statesman Georges Clemenceau. Thirty years earlier Monet had visited London as a penniless and unknown exile; now he found that he had become a celebrity.

[Giverny], 21 July 1890

TO GUSTAVE GEFFROY

...I'm in a very black mood and am profoundly disgusted with painting. It really is a continual torture! Don't expect to see anything new, the little I did manage to do has been destroyed, scraped off or torn up. You've no idea what appalling weather we've had continuously these past two months. When you're trying to convey the weather, the atmosphere and the general mood, it's enough to make you mad with rage.

On top of all this, I've stupidly succumbed to rheumatism. I'm paying for my sessions in rain and snow and it's distressing to think that I'll have to stop braving all weathers and not work outside except when it's fine. What a stupid business life is!...

Yours in friendship, CLAUDE MONET

*

[Giverny], 7 October 1890

TO GUSTAVE GEFFROY

effects (grain stacks), but at this time of the year the sun sets so fast that it's impossible to keep up with it . . . I'm getting so slow at my work it makes me despair, but the further I get, the more I see that a lot of work has to be done in order to render what I'm looking for: 'instantaneity', the 'envelope' above all, the same light spread over everything, and more than ever I'm disgusted by easy things that come in one go. Anyway, I'm increasingly obsessed by the need to render what I experience, and I'm praying that I'll have a few more good years left to me because I think I may make some progress in that direction . . .

Yours in friendship, CLAUDE MONET

*

Giverny, 14 December 1890

TO PAUL DURAND-RUEL

Please forgive me for not having thanked you earlier for sending the photographs along with the journal, but I'm working hard outside all day and I'm thus neglecting all my correspondence. I thought I told you that I had finally finished with the landlord and the house is mine at last.

Mirbeau paid me a visit two days ago and told me he'd written to you, anyway you can count on him and he's going to do the article on me. So write and tell him when you require it. I'll take care of the drawings, but could I ask you to be a little patient as I've got a lot to do outside? It's such beautiful weather that I want to make the best possible use of it. As for your exhibition plans, we'll talk about it when we next get a chance but I for one am against reverting to exhibitions of the old group. You have pictures by every one of us at your gallery, and they're a form of permanent exhibition; I think this is enough and holding the occasional small exhibition of a selection of recent work by any one of us would, I think, be much more worthwhile, whereas it seems to me to be useless to revive our old exhibitions, and perhaps even harmful. That's my opinion at any rate, and we must talk about it at greater length . . .

Yours sincerely, CLAUDE MONET

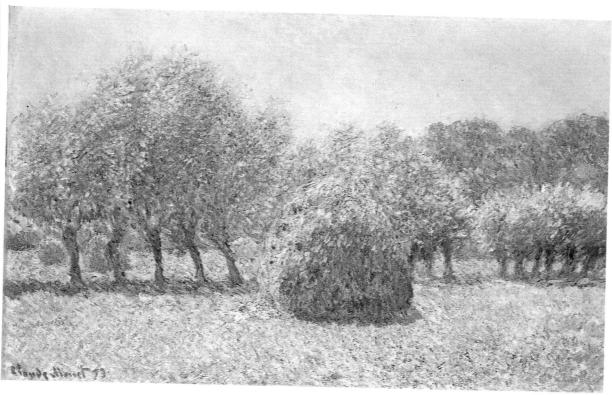

HAYSTACK

Giverny, 2 April 1891

To James Whistler

You must, by now, have received a letter from someone who is a friend of Mirbeau and also one of my own best friends. He wants to write an article on you for the new review (*L'Art dans les deux mondes*) and would like to look over some of your drawings to appear with the article in the above-mentioned review. Our friend Geffroy, who I believe paid you a visit in London this past winter, is a highly talented young man who, quite naturally, admires you and he'd do an excellent article on you. So you need have no fear of compromising yourself if you send him the drawings he'd like. The journal is in its infancy but I think its future looks promising. I'll have a few issues forwarded on to you so you can judge for yourself. My dear old friend, how long it's been since we last set eyes on each other! I had hoped to come to London this winter, but circumstances willed it otherwise. So I look forward to your next visit to Paris so that we can have a good long chat together.

I feel very guilty that I didn't write to thank you for the two lovely lithographs Mallarmé gave me on your behalf; you can't imagine how much pleasure you've given me. Could I ask you to remember me when any others appear?

Kindly remember me to Madame Whistler, all my very best wishes to you, and please don't forget my friend Geffroy.

Yours, CLAUDE MONET

Giverny, 30 June 1891

TO CHARLES DURAND-RUEL

I'll have the six paintings your father bought on his last visit delivered to your address tomorrow. Two of these paintings still need some finishing touches, these being the two pictures of grain stacks; you may keep the four other ones and would you kindly send the two others back in the same crate. I wish I could have sent them off today but delivery to Vernon was impossible. As to what you say in your previous letter, my reply is that I can't cater for those people who visit me at home; I have no wish to sell anything to anyone, American or otherwise. The important thing is not to do you down and you may be assured that I don't, and I generally ask for more than you do from collectors who believe that in coming to see me they can have paintings on the cheap. I sometimes sell sketches at a reduction, but only to artists or friends.

As for dealers' prices, you can be certain I've always given your father preferential treatment and I'm convinced that competition is best not only for me but most of all for you.

My kindest regards,

Your CLAUDE MONET

[Rouen], Friday 5 o'clock [12 February 1892]

To Alice Hoschedé

...It really doesn't suit me living in towns and I'm very fed up, particularly since things aren't going as I want. However, today I feel a little more cheerful: I've been able to move into an empty apartment opposite the cathedral, but it's a tough job I'm setting out to do.

There's a big dinner tonight at the coal merchant's, with the friendly solicitor and Mirbeau etc., but I can't wait to be back with you tomorrow. Hugs to you all and my loving thoughts, Your CLAUDE

Tuesday evening, Rouen [8 March 1892]

To Alice Hoschedé

... I remain in good spirits and have a clear view of what I'm doing; it might turn out well if the sunshine lasts, but I'm very much afraid it won't and I've just seen the moon surrounded by a huge double halo which is a bad sign . . .

Monsieur Depeaux just dropped in where I work with another invitation; he wanted me to come to dinner again this evening, but I've got out of it. I promised I'd go on Thursday; I'm going to be treated to some particularly good shrimps from Honfleur. As I suspected, he asked if he could be first on the list for two Cathedrals, one for himself and another for the Rouen Museum, but while I'll bear his request in mind I told him I could not dispose of a painting before I had first finished with it myself, and had looked over it on more than one occasion back in Giverny.

I'd really love to come to Giverny, but I must stay put all the same as long as the sun continues to shine, since once it goes I'm afraid it will be hidden for some time.

I don't have very much to tell you otherwise, I'm hard at work, I'm taking great pains and think only of my Cathedrals . . .

Your CLAUDE

Rouen, 31 March 1892

To Alice Hoschedé

I am utterly exhausted tonight and it will show in my letter. I've transformed, demolished all my paintings with sunshine; the die is cast, but I confess that there are some I have regrets about. If the fine weather continues, I may come through unscathed, but if there's another break in the weather then I'm done for and I'll have to limit myself to finishing the 2 or 3 grey-weather ones, but who can say what will happen? . . .

*

Rouen, 2 April [1892]

To Alice Hoschedé

Thank you for your welcome letter which awaited me on my return from work. I'm knocked out, I've never felt so physically and mentally exhausted, I'm quite stupid with it and long only for bed; but I am happy, very happy and would be happier still if the wonderful weather holds out for a few more days. Anyway, I think I'll have something to bring home with me, but will my luck hold out? The barometer is visibly dropping.

Naturally, I'll stay here tomorrow, unless there's a great change in the weather, since I've had another stroke of bad luck; the souvenir merchant at whose place I'm working has just asked me not to come in the afternoon in future, as it puts off passing customers; I didn't hide my desperation at the news and offered him one and then two thousand francs, which is what he wanted and he's agreed to put up with me for a few more days, but I can see it's disturbing him . . .

Think of me getting up before 6; I'm at work by 7 and I continue until 6.30 in the evening, standing up all the time, nine canvases. It's murderous and to think I drop everything, you, my garden, all for this...

*

Rouen, 13 April 1892

TO PAUL DURAND-RUEL

I'm writing to acknowledge receipt of your registered letter containing four thousand-franc notes, for which I thank you.

I am utterly discouraged and unhappy with what I'm doing here, I set my sights too high and I've managed to spoil what was good. I haven't been able to work for the last four days and I've decided to drop everything and go home, though I don't even want to unpack my canvases, I have no wish to see them until some time has elapsed; so I'll let you know when I've calmed down a little...

*

Giverny, 22 August 1892

To Eugène Boudin

Forgive me for not having replied sooner to your kind letter; I found it only when I got back from my trip and you can imagine what pleasure it gave me. I was above all very touched as well as very flattered by your request. I am not in a position to send you this memento today. I haven't done any work at all this year and I want to give you something worthy of you, but I won't need reminding.

You know how fond I've always been of you as well as grateful. I haven't forgotten that you were the first to teach me to see and understand.

Like you, I've often looked back on those early days, those delightful outings with Jongkind and Courbet. So I was very happy to see that you had also retained similar memories.

I hope very much to be able to come and see you this winter and talk about the good old days.

Your old friend CLAUDE MONET

*

Giverny, 12 December 1892

TO PAUL DURAND-RUEL

Yes, I have indeed recovered my taste for painting and I am working, but unfortunately it's not yet possible for me to embark on anything new. I've too many paintings which were promised a long time ago and first I must be rid of them, and it's a long and difficult task. Anyway, I'm getting on and I reckon that within a week I'll be able to deliver them all, including three or four that you've been wanting for some time.

After that I'll do something new, I'm feeling full of enthusiasm and I hope that the long rest will have done me some good.

Don't worry, you'll always be first in line.

Hoping to see you soon, yours sincerely, CLAUDE MONET

Giverny, 24 January 1893

TO PAUL DURAND-RUEL

... As you have guessed, I've been labouring all this while, painting outside despite the intense cold, but the thaw has come too soon for me. Not having worked for such a long time, I've done nothing but bad work which I've had to destroy, and it was only towards the end that I began to be my old self again. Result: only four or five paintings, and they're nowhere near complete, but I don't despair of resuming work on them again if the cold weather returns.

Best wishes from yours sincerely, CLAUDE MONET

P.S. It would be kind of you to let me know how long your Japanese exhibition goes on, as I want very much to see it.

1

[Rouen], Thursday evening 6 o'clock [16 February 1893]

TO ALICE MONET

I haven't wasted any time since I got here. Once I'd seen to my room and my luggage was installed, I went to the rue Grand-Pont; it's very well situated and the workers have just finished there. That done, I went to Monsieur Louvet to ask for the keys to the big house and then had easels carried to both spots and this morning I was hard at work.

I've started on two paintings and I'm back in the thick of my subject again. Proceeding in this manner, and when I see last year's effects coming, I'll be able to work without hesitation. So here's something to make you happy, and I have hopes of emerging from all this work victorious...

After work this morning I was able to make my visit to Monsieur Varenne at the Botanical Gardens. He's a very kind man, Monsieur Varenne, and I hope to obtain quite a lot of things from him; he offered me a cutting of that lovely climbing begonia which I'll bring back on Sunday. We visited all the greenhouses, really superb, what orchids! They're gorgeous. As for plants for the young botanists, he's going to introduce me on my next visit to the head gardener who is only allowed to give plants away on Monsieur Varenne's orders, but he tells me that it would be a good idea if the children were to draw up some kind of list of the species and subspecies they would like; they could work out a list with the priest. He gave me quite a lot of good advice on a lot of things; he's worth knowing in short. He told me I could go anywhere I wanted and feel at home . . .

I hope to hear from you this evening and most of all have some good news. Life here is not much fun and while I boast that I've no time to write, I feel the need to talk and tell you what I'm doing. So write to me at length, nothing could give me more pleasure...

*

[Rouen], Wednesday 22 February 1893

TO ALICE MONET

What terrible unsettled weather! I carry on regardleses without a break. I'm feeling better but, dear God, this cursed cathedral is hard to do! Since I've been here, a week tomorrow, I've worked every day on the same two paintings and can't get what I want; well, it will come in the end, with a hard struggle. I'm very glad I decided to come back, it's better like this...

*

[Rouen], Friday 3 March [1893]

TO ALICE MONET

Things went a little better today and I'll finish with this cathedral eventually, but it will take time. It's only with hard work that I can achieve what I want; I wouldn't be surprised if once again nothing definitive comes of it, and I might have to come back next year. I'll certainly do all I can to pull through this time; it depends on the weather, but in any case I don't want to prolong work endlessly or alter my paintings as the sun gets higher. Anyway I'm a little happier today, but I'll have deserved my Sunday off...

[Rouen], Thursday evening [9 March 1893]

TO ALICE MONET

I'm working away like a madman but, alas, all your words are in vain, and I feel empty and good for nothing. It all happens at once, the weather isn't very predictable: wonderful sunshine yesterday, fog this morning, sun this afternoon which disappeared just when I needed it; tomorrow it will be a dark grey day or rainy, and once again, I'm very much afraid I'll leave everything and come home on an impulse . . .

What's the good of working when I don't get to the end of anything? This evening I wanted to compare what I've done now with the old paintings, which I don't like looking at too much in case I fall into the same errors. Well, the result of that was that I was right to be unhappy last year; it's ghastly and what I'm doing now is quite as bad, bad in a different way, that's all. The essential thing is to avoid the urge to do it all too quickly, try, try again, and get it right once and for all...

*

[Rouen], 28 March 1893

To Gustave Geffroy

... My stay here is advancing, which doesn't mean that I'm near to finishing my *Cathedrals*. Regretfully I can only repeat that the further I get, the more difficult it is for me to convey what I feel; and I tell myself that anyone who claims he's finished a painting is terribly arrogant. To finish something means complete, perfect and I'm forcing myself to work, but can't make any progress; looking for something, groping my way forward, but coming up with nothing very special, except to reach the point where I'm exhausted by it all.

Rouen, 29 March 1893

TO ALICE MONET

Thank you for your kind words and for what you've done. You don't mention your poor leg, I hope that's a good sign and that it's better. You've no idea how much I think of Giverny in this fine weather and envy you being there; but I'm a prisoner here and I must see it through to the end, even though as things are my strength is failing, the pace is killing and I'm working feverishly.

Fourteen paintings today, it's unprecedented. If I lived in Rouen, it's now that I'd be starting to understand my subject. I've taken my time but now I'm nearing the end and I won't be here much longer; firstly because I'm too tired and preoccupied with my return home, and also because it (the lighting) is changing drastically; gone is the oblique light of February, every day it gets whiter and higher up, and from tomorrow I'm going to work on two or three more canvases...

*

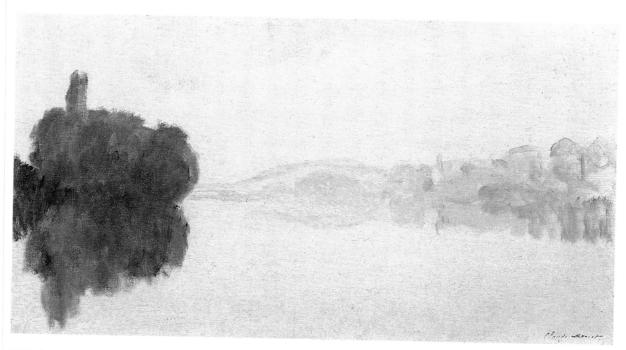

THE SEINE AT PORT-VILLEZ, PINK EFFECT

[Rouen], Tuesday night, 10 o'clock [4 April 1893]

TO ALICE MONET

How guilty and unhappy I felt last night when I saw how much I had pained you. I hope you've forgiven me, realizing the trouble I must have been having to get into a state like that. The weather's unchanged but unfortunately I and my nerves fluctuate with every interruption to my work.

This morning I felt quite out of sorts, my things were all over the place in utter disorder and my paintings looked atrocious in the altered light. In short, I won't be able to do anything worthwhile, it's a stubborn encrustation of colours, that's all, but it's not painting. I'll carry on for one more week so I have no regrets, but I'm very much afraid to no purpose. What is it that's taken hold of me, for me to carry on like this in relentless pursuit of something beyond my powers?

I've only myself to blame for it, my impotence most of all and my weakness. If I do any good work now it will be only by chance.

Giverny, 17 July 1893

To The Préfect of The Eure

May I humbly submit a few observations relative to the opposition drawn up by the municipal council and a few inhabitants of Giverny, relating to two inquests concerning the request I had the honour of making to you with the aim of obtaining authorization for a water channel on the River Epte, the purpose of which is to supply a pond where I would like to grow aquatic plants.

I feel I must point out to you that the above-mentioned opponents are using public health as a pretext, their sole intention being to interfere with my plans out of pure ill-will, a common enough attitude in the country where a private individual, a Parisian, is concerned. Moreover the number of people opposing me, which is very small in relation to our population, consists

of people I do not employ or have ceased to employ at my home, such as Madame Serrurier etc., and they are merely wanting to cause vexation in a vengeful spirit. May I thus be so bold as to hope, Monsieur le Préfet, that you will be so kind as to take these considerations into account and give a favourable response to my request.

I would also like you to know that the above-mentioned cultivation of aquatic plants is not as significant as the term suggests and that it is merely intended for leisure and to delight the eye and also to provide motifs to paint. Finally, in this pond I will grow plants such as waterlilies, reeds, different varieties of irises which for the most part grow wild along our river, and there is thus no question of poisoning the water.

Should the locals remain unconvinced, I will nevertheless undertake to renew the water of the pond mentioned during night hours when no one uses the water.

I hope that these explanations will enable you to make a full appraisal of the facts as they are and that it will be possible for you to make a decision in my favour.

I hope, Monsieur le Préfet, that you will excuse the liberty I have taken in writing to you, I am Sir, your most respectful servant, CLAUDE MONET, painter

Giverny, 21 May 1894

TO PAUL DURAND-RUEL

I rather fear that you're angry with me for having given up my exhibition and most particularly for having given you so little warning, however I'd like to think otherwise, and hope you don't begrudge me quoting such high prices for the *Cathedrals*. I had counted on giving you the first and most complete choice, without even setting any aside for myself (and I would have chosen the better ones). If we could have talked it over more reasonably when you came, I'm sure we might have come to a better understanding.

I still haven't seen everyone, but when I have, we'll discuss this delicate matter again. Anyway, this is what I intend to do. Set aside a number of *Cathedrals*, the ones to which I attach most importance, which would not be for sale for the time being unless at a very high price. This will enable me to sell the others for less. I think this is a better solution and one I ought to have arrived at earlier. I am very glad I postponed the exhibition until October or November. I'm very involved with my work as it is and, with what I do between now and then, I'll have a much more varied and complete exhibition, and I don't want to stop work now despite the problems the unsettled weather is causing.

I'd be very relieved to have a line from you to tell me you don't bear me any ill feeling. Kindest regards,

Yours sincerely, CLAUDE MONET

[Giverny], 23 November 1894

To Gustave Geffroy

...It's settled then for Wednesday.

I hope Cézanne will still be here and will join us, but he's so odd, so afraid to see a new face that I'm afraid he'll give us a miss, despite his keen wish to make your aquaintance. How sad that such a man hasn't had more support in his life! He's a true artist and has come to doubt himself overmuch. He needs encouragement, and he was thus very touched by your article!

CLAUDE MONET

NORWAY, THE RED HOUSES AT BJORNEGAARD

Giverny, 21 January 1895

To Paul Durand-Ruel

As I told you, I'll be leaving next Monday for Norway. So if you intend to come to Giverny, you must hurry, if not don't be suprised if some of my recent paintings go elsewhere. Monsieur Montaignac, as I said, has already made his choice and furthermore Monsieur Valadon wrote to me asking if he could come and see my recent work. I replied that he could visit this week, but warned him of my insistence that the subject of the *Cathedrals* was closed. So if you do intend to acquire some (I'm referring to the *Cathedrals*), you'd do well to back out of your agreement, otherwise you risk getting here after everyone else has made their choice...

Christiania, 3 February 1895

TO ALICE MONET

... I arrived utterly exhausted after all the delays, and generally unenthusiastic. The journey was for the most part monotonous and the endless snow after Paris was a little wearing after a while; however my last day on the train afforded some extraordinary sights, more beautiful even than Christiania, but nightfall prevented me from seeing any more beautiful things; you understand that I can't describe everything I've seen as it would take too long. I'll confine myself to giving you my first impressions of Christiania. My arrival in the evening left me cold and I was even more unimpressed by my first outing yesterday. The place must be infinitely more beautiful without snow, or at least with less than this. The most beautiful feature of the fjords is the water, the sea, and it's nowhere to be seen; there's ice but it's covered with snow and so much so that you can't even see when you're by the sea. A few scattered areas of ice are devoid of snow and there the ice is smooth, a wonderful sight, you can walk across it, go over in a sleigh in the afternoon and today in particular I've seen some very beautiful, even spectacular things, but most delightful of all is the life here: travelling on a sleigh wrapped up in furs is pure delight, then there are the dogs. Everybody, the entire population goes mad and thinks of nothing else, small children and grown-ups alike and all of them in delightful costumes like Lapps. It's a delight for me to watch them: that's all you see, groups heading off with their bags, going up into the mountains, day and night, lit up with torches in the dark . . .

Christiania, Saturday 9 February 1895

TO ALICE MONET

have been in a continual state of amazement, and but for one small snag I'd be overjoyed, which is that there's a little too much attention given to my person from newspapers, in restaurants and cafés. There's talk of a banquet which the painters and writers here want to give me. Jacques had concealed this from me, but I hope to get out of it, having already spread the word that I'm used to a simple life on my own and while very flattered I'm not very fond of such things...

*

Christiania, 13 February 1895

TO ALICE MONET

This morning we at last received your two letters of the 8th and 9th, we were beginning to worry, and had we not received your two dear letters this morning I was ready to send you a telegram.

I can see that it's very cold where you are too, but it's nothing compared to here; your night temperatures are our day ones. I can well understand how happy the skaters are, but I dread what's happening to the garden, the bulbs. Is the ice on the pond being watched carefully? It would be very sad if everything planted there were to die. That aside, I now regret that I went away at this time, since apart from my joy in being with Jacques and sending you good news of him, the trip will have served no purpose. Up to now I had thought I'd be able to work. To that end we travelled all day again yesterday and saw more beautiful things, but I can see it will be far too difficult; getting things set up, and the amount of time it takes to go to and fro makes work out of the question. And as I can't see the point of covering canvases only to leave them behind, I'm giving up the idea, much to Jacques' disappointment. All this is making me rather gloomy and I very much regret not being in Giverny, where I might have taken advantage of the fine sights to be seen there at this time of year, and since I've now seen quite enough of Norway, it's quite possible that I'll make my way back to France unannounced, having little desire to see a country which I can't paint.

*

[Christiania], 15 February 1895

TO ALICE MONET

It's two days now since I last wrote to you, but although I was very discouraged and all set to board the boat for Le Havre, I wanted to have one last try at finding a spot where I could set myself up, a place of work without the need for a sleigh or train journey. After an excursion which was as wonderful as ever, I have, in short, found what I want at last, so I believe. I've just moved in, it's three-quarters of an hour from Christiania. There are painters around and a writer who speaks French, all of whom are very considerate and obliging. When I went yesterday with Jacques and they recognized me, they were falling over themselves to show me around in their sleighs and finally I joined the wife of a painter on a two-hour tour...

[Sandviken], 12 March, 9 pm [1895]

TO ALICE MONET

hampering me a good deal; on top of that it's getting noticeably warmer and I'm dreading a thaw. I've already had to give up on several pretty scenes on the fjord; crossing the fjord in vehicles is now prohibited, you can only go on foot, but it's too far away and what's more very hard going. I'm working without a break despite all these changes and the snow, but I won't be able to get anything finished; I have to limit myself to capturing a view in one or two sessions, impossible to find the same effect again, especially at this time of the winter. I also had several paintings of sunlight but it's a good ten days now since the sun appeared, when it does it will only melt everything. But what wonderful things I'm seeing, what lovely effects I was blind to in the beginning. It's only now that I can see what needs to be done and how; I ought to have come here a month earlier and no doubt this place is worth another visit, you couldn't conceive of snow effects like it in France, it's wonderful, but I'm going on and on and I'm in need of rest. Let me kiss you now and finish these lines tomorrow before Jacques leaves.

Sandviken, 20 March 1895

TO ALICE MONET

the cold has come back with a vengeance, but I can't do very much with it, unfortunately, as everything's changed, the light above all, and the snow has disappeared from the roofs, having been cleared off with the coming of the thaw, to lighten the weight on the rafters; elsewhere the snow which was beginning to thaw is now as hard as ice and it's possible to walk over it almost everywhere, although the sun is hot enough to burn...

I reckon I'll be leaving on the 30th, on the Antwerp boat I think. I'll go to Christiania one morning soon to find out about departure times and look at the boat...

Giverny, 18 May 1896

To James Whistler

I've just learned of the dreadful sorrow that has befallen you and am writing to express my sympathy for you in your distress. I had the good fortune to enjoy the grace and intelligence of Madame Whistler, I know how much she adored you and can imagine how great your affliction must be. But you must be brave and strong in the face of the harsh blow that has been dealt you. May the sympathy of an old friend console you in some small way. I send you my deepest sympathies, and apart from the admiration I have for you, you must know how fond I am of you.

Yours affectionately, CLAUDE MONET

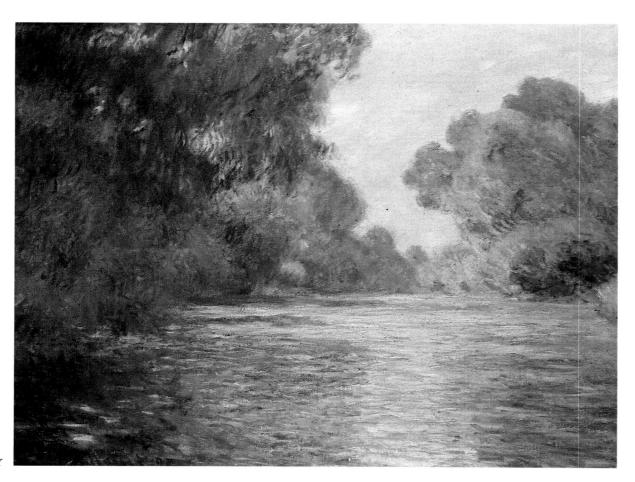

THE SEINE AT GIVERNY

Giverny, 23 April 1897

TO AUGUSTE RODIN

It was not until today that I received the admission card for the private view and even though I had an unexpected visit yesterday, I would have been delighted to have been present at your triumph. For since my visit the other day I haven't stopped thinking of your *Victor Hugo* and of another fine work I saw at your home. But it's something to look forward to, as I intend to come to Paris soon. Thank you for thinking of me and I'm sorry I was unable to come and shake your hand yesterday. And thank you again for the gorgeous things you've given me and which are a joy to me.

*

[Giverny], 3 [December] 1897

TO EMILE ZOLA

Bravo, well done for the two fine articles in the *Figaro*. You are the only one to have said what had to be said, and so well too. I'm delighted to be able to send you my congratulations.

Your old friend, CLAUDE MONET

*

[Giverny], 25 February 1898

To Gustave Geffroy

... Zola's admirable courage! It's absolutely heroic! I'm certain that when things have calmed down a bit, everyone in their right minds will come round to seeing things for what they are and recognize what is so fine about Zola's action.

[Giverny], 30 June 1898

To Auguste Rodin

Can you believe that after various setbacks too numerous to mention, it was only yesterday that I was able to go to the Salon and I couldn't even let you know in time to see you, however briefly.

I finally saw your *Balzac* and although I knew that I would see a fine piece of work, I must tell you in all sincerity that it surpassed my expectations. Let them say what they like, you have excelled yourself; it's absolutely beautiful and magnificent, superb and I can't stop thinking about it.

Cordially yours, your old friend CLAUDE MONET

*

[Giverny], 29 January 1899

TO GUSTAVE GEFFROY

... A week ago poor Sisley called for me to go and see him, and it was then that I saw he wanted to say goodbye. Poor old friend, poor dear children!

*

Giverny, 3 February 1899

To Gustave Geffroy

I received the letter you sent to Sisley's but I didn't have any time to see you, as I had to make several trips to Moret mainly because of the funeral and to spend some time with his poor children. Thank you for offering your services; your help will no doubt prove invaluable. For the time being I'm going to see about holding a sale for the childrens' benefit; that's the most urgent thing, then a good exhibition of Sisley's best work should be arranged.

I'll be seeing you shortly and we'll talk all this over, I hope you're feeling better. I greatly missed you since there was no one at the funeral.

In haste, best wishes and regards to everyone at home.

CLAUDE MONET

*

Giverny, 7 February, 1899

TO PAUL DURAND-RUEL

I have some very sad news for you. Madame Butler, our beloved Suzanne, died last night, while her poor mother was ill in bed with acute bronchitis which she caught the other day in Moret.

One sorrow and affliction after another! All the same I must be strong and comfort my family.

Yours in haste, CLAUDE MONET

Giverny, 17 March, 1899

TO PAUL DURAND-RUEL

Degas's participation in the sale for Sisley's children. The date of the sale is fixed for 1 May, at the Galerie Petit, with a preview on the 29th and 30th; it will consist of the few paintings Sisley left along with gifts from friends and colleagues. I'm sure Degas would be glad to be associated with this act of charity and I'd be very grateful if you could ask him as soon as possible and inform me at once of his reply.

My best regards,

Yours sincerely, CLAUDE MONET

My wife's condition has improved thank God, but the wound will take a long time to heal. I hope you've good news from Renoir.

*

Giverny, 15 January 1900

TO PAUL DURAND-RUEL

As telegraphed last Saturday, I'm sending two crates over to you today in some haste; one containing six canvases in the series (*Water-lily ponds*), the other containing two, another in the same series, and a picture which you will be kind enough to set aside for Monsieur G. Geffroy who will pick it up. As we agreed on your visit here, the prices of the paintings are as follows: six at 6500 and one at 6000, that is 45,000 all together, for which you were so kind as to advance me 30,000 francs. So all is in order. As for the London paintings, I don't know if I'll be able to deliver any before my return. I'll tell you within the week as I only want to send you work I'm satisfied with. I'd be glad to know what Renoir's response was with regard to the Exposition Universelle; I hope he agrees with me.

Pissarro with whom I'm keeping in touch by post is of the same mind and I for my part have informed Monsieur Roger Marx that I personally have taken a stand against participation in the exhibition. Indeed, if the adminstrators were to have had the pleasure of our participation in the exhibition, they ought to have consulted us first, and offered us a proper room where we might have been able to exhibit a number of our paintings. Since this was not the case, all we can do, in my view, is to abstain, and I am counting on you to keep me informed of anything you may learn or hear.

I still intend to leave for London in early February and I'd be obliged if you wouldn't send any of the paintings I'm sending you over to America. It would be better for you to keep them for exhibition this summer.

Regards from

Yours sincerely, CLAUDE MONET

*

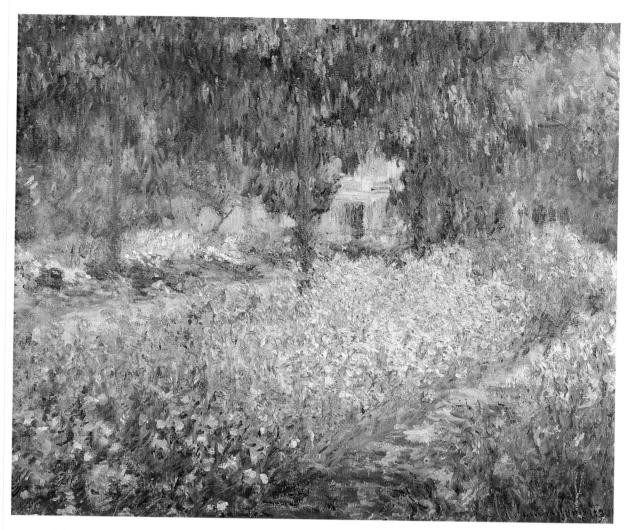

MONET'S GARDEN AT GIVERNY

Giverny [February 1900?]

TO HIS GARDENER

Sowing: around 300 pots Poppies – 60 Sweet pea – around 60 pots white Agremony – 30 yellow Agremony – Blue sage – Blue Waterlilies in beds (greenhouse) - Dahlias - Iris Kaempferi. - From the 15th to the 25th, lay the dahlias down to root; plant out those with shoots before I get back. - Don't forget the lily bulbs. - Should the Japanese paeonies arrive plant them immediately if weather permits, taking care initially to protect buds from the cold, as much as from the heat of the sun. Get down to pruning: rose trees not too long, except for the thorny varieties. In March sow the grass seeds, plant out the little nasturtiums, keep a close eye on the gloxinia, orchids etc., in the greenhouse, as well as the plants under frames. Trim the borders as arranged; put wires in for the clematis and climbing roses as soon as Picard has done the necessary. If the weather's bad, make some straw matting, but lighter than previously. Plant cuttings from the rose trees at the pond around manure in the hen huts. Don't delay work on tarring the planks and plant the Helianthus latiflorus in good clumps right away. If anything's missing such as manure, pots etc., ask Madame if possible on a Friday so as to have it on Saturday. In March force the chrysanthemums along as the buds won't open in damp conditions; and don't forget to put the sulphur sheets back over the greenhouse frames.

London, Wednesday 14 February 1900, 9 p.m.

TO ALICE MONET

... But what weather and how gloomy I was at the prospect of being unable to paint! Fortunately I had a better day than expected, I was able to work before and after lunch from my window and at 5, with the sun setting gloriously in the mist, I started work at the hospital. If only you could have seen how beautiful it was and how I wished you were here on the terrace with me; it seems it was cold and I was oblivious to it in my enthusiasm for the work in hand and for the novelty of it all, but how hard it's going to be!

I had barely settled down to my painting when the hospital treasurer appeared, to invite me downstairs for tea, but he had not imagined that I would be unable to leave my picture; I made it as clear as I could to him, not in good English, but using sign language to express my keenness to get down to work. Ten minutes later, the good man came back in person with a cup of tea, sandwiches and cakes; which did me some good, I must admit...

I get your good letters regularly and they give me a lot of pleasure, but I'd be happier if I knew that the hours passed more easily for both of you, and I'd also be relieved to know that the weather permits a few outings and diversions of some kind. So take comfort in the thought that I'm working.

*

London, Monday morning 10 a.m. [26 February 1900]

TO ALICE MONET

... Rest assured that you have no reason to be jealous and I don't know why you've got the idea that Clemenceau could lead me into bad company. He and Geffroy arrived very promptly, delighted to see me and of course very caught up in what I'm doing. After we changed, we went to the dinner, a very chic affair, not with Madame Asquith but with the lady Clemenceau had introduced to us and whom we saw again at Sargent's; she's a spinster. Clemenceau thought he had introduced us to her sister who is married and her husband, Salisbury's son, who was wounded in the Transvaal. There were a lot of people there, politicians including a current minister and I must say that it was fascinating, with Clemenceau talking as plainly as he does; Mr and Mrs Asquith (Margot) were there, an extraordinary character who is going to send me permission to paint in the Tower of London. Sargent was invited but wasn't able to come or didn't want to because of Clemenceau, it appears, as he once wanted to paint his portrait and he completely failed at the task...

In the early hours of this morning there was an extraordinary completely yellow fog; I did an impression of it which I don't think is bad; otherwise it's still fine, but very variable; so I had to start lots of canvases of Waterloo Bridge and the Houses of Parliament; I also resumed work on several paintings done on the first trip, the least good ones. I'm mostly working here for the time being, and don't go to the hospital until 4 in the afternoon. Unfortunately the fog doesn't seem to want to lift and I fear the morning will be wasted...

*

London, Friday 9 March 1900, 6.30

TO ALICE MONET

My darling, no letter from you again this morning and the only news I've had is in a kind letter of Blanche's who says his house seems very empty now you've gone. Here it's been very fine today with sunshine, which is a rarity, and as I had predicted, the sun already sets a long way from the place I'd wanted to paint it in an enormous fireball behind the Houses of Parliament; so there must be no further thought of that; all the same I had a good day and if I had several more like this I'd do my very best work...

*

London, Sunday 18 March 1900, 5 p.m.

TO ALICE MONET

I don't know if you're having the same weather as we are, but there must have been a severe frost last night; when I awoke everything was white, which doesn't presage good weather; sure enough, since lunch, there's been a terrible wind raging and snow etc... but it didn't stop me from being out in a shower before six this morning, and it was damned beautiful; each morning I get carried away like this until the weather makes things too difficult for me. I had a terrible struggle today, and it will go on like this until the day I leave. The only shortage I have is of canvases, since it's the only way to achieve something, get a picture going for every kind of weather, every colour harmony, it's the only way; in the beginning you always think you'll find an effect again and finish it: hence those unfortunate transformations which get me nowhere.

I'm not lacking for enthusiasm as you can see, given that I have something like 65 canvases covered with paint and I'll be needing more since the place is quite out of the ordinary; so I'm going to order some more canvases...

London, Monday 19 March 1900, noon

TO ALICE MONET

Darling, I am in a state of utter despair and it wouldn't take much for me to drop everything on the spot and go tonight, and leave all my paintings with the artist's colourman until later. I don't know if I'll get over it but I feel enervated and profoundly disgusted. Perhaps I got out of bed on the wrong side? The fact is that I was up at six and was appalled to see the roofs covered in snow; I was hoping that by the time I'd got dressed, it would melt away, but it became terribly foggy, so much so that we were in total darkness, and I had to have the lights on until half-past ten; then I thought I'd be able to work but I've never seen such changeable conditions and I had over 15 canvases under way, going from one to the other and back again, and it was never quite right; a few unfortunate brushstrokes and in the end I lost my nerve and in a temper I packed everything away in crates with no further desire to look out of the window, knowing full well that in this mood I'd only mess things up and all the paintings I'd done were awful, and perhaps they are, more than I suppose. I must confess too that I'm distressed to see you giving in, I can read it between the lines even when you don't say a word, and in the state I'm in, that's enough to finish me off. To have gone to all this trouble to get to this is just too stupid! Outside there's brilliant sunshine but I don't feel up to looking at it . . .

London, Wednesday evening 6.30 [28 March 1900]

TO ALICE MONET

My darling, I can well imagine your joy at the thought of seeing your dear little ones and Marthe again; don't get too anxious or overexcited in the meantime. I'm going to do my very best to come on 5 April as well, a day or two more or less won't get me much further anyway, unless a miracle happens between now and then so that I'd only need one or two more sessions to be able see something through to completion; for you musn't expect to see any finished work; they're only essays, studies, preparatory sketches, in short ridiculous and vain research, and as you say, I must be cut out for such work, both mentally and physically. Just imagine, I'm bringing back eight full crates, that's eighty canvases, isn't it frightening? And if I'd had the right idea in the first place and had started afresh each time the effect changed, I would have made more progress, instead of which I dabbled around and altered paintings that were giving me trouble which as a result are nothing more than rough drafts . . .

Your old CLAUDE

*

London, Saturday 2 February 1901

TO ALICE MONET

... Sargent had me invited along to a house where we could see the funeral procession together, but what we hadn't reckoned on was how hard it would be to meet up and get there, and there wasn't a cab to be had anywhere this morning...

We had planned to meet at the door but fortunately Sargent had given me a word of introduction and seeing that by 9 o'clock there were so many people at the windows and balconies, I finally entered alone. Inside, the drawing room was full of ladies; you can picture my face! Anyway the host and hostess, who were charming, introduced me at once to French speakers and found me a good position. I met the sister of Madamoiselle Maxse, Clemenceau's friend, and also a great American writer living in England, who spoke wonderful French and was very kind to me, explaining everything, showing me all the court personages etc. (his name is Henry James). Sargent tells me he is the greatest English writer. Does Butler know him? We waited until it was almost midday, and as it was cold, some soup was handed round.

There were a good hundred people in the house, on every floor, and I was lucky enough to be on the first floor along with Sargent who arrived after 10. Anyway I'm very happy to have seen it, for it was a unique sight, and to add to it the weather was superb, a light mist, with a glimpse of sunshine and St James's Park in the background. But what a crowd! And how wonderful to have been able to do a rapid sketch.

Standing out against the black of the crowd, the cavalry officers had red coats, wonderful helmets, and a mass of uniforms from every country in the world! But aside from everyone paying respects as the hearse went by, how little like a funeral it was! To begin with, no crepe, no black, every house decorated with mauve fabric, the hearse, a field cannon drawn by magnificent bays, covered in gold and coloured drapes. Then at last, the King and William, who looked so slight I was astonished; I had expected a fine figure of a man. As for the King, he looked stunning on a horse and finely turned out. It was superb.

What a feast of gold and colour and the ceremonial carriages, the horses! It almost hurt my eyes...

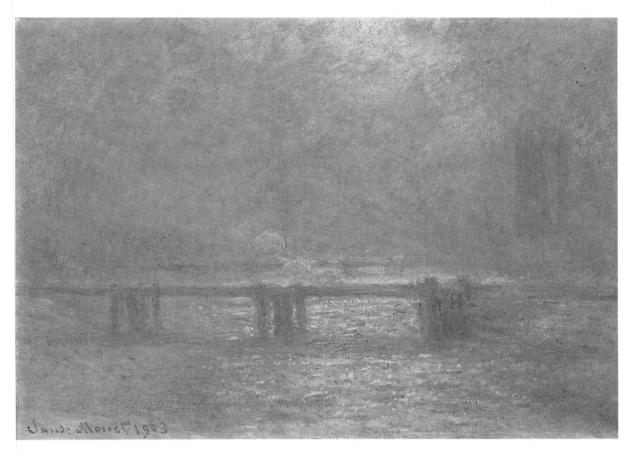

CHARING CROSS BRIDGE

[London, Sunday 3 February] 1901

TO ALICE MONET

... Although by 9 I'd already done some work on four paintings, I was convinced, since I'd got up at 6, that I was going to have a very bad day. As always on Sunday, there wasn't a wisp of fog, it was appallingly clear in fact: then the sun rose and was so dazzling I found it impossible to see. The Thames was all gold. God it was beautiful, so fine that I began work in a frenzy, following the sun and its reflections on the water. Meanwhile, kitchen fires began to be lit. Thanks to the smoke a mist descended, followed by clouds etc. . . .

2.30. I can't begin to describe a day as wonderful as this. One marvel after another, each lasting less than five minutes, it was enough to drive one mad. No country could be more extraordinary for a painter. It's dark now, for a few minutes, and I had to turn on a light so that I could jot down my impressions for you. I was telling you then that it was my worst day for post, although I'd love to know how you are, you and Jean-Pierre, and if there is any news. Also I'm a little worried Michel might have been sent back to Rouen since he didn't come round the other evening. And I have to wait until tomorrow to know all this. Meanwhile for you this is a good day, you're with the children and all the joys and scrapes the little ones get into and you know I won't hear until tomorrow. I musn't complain too much, however. Of course I wish I could be whisked over by magic, to be with you all, but I'm also having some good times. I'm seeing some unique and wonderful sights and splashing about with paint. There are moments when things look up and then once again I plunge into that terrible despair you know. But I'm keeping my courage up, hoping that all these efforts won't be in vain. But here comes the daylight again, so I'll stop.

London, 2 March 1901

TO ALICE MONET

The weather's terrible, just like it was yesterday at Giverny. Torrential rain and it's beating so hard on the windowpanes that I can barely see anything at all. I'm making the best of it by writing to you, very glad to know that at last your minds are at rest, and I hope that you finally have a little peace so you can recover properly.

I'm very disheartened by the weather. Yesterday I was happy and full of energy and was looking forward to a good day; yesterday evening the weather was perfect, but as I've said before, it is not possible to work on the same paintings two days in succession, and I'll have to limit myself to concentrating only on studies and rough sketches so that I make something of them at my leisure in the studio. It's almost impossible to continue work on a painting. I make alterations to paintings and often ones that were passable are worse for the change. No one would ever guess the trouble I'd gone through to end up with so little; besides, it must be said, working in two places is not a good idea; I often have to interrupt work on a painting which I could have finished in another hour because it's time to go to the hospital. I've had that happen to me several times already; still, I'm not giving up hope...

Giverny, 15 April 1901

To Gustave Geffroy

If I didn't reply to your affectionate letter sooner it was only because I wasn't well when I received it, and then taking advantage of a fine day I at last got going again. Back in my beloved Giverny, I needed several days to recover properly, and then sort out everything I'd brought back. That's done now, I'm feeling fine and can tell you to come as soon as you are able and I'd be delighted to see you. I'd also be glad to show you the numerous studies, sketches and attempts of all kinds that I've brought back with me and to have your impressions. I hope that you'll let me know when you're coming as soon as you receive this.

In haste, my best wishes, and remember me to your family.

Yours, CLAUDE MONET

Giverny, 14 February 1902

TO ALICE MONET

My darling, I can't tell you how glad we are to receive your news by telegram. Like you we were very anxious, and we are looking forward to tonight when we'll have more details from J.-P. and Anna since, up to now, we've only had your first letter written the evening you arrived and this morning J.-P.'s, written that same evening but no doubt sent later. So carry on sending us a telegram by post each morning; Fouillard delivers it to me around 11, and send me your news too. And I beg of you, go out a little each day, for a walk or two.

Apart from the great hole you've left with your departure, all's well here and you mustn't worry, Marthe is taking care of everything and last night they asked me and Michel to dine with them, (Michel keeps me company every evening, mainly to have your news). Marthe and

I saw the little ones to bed and made my lonely way to our huge bedroom. I don't need to tell you that Blanche immediately offered to come round. But things are fine as they are and Anna and J.-P. will come and add a bit of a sparkle to evenings which are hard to bear alone. And you can tell Inga that she need not worry, her daughter will be looked after and tell Jacques how glad we are to know he's getting better. Write me a long letter, my darling, and above all look after yourself, tell me honestly how you are. And if you need anything whatever telegraph me for it.

I've sent off the *Vétheuils* to Valadon at last, I still have to deliver Durand's. It's very fine but cold, every night it drops to between 5 and 9 below zero. Work seems to be advancing, but planting is delayed.

In haste now, love and kisses to you, Jacques and Inga.

Your old CLAUDE

Giverny, 23 March 1903

To Paul Durand-Ruel

No, I'm not in London save in thought, working hard on my paintings which are giving me a lot of trouble, and I'm not acquainted with the person who's asking you for my address, but you may give it to him anyway.

I can't send you a single *London* painting since for this kind of work I need to be able to see them all, and quite honestly none of them are completely finished. I'm working on them all, or on a number of them anyway, and don't yet know how many I'll be able to exhibit, since what I'm doing is very delicate. One day I'm satisfied and the next everything looks bad, but anyway there'll be a few good ones at least . . . In haste, best wishes,

Yours sincerely, CLAUDE MONET

Giverny, 15 April 1903

To Gustave Geffroy

... You ask me when the exhibition of my poor old London pictures is due to begin. I promised it would be ready by early May, but I'm afraid they'll all be ruined by then. You tell me calmly to frame them and exhibit them as they are; that I won't, it would be stupid to invite people to look at sketches which are far too incomplete. Where I went wrong was to insist on adding finishing touches to them; a good impression is lost so quickly; I very much regret it and it sickens me because it shows how powerless I am. If I had left them as they were and had not planned to sell them, people could have done what they liked with them after my death. Then these essays, these preliminary studies, could be shown as they are; now that I've had a go on every single one of them, I have to see them through, for better or worse, to some kind of conclusion, but you have no idea what a state of nerves and despair I'm in! So please excuse me.

Your devoted friend CLAUDE MONET

Giverny, Sunday 10 May 1903

TO PAUL DURAND-RUEL

My silence might have given you cause for hope that I was feeling more satisfied and that I would eventually turn up with my paintings. Unfortunately this is not the case. My strength has given out and I've never been so sickened by it all even though I'm still working; but it's rest I need more than anything at the moment, until the fine weather comes and I am able to get back to painting from nature, and that will be the last effort I'll make to see if I'm still good for something. But the important thing is to stop slaving away for the time being at the *London* paintings which I want to put out of my mind . . .

Best wishes,

Yours sincerely, CLAUDE MONET

*

Giverny, 2 March 1904

TO PAUL DURAND-RUEL

I received your letter with the cheque for 10,000 francs it contained, for which many thanks, but I'd prefer not to deposit it until I have a clearer explanation of the meaning of your letter. I'm very well aware that current problems must be affecting business and this is precisely why I insist that our dealings should be straighforward. I've been working on the *London Views* for almost four years now; all along I've continually rejected offers, many on very good terms, to the point where I wrote to you a short while ago to see if I should continue to reject such offers or if it was still certain that you would take them. You replied that I needn't worry, having always said that I could take my time until I was fully satisfied with them. I hope, as you do, that this decline in business is only temporary, and while you might regret that you weren't able to sell a few *London* pictures before the crisis, there's no reason why I should regret having set them aside for you; that's why I don't wish to be indebted to you before knowing what I'm in for. I must therefore be absolutely sure of your intentions. So I look forward to hearing from you before I deposit your cheque.

Yours sincerely, CLAUDE MONET

I don't share your opinion and am very glad I didn't send you a few of the paintings, since the overall view of the complete series will have a much greater effect.

<

Giverny, 4 June 1904

TO GUSTAVE GEFFROY

Here's 100 francs to attend to Fèvre's needs. May they help him in some small way to recover his health and peace of mind! I took my time about sending this to you as I didn't want to write before I'd read your article. There's no doubt this time that the Press has overdone it with the praise they've showered on me, for I know what I'm worth better than anyone, but I'm very touched by your own compliments and thank you for the fine article to add to so many others, and am grateful you remembered your visit to me in London with Clemenceau.

You must come and see us during this fine weather and spend a day enjoying my garden which is quite beautiful at this time of year.

In haste, best wishes, and remember me to your mother and sister. Thank you once again, my dear friend.

Yours, CLAUDE MONET

Giverny, 4 October 1904

TO PAUL DURAND-RUEL

I've been having a few day's rest and I was planning to invite you to lunch some time soon but I've just now decided to put a long-cherished plan of mine into practice: to go to Madrid to see the Velasquez. We are leaving by car on Friday morning for about three weeks, and as soon as I get back I'll invite you here if you can manage it. If there is any way you could facilitate access to any of the masterpieces in Madrid, it would be kind of you to write as soon as you can, given our probable departure on Thursday after lunch.

My regards to you and your family, and looking forward to seeing you soon,
Yours sincerely, CLAUDE MONET

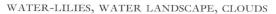

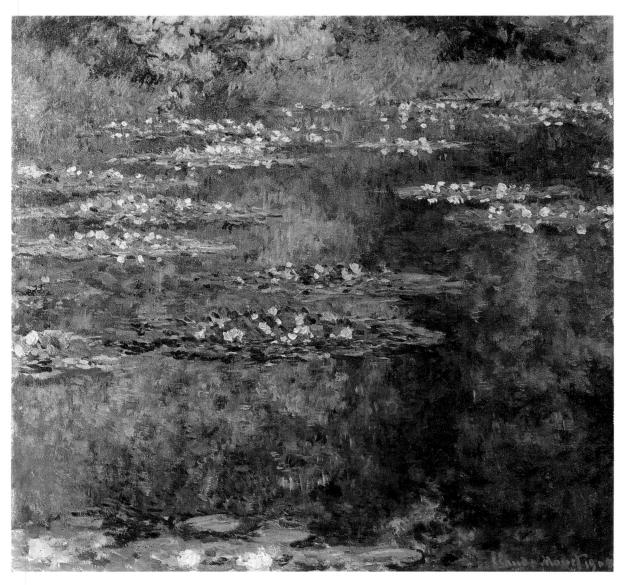

Giverny, 12 February 1905

TO PAUL DURAND-RUEL

You are quite wrong to worry about what you tell me, indications of nothing but bad feeling and jealousy which leave me quite cold. I know neither Mr Rothenstein nor Mr Alexander, but only Mr Harrison, whom Sargent commissioned to do a small photo of Parliament for my benefit which I was never able to use. But it is hardly of any significance, and whether my *Cathedrals* and my *London* paintings and other canvases are done from life or not is none of anyone's business and is quite unimportant. I know so many artists who paint from life and produce nothing but terrible work. That's what your son should tell these gentlemen. It's the result that counts. In haste,

Regards from yours sincerely, CLAUDE MONET

Giverny, 3 [July] 1905

To Georges Durand-Ruel

I am unable to give you any information about the article you mention for the simple reason that I did not keep it.

As for the paints I use, is it really as interesting as all that? I don't think so, considering that one could do something even more luminous and better with another palette. The point is to know how to use the colours, the choice of which is, when all's said and done, a matter of habit. Anyway, I use flake white, cadmium yellow, vermilion, deep madder, cobalt blue, emerald green and that's all.

Regards to your father and to your family,

Cordially, CLAUDE MONET

Giverny, 7 May 1906

To Gustav Pauli

Here is the information you required.

The portrait bought for the Bremen Museum was executed in Paris in 1866 and exhibited at the Salon of that year. Madame Monet, my first wife, did indeed model for it and while I hadn't set out specifically to do a portrait, but merely a Parisian lady of the period, the resemblance is striking.

The painting was known generally as the *Woman with a Green Dress*. I sold it in 1868 to Arsène Houssaye, the former director of the Comédie Française who was at that time attached to the Beaux-Arts as an inspector of national museums.

He bought it for himself, intending to bequeath it later on to the Musée du Luxembourg (for at that time everyone or almost everyone was against me). But he died before public opinion changed and his son, Henri Houssaye, a member of the Académie Française, was quick to dispose of the painting for a derisory sum of money. Things changed later on and the same picture was much admired.

That is all I can tell you, but I must also say how glad I am to know it is in your museum and that I am very flattered.

I am, Sir, yours very sincerely, CLAUDE MONET

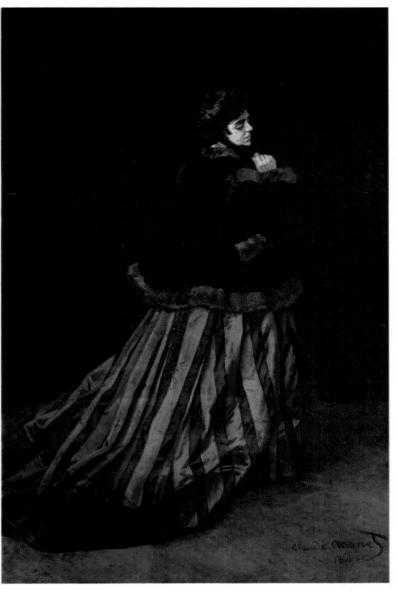

CAMILLE

Giverny, 8 February 1907

To Gustave Geffroy

Thank you for sending me your book, *La Sculpture au Louvre*, proof that you are still working despite everything; it gave me enormous pleasure. You've seen that Manet's *Olympia* is in the Louvre at last. When in Paris the other day it occurred to me that I should track Clemenceau down and tell him that it was incumbent upon him to arrange it. He got the message and withing three days, since I saw him on a Friday, it was done, and how glad I am, for myself and for all those I represent who donated the masterpiece. I remain very grateful to Clemenceau, please tell him so if you see him.

Best wishes, dear Geffroy,

Your CLAUDE MONET

Giverny, 27 April 1907

TO PAUL DURAND-RUEL

Like you I'm sorry not to be able to exhibit the *Water-lilies* series this year, and if I made this decision it's because it was impossible. Perhaps it's true that I'm very hard on myself, but that's better than exhibiting mediocre work. And I'm not delaying the exhibition because I'm keen to show a lot of work, far from it, but too few were satisfactory enough to trouble the public with. At the very most I have five or six that are possible; moreover I've just destroyed thirty at least and this entirely to my satisfaction.

I still have a lot of pleasure doing them, but as time goes by I come to appreciate more clearly which paintings are good and which should be discarded. All the same, this doesn't affect my eagerness and confidence that I can do better.

But I come now to your request and, despite wishing above all to be agreeable to you, I can promise you nothing, at the moment anyway. It would be a very bad idea, moreover, to exhibit even a small number of this new series, as the whole effect can only be achieved from an exhibition of the entire group. On top of that, I need to have finished pictures to look at and compare with what I'm doing . . .

So please don't feel bitter and accept my regrets and most sincere wishes,

CLAUDE MONET

*

Giverny, 6 January 1908

TO PAUL DURAND-RUEL

I received the photograph of the picture that was offered to you, a work which is not of my hand although the false signature is a perfect imitation. All you can do in my name is to let this be known, and have it destroyed.

In haste, my regards, CLAUDE MONET

*

[Giverny], 11 August 1908

TO GUSTAVE GEFFROY

... You must know I'm entirely absorbed in my work. These landscapes of water and reflections have become an obsession. It's quite beyond my powers at my age, and yet I want to succeed in expressing what I feel. I've destroyed some . . . I start others . . . and I hope that something will come out of so much effort . . .

*

Grand Hotel Britannia, Venice, 19 October 1908

TO PAUL DURAND-RUEL

I am overcome with admiration for Venice, but unfortunately I can't stay here long so there's no hope of doing any serious work. I am doing a few paintings in any case, to have a record of the place, but I intend to spend a whole season here next year. I don't yet know when we'll be back. It will depend on the weather.

In haste, regards, CLAUDE MONET

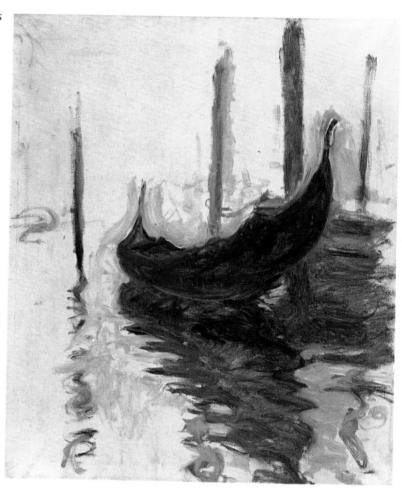

Venice, 25 October 1908

TO GASTON BERNHEIM-JEUNE

Monsieur Durand-Ruel has preempted you in making the same request. So, much to my regret I can't help you, but don't worry, for while I'm excited by Venice and I've a few paintings of it under way, I'm very much afraid I won't be able to bring back anything more than some beginnings which will serve purely as a record, as the period of good weather seems to be over here. For two days it hasn't stopped raining and if this goes on, we'll pack our bags now and come back next autumn. There's too much to do here not to return. It's wonderful. I received both your letters at the same time. I'm writing to Clemenceau by the same post.

In haste, my regards to you and your brother.

Yours sincerely, CLAUDE MONET

*

Venice, 7 December 1908

TO GUSTAVE GEFFROY

Absorbed as I was in my work, I was unable to write to you, and so I handed my wife the task of giving you the news. She no doubt told you of my enthusiasm for Venice. Well, it increases by the day and I'm very sad that I'll soon have to leave this unique light. It's so very beautiful, but we must resign ourselves to the inevitable; we have many pressing obligations at home. I comfort myself with the thought that I'll come back next year, since I've only made some studies, some beginnings. But what a shame I didn't come here when I was a younger man, when I was full of daring! Still . . . I've spent some delightful hours here, almost forgetting that I'm now an old man . . .

Best wishes from my wife and myself.

Your old friend, CLAUDE MONET

HAYSTACKS AT NOON

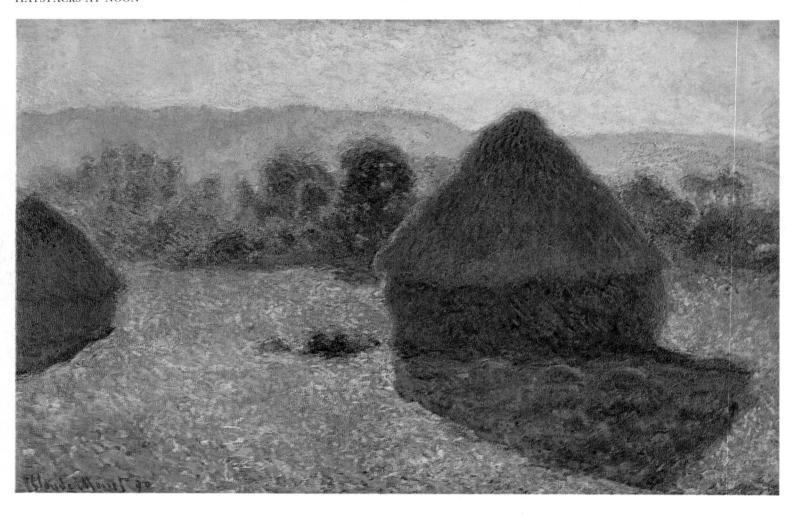

HAYSTACKS

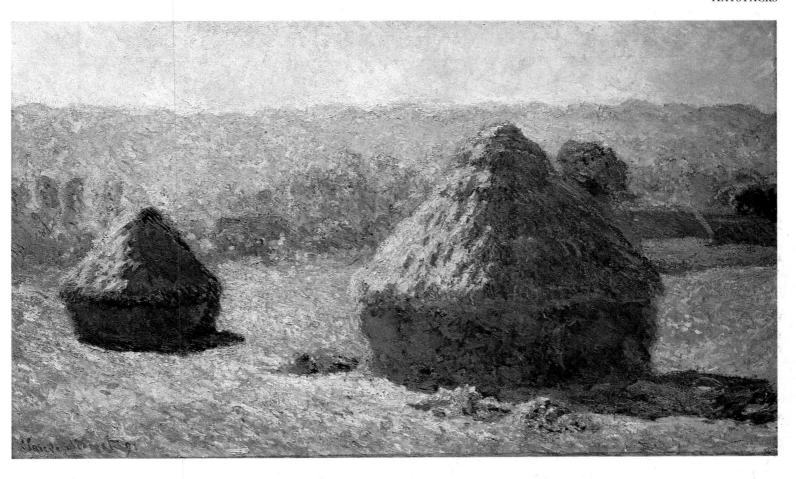

THE HAYSTACKS IN THE SNOW, OVERCAST DAY

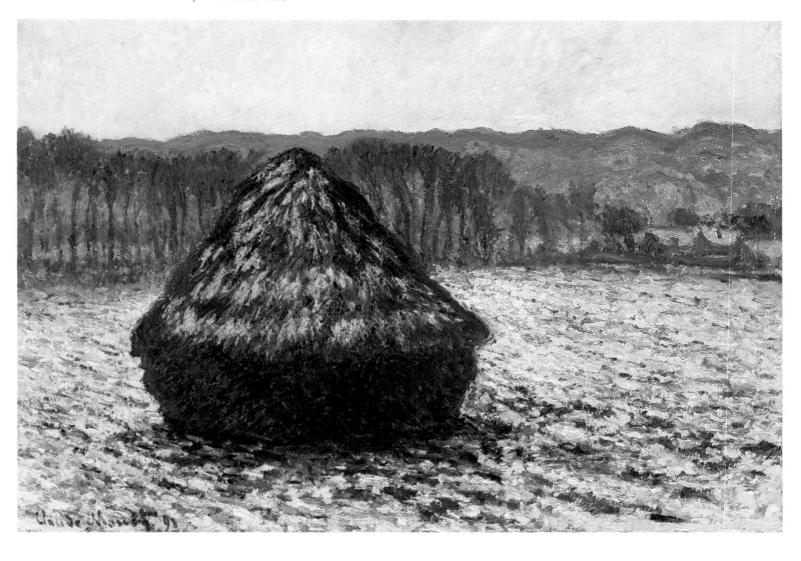

THE HAYSTACK

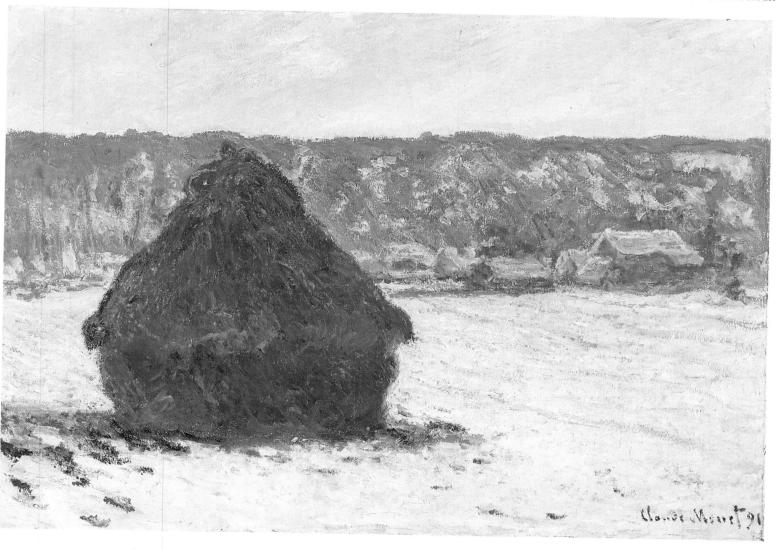

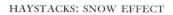

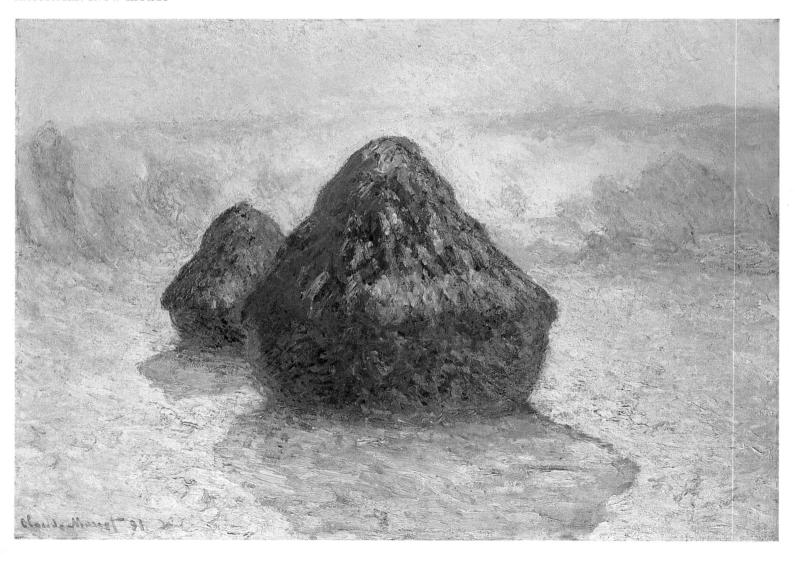

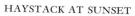

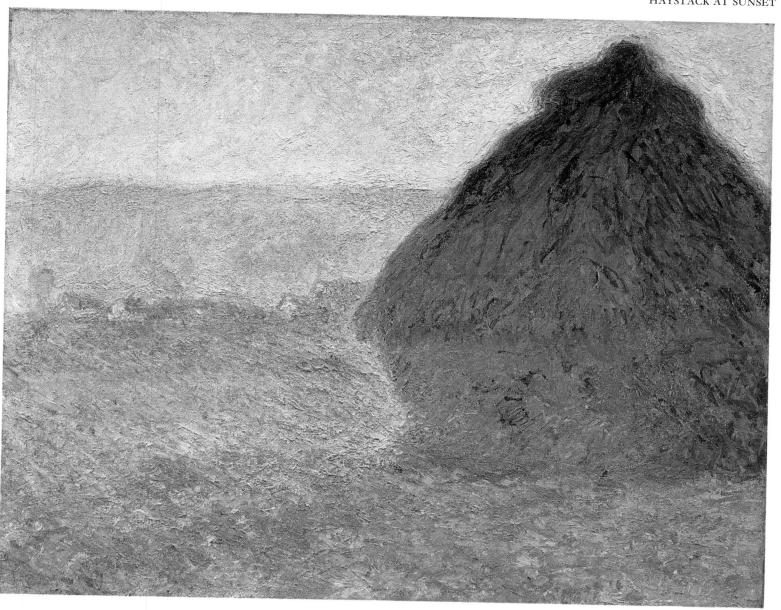

POPLARS ON THE EPTE

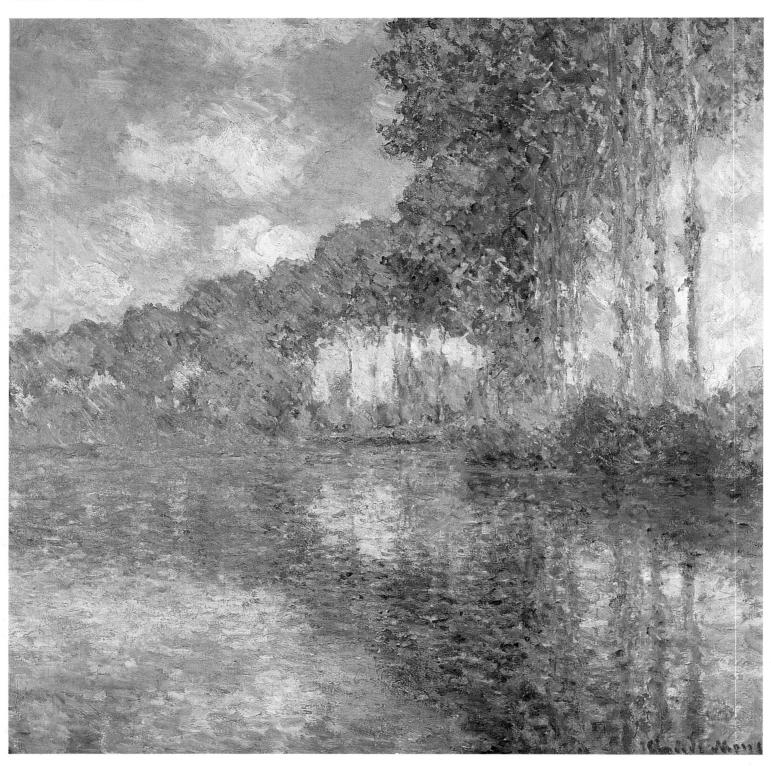

POPLARS

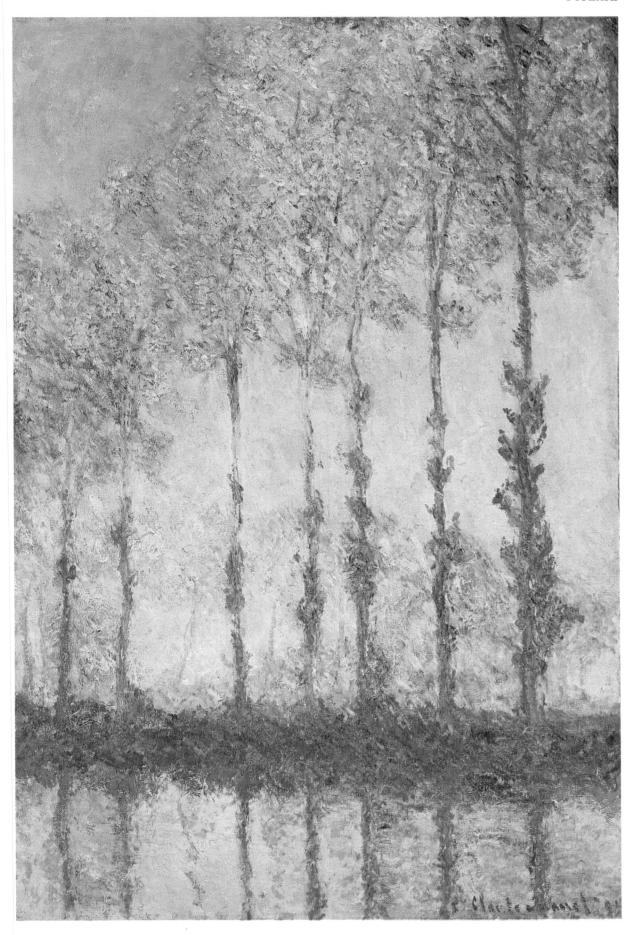

POPLARS

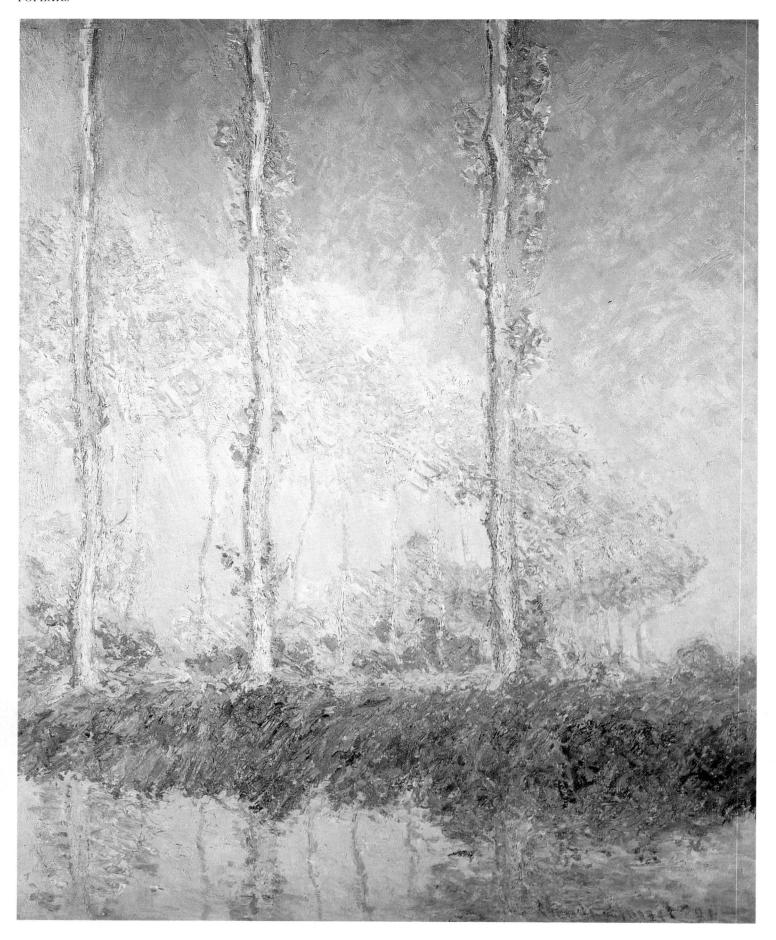

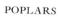

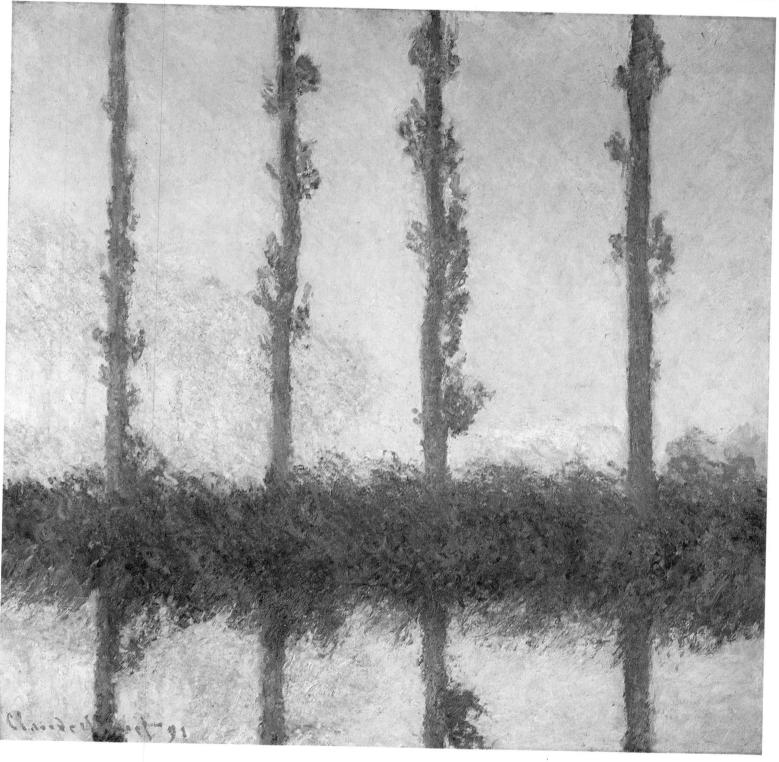

ROUEN CATHEDRAL

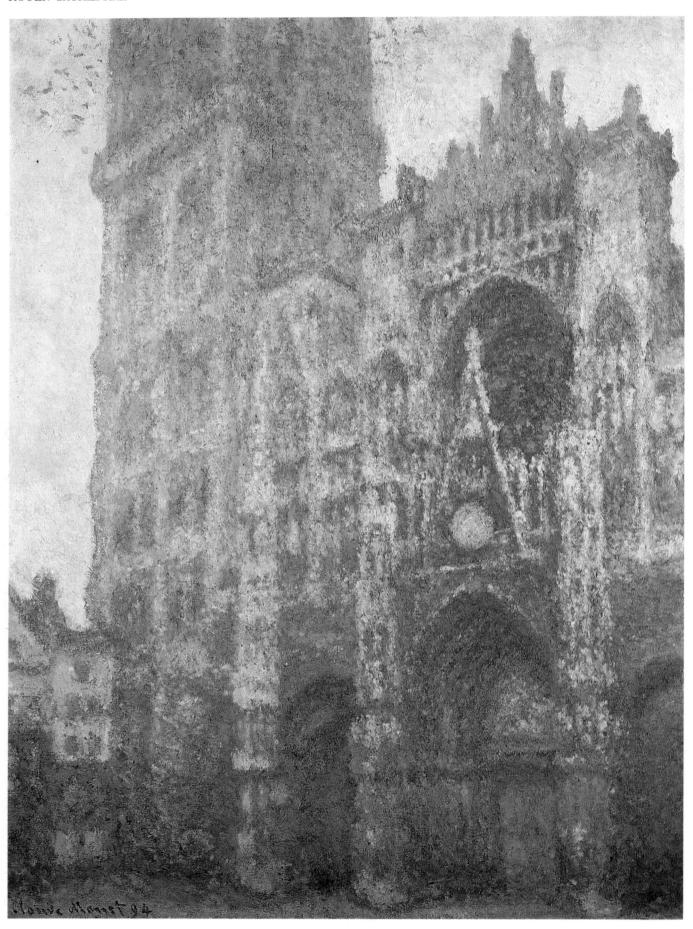

ROUEN CATHEDRAL, THE FAÇADE IN SUNLIGHT

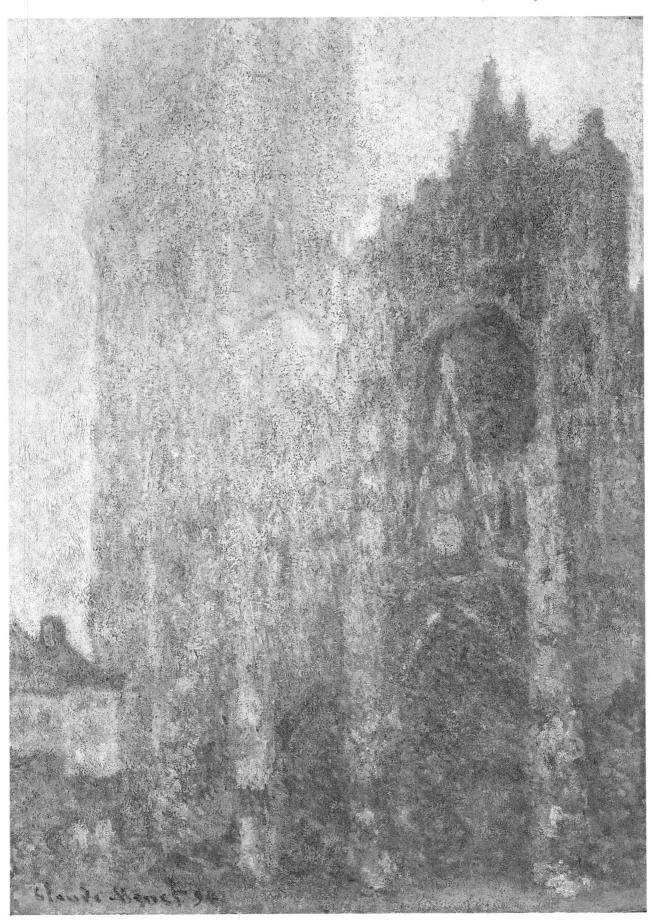

THE FAÇADE, MORNING MIST

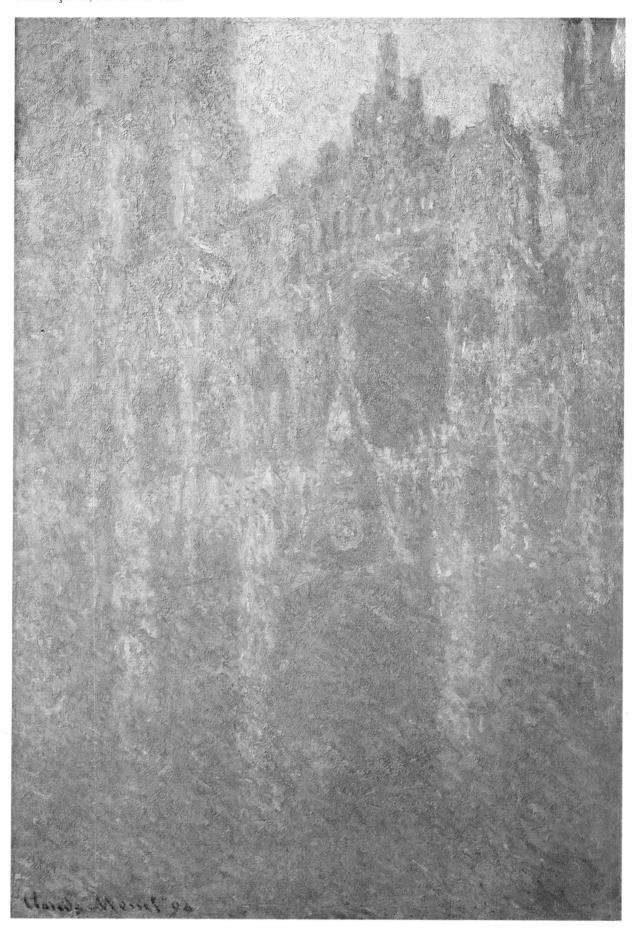

ROUEN CATHEDRAL AT DAWN

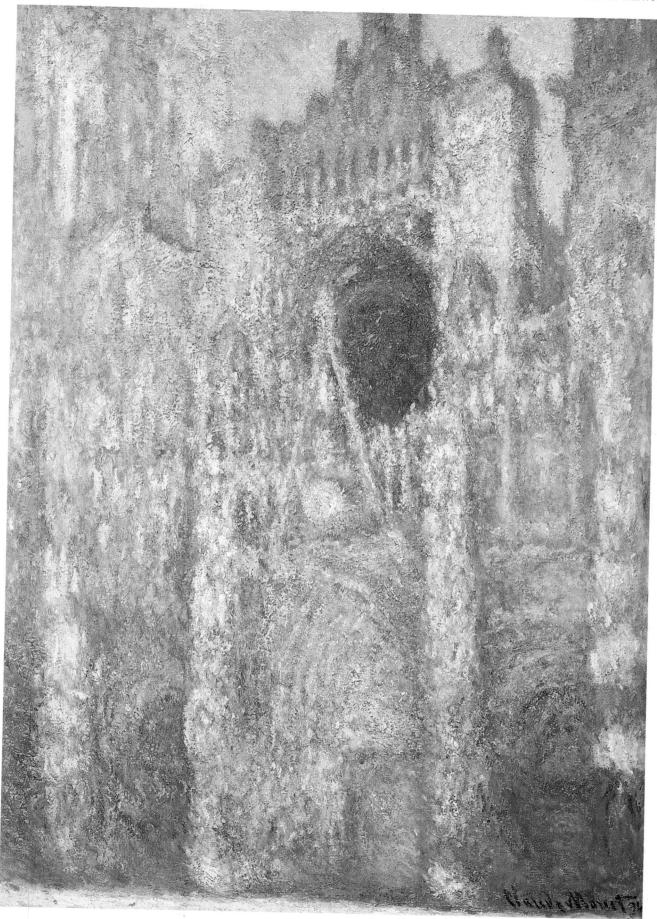

ROUEN CATHEDRAL, WEST FAÇADE, SUNLIGHT

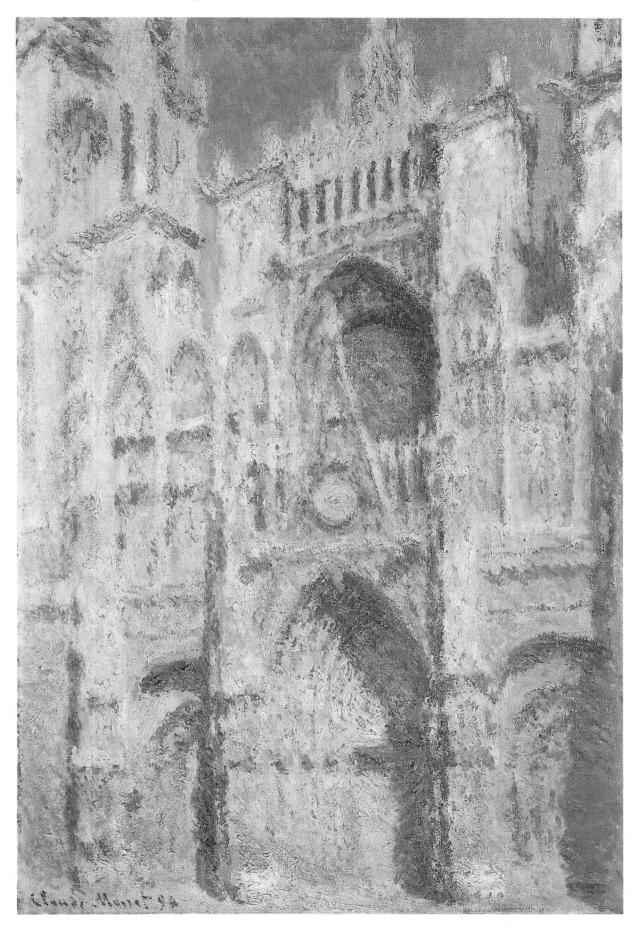

ROUEN CATHEDRAL

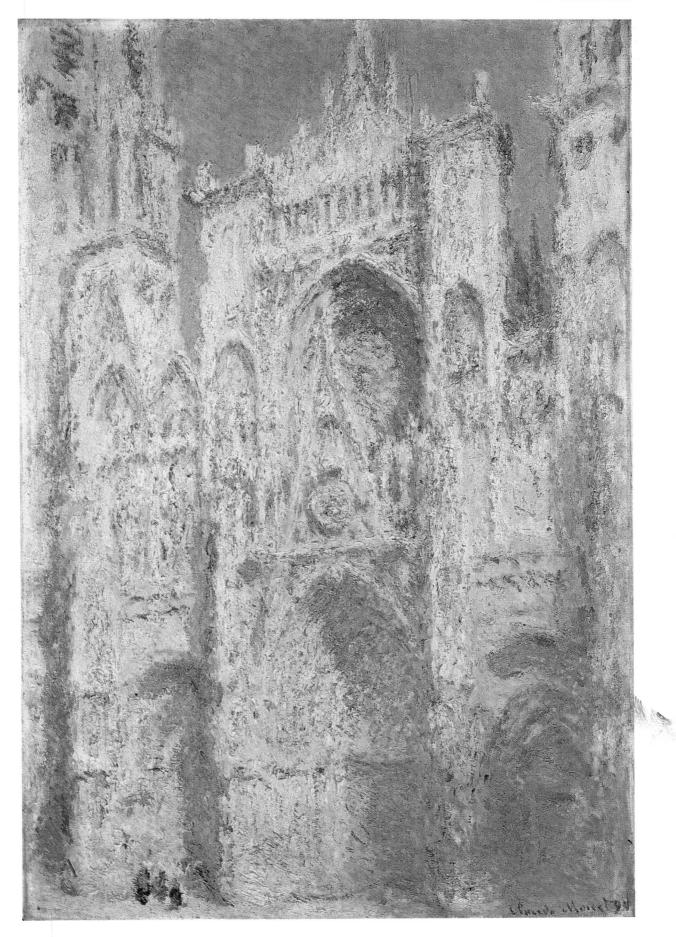

ON THE CLIFFS, DIEPPE

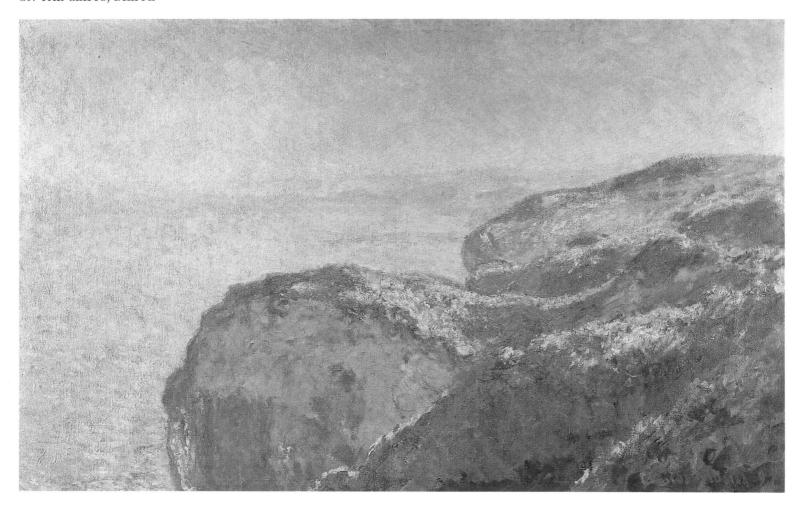

STEEP CLIFFS

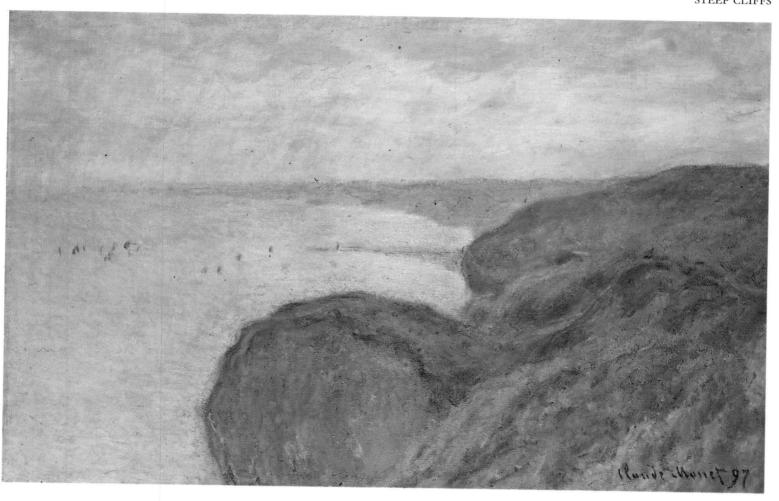

THE SEINE AT GIVERNY

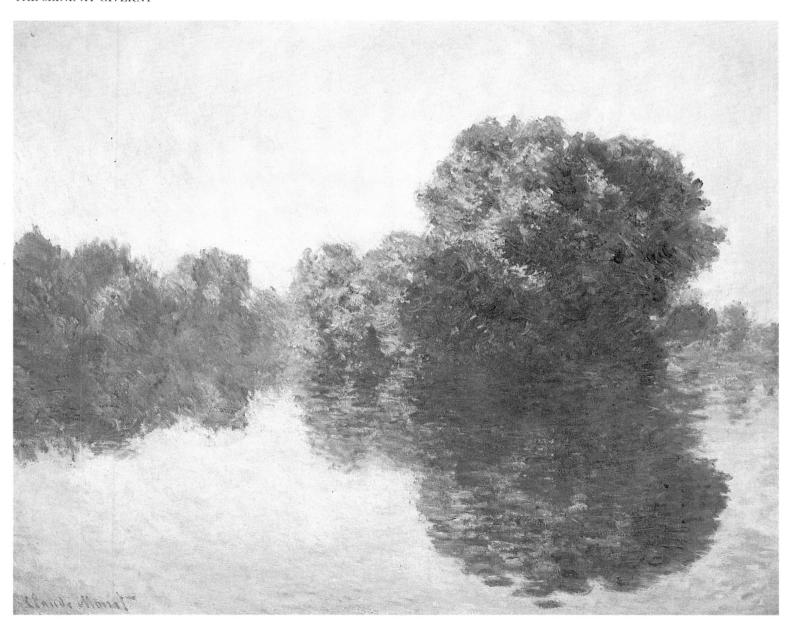

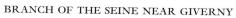

THE SEINE AT GIVERNY, MORNING MISTS

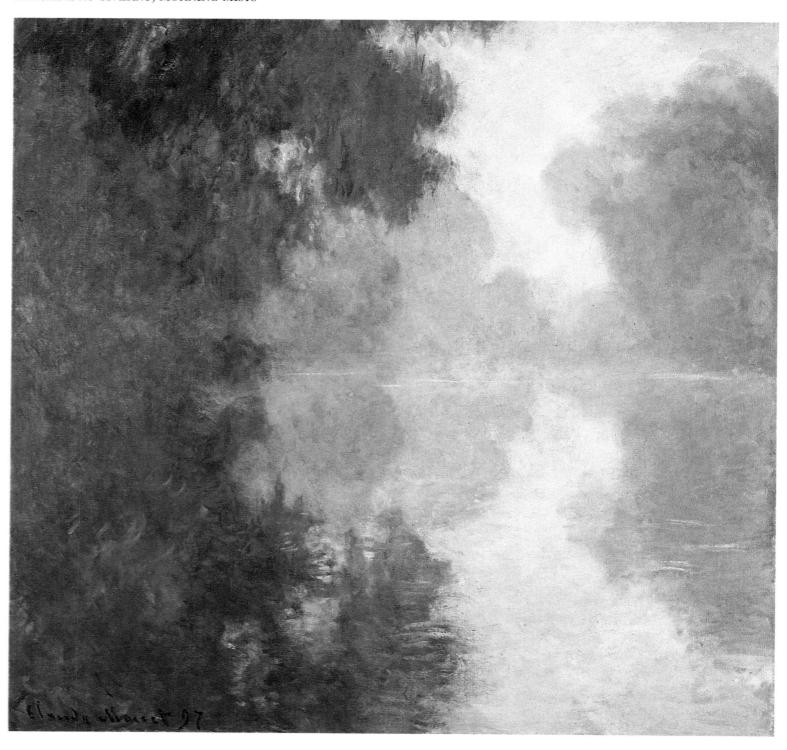

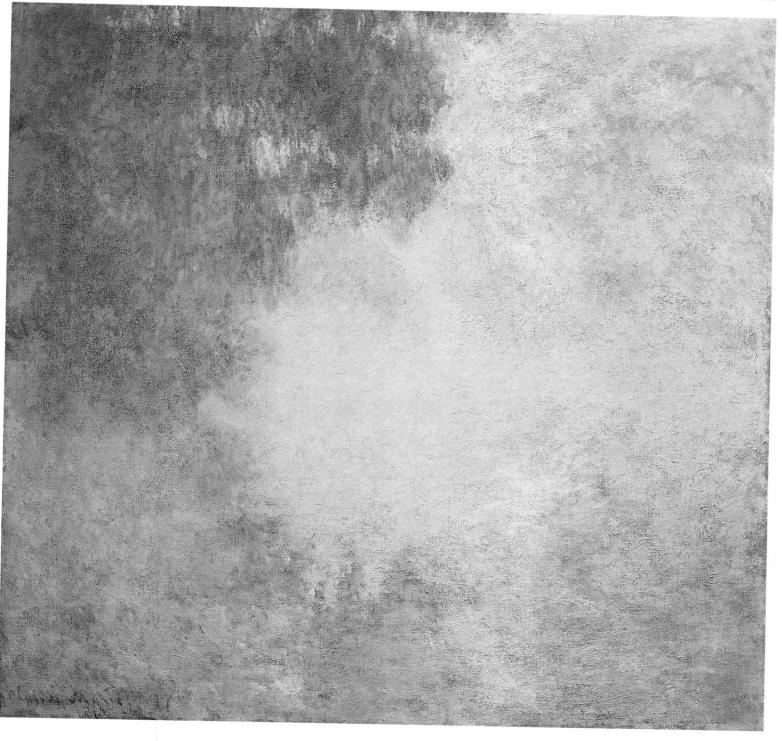

THE ARTIST'S GARDEN AT GIVERNY

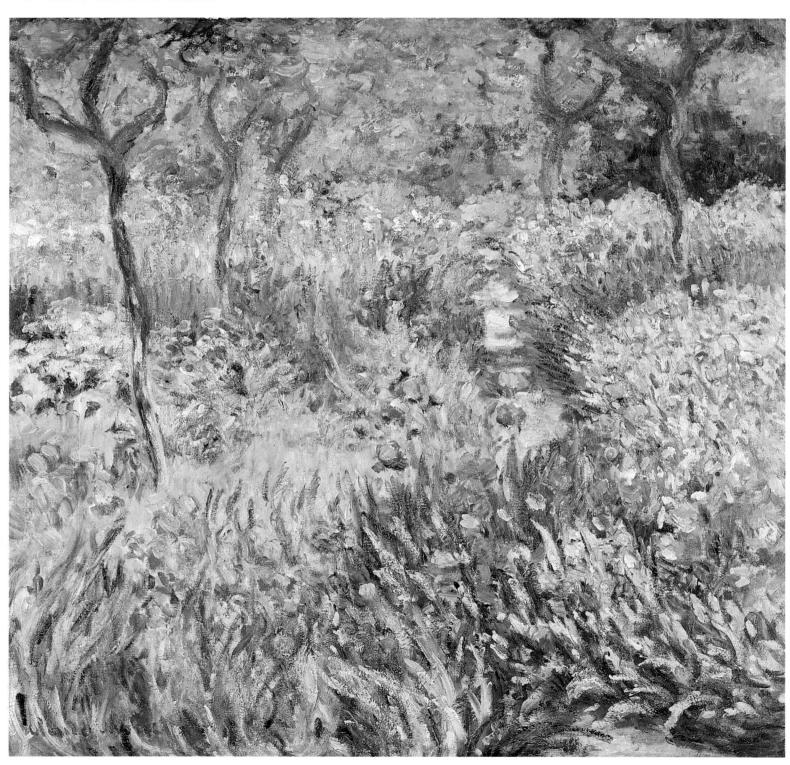

SPRING

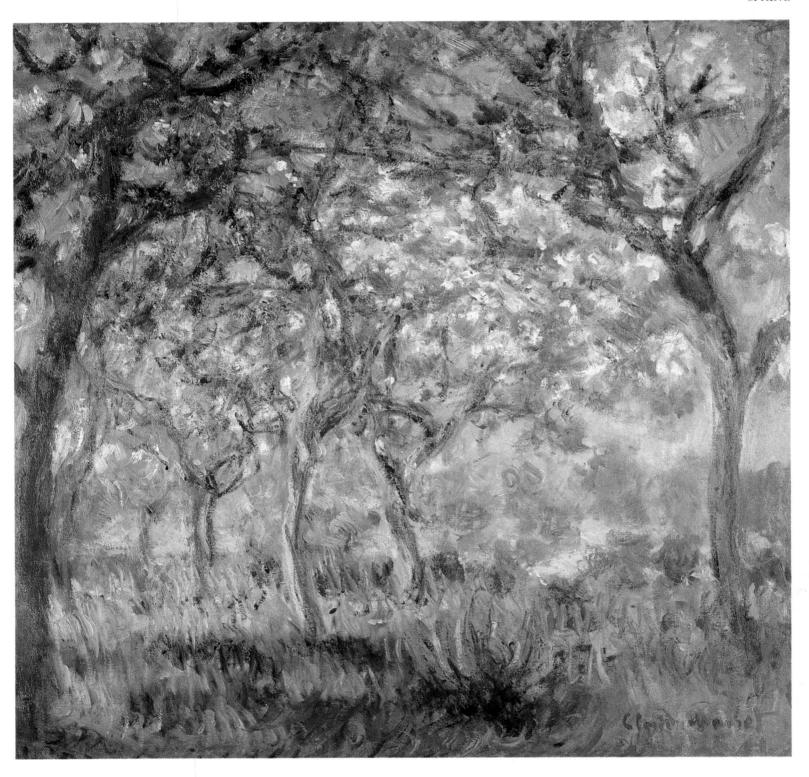

CHARING CROSS BRIDGE

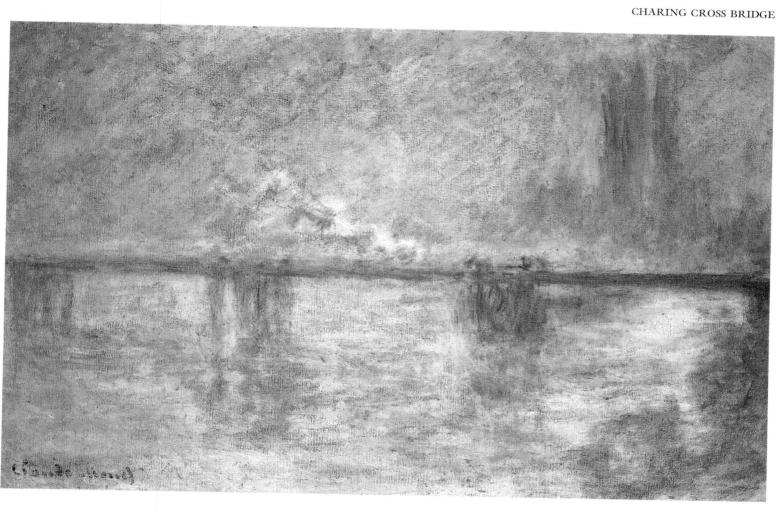

CHARING CROSS BRIDGE

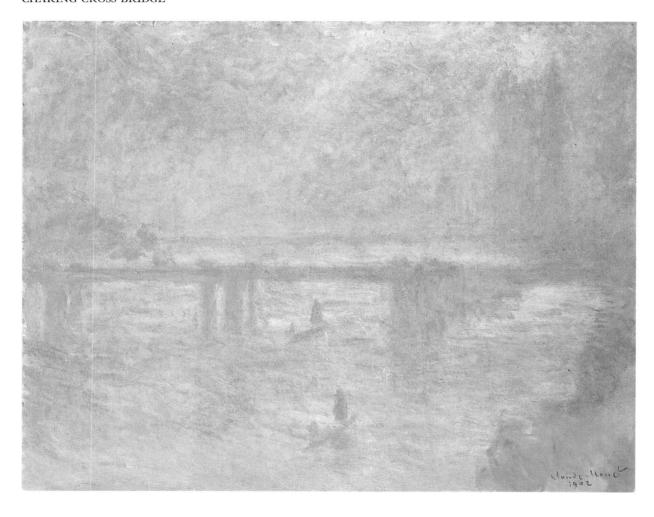

CHARING CROSS BRIDGE

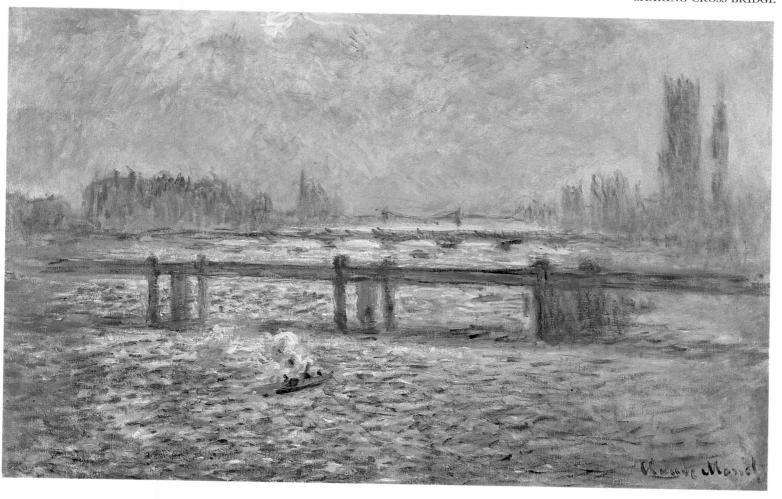

WATERLOO BRIDGE

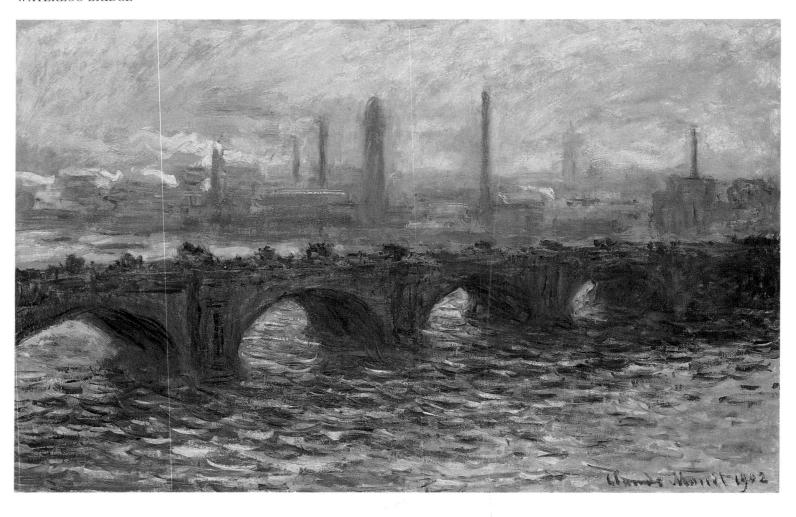

WATERLOO BRIDGE

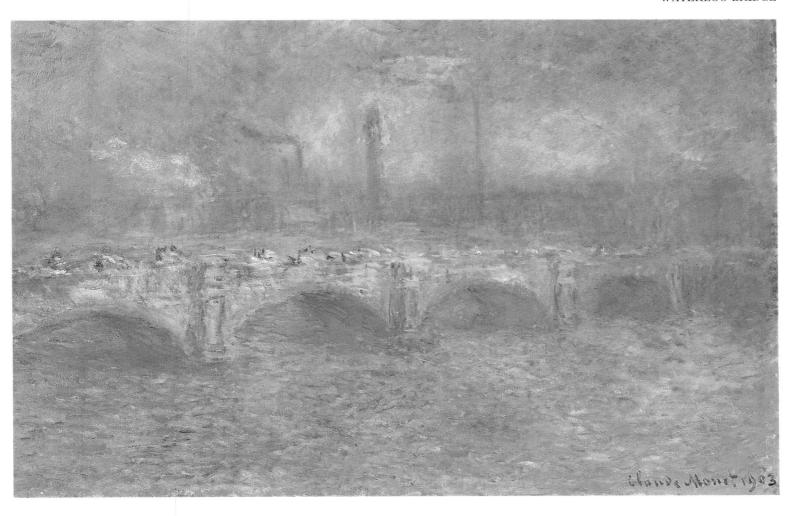

WATERLOO BRIDGE

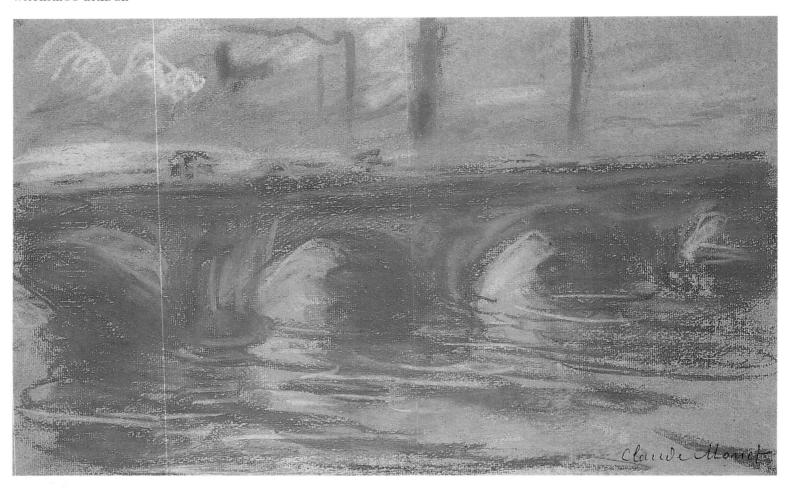

WATERLOO BRIDGE, LONDON, AT DUSK

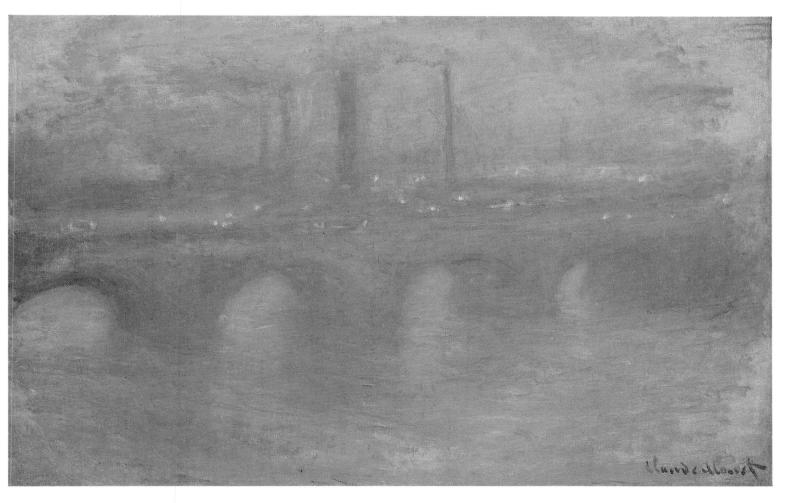

HOUSES OF PARLIAMENT, EFFECT OF SUNLIGHT

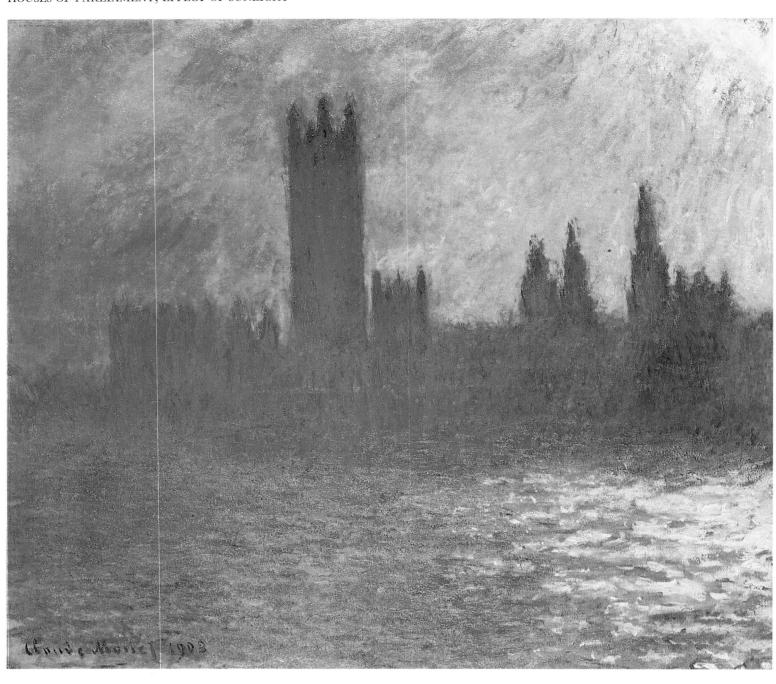

HOUSES OF PARLIAMENT

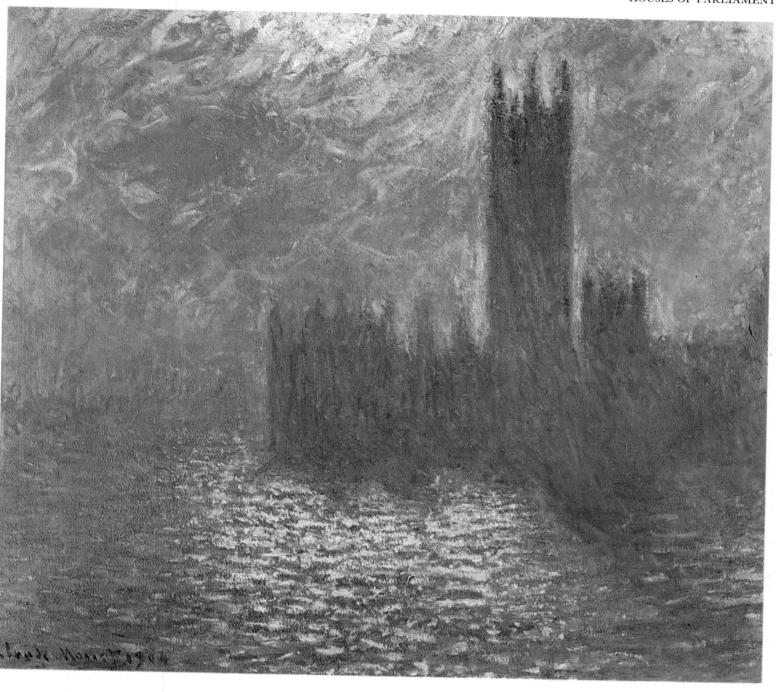

THE GRAND CANAL, VENICE

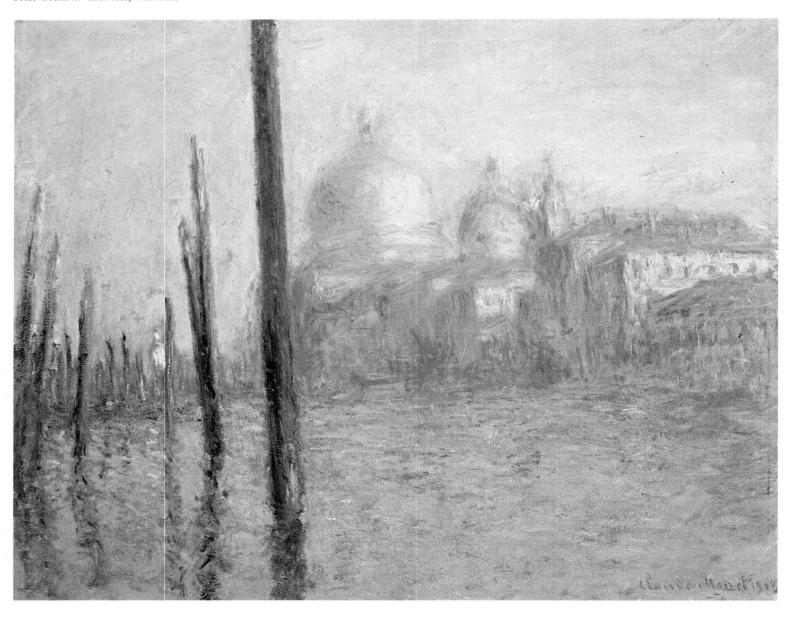

PALAZZO DE MULA, VENICE

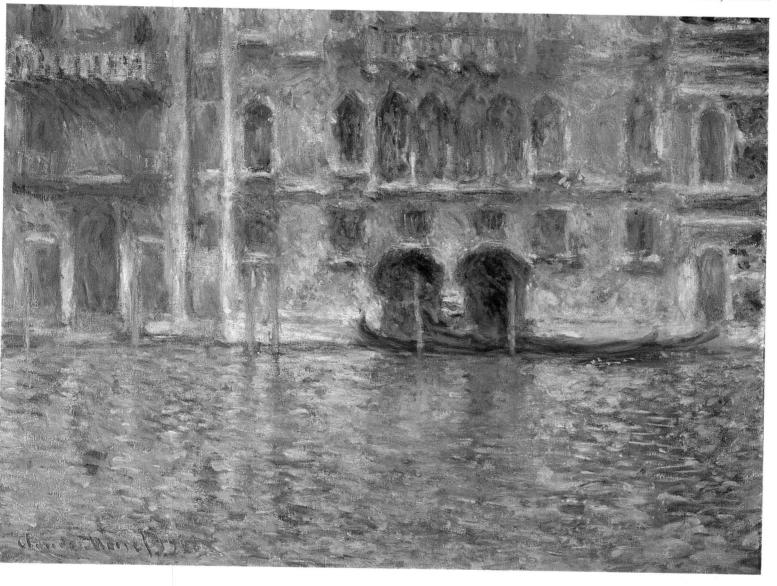

THE DOGE'S PALACE IN VENICE

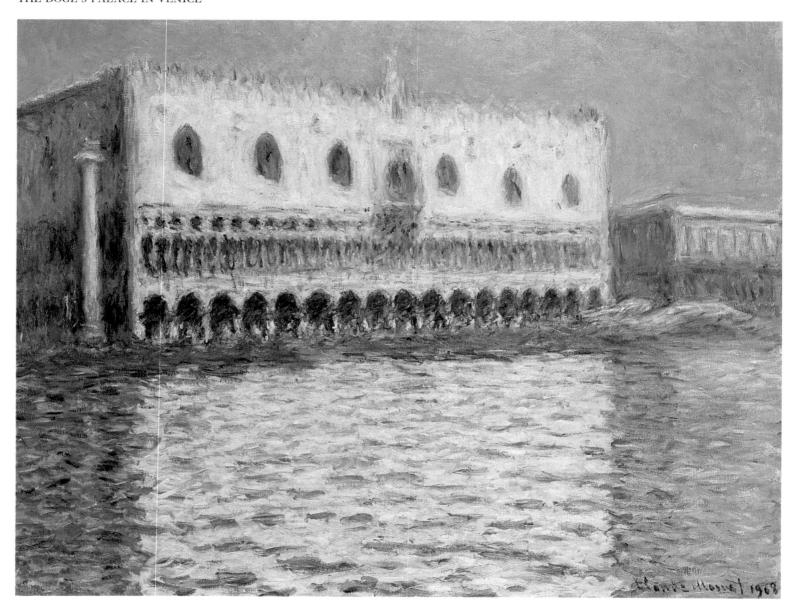

THE DOGE'S PALACE, VENICE

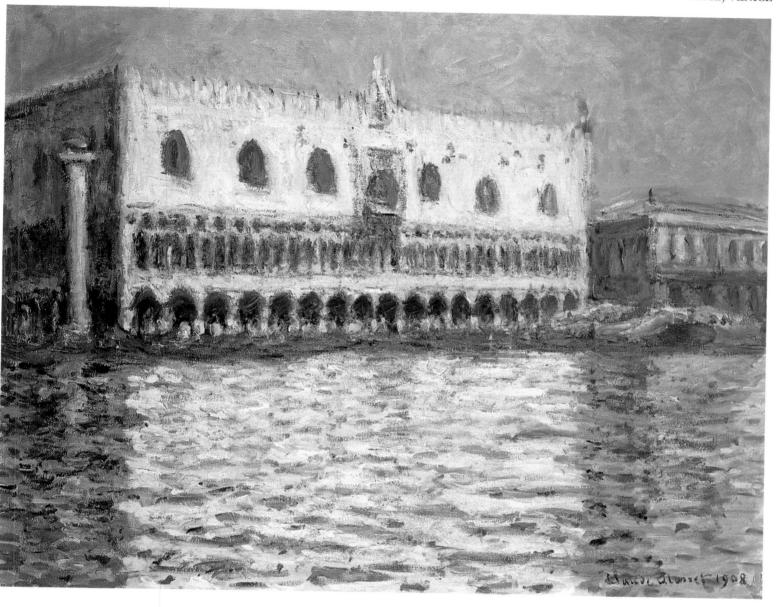

THE DUCAL PALACE

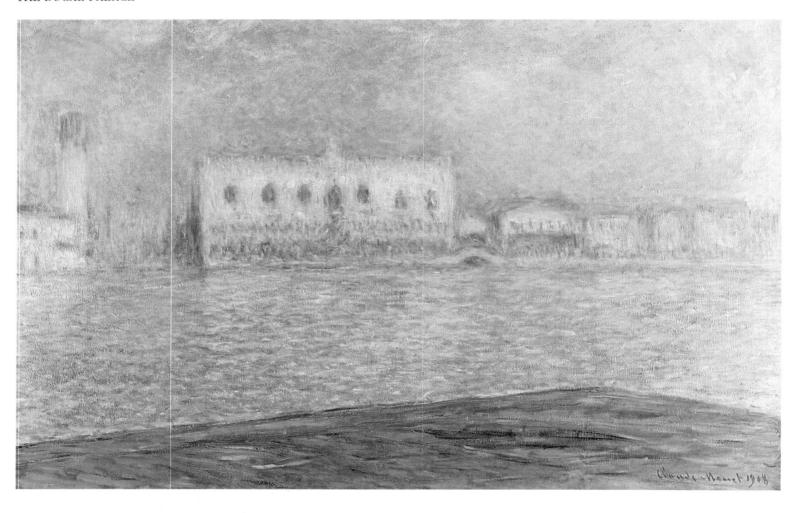

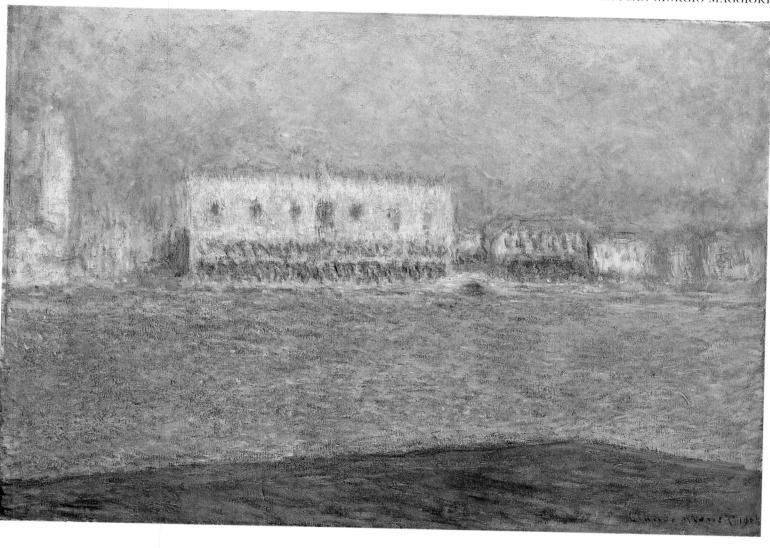

VENICE: THE DOGE'S PALACE SEEN FROM SAN GIORGIO MAGGIORE

Monet's career as an artist covered almost seventy years, from the drawings he made as a teenager at Le Havre in the 1850s to the majestic wall-size canvases completed at Giverny after the First World War. He outlived all his colleagues from the original Impressionist circle, and his letters show his successive attendance at the funerals of Manet, Sisley, Degas and Renoir. His own robust constitution, which had survived decades of exposure to the elements and the seasons, kept him at his easel until his last months, with only occasional lapses in his health. After the death of his wife in 1911, Monet's life was centred almost exclusively on Giverny, where his family and friends relieved his solitude and reassured him in periods of doubt and discouragement. Monet's correspondence records the premature death of his eldest son and his anxiety over the safety of his remaining son, Michel, during active service in the War. The daughters of Alice's first marriage were a continuing comfort in later years; Blanche, said to have been Monet's favourite, accompanied him on local painting excursions and herself became an accomplished artist, while Marthe married the American painter Theodore Butler. A number of photographs exist of their family gatherings, dominated by the patriarchal figure of the heavily bearded Monet and often set against the flowers and shrubs of his magnificent garden.

As the years went by, Monet had turned progressively from the subject matter of distant sea-coasts and rivers to the motifs of his own garden at Giverny. Originally intended as a source of flowers to be painted during had weather, the garden had been systematically extended and elaborated to include formal flowerbeds, trellises and ornamental pathways. By acquiring another piece of land adjacent to his garden, on the other side of a road and a single railway track, Monet had extended his property to include a small tributary of the River Seine. Here he arranged for a system of sluices to feed into a newly constructed pond, soon to be planted with lilies, irises and other aquatic plants. Contemporary photographs show its modest beginnings, with the flowers barely established and the surrounding bushes and willow trees still half-grown, while later pictures record the dense profusion of foliage in the mature garden. Monet's earliest paintings of the pond, which date from the last years of the nineteenth century, show the view along its length, with trees and shrubs framing the recently built Japanese-style bridge. Subsequent paintings tend to isolate a feature or an effect from the pond, concentrating on a pattern of reflected clouds or a single hue pervading the water surface. In this constantly shifting world of colour and light, at once both natural and knowingly artificial, Monet was able to manipulate his subject matter and pursue what he called his 'researches' with a freedom unmatched at any point in his earlier life.

Writing to Gustave Geffroy in 1908, Monet announced: 'These landscapes of water and reflections have become an obsession. It's quite beyond my powers at my age, and yet I want to succeed in expressing what I feel.' A year later an exhibition of water-lily paintings took place at Durand-Ruel's gallery, revealing to the public for the first time the subject that was to preoccupy the artist for much of his late career. As his 'obsession' deepened, Monet ordered larger canvases and tackled even more audacious confections of colour, tone and texture. Slowly the idea took shape of a unified sequence of paintings, combining the vividness of his perceptions of the lily pond with the ornamental possibilities of its patterns and colours. It appears from the artist's letters that his friend Georges Clemenceau was instrumental in this plan, as it progressed from a modest group of pictures commemorating the end of the War to a large-scale enterprise that required its own building in the centre of Paris. Working in a specially designed new studio at Giverny, Monet gradually surrounded himself with a continuous cycle of enormous canvases, some up to six metres in length, which follow

the lily pond through all its characteristic phases and moods. Many paintings were destroyed by the artist and many plans for their installation rejected, but a little while before his death in 1926 Monet was able to write to Clemenceau and announce that the canvases could be transferred to their final resting place in the Orangerie.

The sheer scale and originality of conception of the Orangerie paintings, or Décorations as the artist called them, are extraordinary tributes to Monet's continuing vitality in the final years of his long life. Their technique also shows a number of bold departures from his earlier work, as he built up crusts of multicoloured pigment and gestured with his brush on a scale unthinkable a decade earlier. Although Monet burnt a considerable quantity of unfinished or unresolved canvases, there is enough evidence in his letters and in the surviving half-completed paintings to reconstruct something of his procedure. Working with a large brush, Monet would introduce the dominant colours of the motif while drawing in the principal forms of the composition. A number of highly simplified sketchbook drawings from this period show the importance the artist attached to these underlying rhythms, using them to animate and unify the different canvases within a sequence. Then brushing or streaking the colours on to the picture, Monet would develop his areas of tone, and intensify and modulate the canvas surface. Dense, pitted areas of overpainted brushwork were set against thinner and more delicate passages of colour, deep shadows contrasting with shimmering, sensuous highlights. Repainting, scraping down and endlessly revising his canvases, Monet brought a lifetime's experience of his craft and of his relationship with nature to this most ambitious creation of his career.

Before Monet's development of his house and garden, Giverny had been a quiet rural village overshadowed by the nearby town of Vernon. As the artist's celebrity grew, an increasing number of visitors and admirers made the journey from Paris to see him, and a virtual colony of younger painters set themselves up in the immediate vicinity. Monet's correspondence records his occasional irritation at these unwelcome intrusions, but his delight in the visits of old and distinguished friends is equally evident from letters and contemporary photographs. By now the subject of historical and critical study, Monet patiently answered the inquiries of writers and biographers like Arsène Alexandre, Gustave Geffroy and Etienne Moreau-Nélaton. The artist who had always been his own harshest critic continued to experience periods of self-doubt and to question his own greatness. Writing to Paul Durand-Ruel in 1912 he claimed: 'Now, more than ever, I realize just how illusory my undeserved success has been', and to Geffroy in the same year he wrote: 'No, I am not a great painter.'

The diagnosis of cataracts had appeared to threaten all Monet's activities as an artist, but the encouragement of Clemenceau and the attentions of Dr Coutela, which led to a successful operation in 1923, enabled him to continue painting until his last months. In spite of old age and sporadic infirmity, the octogenarian artist discovered new motifs and new depatures for his art. The last paintings of the Japanese bridge and the house seen from the garden have an intensity of colouring and a dynamism of handling which can hold their own among the younger pioneers of twentieth-century art. To the end, Monet insisted on the vital relationship between his paintings and the direct experience of nature which had sustained him throughout his career, however extravagant or wilful the final result might appear: 'I only know that I do what I can to convey what I experience before nature and that most often, in order to succeed in conveying what I feel, I totally forget the most elementary rules of painting, if they exist that is.'

Giverny, 28 January 1909

TO PAUL DURAND-RUEL

In reply to your son's query, I am writing to tell you that this time you may go ahead and without apprehension announce the much-delayed exhibition for May this year. But not until the 5th, if that suits you, as it's more convenient for me than the 3rd. In any case you can absolutely count on me, I'll be ready, as my trip to Venice has allowed me to look over my paintings with a fresh eye. All the work which isn't worth showing I've put to one side and what is left will go into an exhibition which won't, I believe, be without interest. Before I forget, rather than calling the series *Reflections*, call it *Water-lilies*, *series of materscapes*.

In haste, I send you my best wishes,

Yours sincerely, CLAUDE MONET

*

Giverny, 7 December 1909

To Gustave Geffroy

What must you think of me? I found a letter from you dated 3 August, to which I replied hastily from Landemer near Cherbourg, promising you a longer letter as soon as I got back to Giverny; and it's only now that I'm writing to you. Please don't take it too badly, my dear old friend; 1909 has been a disastrous year for me and you'll see why when I tell you that since getting back from Venice, a year ago now, I've done nothing, I haven't touched a paintbrush. What with the upheaval of my exhibition of *Water-lilies*, the bad weather all summer and worst of all, my own health problems, it's a sad state of affairs as you can see, not to mention all the little miseries and problems that accumulate with age; it's hopeless from every point of view.

Had it not been for this, my dear old friend, you'd have had some sign of life from me earlier. You know how fond I am of you and how glad I would have been to have been agreeable, but what can you do if you've got out of step and don't feel up to doing anything? You know how carried away I was by Venice, well I had to give up my idea of going back, I was so out of sorts and beset with health problems. This past year I've been having terrible headaches, quiet spells followed by more violent relapses, and they leave me with no taste for anything. It's beyond a joke, but at least you'll forgive me now. I think of you often and would be happy to hear you're all well. Best wishes from your faithful and devoted friend,

CLAUDE MONET

*

Giverny, 10 February 1910

TO PAUL DURAND-RUEL

I am sending you in some haste the authorization that you asked for. I hope it is what you require.

We are getting along, but no more than that, especially my wife, floods have also given us a good deal of trouble and anxiety; I thought for a while that my entire garden would be destroyed and I was very concerned. Finally the water receded little by little, and although I've

lost a lot of plants, it will probably be less calamitous than I'd feared. But what a disaster all the same, troubles never cease!

In haste,

Yours most sincerely, CLAUDE MONET

I authorize Monsieur Durand-Ruel to act as my representative for the sale of all pictures from my studio which I have previously sold to him or which, while remaining my property, are exhibited in his galleries.

CLAUDE MONET

*

Giverny, 15 April 1910

TO PAUL DURAND-RUEL

As you doubtless already know, my wife is seriously ill and I'm still not in my right mind with such great worries. A glimmer of hope remains, but it is a hope. And I recall that I promised a painting for the flood victims. I asked my son-in-law to phone you to find out whether I might be permitted to send the painting unframed, as I have neither the time nor the inclination to deal with it myself. I would be grateful for a word in reply. In haste,

Yours sincerely, CLAUDE MONET

*

Giverny, 28 March 1911

TO PAUL DURAND-RUEL

I've just sent to you in some haste a crate containing the eight pictures in the *Water-lilies* series which you selected last Sunday, the total cost of which is 113,000 francs, since I've kept them at their exhibition prices for you, a very fair gesture on my part. Kindly warn Prosper to be careful when unpacking them as two canvases have been freshly retouched. He'll be able to see which they are...

Best wishes from yours sincerely, CLAUDE MONET

*

Giverny, 18 May 1911

TO PAUL DURAND-RUEL

I have some very sad news for you. My beloved wife is dying. It's only a matter of hours now. I can't tell you what I've been going through, particularly this past fortnight. My strength and courage are giving out.

Yours sincerely, CLAUDE MONET

*

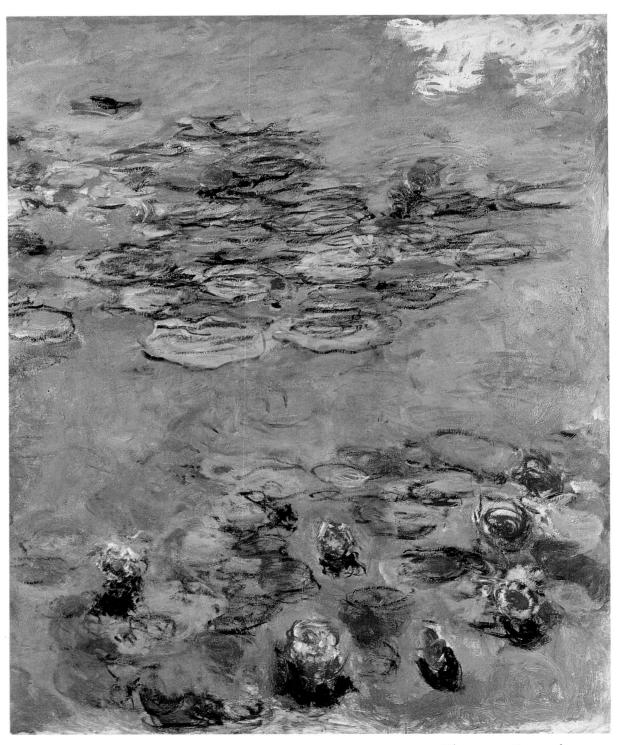

WATER-LILIES

Giverny, 7 September 1911

To Gustave Geffroy

I would certainly be very happy to see you after the long postponement of your visit, but my fear is that if you have to wait for Vaquez you'll postpone it again, although I'd be glad if you could both come; so do what you can but don't put it off. I so need cheering up, and the sight of some friendly faces will help distract me from my sadness. I've had some welcome visits: Clemenceau, as affectionate as ever, Renoir and yesterday Mirbeau, who is certainly better, but very depressed, very downcast, not himself. As for me, I'm in good health. I've had a few very sad months consoling myself with my dear wife's letters, all of which I reread, and going back over most of our life together. Otherwise, I haven't been able to find an interest in anything, overcome as I've been by this terrible heat which really is intolerable, but that's enough about me. Do come, I'd be so glad.

Best wishes from your faithful friend, CLAUDE MONET

Giverny, 16 April 1912

To G. and J. BERNHEIM-JEUNE

JEUNE I'm very sorry to inconvenience you, but I find it impossible to supply you with any more *Venice* pictures. It was useless trying to persuade myself otherwise, the work that's left is too poor for exhibition. Don't insist, my decision is final. I've enough good sense in me to know whether what I'm doing is good or bad, and it's utterly bad, and I can't believe that people of taste, if they have any knowledge at all, could see any value in it. Things have been dragging on like this for far too long and I've had enough; there's one thing I regret, that I sent you the paintings you now have which you don't want to send back. All my apologies and best wishes.

Your very sad and discouraged CLAUDE MONET

*

Giverny, 10 May 1912

TO PAUL DURAND-RUEL

I'm very touched by your kind letter and would be glad to see you, although I doubt whether you can persuade me to go back on a decision which I didn't take lightly, and the reason you've found me dissatisfied with what I've been doing for some while is because that's how I've felt. Now, more than ever, I realize just how illusory my undeserved success has been. I still hold out some hope of doing better, but age and unhappiness have sapped my strength. I know well enough in advance that you'll find my paintings perfect. I know that if they are exhibited they'll be a great success, but I couldn't be more indifferent to it since I know they are bad, I'm certain of it.

I thank you for your comforting words, your kindness and for going to all that trouble. Until Sunday, for lunch, I hope, as usual.

All my excuses and best wishes.

Yours sincerely, CLAUDE MONET

Giverny, 7 June 1912

To Gustave Geffroy

Heartfelt thanks for your two fine articles which I'm very proud of. No, I'm not a great painter. Neither am I a great poet. I only know that I do what I can to convey what I experience before nature and that most often, in order to succeed in conveying what I feel, I totally forget the most elementary rules of painting, if they exist that is. In short, I let a good many mistakes show through when fixing my sensations. It will always be the same and this is what makes me despair.

Thank you for your great and loyal friendship and trust in the no less loyal friendship of your old Claude Monet

*

Giverny, 1 July 1912

TO GUSTAVE GEFFROY

... I am well, but desperate about the weather. I'd begun to work, but I'm having to abandon what I had set out to do. Nature won't be summoned to order and won't be kept waiting. It must be caught, well caught which is not the case today, since I've been indifferent to everything for so long. And then there's my son Jean whose health is a decided worry to me. Please write and tell me how you are.

Best wishes from your old CLAUDE MONET

*

Giverny, 5 August 1912

To G. or J. Bernheim-Jeune

Thank you for your kind letter. I was just about to write to you, not, sadly, to tell you I'm coming, but to say how sorry I am not to be able to get away at the moment. I've been plagued by an endless succession of troubles and anxieties. My eldest son was seriously ill, but has thankfully recovered now, then I myself became so worried about my sight that I made an urgent appointment to see a specialist. I can only see with one eye. I've got a cataract (I wasn't mistaken when I complained about my eyesight). So I'm following a course of treatment in order to delay and if possible avoid an operation. The operation is nothing, but my sight will be totally altered after it, and that's what matters most to me. Anyway, all this isn't very pleasant, so I set to work, but with this weather I haven't managed to do anything and to add to my miseries an appalling storm has created havoc in my garden. The weeping willows I was so proud of have been torn apart and stripped; the finest entirely broken up. In short, a real disaster and a real worry for me.

More than ever and despite my poor sight, I need to paint and paint unceasingly. All the same I'll try and come for a day or two in September. At the moment, I have the Salerous with me and don't feel up to leaving.

My very best wishes to the ladies and to both of you.

Yours sincerely, CLAUDE MONET

Giverny, 18 July 1913

To Gustave Geffroy

As it's been a while since I heard from you, I intended to write, but I'm getting so lazy that I continually put things off until tomorrow. With neither the will nor the desire to do anything, I'm ending my days very sadly, despite my good health, which might have meant I could drown my sorrows in work, were it not for the unhappy sight of my son whose condition deteriorates daily.

My eyes were the cause of considerable anxiety for a while as you know, but they seem better. I can't see very well, it's true, but at least it doesn't seem to be getting any worse. But here I am talking of myself and it's you I want to hear about, you and your family, so please send me your news as soon as you possibly can. And if you can manage it, try and arrange a day to come and see me, it would do me so much good . . .

Yours, CLAUDE MONET

[Vernon, 10 February 1914]

TO GUSTAVE GEFFROY

My poor son died last night.

CLAUDE MONET

*

Giverny, 5 April 1914

To?

Dear Sir, Please forgive me for being so late in replying, owing to several unexpected journeys.

I find it very difficult to know how to deal with your request, since I never draw except with a brush and paint and I've always refused requests even from friends to employ a technique I know nothing about. It's not easy for me to reply in the negative, but what can I do? I still have a few sketches I did in my youth which are of very little interest and scarcely worth reproducing . . .

Yours faithfully, CLAUDE MONET

*

Giverny, 30 April 1914

TO GUSTAVE GEFFROY

... I hope you are well, although you don't mention it in your note. As for myself, I'm in fine fettle and fired with a desire to paint; I've been prevented from doing so by various things during the recent period of good weather, but I planned to begin work yesterday, and then the weather changed; a false start.

I am even planning to embark on some big paintings, for which I found some old attempts in a basement. Clemenceau saw them and was amazed. Anyway, you'll see something of this soon, I hope.

Yours, CLAUDE MONET

*

Giverny, 29 June 1914

TO PAUL DURAND-RUEL

I keep meaning to write and find out how you are, but as you must have heard by now, I've started work again and you know I don't do things by halves; getting up at 4 in the morning, I slave away all day until by the evening I'm exhausted, and I end by forgetting all my responsibilities, thinking only of the work I've set out to do. This is my excuse, but I do think of you and would like to hear from you. So I look forward to a letter from you or one of your sons, who might also give me some news of Renoir and send my best wishes to him if he's in Paris as I think. I'm as well as I can be, my eyesight is good at least. Thanks to my work everything's going well, it's a great consolation. Best wishes to you and your family,

Your old and devoted friend, CLAUDE MONET

Giverny, 1 September 1914

TO GUSTAVE GEFFROY

... One thing I know is that in the present state of things and in my isolation, a letter from a good friend like you is a comfort which makes these anxieties easier to bear. Most of my family has left me with no knowledge of their whereabouts; only my son Michel who has been temporarily discharged is with me, along with Blanche. Germaine Salerou, who was here with her children, left yesterday; a mad panic has swept our area, she has gone to Blois to stay with her aunt Rémy. As for myself, I'm staying here regardless and if those savages insist on killing me, they'll have to do it in the midst of my paintings, before my life's work.

Write, dear friend, and tell me your thoughts, what you know of everyone. I'd like to know how Clemenceau's son is, what an admirable man; I sent a telegram for which he thanked me, without telling me whether his son's wound was serious or not. I hope that you and your sister are not too badly off.

With warmest greetings and affection, CLAUDE MONET

*

WATER-LILIES

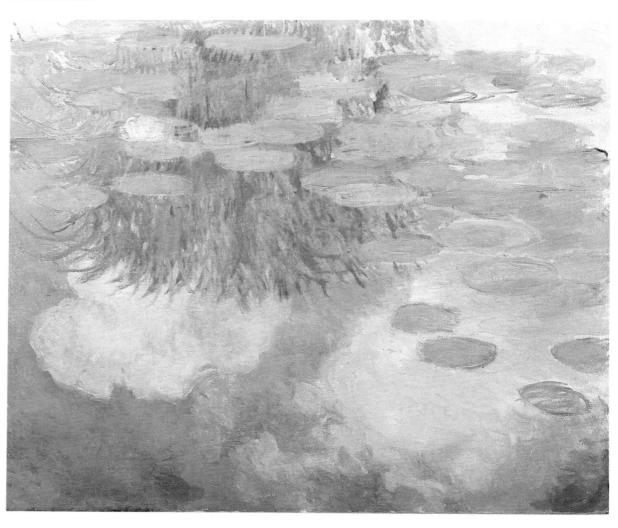

Giverny, 15 January 1915

TO RAYMOND KOECHLIN

I was very pleased by your recollection. I would have replied earlier, were it not for being indisposed, but happily I'm better now, and yesterday I was able to resume work, which is the only way to avoid thinking of these troubled times. All the same I sometimes feel ashamed that I am devoting myself to artistic pursuits while so many of our people are suffering and dying for us. It's true that fretting never did any good. So I'm pursuing my idea of the *Grande Décoration*. It's a very big undertaking, particularly for someone my age, but I have every hope of succeeding if my health doesn't give out.

As you guessed, it's the project that I've had in mind for some time now: water, water-lilies, plants, spread over a huge surface.

Let's hope that events will take a turn for the better. I'd be glad to see you and show you the beginnings of this work.

Friendly greetings, CLAUDE MONET

Giverny, 10 February 1915

To G. or J. Bernheim-Jeune

JEUNE I'm very much to blame for having taken so long to reply to your last letter with some sign of life; I apologize and hope you won't hold it against me. In reply to your wife's kind letter, Blanche gave you my news: good health and lots of work, which is the only excuse I can come up with.

I'm not performing miracles, I'm using up and wasting a lot of paint, but it's absorbing me sufficiently not to dwell too much on this terrible, unbearable war. Michel is still here, still waiting, which suits me since this means that he'll avoid the worst days of winter. Apart from that, good news from everyone, fortunately; Albert Salerou has just been appointed Captain.

We don't see a living soul here, which isn't very cheerful...

Best wishes to the ladies and to your brother.

Yours, CLAUDE MONET

Giverny, 8 February 1916

To G. or J. Bernheim-Jeune

DEUNE Thank you for your fine letter. Yes, the snow was very beautiful but alas, I'm no longer of an age to paint outside in such weather, and despite its beauty I'd rather it had stayed away and alleviated the suffering of so many miserable people and most of all our poor soldiers.

I'm continuing work on my large paintings, although at this time my thoughts are elsewhere, alas! I'm fine and am lucky enough to have Michel with me for a few days; he's seen some terrible sights, but is brave and well; that's the main thing. I hope you're all well. Best wishes to all four of you and Blanche wishes to be remembered.

Best wishes, CLAUDE MONET

Giverny, 11 September 1916

To Gustave Geffroy

... Things are all right here, just about; I was extremely worried about my son Michel who had three terrible weeks at Verdun; he came out of it at last and came here on a six-day leave; how long-drawn-out and painful it all is! I'm continuing to work hard, not without periods of discouragement, but my strength comes back again.

Do come over, I'd be glad to know what you think. I hope you're well and that your stay in La Tranche did you good.

Best wishes, CLAUDE MONET

*

Giverny, 9 October 1917

To Gustave Geffroy

Having come to Paris for Degas's funeral I was hoping to see you. I had also hoped you'd come here with your friend Barbier, but I've been working so hard that I'm exhausted and having just resumed the enormous task in the studio, I feel I won't be able to do without a few weeks' rest, so I'm going off to see the sea. I've just let Monsieur Barbier know, though it's merely a postponement. Could you kindly tell me what happened to the painting sent to Madame Poisson for the benefit of the blind; she did write to me, but absorbed in my work as I was, I don't remember what she said and I've mislaid the letter. If the painting didn't find a buyer for the price that I settled on, I wouldn't want it to go to public auction and be sold off at a low price to some dealer; I'd prefer to have it back and hand over as large a sum of money as I'm able.

WATER-LILIES

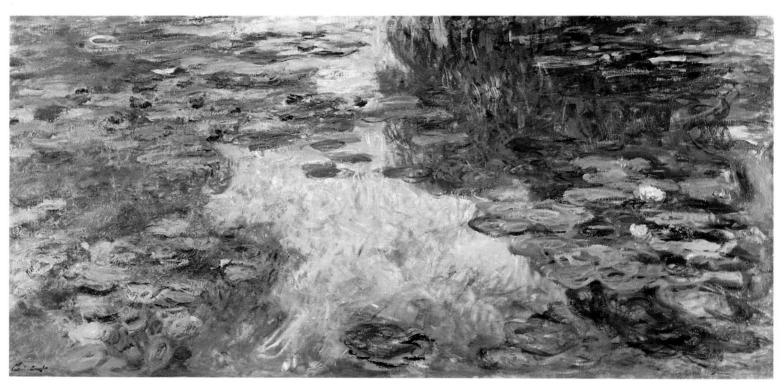

Giverny, 10 October 1917

To G. or J. Bernheim-Jeune

Thank you for the fine photo and my congratulations to the photographer; it looks a little as if I've just been released from prison, but it's very well done. With this terrible wind, work outside has come to a standstill; so I'm going to have a little break; we plan to leave today and tour around Honfleur, Le Havre and the coast up to Dieppe: away for 10–15 days. I can't wait to see the sea which I haven't been near in a good long while; I need it as I'm feeling very tired.

I hope you're all well; we send our best wishes to all four of you.

*

[Giverny], 21 October 1917

To René Degas

You are, of course, aware of my great admiration for the talent of your brother Edgar Degas; I hope you will forgive my indiscretion in offering you a suggestion with regard to the public sale of the work he left behind.

My youthful friendship with him and our common struggle are the reasons for my intervention. I presume that the expertise will, quite rightly, be provided by Messieurs Durand-Ruel, but do you not think it would be a good idea for Messieurs Bernheim-Jeune to join them since they have also done a lot for our group? I believe that the inclusion of these gentlemen could only contribute to the success of the sale on every account.

Forgive me for being so bold, and I remain Sir,

Your obedient servant, CLAUDE MONET

*

Giverny, 3 August 1918

To Gaston Bernheim-Jeune

JEUNE You wanted my news: good as far as my health is concerned although I'm feeling my age, which isn't surprising with all the trouble and heartbreak my painting is causing me. I'm working more and more, but how hard it all is! I am enslaved to my work, always wanting the impossible, and never, I believe, have I been less favoured by the endlessly changeable weather. I have got a mass of varied things under way but can't bring any of them to account; so there are times when I'm very discouraged and out of sorts.

It's very kind of you to invite us, and it would give Blanche and me a great deal of pleasure, but never have I been less keen to take any time off from my painting; I haven't many years left ahead of me and I must devote all my time to painting, in the hope of achieving something worthwhile in the end, something if possible that will satisfy me.

Thank you for thinking of me, for your kind invitation and please accept my sincerest good wishes for you and your family.

CLAUDE MONET

*

[Giverny], 12 November 1918

TO GEORGES CLEMENCEAU

EAU I am on the verge of finishing two decorative panels which I want to sign on Victory day and am writing to ask you if they could be offered to the State with you acting as intermediary. It's little enough, but it's the only way I have of taking part in the victory. I'd like the panels to be placed in the Musée des Arts Décoratifs and would be delighted if you were to select them.

In admiration, I embrace you affectionately . . .

Giverny, 24 November 1918

To G. or J. Bernheim-Jeune

Forgive me for not having written earlier; I was about to, when a slight indisposition prevented me from doing so, some kind of fainting fit brought on no doubt by the cold, and everyone here was somewhat alarmed. It had no sequel, but I'm undoubtedly at an age when you have to watch out for yourself and take precautions, something I'm not good at doing.

All the same I had a fine start to my 79th year, with the glorious victory coming first, along with greetings from old friends and a visit from the great Clemenceau asking me to lunch; it was the first day of his holiday and he chose to come and see me, which makes me feel very proud. But this is no reply to your letter, you'll be thinking. I'm coming to that now and I must admit I'd hoped that you were going to abandon your project entirely, and I was extremely relieved about it, since I'm not very fond of public displays and it's not false modesty on my part which prompts me to say I don't think I deserve it, far from it. I've done what I could as a painter and that seems to me to be sufficient. I don't want to be compared to the great masters of the past, and my painting is open to criticism; that's enough. You know that I am in sympathy with Monsieur Fénéon, which is to say that while I'd be very happy for him to come and talk, I flatly refuse to dictate my memoirs to him, and besides, it's hardly of any great consequence...

My very best wishes to the ladies and to both of you.

Your CLAUDE MONET

*

[Giverny], 10 November 1919

TO GEORGES CLEMENCEAU

you said yesterday very carefully; it's evidence of the depth of your friendship for me, but what can I say? I'm very much afraid that an operation might be fatal, that once the bad eye has been suppressed the other eye will follow. So I prefer to make the best of my bad sight, such as it is, and give up painting if I have to, but at least be able to see something of the things I love, the sky, water and trees, not to mention my nearest and dearest. I've just remembered that a talented actress I know had an operation quite recently; I'll make some discreet enquiries as to her condition after the operation and once I've done that I'll make my decision and ask for your assistance. I hope you'll understand . . .

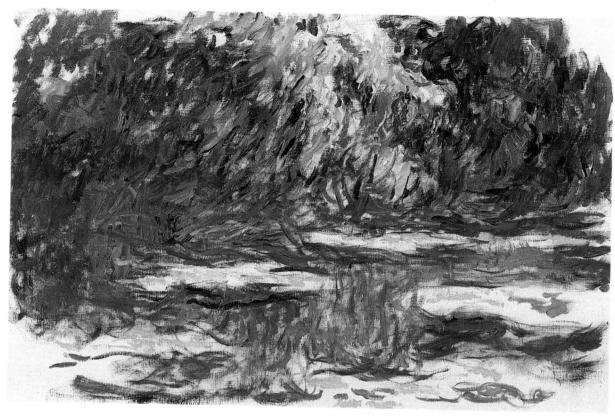

WATER-LILY POND

[Giverny, about mid-December 1919]

To Félix Fénéon

... You can imagine how painful the loss of Renoir has been to me: with him goes a part of my own life. All I've been able to do these last three days has been to go back over our early years of struggle and hope ... It's hard to be alone, though no doubt it won't be for long as I'm feeling my age increasingly as each day goes by, despite what people say ...

CLAUDE MONET

Giverny, 20 January 1920

TO GUSTAVE GEFFROY

I would have replied myself to the requests you directed to Madame Jean Monet, but for some while I've been in a state of utter despair and I'm disgusted with all I've done. Day by day my sight is going and I can sense only too well that with it comes an end to my long-cherished hopes to do better. It's very sad to have come to this; all this to say that I see little point in answering your questions. My work belongs to the public, and people can say what they like about it; I've done what I could, but to answer questionnaires is something I refuse to do, since I can't see any interest in it . . .

In haste, best wishes,

Your loyal friend CLAUDE MONET

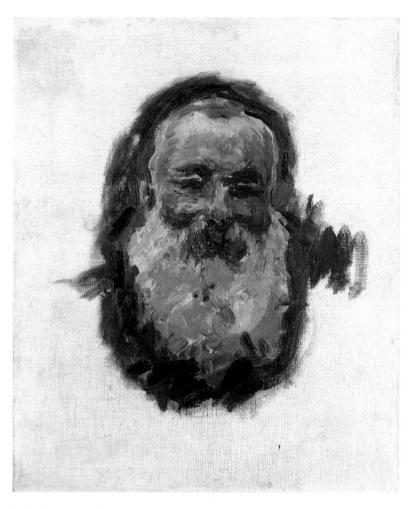

SELF-PORTRAIT

Giverny, 19 February 1920

TO SHINTARO YAMASHITA

I hardly need to tell you how flattered I was by your two letters, having as I do a deep admiration for Japanese art and a great sense of fellowship with the Japanese. But I have an apology to make for my delay in giving you the answer you are expecting. I've had no other excuse but work, which is obsessing me so much that my other responsibilities go by the wayside, and also my age, which makes me very lazy when it comes to letter-writing. But I hope you will kindly forgive me.

I was delighted to receive the fine prints and beautiful fabric you were kind enough to send me and please accept my thanks.

I find it more difficult to know how to reply to your request, as I sell my paintings for fairly high prices and have no small paintings in my possession, and it's very hard to know what to do since I might well send you something which wouldn't be to your liking. But it is the price above all which I am embarrassed about and which I fear you will consider too high; I can, however, let nothing go for less than this price. Canvases between 80 centimetres and I metre are priced around 25,000 francs. In the past I used to sell them from between 50 to 100 francs at the most. I have to say again that I feel somewhat embarrassed at this admission.

Thank you again,

Respectfully yours, CLAUDE MONET

Giverny, 23 February 1920

To Gaston Bernheim-Jeune

JEUNE ... You've guessed how I'm doing: I'm working and not without some difficulty, as my sight is getting worse each day and also I'm extremely busy with my garden; it's such a joy to me, and on fine days like those we've had recently, I am in raptures at the wonders of nature; so there's no time to get bored and I'm still in good health, which is saying a lot at my age.

I'm still hoping to send you the four paintings you selected; one of these days you'll get them.

As for the prices reached in the New York sale, I have to admit that I'm not impressed; all it does is show how stupid people are, since even a short while ago you could acquire the same paintings for much less . . .

Madame Jean Monet joins me in sending best wishes to the ladies and I extend good wishes to all.

CLAUDE MONET

*

Giverny, 8 May 1920

TO GUSTAVE GEFFROY

Really, you never seem to lose interest in me. I am honoured indeed; however, it's Boudin who concerns us here. On this matter, concerning my relationship with the 'King of skies', I think I've already told you that I consider Boudin as my Master.

You are quite right, I did meet Boudin, my senior, I believe, by about fifteen years, in Le Havre, while I was struggling to earn a reputation as a caricaturist. It's true that I was fifteen or so at the time. I was known throughout the town of Le Havre. I charged between 10 and 20 francs for my portraits and signed them Oscar, my second name. I often exhibited them with Boudin, whose painting I didn't appreciate at first, influenced as I was by academic theories. Troyon and Millet also frequented the gallery shop. One day Boudin said to me: 'You're talented, you should drop this kind of work which you'll tire of sooner or later. Your sketches are excellent, you're not going to leave it at that. Do what I do, learn to draw well and appreciate the sea, light, the blue sky.' I took his advice and together we went on long outings during which I painted constantly from nature. That was how I came to understand nature and learnt to love it passionately and how I became interested in the high-keyed painting of Boudin. It should be remembered that he had received some training from a master, Jongkind, whose work (his watercolours in particular) lies with Corot's at the origin of what has been called Impressionism. I've said it before and can only repeat that I owe everything to Boudin and I attribute my success to him. I came to be fascinated by his studies, the products of what I call instantaneity.

As for my stay in Algeria, I was entranced by it. I did my military service there with the Chasseurs d'Afrique in Oran and I met a fellow Norman, Pierre-Benoît Delpech of Granville, who was later to live in that lovely countryside. I kept in touch with him and we used to see each other almost every year. He also bought several paintings of mine and when I saw him in Giverny last year, he showed me numerous drawings and watercolours which I had done in Algeria, dating from 1862. He'll show them to you if you ask, since you know him.

At the time I regarded watercolour as a rapid and excellent means for expressing that 'instantaneity' of light. One day Clemenceau went off with one of my Algerian watercolours and in his Vendée house I saw this work of my youth depicting the old Spanish door in the Oran kasbah. I'll send you two sketches of Algerian landscapes from the same period. Clemenceau also has two watercolours of mine, the *Water-lilies* which you can see at his home and another watercolour showing his house at Saint-Vincent-sur Jard. I like the watercolour technique and regret not having worked in it more often. But I must go back to Boudin to tell you an anecdote. One day we were at Saint-Adresse together and had set up our easels in the shade of a tent out of the sun, when a respectable, and to all appearances very grand, gentleman came up to us. He congratulated us on our bold approach and declared that nature, the open air and high-keyed painting were bound to bring about a renewal in the art of painting. He shook our hands on leaving, with the words 'I am Théophile Gautier, the poet who almost became a painter.' You can imagine how astonished we were when we discovered we'd conversed so pleasantly with such a great poet. His book *Emaux et camées* always delighted me.

Cordially, CLAUDE MONET

*

Giverny, 11 June 1920

To Gustave Geffroy

I'm very late in thanking you for your two books which will be a great pleasure to read on winter evenings; at the moment the only joy I have is in contemplating nature, since my eyesight is preventing me from working outside as I once did, and this is not without its sadness. I save my strength in order to carry on working on my *Décorations* when it's not too hot in the studio; other than that I'm in excellent form and it was only my eyesight that prevented me from writing earlier...

Your friend, CLAUDE MONET

*

Giverny, 17 September 1921

To G. and J. Bernheim-Jeune

I'm making the best of the bad weather today to let you know how I am and also ask you whether, as I hope, you'll stop here on your return journey, in which case I'd like some idea of when you're coming as I'm planning a couple of short breaks and wouldn't like to miss you.

I've been working hard and non-stop during this marvellous weather. I wouldn't presume to say I was satisfied with what I've done, although I believe I've made some progress. My health is better and I wish next year was here already so that I could carry on my research in spite of my poor eyesight.

So let me know how you're getting on and tell me what you plan to do on your way back. We send our very best wishes to the ladies, to both of you and your children and look forward to seeing you.

Yours sincerely, CLAUDE MONET

*

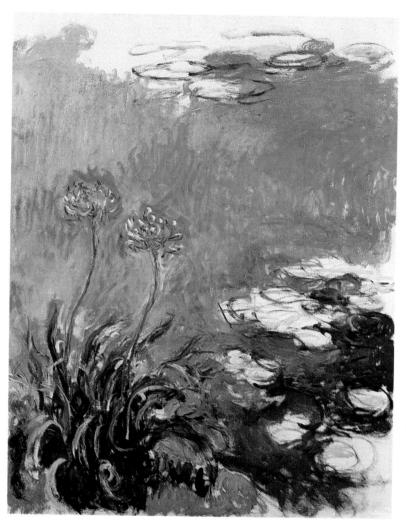

AGAPANTHUS

Giverny, 22 October 1921

To Arsène Alexandre

You must have been somewhat surprised that you never received so much as a word of thanks from me, but it's because your book only got to me eight days after it was sent and I didn't want to write until I had read the whole thing. So first I must apologize for this delay; to assure you without false modesty that I'm very touched by everything you're kind enough to credit me with.

Leaving the introductory paragraph aside your study is perfect in that you have managed to arrange all the various phases of my experiments and researches into a coherent chronology, and you have done so without making a single mistake, and without hurting anyone, so please accept my sincerest and profoundest thanks.

I'd like to think I might have the pleasure of seeing you in Giverny again one of these days and we could have another talk about my gift to the State (I'm not getting any younger). It's important, indeed urgent, that this matter should be settled once and for all. Moreover I'm planning to have a frank talk with Monsieur Paul Léon about it.

With all my thanks, in sincerest friendship, CLAUDE MONET

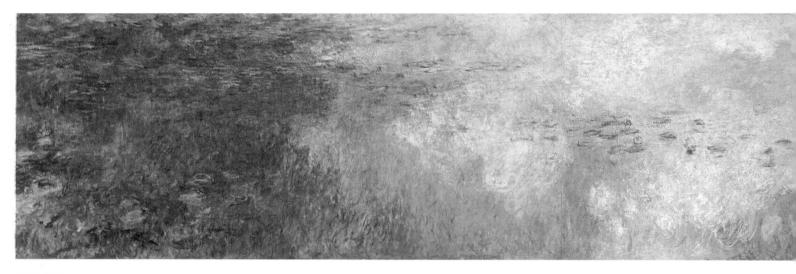

THE CLOUDS

Giverny, 31 October 1921

TO GEORGES CLEMENCEAU

I am sending you the detailed information I promised you on the subject of the donation of my *Décorations* to the State. First of all it must be understood that I refuse the room that was offered in the Jeu de Paume, and that's final. But I will agree to the room in the Orangerie on condition that the Beaux-Arts administration undertakes to do the work there which I judge necessary. With this prospect in mind I have reduced several motifs of the *Décorations* and believe I have come up with a satisfactory arrangement, keeping to the oval form I always wanted. Instead of the 12 panels I gave I'll provide 18. It's true that the number doesn't matter, only the quality, and I myself no longer know what to think of this work. The essential thing is that it should be well displayed and after much deliberation I believe I've come up with a successful solution. I enclose a rough plan of what I'd like: a first room, the effect of which you were able to judge yesterday, and a second with the four panels of the *Three Willows* as a kingpin at the end, with the *Tree Reflections* opposite and on either side a panel of 6 metres.

If the administration accepts this proposal and undertakes to do the necessary work, then the matter is settled. A straightforward discussion with Monsieur Paul Léon and the architect he considers most suitable to carry out the aforementioned work, and then all I'll have to do is to wait till it's done, as I don't intend to deliver my panels until the work is completely finished.

Very glad to have seen you yesterday, and I look forward to your next visit with your friends from Nantes.

Your old friend CLAUDE MONET

k

Giverny, 16 February 1922

To G. and J. Bernheim-Jeune

A line to let you know how I am and to ask you to forgive me for not inviting you; it would undoubtedly be a great pleasure to see you, but I'm still working despite my sight which is getting worse by the day; that's why I'm feeling very nervous, and don't want to see anyone for the moment, as I can only think of working while I still can, but as soon as it gets warmer and it becomes impossible to work in the studio, I'll be in touch. I hope you're all well and send you my very best wishes.

Yours sincerely, CLAUDE MONET

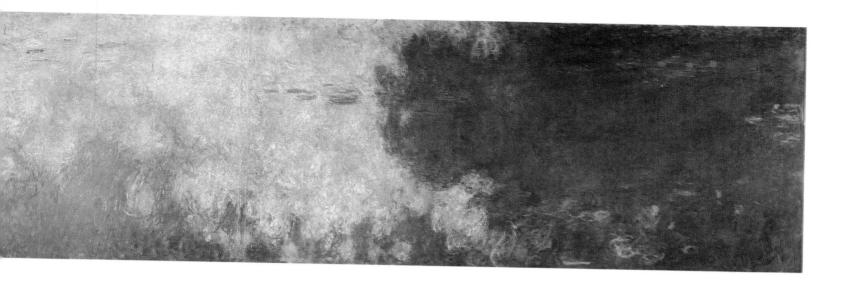

[Giverny], 8 May 1922

TO MARC ELDER

... All winter my door has been closed to everyone. I knew the days were getting shorter and I wanted to use what sight I had left to bring off a number of my *Décorations*. And I made a great mistake. For in the end I was forced to recognize that I was spoiling them, that I was no longer capable of doing anything good. So I destroyed several of my panels. Now I'm almost blind and I'm having to abandon work altogether. It's hard but that's the way it is: a sad end despite my good health!...

[Giverny], 22 May 1922

To Georges Clemenceau

I'm very upset since the wistaria has never been lovelier and in this heat it won't last any time. Everything looks wonderful at the moment and the light is dazzling...

Giverny, 11 August 1922

To G. or J. Bernheim-Jeune

didn't, but as you may imagine, this ghastly weather has upset me so much I'm still angry about it. To think I was getting on so well, more absorbed than I've ever been and expecting to achieve something, but I was forced to change my tune and give up a lot of promising beginnings and abandon the rest; and on top of that, my poor eyesight makes me see everything in a complete fog. It's very beautiful all the same and it's this which I'd love to have been able to convey. All in all, I am very unhappy. The season's gone to waste and at my age it may be the last.

Aside from that my health is excellent. All I can do is hope for a fine autumn and I mustn't think of moving from here. My last trip will be to see to the installation of my paintings in the Orangerie or possibly to come and be operated on. We'd be very happy to see you when you get back and hope you have a good end to the season. Madame Jean joins me in sending best wishes to the ladies.

Your old friend, CLAUDE MONET

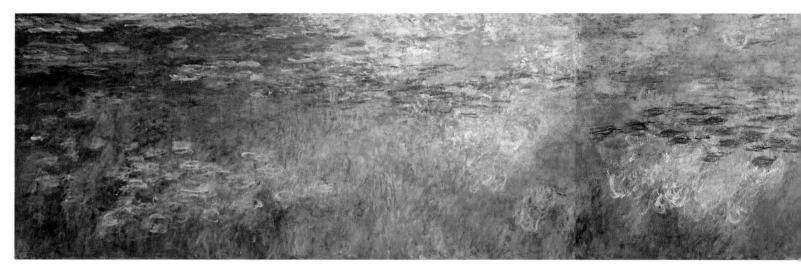

WATER-LILIES

[Giverny?], 9 September 1922

To Georges Clemenceau

eye absolutely gone, an operation will be essential and even unavoidable in the near future.

Meanwhile, there's a course of treatment which might make the other eye better and enable me to paint. That said, I wanted to see how the work at the Orangerie was getting on. Not a worker in sight. Absolute silence . . . Just a little pile of rubble at the door . . .

*

Giverny, 13 September 1922

TO DOCTOR CHARLES COUTELA

I have to tell you at once of the effect that the drops you prescribed for my left eye have had. It's quite simply wonderful. I haven't seen as well as I can now for a long while, and I greatly regret not having consulted you sooner! It would have meant that I could have painted some passable work instead of the daubs I persisted in doing when I could see nothing but a fog.

I can now see everything in my garden. I'm overjoyed at my perception of every colour in the spectrum. One thing only: my right eye is still more veiled. May I continue the treatment so that I can do what is most urgent? I would be grateful for a word in reply.

Yours sincerely and gratefully, CLAUDE MONET

*

Giverny, 18 January 1923

To Paul Léon, Director of the Beaux-Arts A few words to say that I've just undergone a preliminary operation which went very well, I'm due for another definitive operation and then I'll most certainly be able to install the panels which I've given to the State. I'm sure you'll be pleased with this news.

Yours sincerely, CLAUDE MONET

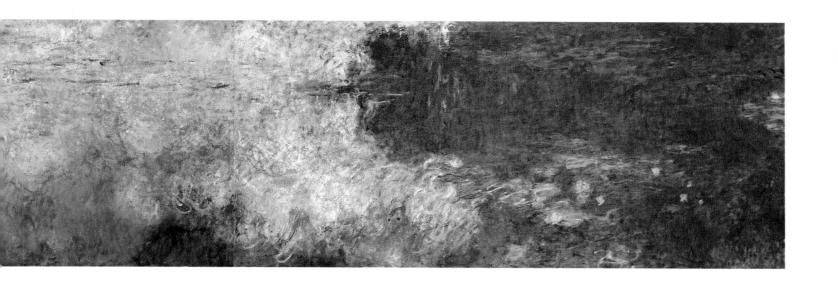

Giverny, 22 June 1923

To Doctor Charles Coutela

My apologies for not coming to the appointment. I'm in the depths of despair and though I'm reading some 15 to 20 pages a day, though not without a struggle I might add, I can see nothing outside or in the distance, either with or without my spectacles. And for the last two days I've been plagued by black specks.

To think that it's now six months since the first operation, five since I left the clinic, and soon it will be four since I've worn spectacles, which is nowhere near the four or five weeks to get used to my new vision! I might have put those six months to good use if you had been honest with me. I might have finished the *Décorations* which I have to deliver in April and I'm certain now that I won't be able to finish them as I'd have liked.

That's the greatest blow I could have had and it makes me sorry that I ever decided to go ahead with that fatal operation. Excuse me for being so frank and allow me to say that I think it's criminal to have placed me in such a predicament.

Yours very unhappily, CLAUDE MONET

*

Giverny, Saturday evening [4 August 1923]

To G. or J. Bernheim-Jeune

Dear friend, I'm somewhat behind in writing to you but the last operation, more painful than the previous ones, has left me with some rather unpleasant twinges of pain. All the same I've been able to set various paintings aside though it's not easy to communicate their prices by letter. The prices vary according to size and quality, from 30, 35, 40 to 50,000 francs. Naturally if I'm to expect a visit from you one of these days could you kindly let me know in advance?

Despite the bouts of pain, my condition seems to be improving, the doctors are very satisfied. I'm the only one who's finding it very slow; not until the end of the month will I be able to use remedial spectacles.

All our best to the ladies and to everyone.

Yours, CLAUDE MONET

Giverny, Thursday 30 August 1923

To Georges Clemenceau

To confirm what I said in my telegram after new trials with the lenses and with small doses, on Coutela's advice; I'm doing exercises and can read easily; that much is certain and it's restoring my confidence, but the distortion and exaggerated colours that I see are quite terrifying. As for going out for a walk in these spectacles, it's out of the question for the moment anyway, and if I was condemned to see nature as I see it now, I'd prefer to be blind and keep my memories of the beauties I've always seen, though this undoubtedly won't be the case. What annoys me the most now, is that since I have to ration my use of the lenses and as Coutela has forbidden the artificial use of eye drops in my left eye, I am quite helpless and can't see at all.

I've just written to see if he'll allow me one drop each morning so I can attend to personal matters.

He'll be back in Paris on the 4th and I won't hesitate to go and see him if I have to; in any case you'll be kept informed every other day by telegram or letter.

I embrace you warmly.

P.S. My need for drops for the left eye is all the more pressing since I've several canvases to touch up and deliver straight away, which I couldn't do with the exaggerated vision the new lenses provide.

CLAUDE MONET

Giverny, 22 September 1923

TO GEORGES CLEMENCEAU

I can't put off replying to your affectionate letter any further, but I have to say that in all sincerity and after much deliberation, I absolutely refuse (for the moment at least) to have the operation done to my left eye; you are far away and can have no idea of the state I'm in as regards my sight and the alteration of colours, and you cannot do anything to help me.

I can see, read, and write and I fear that this is very probably the only result that can be obtained. So unless I find a painter, of whatever kind, who's had the operation and can tell me that he can see the same colours he did before, I won't allow it.

I'm expecting Coutela tomorrow. I hope he'll change my lenses and we'll see if there's an improvement. I've been patient, and now you must be too.

But what about you, how are you getting on? Morale's good on the whole.

Blanche and I send our love.

CLAUDE MONET

Giverny, 21 October, 1923

To Doctor Charles Coutela

SOUTELA ... I received the spectacles from Germany and much to my surprise the results are very good. I can see green again, red and, at last, an attenuated blue. It would be perfect if the frames were better, the two lenses are too close together ... Believe me,

Yours in friendship, CLAUDE MONET

Giverny, 20 November 1923

To Joseph Durand-Ruel

In reply to your letter I have to say that since I've plunged into my work again and am having to make up for so much lost time, I can't receive visitors here for the time being. I'm working hard in order that my *Décorations* will be ready on time...

Your old friend, CLAUDE MONET

THE ROSE-TRELLISES, GIVERNY

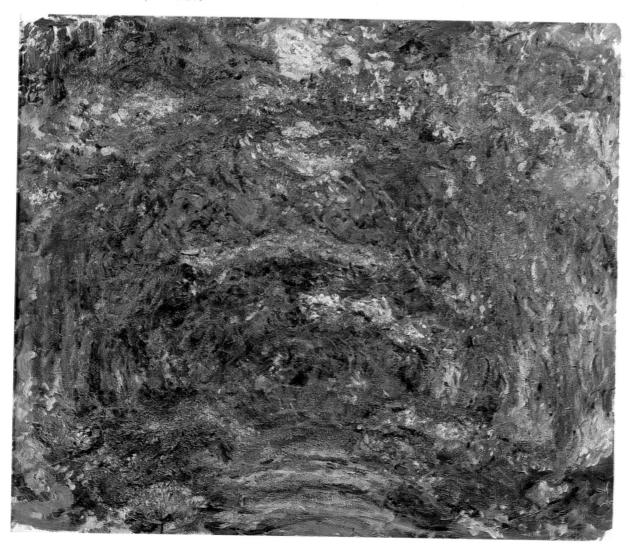

Giverny, 9 April 1924

TO DOCTOR CHARLES COUTELA

You haven't heard from me as I promised, and there's a reason for it since I didn't want to tell you how discouraged I've been feeling. For months I've been slaving away and have achieved nothing worthwhile. Is it my age or faulty sight? Both no doubt, but my sight most of all. You have recovered my perception of black and white, for reading and writing in other words, and I'm grateful for that of course, but my vision as a painter has, alas, gone as I'd thought and it's not your fault.

I tell you this in complete confidence. I hide it as much as possible, but I'm feeling terribly saddened and discouraged. Life is a torture to me. I don't know what to say. You know that I'm surrounded by care and affection. Perhaps it's fatigue, but apart from near sight, there's no doubt that I see with increasing difficulty. The first spectacles are the only ones I'm satisfied with in artificial light, and the odd thing is that I accidentally put them on in daylight and no longer noticed those yellows and blues which made you choose tinted lenses. So what's to be done and what hope is there? It's up to you to tell me.

With gratitude and best wishes; my daughter-in-law sends her regards.

CLAUDE MONET

Giverny, 22 June 1924

To G. or J. Bernheim-Jeune

JEUNE I'm replying to your letter at once, to say that of course I agree with you and you can arrange for the translation you want to be done. While I'm at it, I can give you some good news. The last few days I've been working from nature and, indeed, it looks as if it's going well.

My best wishes to everyone,

CLAUDE MONET

*

Giverny, 14 January 1925

TO ETIENNE MOREAU-NÉLATON

All that you say about Daubigny in connection with me is correct and I have good reason to be grateful to him. I met him in London during the Commune; he saw that I was in some distress, to say the least, and enthused over some of my *Thames* paintings, and through him I met Monsieur Durand-Ruel, without whose help I and several of my friends would have died of starvation. Subsequently, I was particularly touched by Daubigny's purchase from Durand-Ruel of one of my *Views of Holland*. But it was to his greatest credit that he resigned as a member of the jury at the official Salon of the time, because my work and that of several friends was unfairly rejected.

Please forgive this poor writing, but I'm very old and my sight is far from perfect.

Yours sincerely, CLAUDE MONET

×

Giverny, 27 July 1925

TO DOCTOR CHARLES COUTELA

I myself am writing this, since we both were particularly touched by your letter and I want to thank you for your kind thought. Furthermore, I'm delighted to be able to tell you that I've truly recovered my sight at last and did so virtually at a stroke. In short, I can live and breathe again, am overjoyed to see everything once more, and I'm working passionately.

Your grateful and loyal patient, CLAUDE MONET

Giverny, 21 June 1926

To Evan Charteris

Forgive me for not having replied sooner, but as I'm still somewhat indisposed, I can't yet write to you myself. Moreover, all I'm able to do is confirm what I told you in our last discussion. Having reread your letter closely, together with the copy of Sargent's letter, I have to say that if the translation of Sargent's letter is accurate I don't approve of it, firstly because Sargent makes me into something much grander than I am, and I've always had a horror of theories, and finally the only merit I have is to have painted directly from nature with the aim of conveying my impressions in front of the most fugitive effects, and it still upsets me that I was responsible for the name given to a group the majority of whom had nothing of the impressionist about them.

With apologies for not being able to be of any greater help,

Yours sincerely, CLAUDE MONET

Giverny, 18 September 1926

TO GEORGES CLEMENCEAU

I am the one to be writing, at last, and I'm glad to say that I'm getting better (although at times I'm in great pain), but I'm being sensible, recovering my taste for food, and sleep quite well thanks to Rebière and Doctor Florand's care, so much so in fact that I was thinking of preparing my palette and brushes to resume work, but relapses and further bouts of pain prevented it. I'm not giving up that hope and am occupying myself with some major alterations in my studios and plans to perfect the garden. All this to show you that, with courage, I'm getting the upper hand.

Can you read this scribble? I hope so and look forward to a visit from you soon, that would really put me right again. You ought to know in any case, that if I don't recover my strength sufficiently to do what I want to my panels, I've decided to offer them as they are, or some of them at least. But how about yourself, how are you? Better than me, I hope. I embrace you warmly. Blanche and Michel also send their love.

Yours ever, CLAUDE MONET

WATER-LILIES

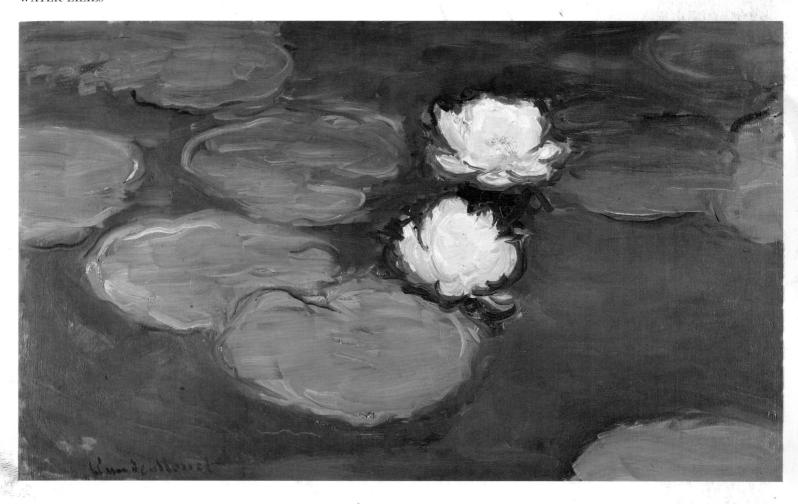

WATER-LILIES: EVENING

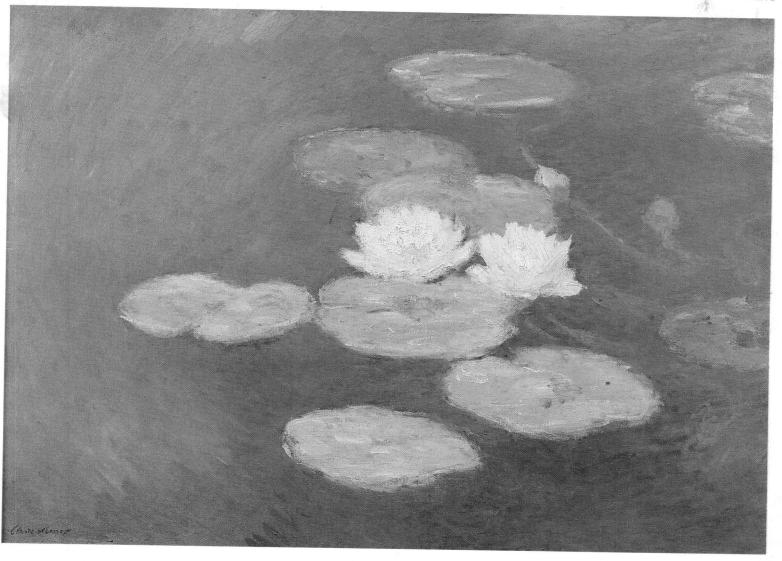

JAPANESE BRIDGE AT GIVERNY

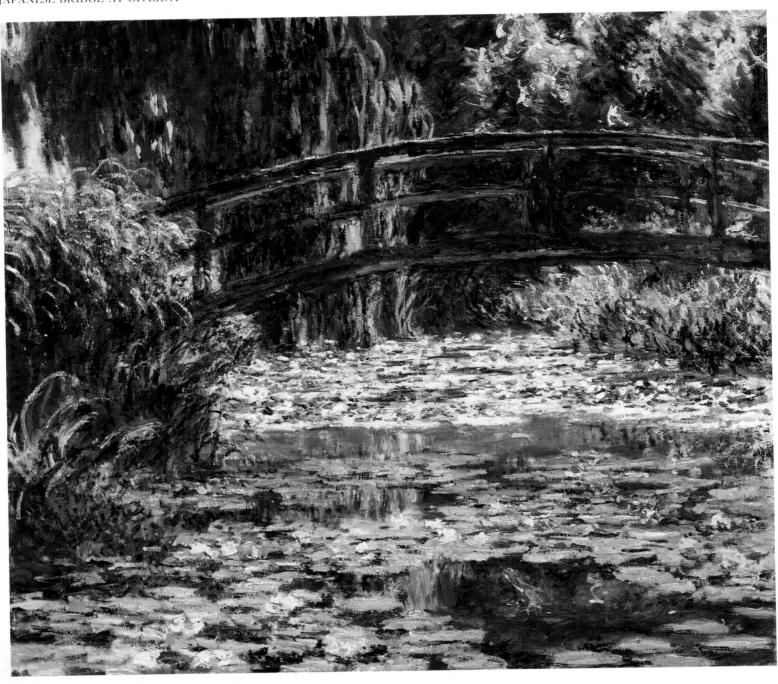

WATER-LILIES AND JAPANESE BRIDGE

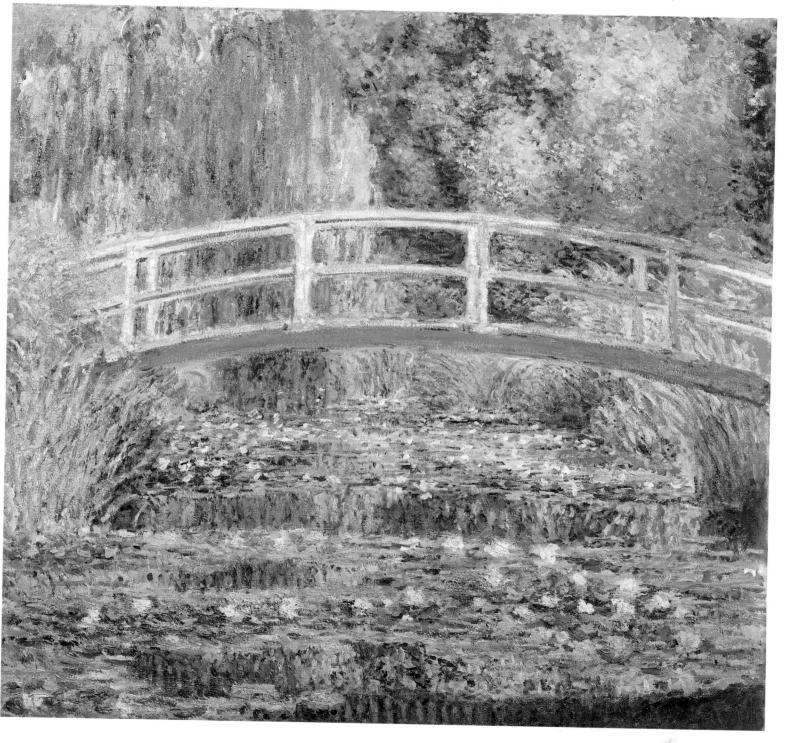

WATER-LILIES

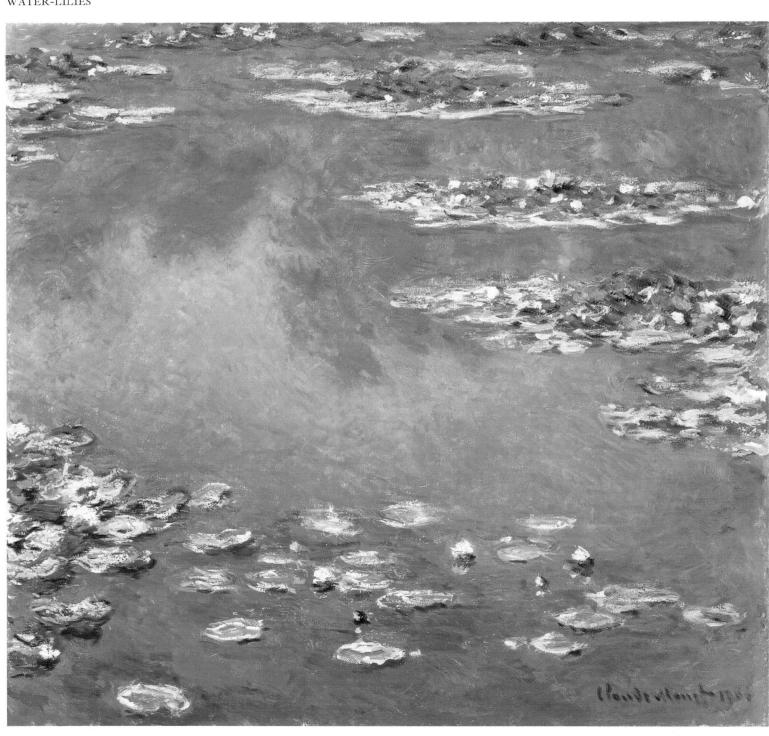

WATER-LILIES

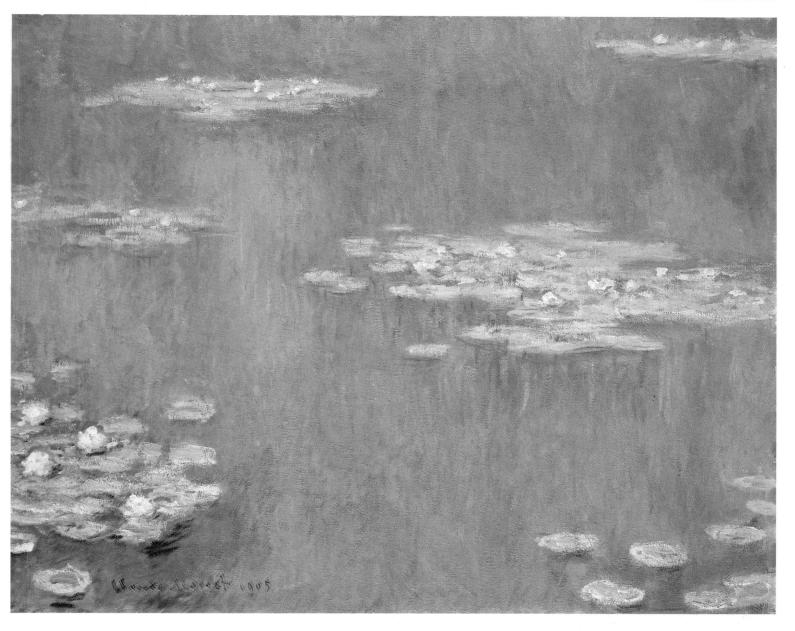

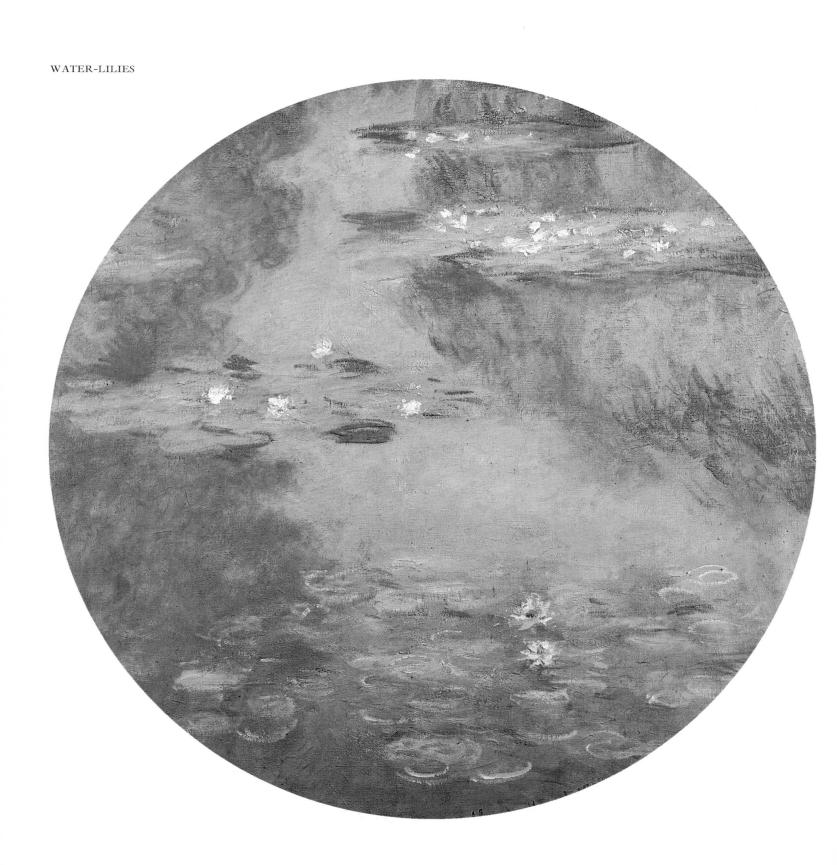

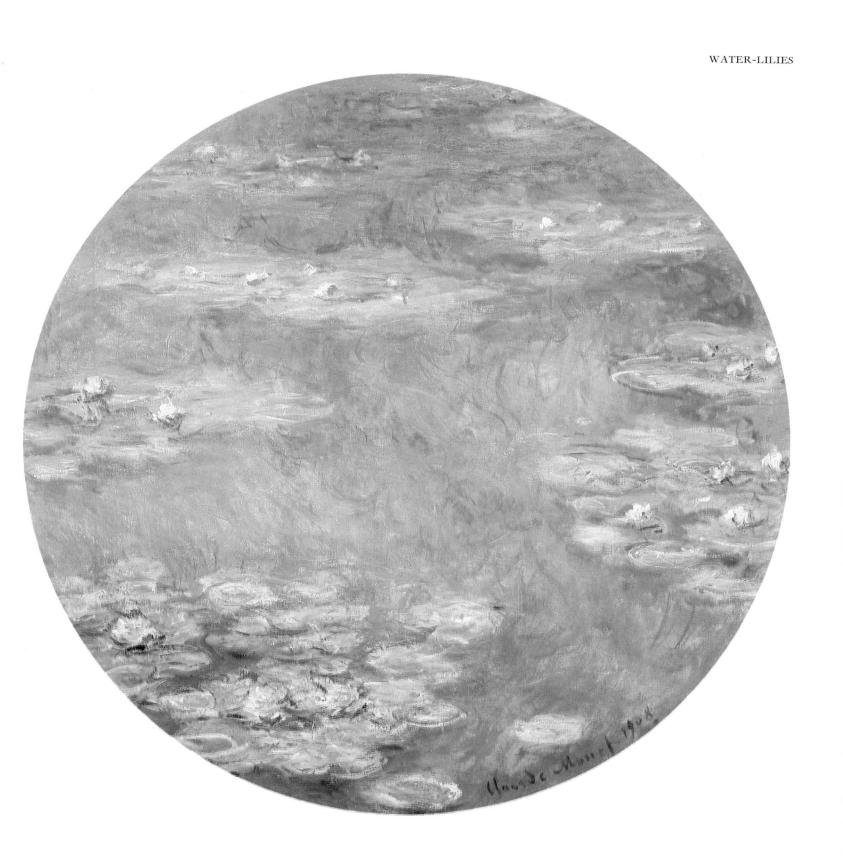

WATER-LILIES: WATER LANDSCAPE

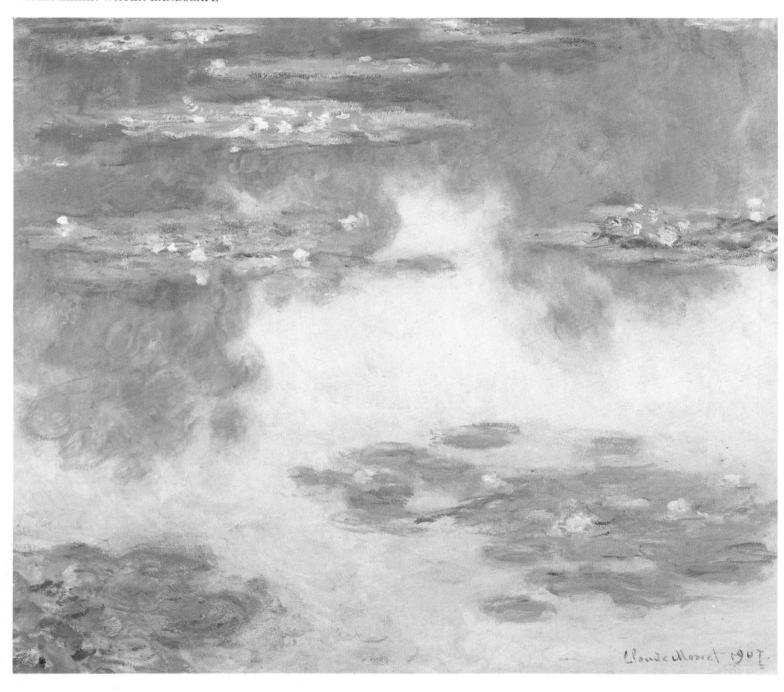

WATER-LILIES

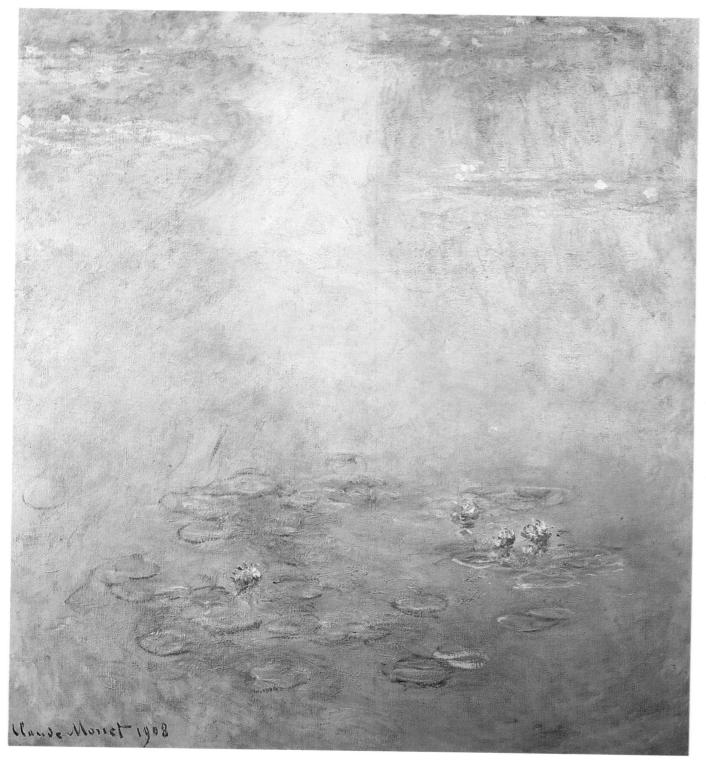

WATER-LILIES

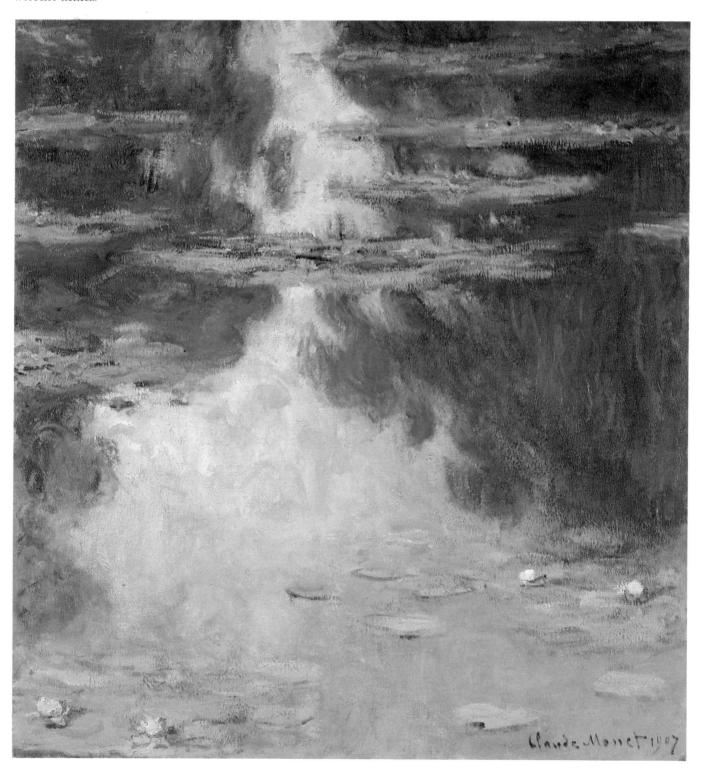

WATER-LILY POND

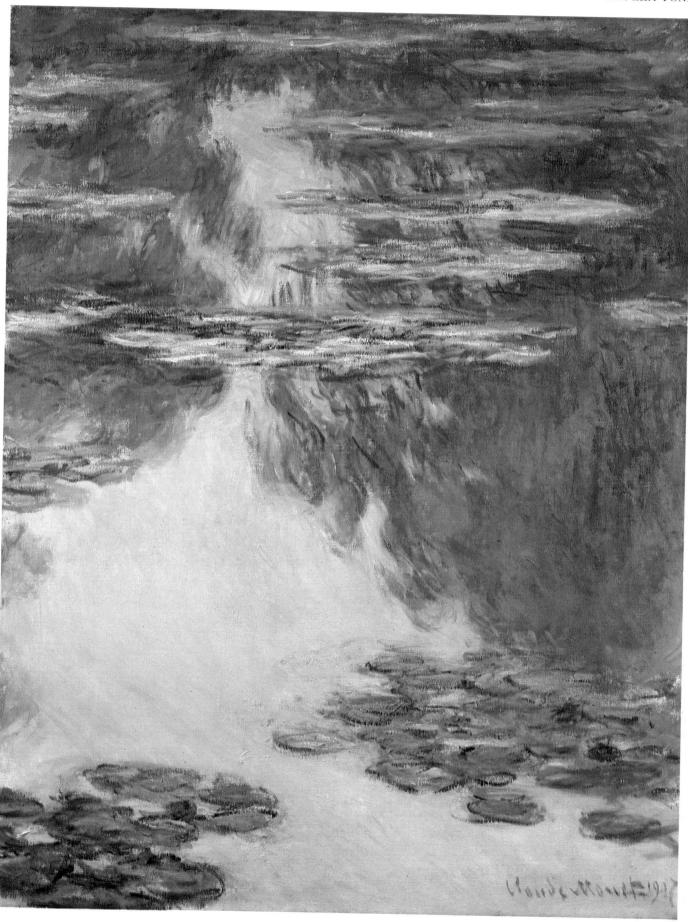

WATER-LILIES

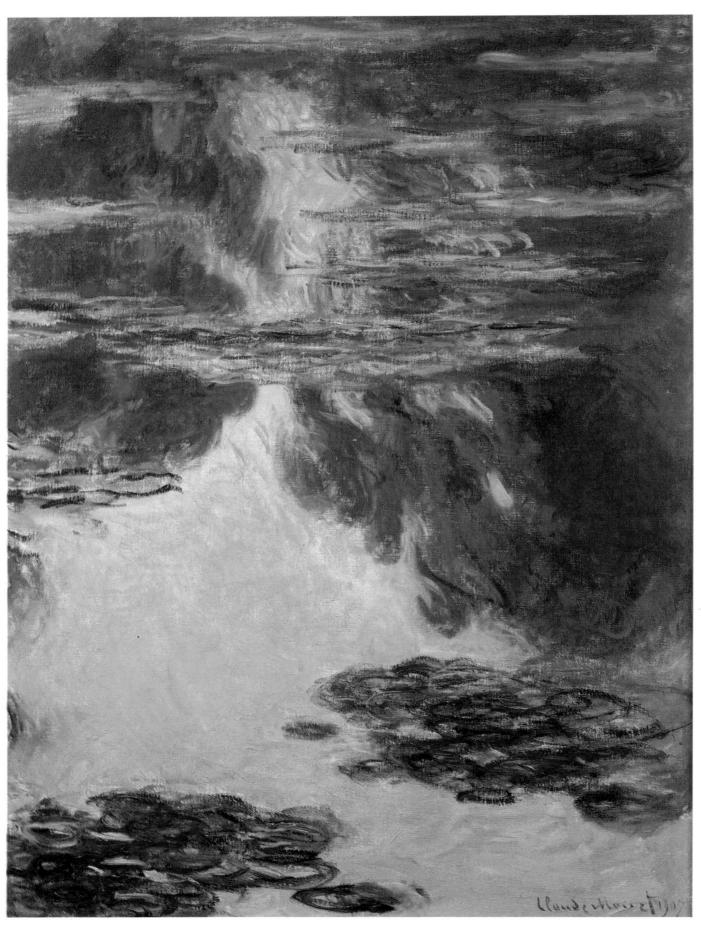

WATER-LILIES: STUDY

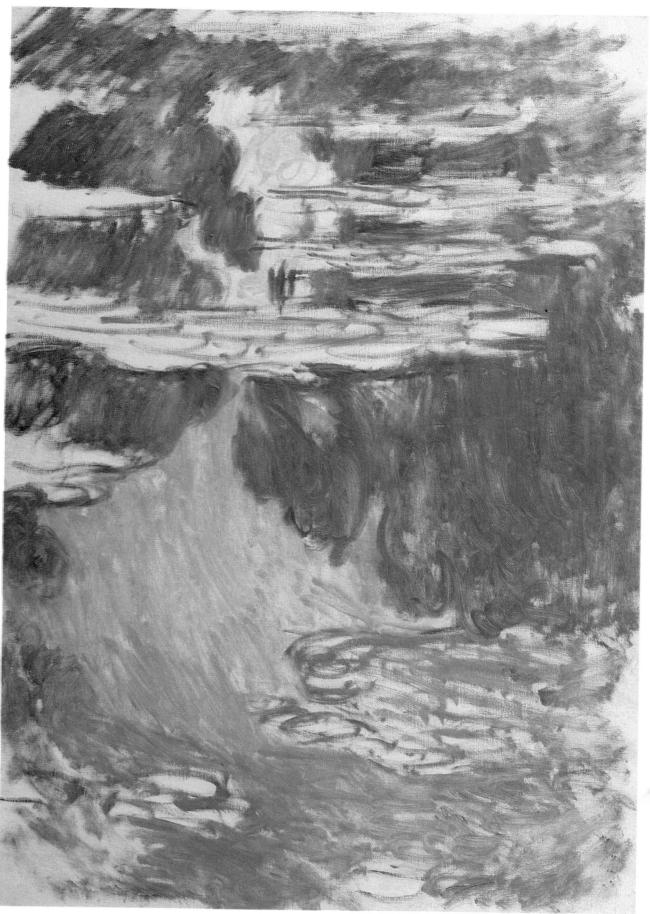

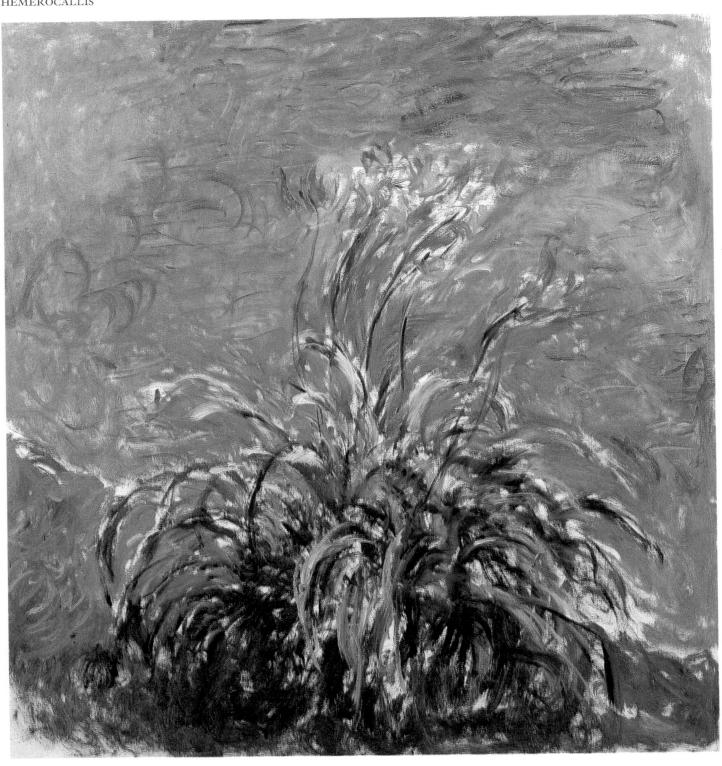

IRIS

THE WATER-LILY POND

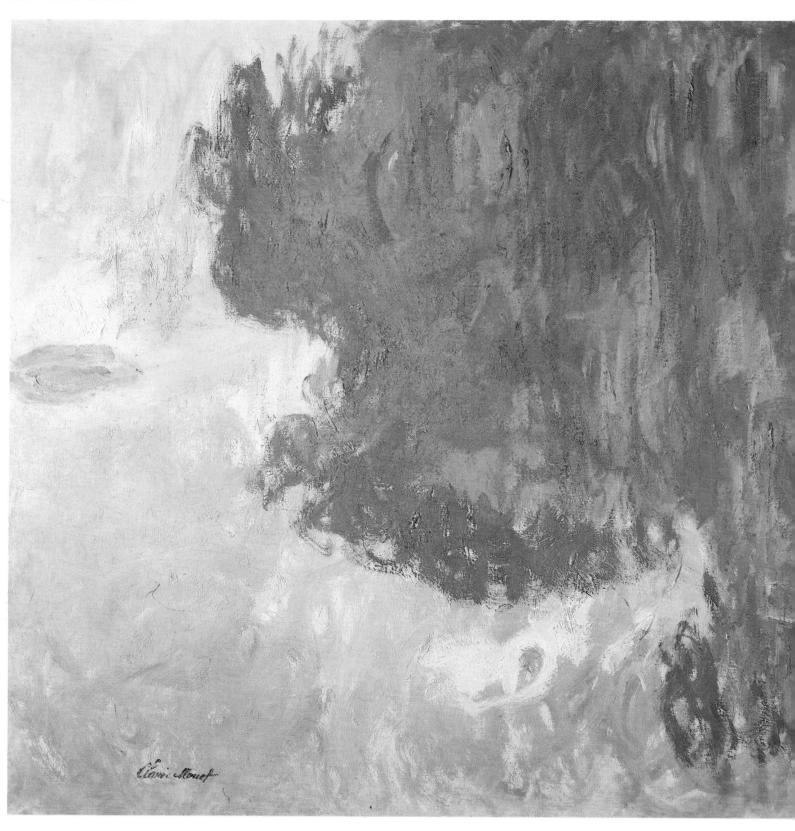

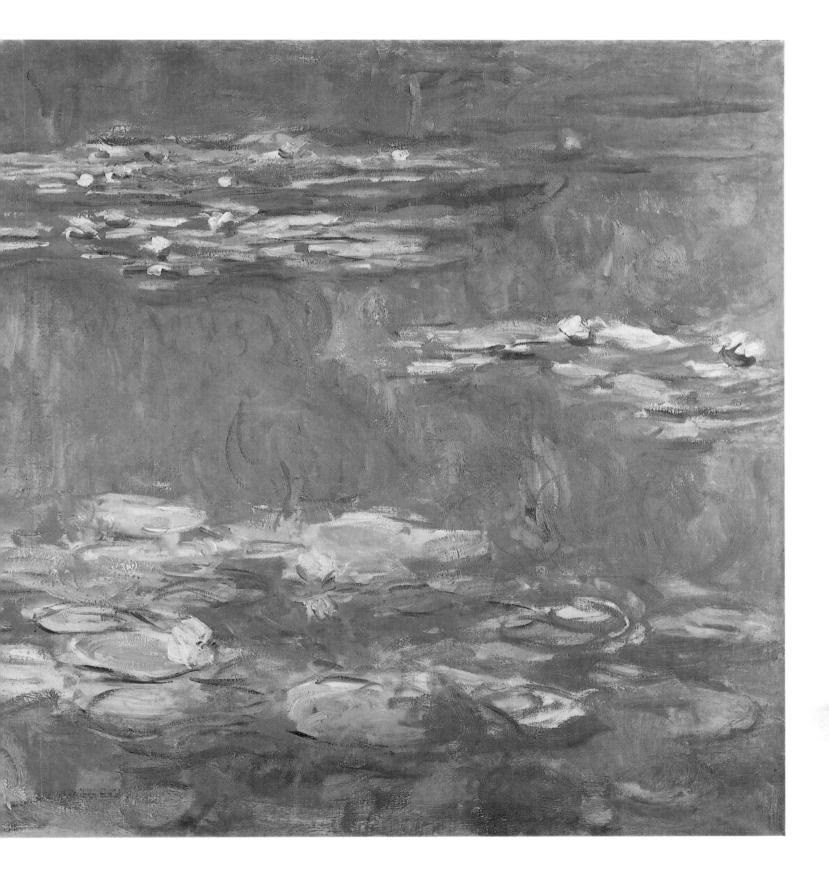

WATER-LILIES

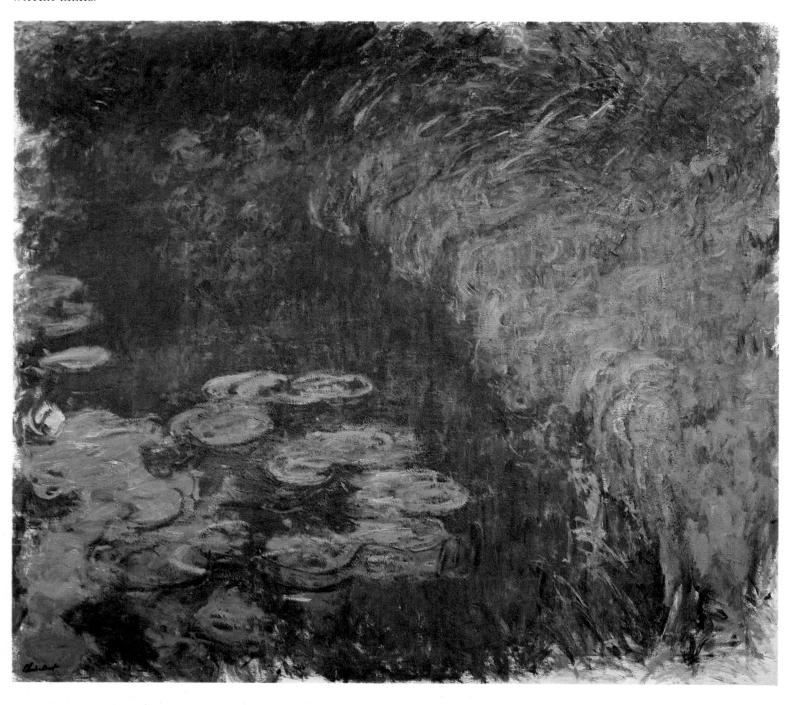

WATER-LILIES

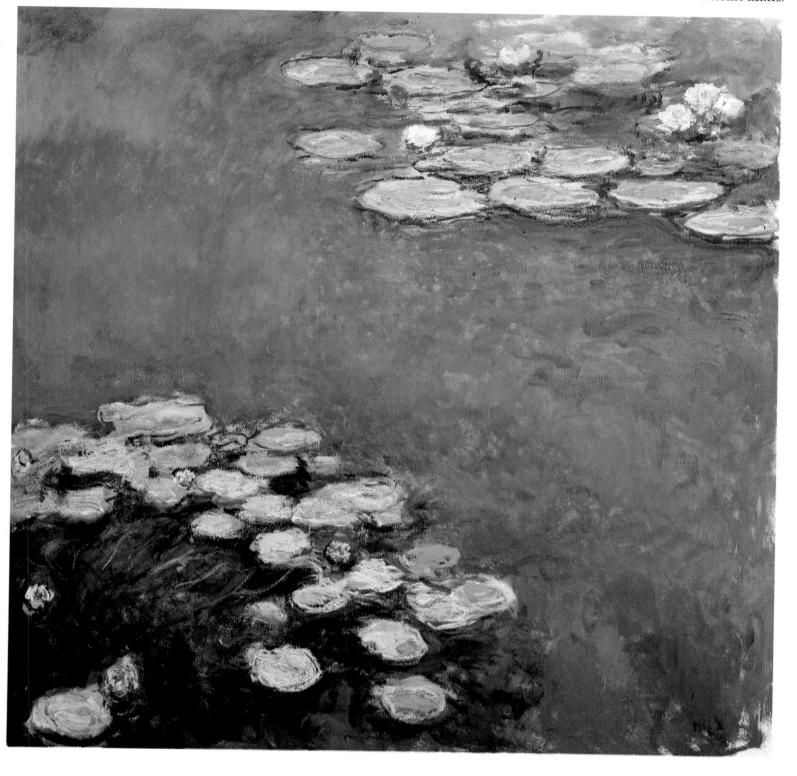

WATER-LILIES

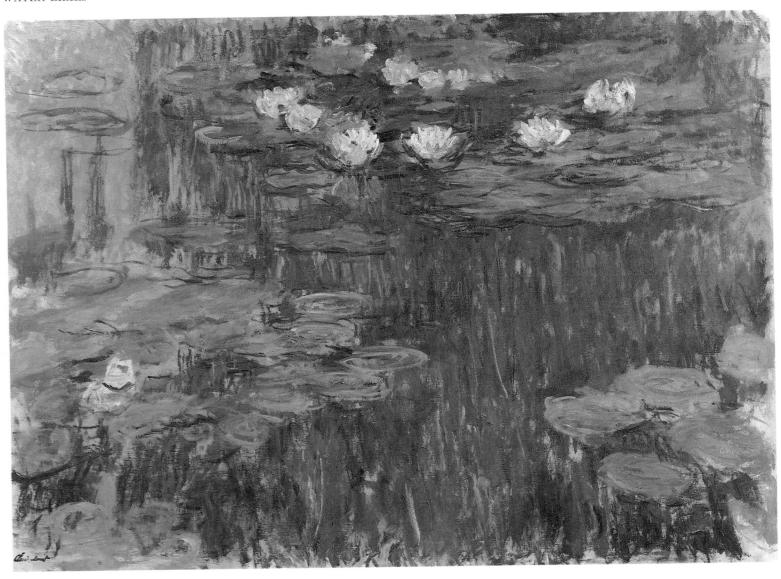

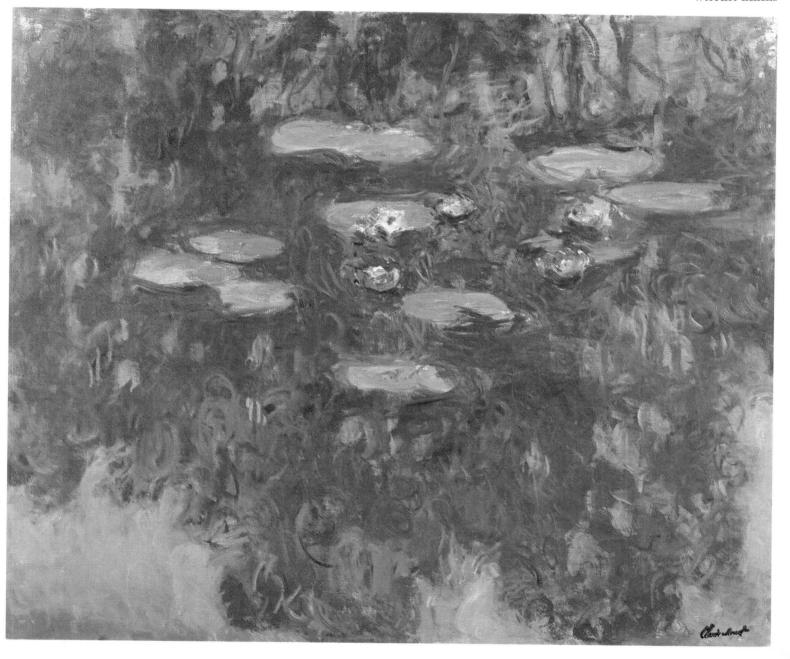

WATER-LILIES

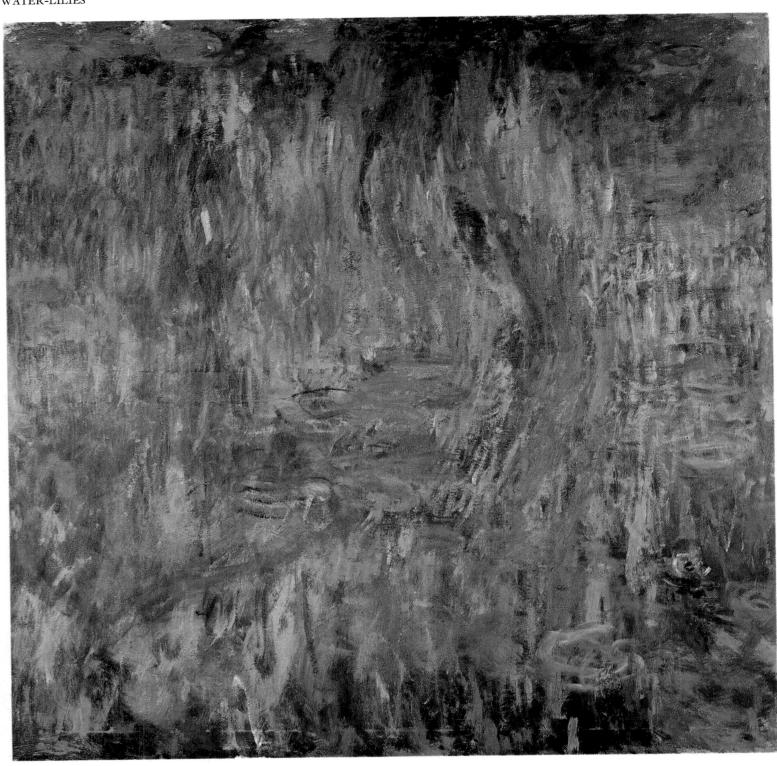

WATER-LILIES

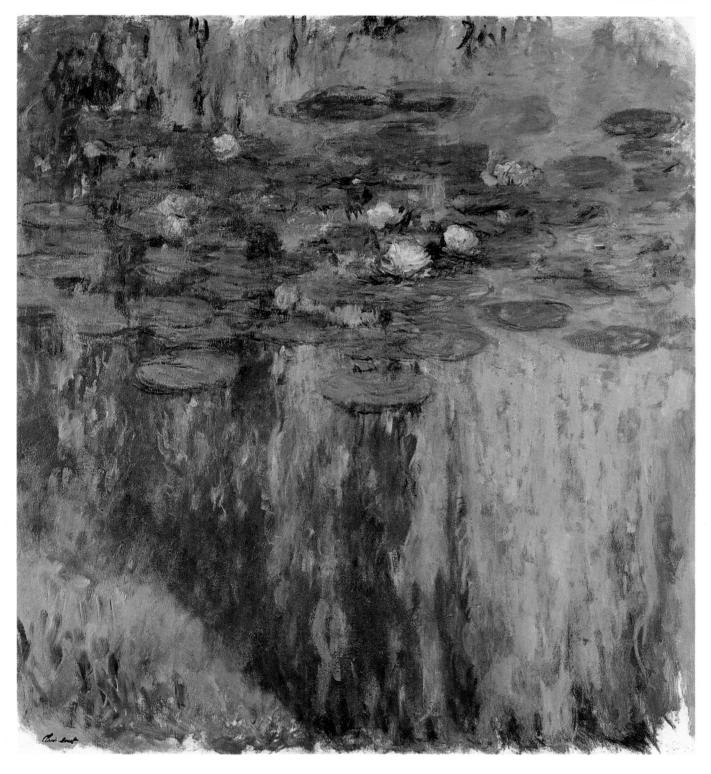

WATER-LILIES

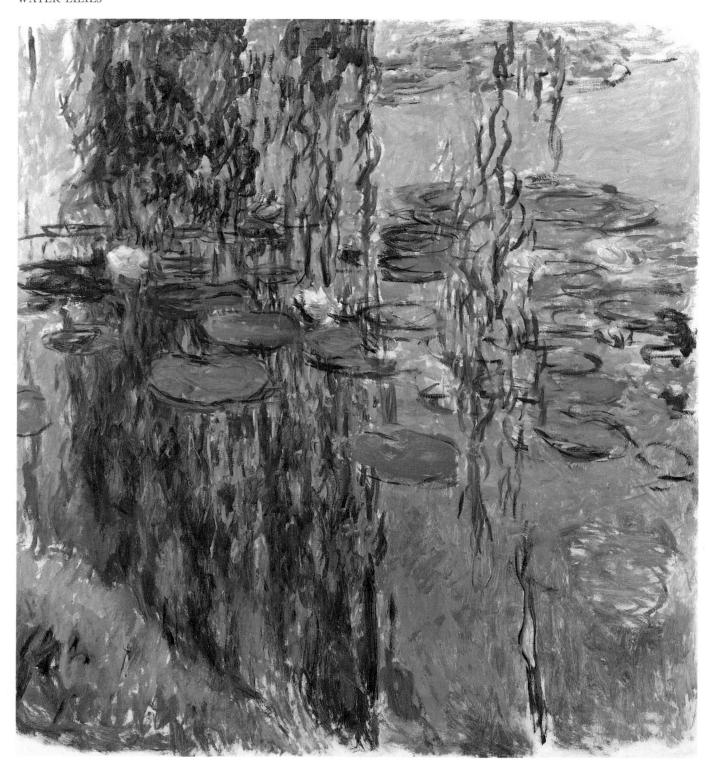

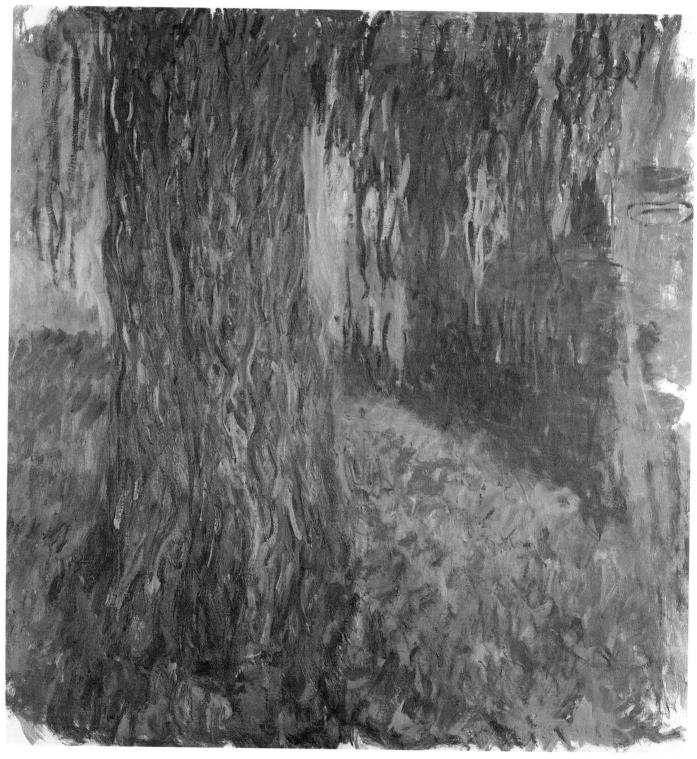

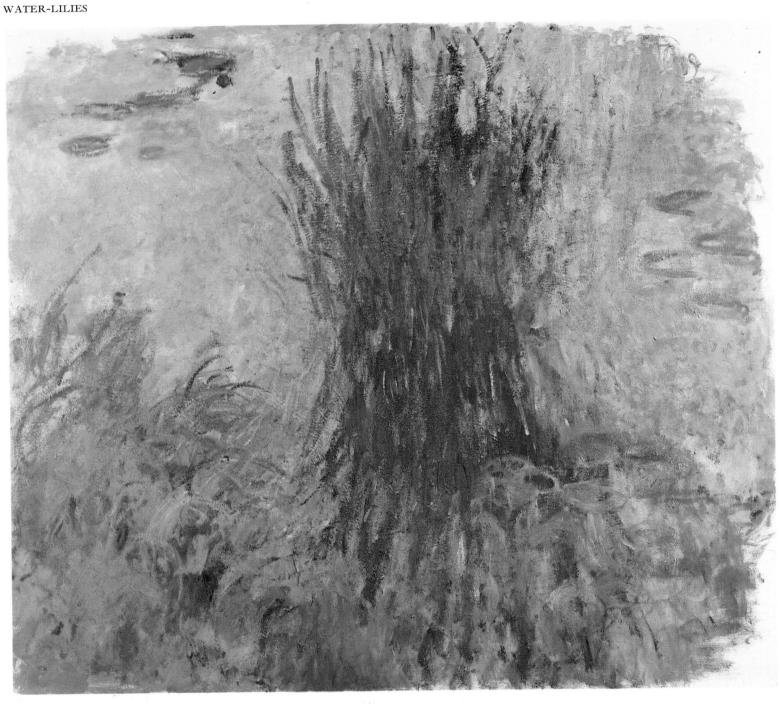

WATER-LILY POND

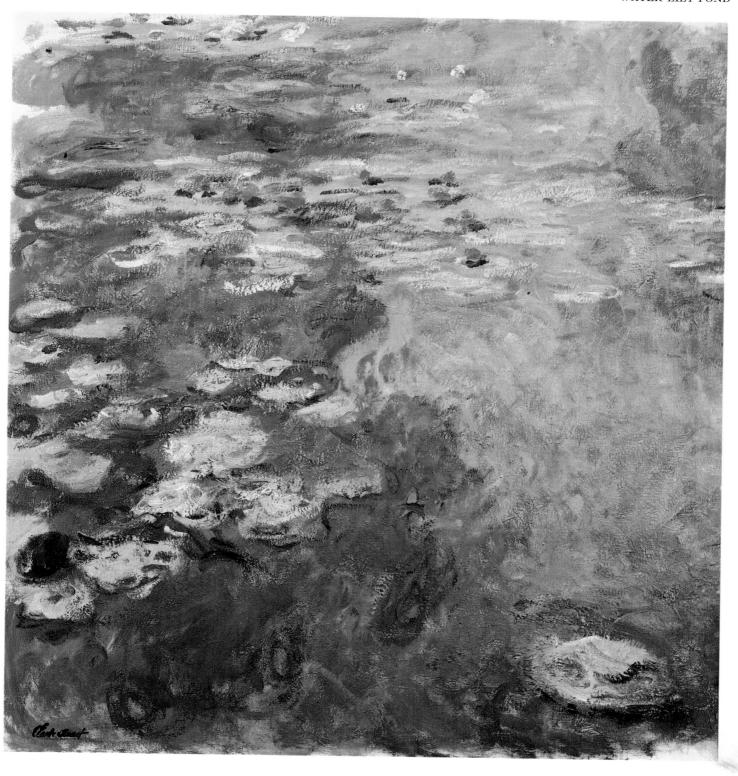

VIEW OF THE WATER-LILY POND WITH WILLOW TREE

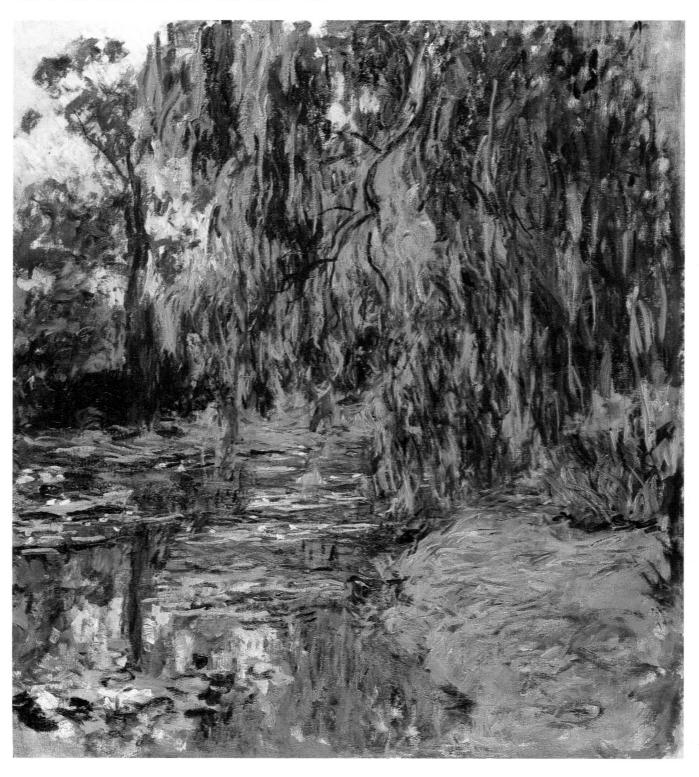

WEEPING WILLOW

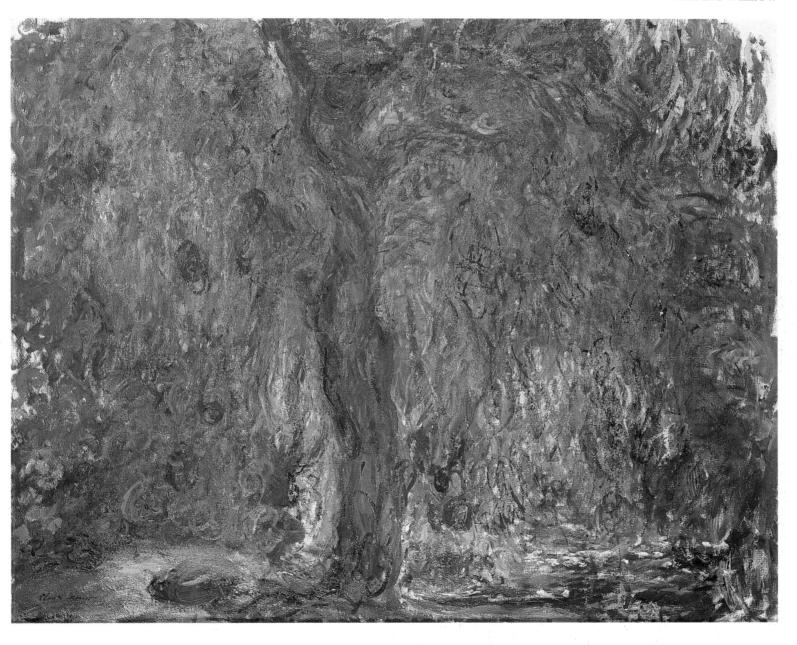

WATER-LILIES: WILLOW REFLECTIONS

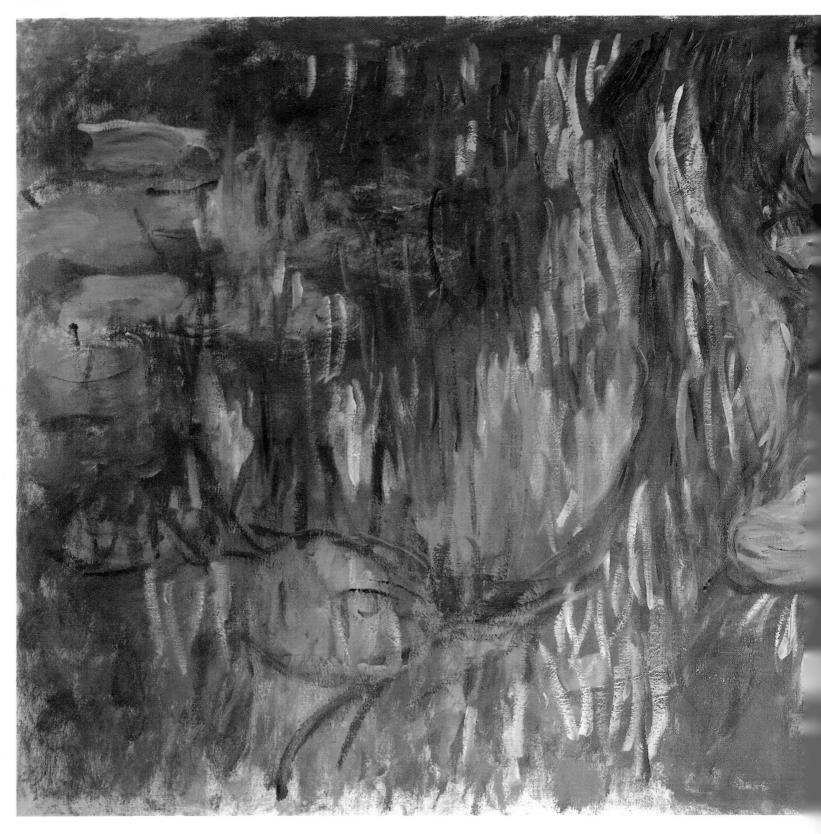

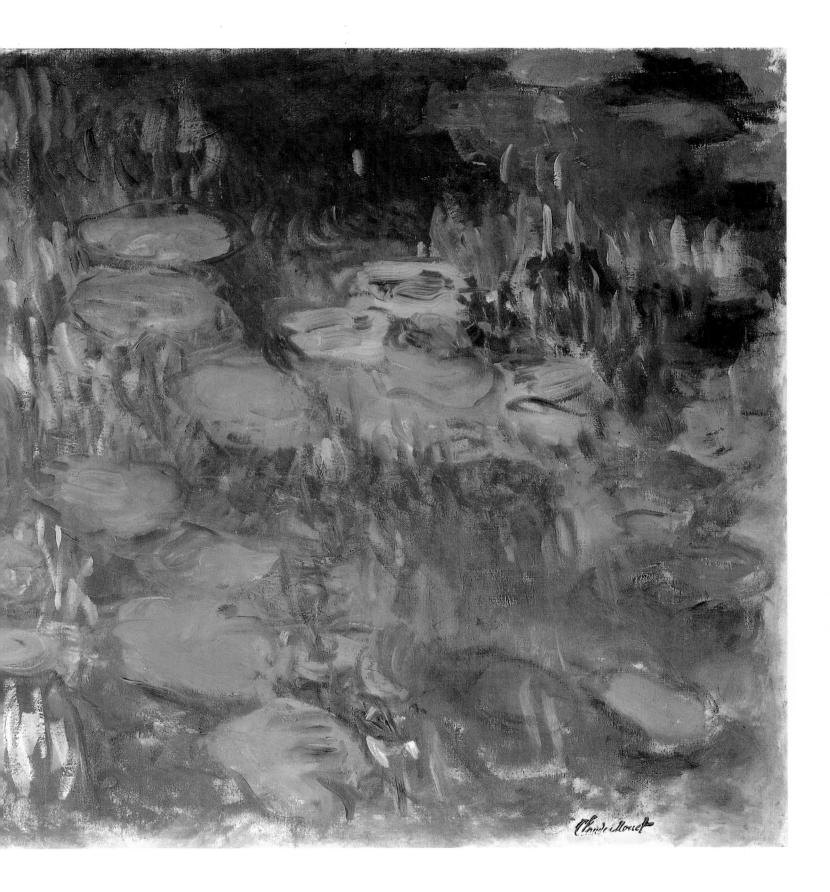

WATER-LILIES

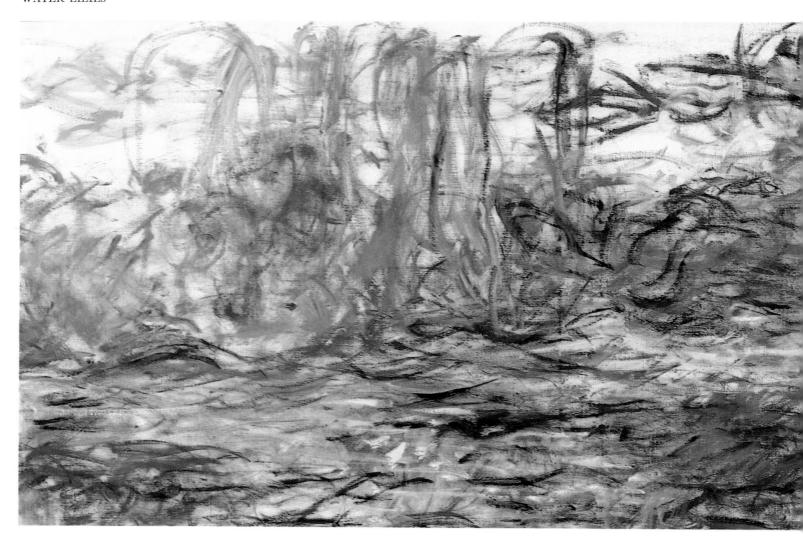

WATER-LILY POND: EVENING

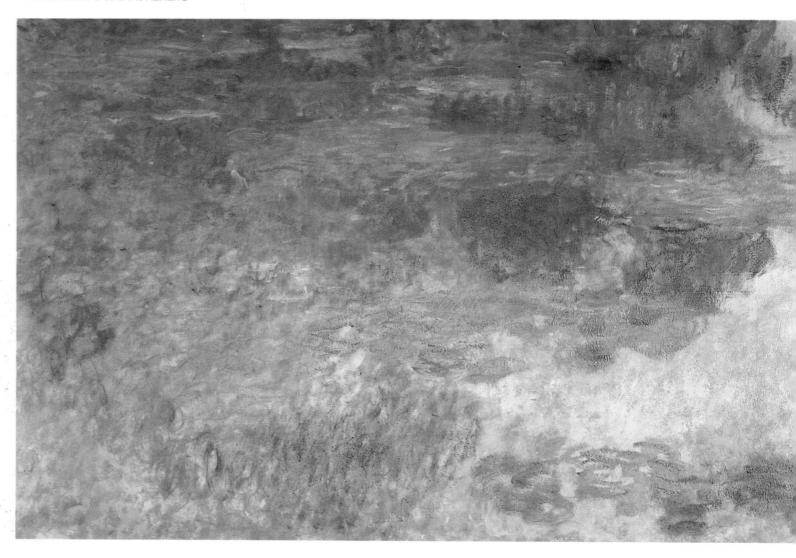

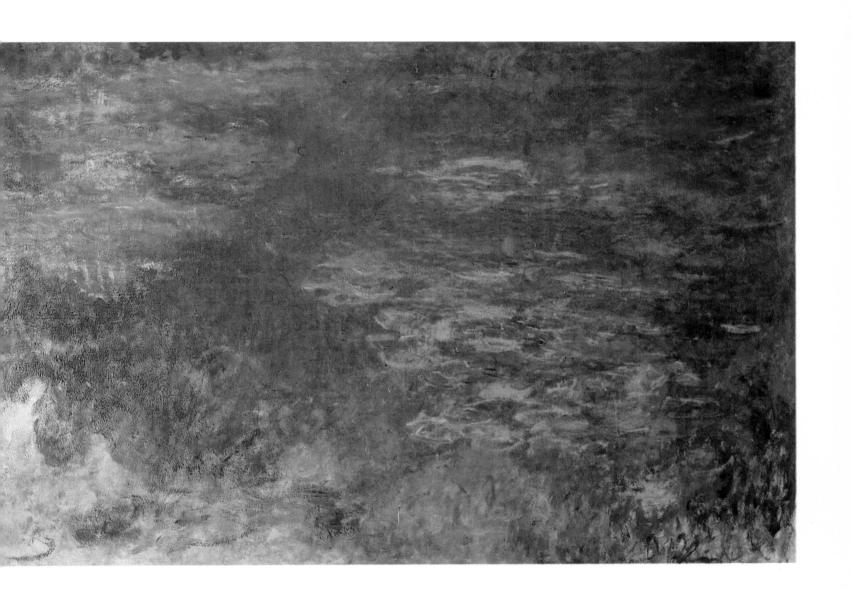

WATER-LILY POND WITH IRISES

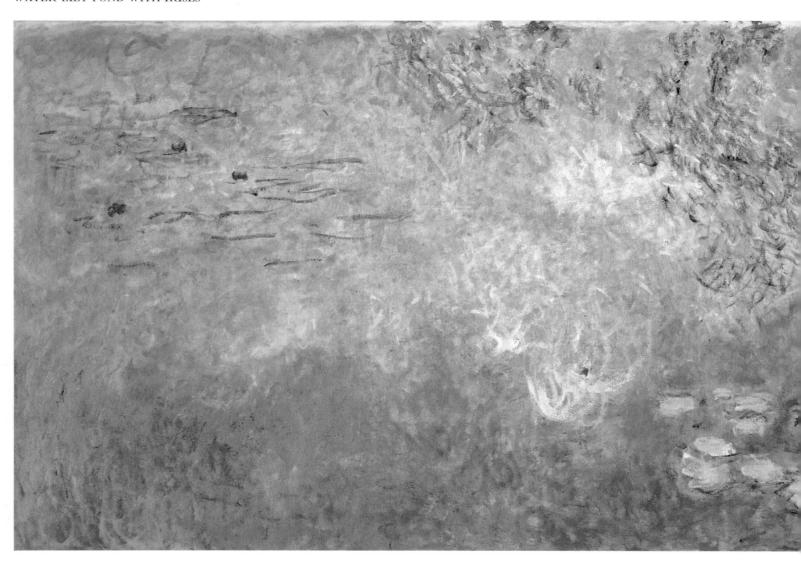

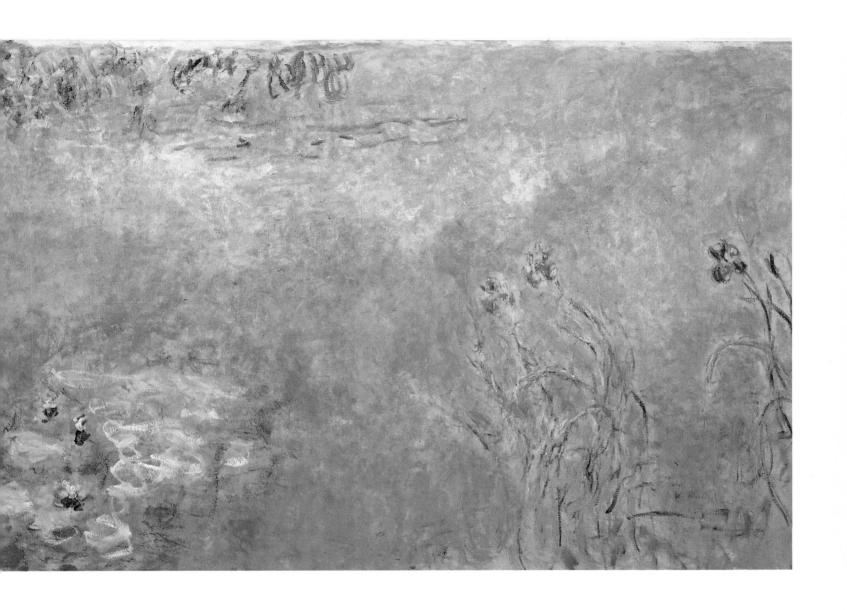

WATER-LILIES

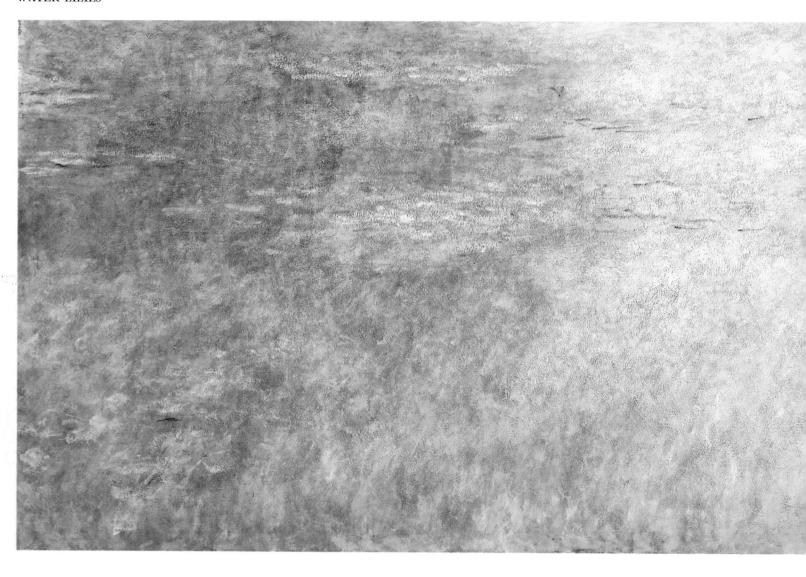

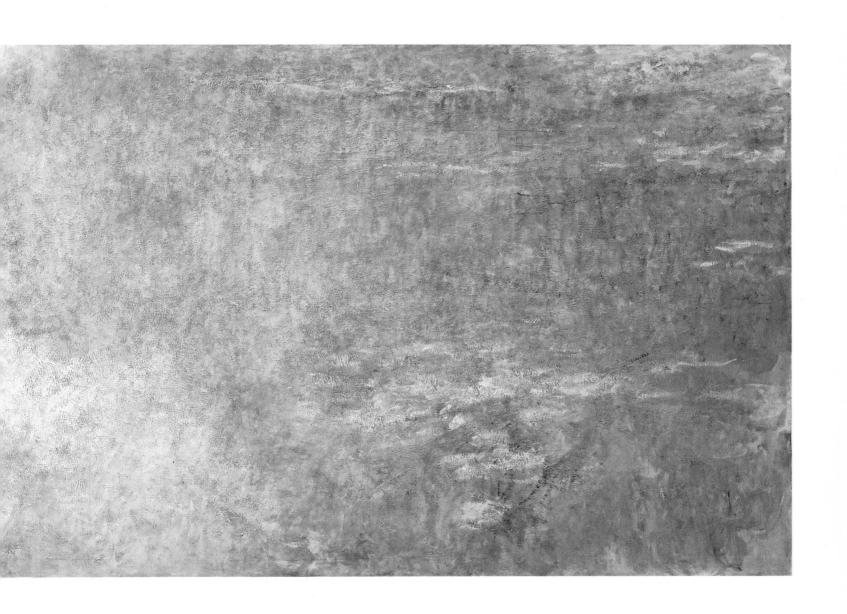

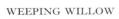

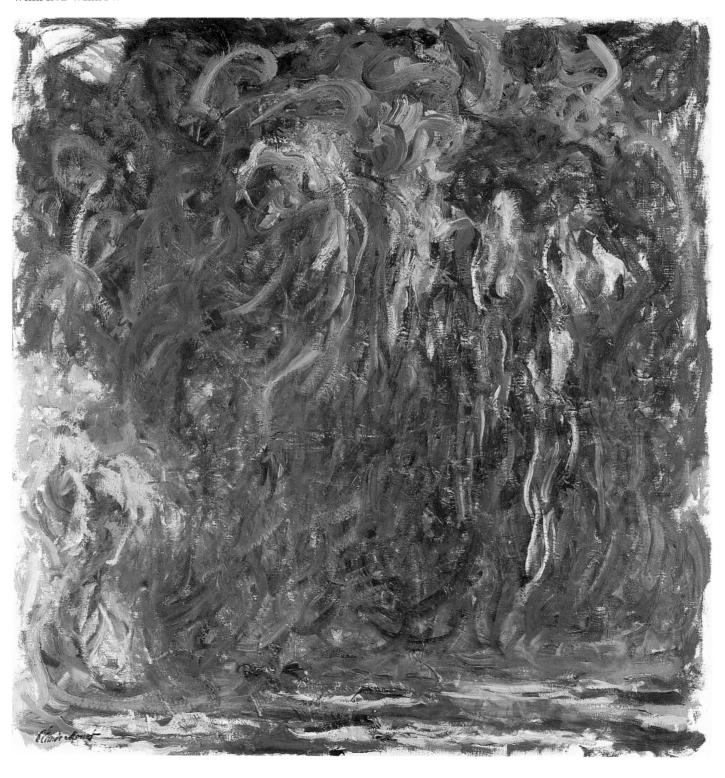

THE ROSE-TRELLISES

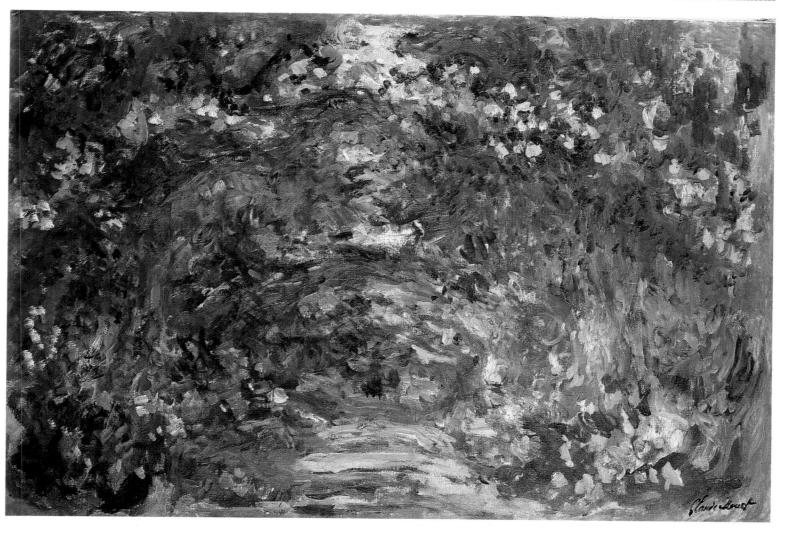

THE JAPANESE BRIDGE

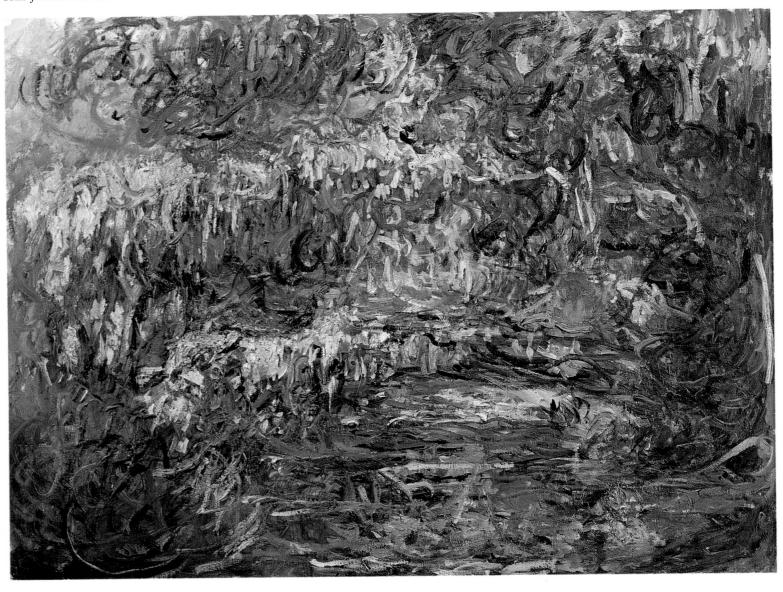

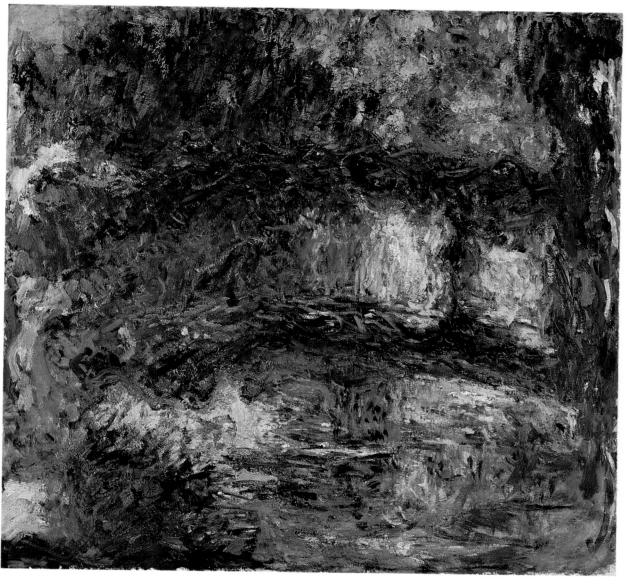

THE JAPANESE BRIDGE

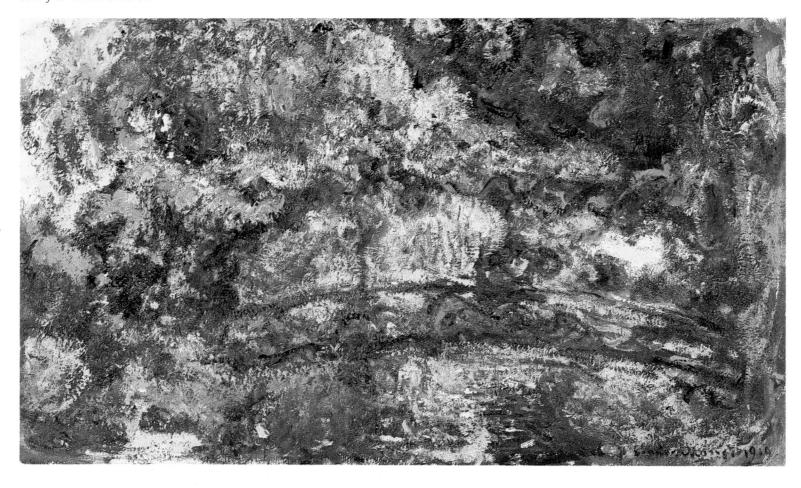

THE JAPANESE FOOTBRIDGE

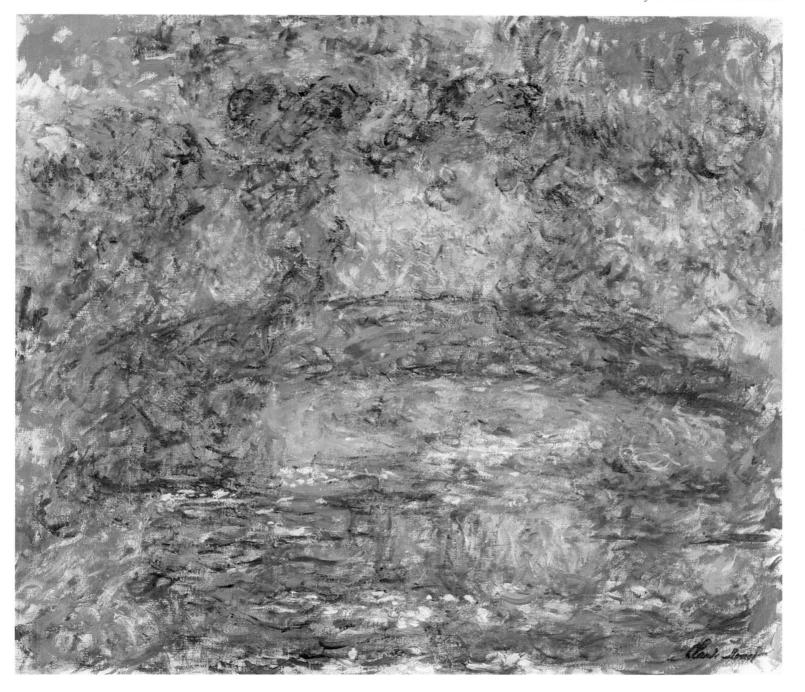

THE HOUSE SEEN FROM THE ROSE-GARDEN

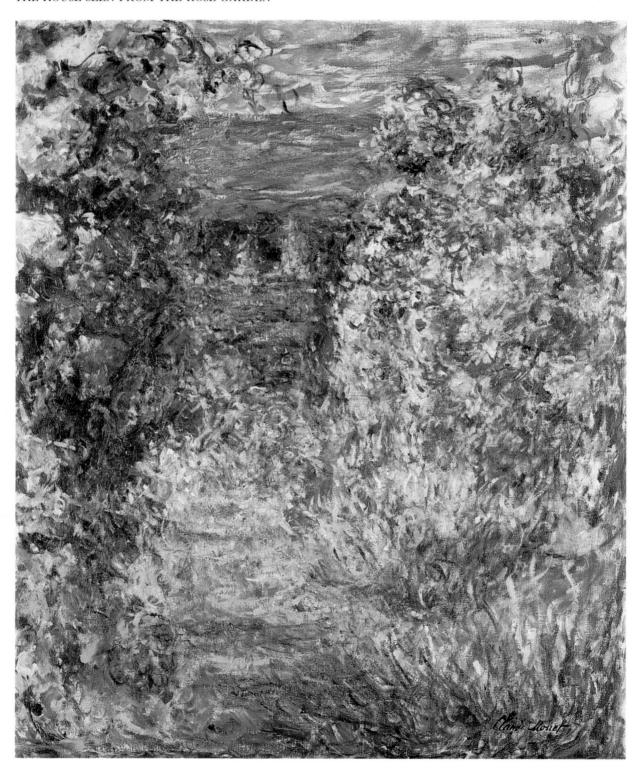

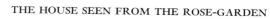

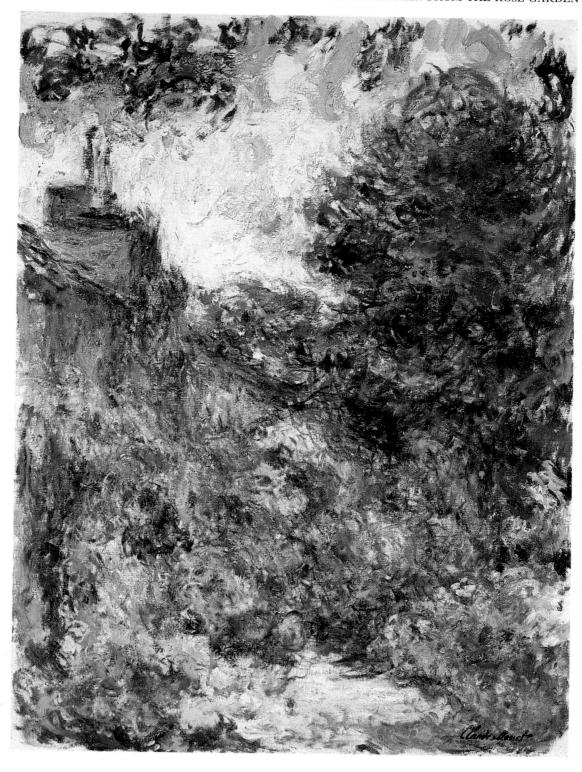

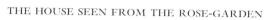

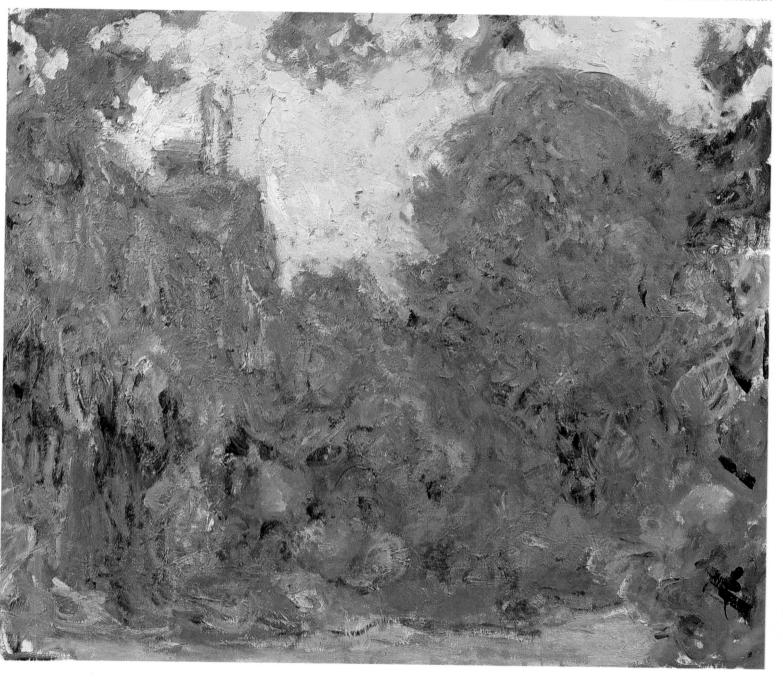

List of Plates

The numbers preceded by W refer to catalogue entries in Daniel Wildenstein, Claude Monet, biographie et catalogue raisonné.

- YOUNG DANDY WITH MONOCLE, c. 1856–7
 left Black chalk, 25 × 16 cm
 Musée Marmottan, Paris
- 19 CARICATURE OF A MAN WITH A LARGE NOSE, c.1855/6 right Graphite on tan wove paper, 24.9 × 15.2 cm

 Art Institute of Chicago; Gift of Carter H. Harrison
 - THE COAST OF NORMANDY VIEWED FROM SAINTE-ADRESSE, c.1864
 Black chalk, 19.5 × 30.8 cm
 Fine Art Museums of San Francisco; Achenbach Foundation for Graphic Arts,
 Memorial Gift from Edward & Tullah Hanley Bradford, Pennsylvania
 - 22 LE PAVÉ DE CHAILLY, 1865 Oil on canvas, 42 × 59 cm W56 Musée d'Orsay, Paris
 - 25 THE ARTIST'S SON ASLEEP, 1867–8 Oil on canvas, 42.5 × 50 cm W108 Ny Carlsberg Glyptothek, Copenhagen
 - 27 THE DINNER, 1868/9
 Oil on canvas, 51 × 66 cm W129
 Foundation E.G. Bubrle, Zurich
 - 28 MADAME GAUDIBERT, c. 1868 Oil on canvas, 65 × 81 cm W121 Musée d'Orsay, Paris
 - 30 THE STUDIO BOAT, c.1874 Oil on canvas, 50 × 64 cm W323 Rijksmuseum Kroller-Muller, Otterlo
 - 32 CAMILLE ON HER DEATHBED, 1879 Oil on canvas, 90 × 68 cm W543 Musée d'Orsay, Paris
 - 34 CORNER OF THE STUDIO, c.1861 Oil on canvas, 1.82 × 1.27 m W6 Musée d'Orsay, Paris
 - 35 SPRING FLOWERS, c.1864
 Oil on canvas, 117 × 90.1 cm W20
 Cleveland Museum of Art; Bequest of Leonard C. Hanna Fund
 - 36 RUE DE LA BAVOLLE, HONFLEUR, 1864 Oil on canvas, 56 × 63 cm W34 Kunstballe, Mambeim
 - 37 RUE DE LA BAVOLLE, HONFLEUR, 1864
 Oil on canvas, 55.9 × 61 cm W33
 Courtesy, Museum of Fine Arts, Boston; Bequest of John T. Spaulding
 - 38 CLIFFS AND SEA, c.1865 Black chalk on paper, 21 × 41 cm Art Institute of Chicago
 - 39 NEAR ETRETAT, c.1868 Pastel on paper, 20.7 × 40.5 cm Israel Museum, Jerusalem
 - 40 THE GREEN WAVE, c.1865
 Oil on canvas, 48.6 × 64.8 cm W73
 Metropolitan Museum of Art, New York; Bequest of Mrs. H.O. Havemeyer
 - 41 SEASCAPE, STORM, 1867
 Oil on canvas, 20 × 42 cm W86
 Sterling and Francine Clark Institute, Williamstown, Massachusetts

- 42 THE REGATTA AT SAINTE-ADRESSE, 1867
 Oil on canvas, 75.2 × 101.6 cm W91
 Metropolitan Museum of Art, New York; Bequest of William Church Osborn
- 43 THE BEACH AT SAINTE-ADRESSE, 1867 Oil on canvas, 75.8 × 102.5 cm W92 Art Institute of Chicago; Mr and Mrs Lewis Larned Coburn Memorial Colection
- 44 WOMEN IN THE GARDEN, 1866 Oil on canvas, 2.55 × 2.05 m W67 Musée d'Orsay, Paris
- 45 GARDEN IN FLOWER, 1866 Oil on canvas, 65 × 54 cm W69 Musée d'Orsay, Paris
- 46 THE QUAI DU LOUVRE, 1867 Oil on canvas, 65 × 93 cm W83 Haags Gemeentemuseum, Rotterdam
- 47 THE GARDEN OF THE PRINCESS, THE LOUVRE, 1867 Oil on canvas, 91.8 × 62 cm W85 Allen Memorial Art Museum, Oberlin; R.T. Miller, Jr. Fund
- 48 ICE ON THE SEINE AT BOUGIVAL, 1867 Oil on canvas, 65 × 81 cm W105 Musée du Louvre, Paris
- 49 THE MAGPIE, 1869 Oil on canvas, 89 × 130 cm W133 Musée d'Orsay, Paris
- 50 BATHERS AT LA GRENOUILLÈRE, 1869 Oil on canvas, 73 × 92 cm W135 National Gallery, London
- 51 LA GRENOUILLÈRE, 1869 Oil on canvas, 74.6 × 99.7 cm W134 Metropolitan Museum of Art, New York; Bequest of Mrs H.O. Havemeyer
- 52 THE POOL OF LONDON, 1871 Oil on canvas, 49 × 74 cm W168 National Museum of Wales, Cardiff
- 53 THE JETTY AT LE HAVRE c.1867 (dated 1870) Oil on canvas, 61 × 80 cm W88 Private collection
- 54 THE BEACH AT TROUVILLE, 1870 Oil on canvas, 37.5 × 45.7 cm W158 National Gallery, London
- 55 CAMILLE ON THE BEACH, 1870 Oil on canvas, 48 × 63 cm W161 Musée Marmottan, Paris
- 56 THE THAMES BELOW WESTMINSTER, 1871 Oil on canvas, 47 × 72.5 W166 National Gallery, London
- 57 ZAANDAM (HOLLAND), 1871 Oil on canvas, 48 × 73 cm W183 Musée d'Orsay, Paris
- 58 THE ZAAN AT ZAANDAM, 1871 Oil on canvas, 42 × 73 cm W172 Private collection
- 59 A MILL NEAR ZAANDAM, 1871 Oil on canvas, 43 × 73 cm W178 Ashmolean Museum, Oxford

- 60 ARGENTEUIL, LATE AFTERNOON, 1872 Oil on canvas, 60 × 81 cm W224 Private collection
- 61 ARGENTEUIL, 1872
 Oil on canvas, 50.4 × 65.2 cm W223
 National Gallery of Art, Washington; Ailsa Mellon Bruce Collection
- 62 LE BASSIN D'ARGENTEUIL, 1872 Oil on canvas, 60 × 80.5 cm W225 Musée d'Orsay, Paris
- 63 THE PLAINE DES COLOMBES, HOAR FROST, 1873 Oil on canvas, 100.3 × 90.8 cm W256 Courtesy of the Lefevre Gallery, London
- 64 SHIPS IN A HARBOUR, 1873
 Oil on canvas, 49.8 × 60.3 cm W259
 Courtesy, Museum of Fine Arts, Boston; Denham Waldo Ross Collection
- 65 IMPRESSION, SUNRISE, 1873 Oil on canvas, 48 × 63 cm W263 Musée Marmottan, Paris
- 66 THE READER, 1872 Oil on canvas, 50 × 65 cm W205 Walters Art Gallery, Baltimore
- 67 BENEATH THE LILACS, 1873 Oil on canvas, 50 × 65.7 cm W203 Musée d'Orsay, Paris
- 68 MONET'S HOUSE AT ARGENTEUIL, 1873 Oil on canvas, 60.2 × 73.3 cm W284 Art Institute of Chicago; Mr & Mrs Martin A. Ryerson Collection
- 69 CAMILLE AT HER WINDOW, ARGENTEUIL, 1873
 Oil on canvas, 60.3 × 49.8 cm W287
 Virginia Museum of Fine Arts, Richmond; Collection of Mr & Mrs Paul Mellon
- 70 APPLE TREES IN BLOOM, 1873 Oil on canvas, 62.2 × 100.6 cm W271 Metropolitan Museum of Art, New York; Bequest of Mary Livingston Willard
- 71 THE PARC MONCEAU, PARIS, 1876
 Oil on canvas, 59.7 × 82.6 cm W398
 Metropolitan Museum of Art, New York; Bequest of Loula D. Lasker
- 72 MEADOW WITH POPLARS, 1875
 Oil on canvas, 54.5 × 65.5 cm W378
 Courtesy, Museum of Fine Arts, Boston; Bequest of David P. Kimball in memory of bis wife Clara Bertram Kimball
- 73 THE SHELTERED PATH, 1873
 Oil on canvas, 65 × 54 cm W288
 Philadelphia Museum of Art; Given by Mr & Mrs Hughes Norment, in honour of
 William H. Donner
- 74 THE SEINE AT ARGENTEUIL, AUTUMN, 1873 Oil on canvas, 56 × 75 cm W290 Courtauld Institute Galleries (Courtauld Collection), London
- 75 THE BRIDGE AT ARGENTEUIL, 1874 Oil on canvas, 60.5 × 80 cm W311 Musée d'Orsay, Paris.
- 76 THE BOULEVARD DES CAPUCINES, 1873 Oil on canvas, 61 × 80 cm W292 Pushkin Museum, Moscow

- 77 THE RUE MONTORGEUIL, 30 JUNE 1878, 1878 Oil on canvas, 80 × 50 cm W469 Musée d'Orsay, Paris
- 78 SNOW AT ARGENTEUIL, 1874 Oil on canvas, 54.6 × 73.8 cm W348 Courtesy, Museum of Fine Arts, Boston; Bequest of Anna Perkins Rogers
- 79 BOULEVARD ST-DENIS, ARGENTEUIL, IN WINTER, 1875 Oil on canvas, 60.9 × 81.5 cm Courtesy, Museum of Fine Arts, Boston; Gift of Richard Saltonstall
- 80 THE RAILWAY BRIDGE, ARGENTEUIL, 1874 Oil on canvas, 15 × 23 cm W320 Musée Marmottan, Paris
- 81 THE RAILWAY BRIDGE, ARGENTEUIL, 1874 Oil on canvas, 55 × 72 cm W319 Musée d'Orsay, Paris
- 82 THE PONT DE L'EUROPE, GARE ST-LAZARE, 1877 Oil on canvas, 64 × 81 cm W442 Musée Marmottan, Paris
- 83 THE GARE ST-LAZARE, 1877 Oil on canvas, 75 × 100 cm W438 Musée d'Orsay, Paris
- 84 THE GARE ST-LAZARE, EXTERIOR (THE SIGNAL), 1877 Oil on canvas, 65.5 × 81.5 cm W448 Niedersachsisches Landesmuseum, Hanover
- 85 THE GARE ST-LAZARE, 1877 Oil on canvas, 54.3 × 73.6 cm W441 National Gallery, London
- 86 THE CHURCH AT VÉTHEUIL, SNOW, 1879 Oil on canvas, 52 × 71 cm W506 Musée d'Orsay, Paris
- 87 ENTRANCE TO THE VILLAGE OF VÉTHEUIL IN WINTER, 1879 Oil on canvas, 60 × 80.6 cm W509 Museum of Fine Arts, Boston; Gift of Julia C. Prendergast in memory of her brother James Maurice Prendergast
- 88 THE FLOATING ICE, 1880
 Oil on canvas, 97 × 151 cm W568
 Shelburne Museum, Shelburne, Vermont, USA
- 89 THE ICE-FLOES, 1880 Oil on canvas, 52 × 71 cm W567 Musée d'Orsay, Paris
- 90 VÉTHEUIL IN WINTER, 1879 Oil on canvas 68.6 × 89.9 cm W507 Frick Collection, New York
- 91 VÉTHEUIL IN SUMMER, 1880 Oil on canvas, 60 × 99.7 cm W605 Metropolitan Museum of Art, New York; Bequest of William Church Osborn
- 92 VÉTHEUIL, 1880 Oil on canvas, 61 × 79 cm W594 Glasgow Art Gallery and Museum
- 93 PATH IN THE ÎLE ST-MARTIN, VÉTHEUIL, 1880 Oil on canvas, 80 × 60.3 cm W592 Metropolitan Museum of Art, New York; Bequest of Julia W. Emmons
- 94 THE ARTIST'S GARDEN AT VÉTHEUIL, 1880 Oil on canvas, 151.4 × 121 cm W685 National Gallery of Art, Washington; Ailsa Mellon Bruce Collection

- 95 THE STEPS AT VÉTHEUIL, 1881 Oil on canvas, 80 × 65 cm W682 Collection of Mr & Mrs Herbert J. Klapper
- 96 SUNFLOWERS, 1881 Oil on canvas, 101 × 81.3 cm W628 Metropolitan Museum of Art, New York; Bequest of Mrs H.O. Haver
- 97 VASE OF FLOWERS, 1880
 Oil on canvas, 100 × 81 cm W628
 Courtauld Institute Galleries (Courtauld Collection), London
- THE FISHERMAN'S HOUSE, VARENGEVILLE, 1882
 Oil on canvas, 60 × 78 cm W732
 Museum Boymans-van Beuningen, Rotterdam
- 104 ETRETAT, ROUGH SEA, 1883 Oil on canvas, 81 × 100 cm W821 Musée des Beaux-Arts, Lyons
- THE RIVER EPTE, AT GIVERNY, 1883 Oil on canvas, 60.5 × 81.5 cm W898
- 111 VALLÉE DE SASSO, SUNSHINE, 1884 Oil on canvas, 65 × 81 cm W862 Musée Marmottan, Paris
- 114 WOMAN WITH A PARASOL, 1886 Oil on canvas, 131 × 88 cm W1077 Musée d'Orsay, Paris
- 117 HAYSTACK AT GIVERNY c.1886 Oil on canvas, 61 × 81 cm W1073 Hermitage Museum, Leningrad
- 120 ROCKS AT BELLE-ÎLE, 1886 Oil on canvas, 65 × 81 cm W1100 Musée d'Orsay, Paris
- 123 PORTRAIT OF POLY, 1886 Oil on canvas, 74 × 53 cm W1122 Musée Marmottan, Paris
- 125 ON THE BOAT, 1887 Oil on canvas, 145.5 × 133.5 cm W1152 National Museum of Western Art, Tokyo; Matsukata Collection
- 128 HAYSTACK AT GIVERNY, 1889 Oil on canvas, 65 × 81.5 cm W-1216 Collection of the Tel Aviv Museum of Art
- 131 CREUSE VALLEY, EVENING, 1889 Oil on canvas, 65 × 81 cm W1225 Musée Marmottan, Paris
- 134 WAVES BREAKING, 1881 Oil on canvas, 60.6 × 82.6 cm W661 Fine Art Museums of San Francisco; Gift of Prentis Cobb Hale
- 135 THE ROCKS AT POURVILLE, LOW TIDE, 1882
 Oil on canvas, 63.8 × 78 cm W767
 Memorial Art Gallery of the University of Rochester, Rochester, New York; Gift of Emily Sibley Watson
- 136 SEA COAST AT TROUVILLE, 1881 Oil on canvas, 59.7 × 91 cm W687 Courtesy, Museum of Fine Arts, Boston; John Pickering Lyman Collection, gift of Theodora Lyman

- 137 ROAD AT LA CAVÉE, POURVILLE, 1882 Oil on canvas, 60 × 81.6 cm W762 Courtesy, Museum of Fine Arts, Boston; Bequest of Mrs Susan Mason Loring
- 138 FISHERMAN'S COTTAGE ON THE CLIFFS AT VARENGEVILLE, 1882
 Oil canvas, 60.5 × 81.5 cm W805
 Courtesy, Museum of Modern Art, Boston; Bequest of Anna Perkins Rogers
- 139 CLIFF AT DIEPPE, 1882 Oil on canvas, 66 × 82 cm W759 Kunsthaus, Zurich
- 140 THE MANNEPORTE, ETRETAT, 1883 Oil on canvas, 65.4 × 81.3 cm W832 Metropolitan Museum of Art, New York; Bequest of William Church Osborn, 1951
- THE MANNEPORTE, ETRETAT, 1886
 Oil on canvas, 81.3 × 65.4 cm W1052
 Metropolitan Museum of Art, New York; Bequest of Lizzie P. Bliss
- 142 THE CLIFFS AT ETRETAT, 1885 Oil on canvas, 65.8 × 82.4 cm W1034 Sterling and Francine Clark Institute, Williamstown, Massachusetts
- 143 ETRETAT, 1886 Oil on canvas, 60.5 × 73.5 cm W1044 Nasjonalgalleriet, Oslo
- THE DEPARTURE OF THE BOATS, ETRETAT, 1885 Oil on canvas, 73.5 × 93 cm W1025 Art Institute of Chicago; Potter Palmer Collection
- 145 BOATS IN WINTER QUARTERS, ETRETAT, 1885 Oil on canvas, 65.5 × 81.3 cm W1024 Art Institute of Chicago; Charles H. & Mary F.S. Worcester Collection
- BORDIGHERA, 1884
 Oil on canvas, 64.8 × 81.3 cm W877
 Metropolitan Museum of Art, New York; Bequest of Miss Adelaide Milton de Groot
- 147 BORDIGHERA, 1884
 Oil on canvas, 64.8 × 81.3 cm W854
 Art Institute of Chicago; Potter Palmer Collection
- 148 CAP MARTIN, NEAR MENTON, c.1884
 Oil on canvas, 67.2 × 81.6 cm W897
 Courtesy, Museum of Fine Arts, Boston; Juliana Cheney Edwards Collection
- 149 LA CORNICHE DE MONACO, 1884
 Oil on canvas, 74 × 92 cm W890
 Collection Stedelijk Museum, Amsterdam
- POPPY FIELD IN A HOLLOW NEAR GIVERNY, 1885
 Oil on canvas, 65.2 × 81.2 cm W1000
 Courtesy Museum of Fine Arts, Boston; Juliana Cheney Edwards Collection
- FIELD OF POPPIES, GIVERNY, 1885
 Oil on canvas, 60 × 73 cm W997
 Virginia Museum of Fine Arts, Richmond; Collection of Mr & Mrs Paul Mellon
- 152 SPRING, 1886 Oil on canvas, 65 × 81 cm W1066 Fitzwilliam Museum, Cambridge
- IN THE WOODS AT GIVERNY BLANCHE HOSCHEDÉ MONET AT HER EASEL WITH SUZANNE HOSCHEDÉ READING, 1887 Oil on canvas, 91.4 × 97.8 cm W1131 Los Angeles County Museum of Art, Mr & Mrs George Gard de Sylva Collection

- THE BOAT, c.1887Oil on canvas, 1.46 × 1.33 cm W1154Musée Marmottan, Paris
- 155 BOATING ON THE EPTE, c.1890 Oil on canvas, 133 × 145 cm W1250 Museu de Arte de Sao Paulo, Brazil
- 156 THE 'PYRAMIDES' AT PORT-COTON, BELLE-ÎLE-EN-MER, 1886 Oil on canvas, 59.5 × 73 cm W1086 Ny Carlsberg Glyptothek, Copenhagen
- 157 BELLE-ÎLE, RAIN EFFECT, 1886
 Oil on canvas, 60 × 73 cm W1112
 Bridgestone Museum of Art, Tokyo; Isbibashi Foundation
- 158 ROCKS AT BELLE-ÎLE, 1886
 Oil on canvas, 66 × 81.8 cm W1095
 Art Institute of Chicago; Gift of Mr & Mrs Chauncy B. Borland
- 159 PORT DONNANT, BELLE-ÎLE, 1886 Oil on canvas, 65.6 × 81.3 cm W1108 Yale University Art Gallery, New Haven; Gift of Mr & Mrs Paul Mellon
- 160-1 A BEND IN THE RIVER EPTE, NEAR GIVERNY, 1888 Oil on canvas, 75.1 × 68.4 cm W1209 Philadelphia Museum of Art; William L. Elkins Collection
- 162 AN'TIBES, 1888
 Oil on canvas, 73.3 × 92 cm W1168
 Toledo Museum of Art; Gift of Edward Drummond Libbey
- 163 ANTIBES, VIEW FROM THE SALIS, 1888 Oil on canvas, 65×92 cm W1167 Private collection
- 164 ANTIBES SEEN FROM PLATEAU NOTRE DAME, 1888 Oil on canvas, 65.4 × 81.3 cm W1172 Courtesy, Museum of Fine Arts, Boston; Juliana Cheney Edwards Collection
- CAP D'ANTIBES: MISTRAL, 1888
 Oil on canvas, 66 × 81.3 cm W1176
 Courtesy, Museum of Fine Arts, Boston; Bequest of Arthur Tracy Cabot
- 166 RAVINE OF THE CREUSE IN SUNLIGHT, 1889 Oil on canvas, 65 × 92.4 cm W1219 Courtesy, Museum of Fine Arts, Boston; Juliana Cheney Edwards Collection
- 167 RAPIDS ON THE PETITE CREUSE AT FRESSELINES, 1889
 Oil on canvas, 65.4 × 91.8 cm W1239
 Metropolitan Museum of Art, New York; Bequest of Miss Adelaide Milton de Groot
- 168 RAVINE OF THE PETITE CREUSE, 1889
 Oil on canvas, 65.6 × 81.3 cm W1230
 Courtesy, Museum of Fine Arts, Boston; Bequest of David Kimball in Memory of bis wife Clara Bertram Kimball
- 169 TORRENT, CREUSE, 1888–9 Oil on canvas, 65.9 × 93.1 cm W1231 Art Institute of Chicago; Potter Palmer Collection
- 173 HAYSTACK, 1893 Oil on canvas, 65 × 100 cm W1364 Museum of Fine Arts, Springfield, Massachusetts
- 179 THE SEINE AT PORT-VILLEZ, PINK EFFECT c.1894 Oil on canvas, 52 × 92 cm W1380 Musée Marmottan, Paris
- ¹⁸¹ NORWAY, THE RED HOUSES AT BJORNEGAARD, 1895 Oil on canvas, 65×81 cm W1393 Musée Marmottan, Paris

- 184 THE SEINE AT GIVERNY, 1897 Oil on canvas, 75 × 92.5 cm W1487 Musée d'Orsay, Paris
- 187 MONET'S GARDEN AT GIVERNY, 1900 Oil on canvas, 81 × 92 cm W1624 Musée d'Orsay, Paris
- 191 CHARING CROSS BRIDGE, 1903 Oil on canvas, 73 × 100 cm W1537 Musée des Beaux-Arts, Lyons
- 195 WATER-LILIES, WATER LANDSCAPE, CLOUDS, 1903 Oil on canvas, 73 × 100 cm W1656 Private collection
- 197 CAMILLE, 1866 Oil on canvas, 231 × 151 cm W65 Kunsthalle, Bremen
- 199 GONDOLAS, 1908 Oil on canvas, 81 × 55 cm W1772 Musée des Beaux-Arts, Nantes
- 200 HAYSTACKS AT NOON, 1890 Oil on canvas, 65.4 × 100.3 cm W1271 Australian National Gallery, Canberra
- 201 HAYSTACKS, 1891 Oil on canvas, 60.5 × 100.5 cm W1266 Musée d'Orsay, Paris
- 202 THE HAYSTACKS IN THE SNOW, OVERCAST DAY, 1891 Oil on canvas, 66 × 93 cm W1281 Art Institute of Chicago; Mr & Mrs Martin A. Ryerson Collection
- 203 THE HAYSTACK, 1891 Oil on canvas, 65.6 × 92 cm W1283 Art Institute of Chicago; Martin A. Ryerson Collection, Potter Palmer Collection, Bequest of Jerome Friedman, Major Acquisitions Centennial Fund, and Searle Family Trust
- 204 HAYSTACKS: SNOW EFFECT, 1891 Oil on canvas, 64.8 × 92.1 cm W1277 National Galleries of Scotland, Edinburgh
- 205 HAYSTACK AT SUNSET, 1891
 Oil on canvas, 73.3 × 92.6 cm W1289
 Courtesy, Museum of Fine Arts, Boston; Juliana Cheney Edwards Collection
- 206 POPLARS ON THE EPTE, 1891 Oil on canvas, 81.9 × 81.3 cm W1310 National Galleries of Scotland, Edinburgh
- POPLARS, 1891
 Oil on canvas, 101.9 × 71.5 cm W1298
 Philadelphia Museum of Art; Bequest of Anne Thomson as a memorial to her father Frank Thomson and her mother Mary Elizabeth Clarke Thomson
- 208 POPLARS, 1891 Oil on canvas, 94.5 × 75.5 cm W1307 Philadelphia Museum of Art; Given by Chester Dale
- 209 POPLARS, 1891 Oil on canvas, 81.9 × 81.6 cm W1309 Metropolitan Museum of Art, New York; Bequest of Mrs H.O. Havemeyer, 1929, Havemeyer Collection
- 210 ROUEN CATHEDRAL, 1894 Oil on canvas, 100 × 73 cm W1345 Musée des Beaux-Arts, Rouen

- 211 ROUEN CATHEDRAL, THE FAÇADE IN SUNLIGHT, 1894 Oil on canvas, 76 × 82.5 cm W1358 Sterling and Francine Clark Institute, Williamstown, Massachusetts
- 212 THE FAÇADE, MORNING MIST, 1894 Oil on canvas, 100 × 73 cm W1352 Museum Folkwang, Essen
- 213 ROUEN CATHEDRAL AT DAWN, 1894 Oil on canvas, 106.1 × 73.9 cm W1348 Courtesy, Museum of Fine Arts, Boston; Tompkins Collection
- 214 ROUEN CATHEDRAL, WEST FAÇADE, SUNLIGHT, 1894 Oil on canvas, 100.2 × 66 cm W1324 National Gallery of Art, Washington; Chester Dale Collection
- 215 ROUEN CATHEDRAL, 1894
 Oil on canvas, 99.7 × 65.7 cm W1325
 Metropolitan Museum of Art, New York; Bequest of Theodore M. Davis, 1915,
 Theodore M. Davis Collection
- 216 ON THE CLIFFS, DIEPPE, 1897 Oil on canvas, 65.1 × 100 cm W1466 Phillips Collection, Washington, DC
- 217 STEEP CLIFFS, 1897 Oil on canvas, 65 × 100 cm W1467 Hermitage Museum, Leningrad
- 218 THE SEINE AT GIVERNY, 1897
 Oil on canvas, 81.6 × 100.3 cm W1494
 National Gallery of Art, Washington; Ailsa Mellon Bruce Collection
- 219 BRANCH OF THE SEINE NEAR GIVERNY, 1896
 Oil on canvas, 73.8 × 93 cm W1435
 Courtesy, Museum of Fine Arts, Boston; Juliana Cheney Edwards Collection
- 220 THE SEINE AT GIVERNY, MORNING MISTS, 1897
 Oil on canvas, 88.9 × 91.4 cm W1474
 North Carolina Museum of Art, Raleigh; Purchased with funds from the Sarah
 Graham Kenan Foundation and the North Carolina Art Society (Robert F. Phifer
 Bequest)
- 221 MORNING ON THE SEINE, 1897 Oil on canvas, 89.9 × 92.7 cm W1475 Art Institute of Chicago; Mr & Mrs Martin A. Ryerson Collection
- 222 THE ARTIST'S GARDEN AT GIVERNY, 1900 Oil on canvas, 91 × 93.5 cm W1622 Yale University Art Gallery, New Haven; Gift of Mr & Mrs Paul Mellon
- 223 SPRING, 1900 Oil on canvas, 90 × 92 cm W1620 Private collection, Geneva
- 224 CHARING CROSS BRIDGE, c.1900 Oil on canvas, 60 × 100 cm W1553 Musée Marmottan, Paris
- 225 CHARING CROSS BRIDGE, 1899–1901 Oil on canvas, 62 × 100 cm W1525 National Museum of Western Art, Tokyo; Matsukata Collection
- 226 CHARING CROSS BRIDGE, 1902 Oil on canvas, 65 × 81 cm W1529 National Museum of Wales, Cardiff
- 227 CHARING CROSS BRIDGE, c.1901–4 Oil on canvas, 66.1 × 101 cm W1532 Baltimore Museum of Art; Helen & Abram Eisenberg Collection

- 228 WATERLOO BRIDGE, 1902 Oil on canvas, 65 × 100 cm W1560 Kunsthalle, Hamburg
- Oil on canvas, 65.7 × 101 cm W1586

 Art Institute of Chicago; Mr & Mrs Martin A. Ryerson Collection
- 230 WATERLOO BRIDGE, 1900 Pastel, 31.1 × 48.5 cm Musée du Louvre, Cabinet des Dessins
- 231 WATERLOO BRIDGE, LONDON, AT DUSK, c.1904 Oil on canvas, 65.7 × 110.2 cm W1564 National Gallery of Art, Washington; Chester Dale Collection
- 232 HOUSES OF PARLIAMENT, EFFECT OF SUNLIGHT, 1903 Oil on canvas, 81 × 92 cm W1597 Brooklyn Museum, New York
- 233 HOUSES OF PARLIAMENT, 1904 Oil on canvas, 81 × 92 cm W1610 Musée d'Orsay, Paris
- 234 THE GRAND CANAL, VENICE, 1908 Oil on canvas, 74 × 91 cm W1736 Fine Arts Museums of San Francisco; Gift of Osgood Hooker
- PALAZZO DE MULA, VENICE, 1908 Oil on canvas, 62 × 81.1 cm W1764 National Gallery of Art, Washington; Chester Dale Collection
- 236 THE DOGE'S PALACE IN VENICE, 1908 Oil on canvas, 81 × 100 cm W1743 Brooklyn Museum, New York
- 237 THE DOGE'S PALACE, VENICE, 1908 Oil on canvas, 65 × 100 cm W1742 Private collection
- 238 THE DUCAL PALACE, 1908
 Oil on canvas, 74 × 94 cm W1742
 Collection of Mr & Mrs Herbert J. Klapper
- VENICE: THE DOGE'S PALACE SEEN FROM SAN GIORGIO MAGGIORE, 1908
 Oil on canvas, 65.4 × 92.7 cm W1755
 Metropolitan Museum of Art, New York; Gift of Mr & Mrs Charles S. McVeigh, 1959
- 244 WATER-LILIES, c.1914–17 Oil on canvas, 1.83 × 1.48 m W1788 Fine Art Museums of San Francisco; Mildred Anna Williams Collection
- 248 WATER-LILIES, c.1914–17 Oil on canvas, 1.3 × 1.5 m W1783 Musée Marmottan, Paris
- WATER-LILIES, c.1917–19
 Oil on canvas, 99.7 × 201 cm W1895
 Honolulu Academy of Arts; Purchased in Memory of Robert Allerton, 1966
- 253 WATER-LILY POND, c.1918–19 Oil on canvas, 73 × 105 cm W1882 Musée Marmottan, Paris
- 254 SELF-PORTRAIT, 1917 Oil on canvas, 71 × 55 cm W1843 Musée d'Orsay, Paris
- 257 AGAPANTHUS, c.1914–17 Oil on canvas, 2.00 × 1.50 m W1820 Musée Marmottan, Paris

- 258-9 THE CLOUDS, 1915 Oil on canvas, 2.00 × 12.75 m Musée de l'Orangerie, Paris
- 260-1 WATER-LILIES, c.1920
 Oil on canvas: triptych, each section 2.00 × 4.25 m W1972-4
 Collection, The Museum of Modern Art, New York; Mrs Simon Guggenheim Fund
- ²⁶³ THE ROSE-TRELLISES, GIVERNY, c.1920-22 Oil on canvas, 89×100 cm W1934 Musée Marmottan, Paris
- WATER-LILIES, c.1897–8
 Oil on canvas, 66 × 104.1 cm W1501
 Los Angeles County Museum of Art, Bequest of Mrs Fred Hathaway Bixby
- 267 WATER-LILIES: EVENING, c.1897–8 Oil on canvas, 73 × 100 cm W1504 Musée Marmottan, Paris
- 268 JAPANESE BRIDGE AT GIVERNY, c.1900 Oil on canvas, 89.9 × 101 cm W1628 Art Institute of Chicago; Mr & Mrs Lewis Larned Coburn Memorial Collection
- 269 WATER-LILIES AND JAPANESE BRIDGE, c.1900 Oil on canvas, 90.5 × 89.7 cm W₁₅₀₉ Art Museum, Princeton University; William Church Osborn Collection
- WATER-LILIES, c.1906
 Oil on canvas, 87.6 × 92.7 cm W1683
 Art Institute of Chicago; Mr & Mrs Martin A. Ryerson Collection
- 271 WATER-LILIES, c.1905 Oil on canvas, 81 × 100 cm W1680 National Museum of Wales, Cardiff
- 272 WATER-LILIES, c.1908
 Oil on canvas, 90 cm diameter W1724
 Musée Alphonse Georges Poulain, Vernon
- 273 WATER-LILIES, c.1908
 Oil on canvas, 81.3 cm diameter W1729
 Dallas Museum of Art; Gift of the Meadows Foundation Incorporated
- 274 WATER-LILIES: WATER LANDSCAPE, c.1907 Oil on canvas, 82.5 × 93 W 1696 Wadsworth Atheneum, Hartford; Bequest of Anne Parrish Titzell
- 275 WATER-LILIES, 1904 Oil on canvas, 100.3 × 90.8 cm W1665 Lefevre Gallery, London
- 276 WATER-LILIES, c.1908
 Oil on canvas, 92.1 × 81.2 cm W1703
 Museum of Fine Arts, Houston; Gift of Mrs Harry C. Hanszen
- 277 WATER-LILY POND, c.1907 Oil on canvas, 101 × 74.5 cm W1715 Bridgestone Museum of Art, Isbibasbi Foundation, Tokyo
- 278 WATER-LILIES, c.1907 Oil on canvas, 100 × 73 cm W1714 Musée Marmottan, Paris
- 279 WATER-LILIES: STUDY, c.1907 Oil on canvas, 105 × 73 cm W1717 Musée Marmottan, Paris
- 280 HEMEROCALLIS, c.1914–17 Oil on canvas, 1.50 × 1.40 m W1818 Musée Marmottan, Paris

- 281 IRIS, c.1914–17 Oil on canvas, 2.00 × 2.00 m W1841 Musée Marmottan, Paris
- 282-3 THE WATER-LILY POND, c.1917–19 Oil on canvas, 1.00 × 2.00 m W1899 Private collection, Switzerland
- 284 WATER-LILIES, c.1914–17 Oil on canvas, 1.80 × 2.00 m W1815 Wallraf-Richartz Museum, Cologne
- 285 WATER-LILIES, c.1914–17 Oil on canvas, 2.00 × 2.00 m W1811 Musée Marmottan, Paris
- 286 WATER-LILIES, c.1914–17 Oil on canvas, 1.50 × 2.00 m W1791 Musée Marmottan, Paris
- 287 WATER-LILIES, c.1916–19 Oil on canvas, 1.30 × 1.52 m W1864 Musée Marmottan, Paris
- 288 WATER-LILIES, c.1916–19 Oil on canvas, 2.00 × 2.00 m W1862 Musée Marmottan, Paris
- 289 WATER-LILIES, c.1916–19 Oil on canvas, 2.00 × 1.80 m W1855 Musée Marmottan, Paris
- 290 WATER-LILIES c.1916–19 Oil on canvas, 2.00 × 1.80 m W1850 Musée Marmottan, Paris
- 291 WILLOW TREE AND WATER-LILY POND, c.1916–19 Oil on canvas, 2.00 × 1.80 m W1848 Musée Marmottan, Paris
- 292 WATER-LILIES c.1914–17 Oil on canvas, 1.80 × 2.00 m W1816 Musée Marmottan, Paris
- 293 WATER-LILY POND, c.1917–19 Oil on canvas, 1.30 × 2.00 m W1888a Musée Marmottan, Paris
- 294 VIEW OF THE WATER-LILY POND WITH WILLOW TREE, c.1918 Oil on canvas, 1.30 × 90 m W1868 Private collection
- 295 WEEPING WILLOW, c.1918−19 Oil on canvas, 1.00 × 1.20 m W1874 Private collection
- 296-7 WATER-LILIES: WILLOW REFLECTIONS, ϵ .1916–19 Oil on canvas, 1.00×2.00 m W1857 Private collection
- 298-9 WATER-LILIES, c.1917–19 Oil on canvas, 1.00 × 3.00 m W1902 Musée Marmottan, Paris
- 300-1 WATER-LILY POND: EVENING, c.1916-22
 Oil on canvas, 2 panels, each 200 × 300 cm W1964 and 1965
 Kunsthaus, Zurich
- 302-3 WATER-LILY POND WITH IRISES, ϵ .1914–22 Oil on canvas, 200 × 600 cm W1980 Kunsthaus, Zurich

- 304-5 WATER-LILIES, c.1920
 Oil on canvas, 199.5 × 599 cm W1981
 Collection, The Museum of Modern Art, New York; Mrs. Simon Guggenheim Fund
- 306 WEEPING WILLOW, c.1920–22 Oil on canvas, 1.10 × 1.00 m W1941 Private collection
- 307 THE ROSE TRELLISES, c.1922 Oil on canvas, 73 × 105 cm, W1940 Private collection
- 308 THE JAPANESE BRIDGE, c.1918–24 Oil on canvas, 100 × 200 cm W1911 Musée Marmottan, Paris
- 309 THE JAPANESE FOOTBRIDGE AT GIVERNY, c.1922 Oil on canvas, 89 × 93 cm W1925 Museum of Fine Arts, Houston; The John A. and Audrey Jones Beck Collectioin
- 310 THE JAPANESE BRIDGE, c.1918–24 Oil on canvas, 81 × 92 cm W1920 Kunsthaus, Zurich
- 311 THE JAPANESE FOOTBRIDGE, c.1920–22
 Oil on canvas, 89.5 × 116.3 cm W1932
 Museum of Modern Art, New York; Grace Rainey Rogers Fund
- 312 THE HOUSE SEEN FROM THE ROSE-GARDEN, c.1922-4 Oil on canvas, 81 × 92 cm W1946 Musée Marmottan. Paris
- 313 THE HOUSE SEEN FROM THE ROSE-GARDEN, c.1922-4 Oil on canvas, 100 × 73 cm W1949 Private collection, Switzerland
- 314 THE HOUSE AMONG THE ROSES, c.1925 Oil on canvas, 92 × 73 cm W1958 Private collection, Switzerland
- 315 THE HOUSE SEEN FROM THE ROSE-GARDEN, c.1922–24 Oil on canvas, 89 × 100 cm W1947 Musée Marmottan, Paris

Picture acknowledgements

The editor and Publisher would like to express their gratitude to the museums, galleries and collections credited with the note to each plate for permission to reproduce the works in this book. Photographs were kindly supplied by the collections concerned with the exception of the following: Bridgeman Art Library, London (p 76), Giraudon, Paris (p 210), Réunion des Musées Nationaux, Paris (pp 22, 28, 32, 34, 44, 45, 48, 49, 57, 62, 66, 75, 77, 81, 83, 86, 89, 114, 120, 184, 187, 201, 233, 254, 258/9, 272), Studio Lourmel, Paris (pp 19r, 55, 65, 80, 82, 111, 123, 131, 155, 179, 181, 224, 248, 253, 257, 263, 267, 278, 279, 280, 281, 285, 286, 287, 288, 289, 290, 291, 292, 293, 298/9, 308, 312, 315).

All paintings are reproduced under licence © DACS 1989.

Guide to the Principal Personalities Mentioned in the Text

ALEXANDRE, Arsène

A writer and critic, Alexandre wrote books and articles about a number of the artists of the Impressionist generation — including Degas, Monet and Renoir — towards the end of their careers. He visited Monet at Giverny and in 1921 published one of the first books on the artist's work.

BAZILLE, Frédéric

The friendship and financial support offered by Bazille were of critical importance to Monet in the early years of his career. Bazille began as a student of medicine in Paris, but increasingly spent time at the studio of Gleyre in the company of Renoir, Sisley and Monet. He produced a number of striking portraits and outdoor figure compositions, but his career ended tragically with his early death in the Franco-Prussian War of 1870–71. In Monet's composition *Le déjeuner sur l'berbe*, the slender and long-legged figure seated in the foreground was posed by Bazille.

DE BELLIO, Georges

Georges De Bellio was a doctor who supported a number of artists in Monet's circle and also attended them in his professional capacity. He owned pictures by Manet, Renoir, Sisley and others, and bought several works from Monet when the artist was living in straightened circumstances at Argenteuil.

BERNHEIM-JEUNE, Gaston

One of several Paris picture-dealers who dealt with Monet, Bernheim-Jeune was principally associated with the work of the artist's later years.

BOUDIN, Eugène

Born at Honfieur in 1824, Boudin devoted his career to painting the landscape of the Normandy coast. He became celebrated for his brilliant, crisply executed pictures of skies and beaches, and it was he who first encouraged the young Claude Monet to paint from nature in the open air. Boudin's work was admired by the artists of the Impressionist movement, and he participated in their first exhibition in 1874.

BOUSSOD et VALADON

During the 1880s Monet dealt openly with a number of rival picture-dealers without entering into an exclusive contract with any of them. Boussod et Valadon dealt in the work of several of the Impressionist artists, and were successful for a while in obtaining pictures from Monet and selling them to collectors.

BUTLER, Theodore

Butler was an American painter who established an unusually close relationship with the Monet family. In 1882 he married Suzanne Hoschedé, one of the daughters of Alice Monet's first marriage. After the death of Suzanne in 1899, Butler married Alice's eldest daughter, Marthe.

CAILLEBOTTE, Gustave

The careers of Monet and the wealthy amateur painter Gustave Caillebotte have a number of curious parallels. Both artists were instrumental in the early exhibitions of the Impressionist movement, and both distanced themselves from that movement before it had run its course; in their maturity, each artist developed a passion for gardening and produced a number of canvases of their own flowers; and both of them shared an interest in boats, boating scenes and paintings of water.

CÉZANNE, Paul

Monet and Cézanne first met in the 1860s, when they were both unknown young artists in the studios of Paris. They maintained contact during the following decade, and both participated in the First and Third Impressionist Exhibitions. Cézanne's return to his native Provence discouraged a close relationship, but it is known that he maintained the highest regard for Monet's painting. Both artists believed in the rigorous study of nature at first hand, and some of Cézanne's groups of landscapes, for example those of Mont Sainte-Victoire, can be compared to Monet's Series pictures. In later life Monet acquired examples of Cézanne's paintings and invited him to a famous gathering at Giverny.

CHOQUET, Victor

Among the first serious collectors of Impressionist paintings, Choquet befriended artists like Cézanne and Renoir, both of whom painted his portrait. In the 1870s Monet succeeded in interesting Choquet in his work, and eventually Choquet owned at least twelve of his paintings.

CLEMENCEAU, Georges

Clemenceau was a major figure in French political life throughout Monet's career, and was distinguished by an active interest in the arts. His portrait was painted by artists as diverse as Manet and Raffaelli, and in later life his acquisition of a property near Giverny led to a remarkable friendship with Monet. The plan for Monet's *Décorations* seems to have been inspired by Clemenceau, and it was he who persuaded Monet to undergo surgery for his eye complaints. Clemenceau published a book about the artist, *Les Nymphéas*, in 1928.

COURBET, Gustave

More than twenty years older than Monet, Courbet had been one of the pioneers of an aggressive realism in painting and an outspoken hostility towards existing art institutions. Monet's brief friendship with Courbet in the 1860s (Courbet was one of the witnesses at his wedding) influenced both his technique and his attitude to his vocation, and the older artist's paintings of the sea and the coast (notably some pictures of Etretat) also made their mark on him.

COUTELA, Charles

Dr Charles Coutela was the ophthalmologist who treated Monet's eye problems in the last years of his life. He performed an operation to remove a cataract from Monet's right eye in 1923.

DEGAS, Edgar

Degas was the most metropolitan of the Impressionists, preferring the subject matter of the Parisian cabarets, brothels and ballet rehearsal-rooms to the landscapes associated with his colleagues. Despite their differences, Monet expressed a high regard for Degas' art and owned some pastels by him. Degas, in his turn, seems to have had Monet's example in mind when he exhibited a sequence of his own landscapes in 1892 at Durand-Ruel's gallery, where Monet had shown some of his own Series pictures only months before.

DEGAS, René

The younger brother of Edgar, René Degas was involved in the settlement of his estate at the time of the artist's death. Monet wrote to René to offer advice on the arrangements for the auctions of Degas' works.

DURAND-RUEL, Charles

The son of the picture-dealer Paul Durand-Ruel, Charles joined him in the family business and was involved in their extensive dealings with Monet.

DURAND-RUEL, Paul

The early careers of many of the Impressionist artists were greatly influenced by the support of the picture-dealer Paul Durand-Ruel. His own fortunes fluctuated dramatically, following changes in public taste and the state of the French economy, but he survived the lean years and emerged as the major dealer in the work of Monet and others. Most of Monet's major exhibitions were held at his gallery, and Durand-Ruel acted as his informal banker, advancing him sums of money as the artist kept him supplied with paintings. A large number of letters from Monet, preserved by the Durand-Ruel family, show a relationship between the two men that could be both businesslike and affectionate.

FÉNÉON, Félix

One of the most extraordinary characters in the Paris art world of the late nineteenth century, Fénéon combined the vocations of civil servant, anarchist and art critic. He wrote in a dense, alliterative style and favoured the art of the Pointillistes and Symbolists, but surviving letters from Monet's last years indicate a certain sympathy between the two men.

GAUTIER, Amand

Monet met Amand Gautier in the early 1860s, when he was one of a number of artists associated with Courbet and the Realist movement. Monet visited his studio when he first went to Paris, and Monet's Aunt Lecadre corresponded with Gautier in her efforts to influence the young artist's career.

GEFFROY, Gustave

Born in 1855, Geffroy became one of the most versatile and respected writers on art of his generation. His interests ranged from Japanese art to contemporary literature, and he wrote reviews, catalogues and books about a number of contemporary painters and sculptors. Meeting Monet by chance during his visit to Belle-Île in 1886, Geffroy developed a particular admiration for his work and a warm affection for the man. Their subsequent correspondence includes some of Monet's most incisive observations on his own art, many of which the writer included in his biography of the painter published in 1922.

HELLEU, Paul

Paul Helleu was a close friend of the English painter John Singer Sargent, and as young men they introduced themselves to Monet and expressed their admiration for his painting. Known for his elegant and pale-toned society portraits, Helleu stayed in contact with Monet for many years, even presenting him with a canvas by Cézanne to add to his collection.

HOSCHEDÉ, Ernest

An enigmatic figure in Monet's career, Hoschedé established himself as a major patron of early Impressionist painting. Having made his money from a Paris department store, Hoschedé bought a number of paintings by Monet and commissioned him to paint several decorative panels for his house at Mongeron. Forced by bankruptcy to sell his collection in 1878, Hoschedé was obliged to stop collecting and effectively abandoned his own family. His wife Alice, who was left with their six children (Marthe, Blanche, Suzanne, Jacques, Germaine and Jean-Pierre), later became Monet's second wife.

HOUSSAYE, Arsène

Houssaye features principally in Monet's career as the collector who bought one of his first publicly exhibited paintings, *Camille, Woman in a Green Dress* of 1866. Monet wrote to him subsequently in the hope of selling further pictures, but apparently without success. An editor and critic who published articles supporting the new tendencies in contemporary painting, Houssaye was also the official Inspector of Fine Arts.

JONGKIND, Barthold

A landscape painter who originally came from Holland, Jongkind spent much of his life in France and associated for a while with Boudin and Courbet. Monet met him in early life when he was painting in the area around Le Havre, and was impressed by his lively technique and first-hand study of nature.

KOECHLIN, Raymond

Koechlin was a collector, art historian and arts administrator who owned a number of paintings by artists of the Impressionist generation. Monet corresponded with him briefly over his plans for the *Décorations*, and Koechlin published his memories of the artist soon after the latter's death.

MALLARMÉ, Stéphane

A leading poet of the Symbolist movement, Mallarmé had close ties with a number of artists of Monet's generation. He was painted by Manet, photographed by Degas in the company of Renoir, and almost managed to persuade Monet to illustrate one of his books. The correspondence between the two men suggests a relationship of mutual affection and respect.

MANET, Edouard

Eight years older than Monet, Manet had already made a controversial impact on the Paris art world when Monet was still an unknown student. Though he never exhibited with the Impressionists, Manet provided an example of professional audacity and technical originality for Monet and his generation. Monet's own painting seems to have influenced the work of the older man in the 1870s, and it was Monet who later organized a subscription for the presentation of Manet's painting *Olympia* to the State.

MIRBEAU, Octave

Author and playwright, Mirbeau befriended Monet and often visited him at Giverny. In 1891 Mirbeau published one of the first substantial articles on Monet's art to appear in the Press.

MONET, Alice

When Claude Monet first met Alice, she was the wife of Ernest Hoschedé and had a family of six children by that marriage. After the breakdown of her relationship with Hoschedé and the death of Monet's first wife Camille, Alice and her children shared a house with Monet and his two sons, first at Vétheuil and Poissy and later at Giverny. Alice acted as mother to Monet's children when he was away on painting expeditions and maintained a daily correspondence with the artist. After the death of her first husband, Alice married Claude in 1892 and continued to live at Giverny until her death in 1911.

MONET, Camille

As a teenager, Camille Doncieux met the still-unknown Monet and posed for some of his canvases (such as *Women in the Garden* and *Camille, Woman in the Green Dress*). In 1867 Camille gave birth to their first son, Jean, and in 1870 she and Monet were married. Their life together was dominated by Monet's working routine and their lack of funds, and Monet's numerous representations of her show her as a rather mournful figure. In the late 1870s Camille's health deteriorated, and she died in 1879, soon after the birth of their second child.

MONET, Jean

Jean was born in 1867, the eldest of Monet's two children. His father's letters show a concern for his health and education, and Jean appears in a number of portraits and larger compositions. In 1897 Jean Monet married Blanche Hoschedé, the daughter of Monet's second wife, and he died at the age of forty-seven in 1914.

MONET, Michel

Michel Monet was born in 1878, a year before the death of Monet's first wife, Camille. He grew up in the joint household of the Monet and Hoschedé families and appears as a small child in some of the Vétheuil paintings. Michel fought in the Great War, causing his father much concern, but went on to live to a great age. He left many of his father's paintings to the Musée Marmottan in Paris.

MOREAU-NÉLATON, Etienne

A painter and critic, Moreau-Nélaton published studies on Manet, Degas and others. He corresponded with Monet towards the end of the artist's life.

MORISOT, Berthe

The leading female painter among the French Impressionists, Morisot exhibited at most of their group shows. She developed a distinctive subject matter and a high-toned palette, and may have influenced her brother-in-law, the painter Edouard Manet, in his move towards Impressionist techniques.

PETIT, Georges

Petit was one of the principal rivals of the art dealer Paul Durand-Ruel, a rivalry that Monet was sometimes able to exploit to his own advantage. In the 1880s Petit presented a series of *Expositions Internationales* in which Monet featured regularly, and in 1889 Monet shared an important exhibition with Rodin at the Galerie Georges Petit.

PISSARRO, Camille

The oldest of the prominent members of the Impressionist group, Pissarro was able to give encouragement and advice to many of its adherents. In the 1860s he associated with Cézanne, Monet, Renoir and others, and later became one of the stalwarts of the Impressionist Exhibitions. Monet and Pissarro both visited London during the Franco-Prussian War of 1870–71, and it was there that Pissarro introduced Monet to the picture-dealer Paul Durand-Ruel, who was to be so important to Monet's subsequent career.

RENOIR, Pierre-Auguste

Monet first met Renoir in about 1863, and they remained on friendly terms throughout their lives. In their early days the two artists shared many interests and even painted side by side in front of the same subjects, such as *La Grenouillère* on the River Seine. In the 1870s they both contributed to several of the Impressionist Exhibitions, and they continued to see each other regularly at the 'Impressionist Dinners' held in Paris. Renoir painted a number of richly coloured landscapes that may have influenced Monet, but he later enjoyed great success as a painter of portraits and nudes.

RODIN, Auguste

Born just two days before Monet, Rodin brought to contemporary sculpture much of the same freshness of approach and originality of technique that the Impressionists brought to their painting. Monet shared an exhibition with Rodin at Petit's gallery in 1889 and repeatedly expressed his support for the sculptor in spite of public hostility towards his work.

SARGENT, John Singer

American by birth, Sargent studied in Paris, where he admired the work of Monet and established a lifelong friendship with him. Subsequently Sargent established himself in England and enjoyed a successful career as a fashionable portraitist, introducing Monet into high society on the latter's visits to London.

SISLEY, Alfred

Part of the original group that included Bazille, Renoir and Monet at Gleyre's studio, Sisley stayed close to the original Impressionist approach to landscape throughout his career. Despite support from Durand-Ruel, Sisley's work found little favour with collectors, and at his death in 1899 a number of his colleagues, led by Monet, organized a sale of pictures to assist his widow.

WHISTLER, James McNeill

Whistler's painting has a number of affinities with Monet's, and the two artists enjoyed a long friendship and a relationship of mutual respect. The Americanborn Whistler worked in France and England, and his pictures of London and Venice may have influenced Monet's decision to paint in those cities, as well as the paintings that he produced there.

ZOLA, Emile

In the 1860s and the 1870s, the novelist Emile Zola was a vocal champion of realism in literature and the arts. A childhood friend of Cézanne, Zola published a number of controversial novels based on contemporary themes, and wrote articles in support of Courbet, Manet and others. Monet corresponded with him sporadically and supported him enthusiastically at the time of the Dreyfus affair.

Académie Française 196 Doncieux, Camille see Monet, Camille drawing 8-10, 16, 18-19, 240-41, 247 Africa 8, 225-6 Dreyfus, Alfred 170 Agay 126 Durand-Ruel, Charles 127, 174 Alexandre, Arsène 241, 257 Durand-Ruel, Georges 196 Alexis, Paul 28 Algeria 255-6 Durand-Ruel, Joseph 263 Durand-Ruel, Paul 9-14, 33, 98-9, 101-3, 105-8, America 11, 13, 116, 124, 127, 133, 170, 186 Antibes 12, 125-7 112-4, 116-7, 122, 127-8, 170, 172, 175-6, 180-81, Antwerp 183 185-6, 193-6, 198-9, 240-43, 245, 247, 251, 264 Argenteuil 8–11, 17, 28–9 Duranty, Edmond 10 Asquith, Mr & Mrs (Margot) 188 Avenir National 28 Ecole des Beaux-Arts 196, 258 Edward VII, King 190 bailiffs 27 Elder, Marc 259 Barbier, André 250 Epte, River 179 Barbizon School 9 Etretat 11, 21, 26, 98, 104-5, 113-6 Bazille, Frédéric 8, 16, 20–26 Eure, Prefect of the 179 Becq 18 Evénement 23 Belle-Île 12, 98–9, 119–23, 171 exhibitions 8, 10–14, 18, 20, 24, 30, 98, 103, 106, Bernheim-Jeune, G. & J. 14, 245–6, 251–2, 256, 118, 124, 126, 128, 170, 172, 176, 180, 185, 193, 258-9, 261, 264 198, 240, 242-3, 245, 255 Bernheim-Jeune, Gaston 199, 251, 255 Exposition Universelle (1900) 186 Blanche, M 117 eyesight 15, 241, 246-7, 252-3, 256, 258-65 Blanche, Jacques-Emile 189 Blois 248 Fallières, Armand 133 Bordighera 11, 108-11 Fécamp 11, 33, 98, 100 Boudin, Eugène 8-9, 16, 18, 21, 170, 176, 255 Fénéon, Félix 252-3 Boussod see Boussod & Valadon Fèvre 194 Boussod & Valadon 12, 124, 181, 193 Figaro 184 Bremen Museum 196 Florand 265 Brittany 11-12, 98-9, 118-23 forgeries 13, 114, 198 Fouillard 192 Bruyas, Alfred 24 Butler, Suzanne (née Hoschedé) 185, 240 Fouquières 18 Butler, Theodore E. 190, 240 frames 18, 22, 124, 193, 243 France-Prussian War 9 Cadart, Alphonse 24 Fresselines 12, 129-32 Café Riche 118 Caillebotte, Gustave 101 gardens 8, 10, 13-15, 99, 109, 171, 177, 179, 182, canvases, supply of 107, 110, 115, 189 194, 240-43, 246, 255, 259, 265 caricature 8, 255 Gaudibert, Louis-Joachim 27 Cassis 126 Gautier, Amand 18–19, 23 Castagnary, Jules 10 Gautier, Théophile 256 Cézanne, Paul 9-10, 17, 29, 113, 170-71, 180 Emaux et Camées 256 Chailly 9, 19, 23 Gazette des Beaux-Arts 102 Charpentier, Georges 21 Geffroy, Gustave 12, 14, 120, 128, 170-73, 178, 180, Charteris, Evan 265 184-6, 188, 192-4, 197-8, 240-42, 244-8, 250, 253, Chocquet, Victor 29 255-6 Christiana 181-3 Claude Monet, Sa Vie, Son Oeuvre 171 cine film 15 La Sculpture au Louvre 197 Clemenceau, Georges 14-15, 171, 188, 190, 194, Giverny 8, 11-15, 98-9, 106-9, 112, 116-18, 124-5, 197, 199, 240–1, 244, 247–8, 252, 258–60, 265 127-9, 132, 170-74, 176, 179-87, 192-8, 240-65 Cognier 18 Glevre, Charles 8 collectors 8-10, 12-13, 27, 98, 102, 105, 112, 116, Gonse, Louis 102 118, 170, 174 Granville 255 Comédie Française 196 Guitry, Sacha 15 Corot, Jean-Baptiste-Camille 18, 22, 133, 255 Côte d'Azur 10, 12, 110, 125-7 Courbet, Gustave 9, 16, 24, 104, 133, 176 Harrison, Alexander 196 Coutela, Charles 241, 260-65 Helleu, Paul 126 Holland 9–10 Couture, Thomas 18 Creuse, River 12, 17, 130-31 Honfleur 18, 20–1, 174, 251 Hoschedé, Alice see Monet, Alice Crozant 130 Hoschedé, Blanche see Monet, Blanche Hoschedé, Ernest 10, 13, 17, 30–31, 98, 104 Daubigny, Charles François 18, 264 de Bellio, Georges 10, 17, 31-2 Hoschedé, Germaine see Salerou, Germaine dealers 8, 10-13, 23, 27, 98, 128, 174, 250 Hoschedé, Inga 193 Degas, Edgar 9–10, 14, 103, 124, 186, 240, 250–51 Hoschedé, Jacques 171, 182-3, 193 Degas, René 251 Hoschedé, Jean-Pierre 191-3 Delacroix, Eugène 133 Hoschedé, Marthe 100, 102, 109–10, 115, 118, Delpech, Pierre Benoît 255 121-2, 126-7, 129-30, 190, 192 Depeaux 174 Hoschedé, Suzanne see Butler, Suzanne Houssaye, Arsène 27, 196 Houssaye, Henri 196 Diaz de la Pena, Narciso Virgilio 18

Dieppe 100, 251

ill-health 126-7, 172, 242, 252, 265 Mornings on the Seine Series 12 Saint-Siméon 20 Impressionism 8–13, 17, 119, 258 Poplars, near Argenteuil 9 Saint-Vincent-sur-Jard 256 Italy 10-11, 13-14, 16, 108-11, 116, 171, 198-9 Poplars Series 12 Sainte-Adresse 20, 22, 24–5, 256 Salerou, Albert 246, 249 Railway Bridge at Argenteuil 9 James, Henry 190 Three Willows 258 Salerou, Germaine (née Hoschedé) 246, 248 Japan 13 Tree Reflections 258 Salisbury, Lord, son of 188 Japanese art 12, 176, 254 Venice paintings 245 Jeu de Paume 258 Salon 8, 11, 23-4, 26-7, 113, 185, 196, 264 Vetheuil paintings 193 Sandviken 183 Jongkind, Johan Barthold 9, 21, 176, 255 Views of Holland 264 Sargent, John Singer 171, 188, 190, 196, 265 Journal de Paris 106 Water-lilies Series 13-14, 186, 198, 240, 242-3, Seine, River 8-12, 16-17, 98-9, 102-3, 106-7, 170, Kervilahouen 119-23 240 The Wave 9 Koechlin, Raymond 249 Serrurier, Mme 179 Woman With a Green Dress 196 servants 10, 31, 103, 110, 121, 170, 187 L'Art Dans les Deux Mondes 173 Women in the Garden 8–9 Sèvres 23 La Grenouillère 9 Monet, Jean 9, 14, 17, 25-6, 98, 100, 118, 125, 171, Sisley, Alfred 8-9, 16, 103, 113, 124, 170, 185-6, 240. 246-La Mer Terrible 118 206, 240 La Tranche 250 Monet, Michel 10, 14, 17, 98, 191-2, 240, 248-50, Société Anonyme des Artistes, Peintres, Sculptures, 265 Landemer 242 Graveurs, etc. 28 Latouche 24 Montaignac 181 spectacles 261-3 Moore, George 171 Le Havre 8, 10, 16, 18–20, 23–4, 26–7, 182, 240, studio, education in 8, 18-19 Moreau-Nélaton, Etienne 241, 264 251, 255 Moret 185 Le Palais 118 Thames, River 171, 191 Lecadre, Marie-Jeanne 8, 19, 23 Morisot, Berthe 9, 118 Toulemouche 19 Musée des Arts Décoratifs 252 Lemarrois 33 Toutain, Mme & Mlle 21 Musée du Luxembourg 133, 196 Léon, Paul 257-8, 260 Troisgros 115 Trouville 21 Lhuillier 18 Nadar, Felix Tournachon 10 Lille 23 Troyon, Constant 18, 255 lily ponds 13-15, 179, 240 Nantes 258 Turin 110 Nature 8–9, 12, 15, 26, 99, 102–3, 246, 255–6 lithographs 18, 173 New York 255 London 9-10, 13-14, 16, 171, 173, 186, 188-94, Valadon see Boussod & Valadon Norway 171, 181-3 196, 264 Van Gogh, Theo 12, 124, 127 Louvet 177 Vaquez 244 Louvre 15, 18, 132-3, 197 Oran 255-6 Varengeville 98 Orangerie 13, 15, 241, 258–60 Varenne 177 Madrid 195 Velasquez, Diego de Silva y 195 Mallarmé, Stéphane 129, 132, 170, 173 paintings, destruction of, 15, 102, 115, 123, 172, 241, Venice 13-14, 16, 171, 198-9, 242 La Gloire 132 Verdun 14, 250 Vernon 106–7, 127, 174, 241, 247 Manet, Edouard 9, 14, 17, 24, 28, 106, 116, 129, paintings, packaging of 243 paints 31, 110, 196 parents 8, 16, 18, 24 132-3, 197, 240 Vétheuil 8, 11, 17, 30–33, 104 Femme Rose 24 Victoria, Queen 190 Paris 8–10, 13, 16–18, 20, 23–4, 26–7, 30, 33, 98, Olympia 132-3 Vie Moderne 98 Manet, Mme 118, 132 Manneporte 115 102, 105-6, 108, 112, 117-8, 127, 132-3, 173, 178, Vivien 21 184, 197, 240-41, 247, 250, 260, 262 Marx, Roger 186 Pauli, Gustav 196 watercolours 255-6 Maupassant, Guy de 113 pawnbrokers 32 Whistler, James McNeill 12, 124, 129, 170-71, 173, Maxse, Mlle 190 Petit, Georges 12, 98, 124-5, 127, 186 182 Menton 110 photographs 15, 172, 196, 198, 240-41, 251 Whistler, Mrs 173, 183 William, Prince 190 military service 8, 255 Picard 187 Millet, Jean François 9, 133, 255 Picot 18 woodcuts 12 Pissarro, Camille 9–10, 17, 32, 101, 113 Mirbeau, Octave 140, 170, 173, 244 World War I 13-14, 240, 248-50, 252 Monet, Alice (née Hoschedé) 10-11, 13-14, 30, Pissarro, Lucien 113 98-100, 102, 104-6, 108-11, 113-6, 118-23, 125-7, Pissarro, Mme 113 Yamashita, Shintaro 254 129-32, 170-71, 174-5, 177-8, 180-3, 186-93, 199, Poe, Edgar Allan 129 Yport 100 Poisson, Mme 250 240, 242-4 Monet, Blanche (née Hoschedé) 171, 240, 248–50, Poissy 11, 103, 105-6 Zola, Emile 116-17, 170, 184 253, 255, 259, 262, 264-5 Poly, Père 123 L'Oeuvre 116-17 Monet, Camille (née Doncieux) 9-11, 17, 24-6, Pourville 11, 98, 100-03 Zola, Mme 117 30-32, 196 press 13, 103, 105-6, 116, 182, 194 Monet, Claude [The entries below are to paintings public opinion 10-11, 103, 105-6, 116, 118, 196, referred to in the letters or text, not to the 253 illustrations] Boulevard des Capucines 10 Rebière 265 Renoir, Pierre-Auguste 8–10, 14, 16–17, 24, 101, Cathedrals Series 170, 174, 177-8, 180-81, 196 Décorations 13, 15, 240-41, 249, 256, 258-61, 103, 108, 113, 124, 170, 186, 240, 244, 247, 253 263 République Française 113 Déjeuner sur l'herbe 8 Ribot, Théodule-Augustin 21 Gare Saint-Lazare 10 Rodin, Auguste 12, 14, 98, 128, 184-5 Grain Stacks Series 12-13 Balzac 185 Haystacks Series 12 Victor Hugo 184 Rollinat, Maurice 129 Impression, Sunrise 9 London Series 171, 186, 188-94, 196, 264 Rothenstein, Sir William 196

Rouen 8, 12–13, 16, 21, 170–71, 174–5, 177–8, 180

Rozias 21

Mer de Belle-Île 124

Meules 174

Text Acknowledgements ST. LOUIS COMMUNITY COLLEGE AT FLORISSANT VALLEY

Permission to reproduce Monet's letters has been generously granted by many libraries, archives, galleries, dealers and private collectors; we gratefully acknowledge the following:

Archives du Musée Rodin: 15.5.1888; 23.4.1897; 30.6.1898.

Musée Marmottan: 31.10.1921; 18.1.1923.

Fondation Custodia (Coll. F. Lugt), Institut Néerlandais, Paris: 4.4.1882.

The descendants of Alice Monet (Numbers prefixed by a W. indicate the numbering used in the catalogue of letters in D. Wildenstein, Claude Monet, biographie et catalogue raisonné): W312, 1.2.1883; W313, 2.2.1883; W334, 19.2.1883; W392, 24.1.1884; W394, 26.1.1884; W398, 29.1.1884; W404, 3.2.1884; W436, 3.3.1884; W438, 5.3.1884; W441, 10.3.1884; W451, 21.3.1884; W590, 15.10.1885; W592, 20.10, 1885; W615, 9.11.1885; W631, 27.11.1885; W656, 22.2.1886; W686, 14.9.1886; W688, 18.9.1886; W690, 21.9.1886; W697, 27.9.1886, W700, 1.10.1886; W704, 4.10.1886; W721, 23.10.1886; W723, 26.10.1886; W730, 30.10.1886; W741, 9.11.1886; W742, 10.11.1886; W746, 14.11.1886; W750, 17.11.1886; W814, 23.1.1888; W824, 1.2.1888; W842, 24.2.1888; W875, 19.4.1888; W914, 9.3.1889; W924, 22.3.1889; W932, 31.3.1889; W937, 4.4.1889; W954, 17.4.1889; W975, 8.5.1889; W976, 9.5.1889; W1132, 12.2.1892; W1137, 8.3.1892; W1144, 31.3.1892; W1145, 2.4.1892; W1175, 16.2.1893; W1179, 22.2.1893; W1183, 3.3.1893; W1186, 9.3.1893; W1203, 29.3.1893; W1207, 4.4.1893; W1265, 3.2.1895; W1266, 9.2.1895; W1268, 13.2.1895; W1269, 15.2.1895; W1282, 12.3.1895; W1286, 20.3.1895; W1507, 13.2.1900; W1519.2.1900; W1527, 9.3.1900; W1532, 18.3.1900; W1533, 19.3.1900; W1543, 28.3.1900; W1592, 2.2.1901; W1593, 3.2.1901; W1611, 2.3.1901; W1652, 14.2.1902.

Note

Where the date of a letter is not known, a suggested date is given in brackets.

Further Reading

- GEFFROY, Gustave, Claude Monet: sa vie, son oeuvre, Paris 1922 (reprinted 1980)
- WILDENSTEIN, Daniel, Claude Monet, biographie et catalogue raisonné, 4 volumes, Lausanne and Paris 1974–85
- JOYES, Claire, Monet at Giverny, London 1975
- ISAACSON, Joel, Claude Monet, Observation and Reflection, Oxford 1978.
- METROPOLITAN MUSEUM OF ART, Monet's Years at Giverny: Beyond Impressionism, New York 1978.
- ADHEMAR, Hélène, Hommage à Claude Monet, Paris 1980 TUCKER, Paul, Monet at Argenteuil, New Haven and London
- GUILLAUD, Jacqueline and Maurice, Claude Monet at the Time of Giverny, Paris 1983.
- STUCKEY, Charles, *Monet, a Retrospective*, New York 1985 HOUSE, John, *Monet: Nature into Art*, New Haven and London 1986